Cardo Col

Nadeije LANEYRIE-DAGEN

HOW TO READ PAINTINGS 2
THE SECRETS OF THE ARTIST'S STUDIO

with **Philippe Dagen**
and **Pierre Wat**

CHAMBERS

For the English-language edition:

Translator
Richard Elliott

Editor
Stuart Fortey

Art consultant
Dr Patricia Campbell, University of Edinburgh

Series editor
Camilla Rockwood

Publishing manager
Patrick White

Prepress
Vienna Leigh

Prepress manager
Sharon McTeir

Proofreader
Ingalo Thomson

Originally published by Larousse as *Lire la Peinture Tome 2: dans le secret des ateliers* by Nadeije Laneyrie-Dagen

© Larousse/SEJER, 2004

English-language edition
© Chambers Harrap Publishers Ltd 2005

ISBN 0550 10189 6

Cover image: Caspar David Friedrich, *The Wanderer above the Sea of Clouds,* © Bridgeman-Giraudon

Typeset by Chambers Harrap Publishers Ltd, Edinburgh
Printed in France by MAME

Contents

The age of the avant-garde: 20th century 186

Foreword

As its title suggests, this book invites you to exchange the role of viewer for that of (virtual) friend or confidant of the artists. These artists are predominantly painters, but – since the book aims to reflect the full richness and diversity of artistic creation – sculptors, engravers, photographers and video artists are also included.

This book is written in a very different style from that of traditional art books. It follows on from a first volume, *How to Read Paintings*, the purpose of which was to help readers progress beyond their initial, instinctive pleasure in a work of art to an examination of the techniques employed by artists in order to generate this pleasure. Now, by entering the 'laboratory' in which the works of art were conceived and made, the reader will experience a feeling of real intimacy with the artists.

The chronological structure will take you into the medieval workshops where collective artworks were produced; introduce you to the artists of the Renaissance (the period that marked the beginning of solo artistic creation); invite you to share the preoccupations and aspirations of painters during the heyday of the academies and the subsequent rebellion against them in the 19th century; and finally take you through the perilous adventures of the 20th-century avant-garde. With the help of panels covering special issues in depth, the book examines the lives of artists, analyses their social and economic positions and assesses their training and knowledge. You will look at the relationship between artists and their 'public': those who viewed their works first of all in churches and other public buildings, then at the 'salons' and in galleries and museums, as well as those who bought, commissioned or collected them. The book pays a good deal of attention to techniques both ancient (fresco, oil painting, the miniature, tempera) and modern (collages, drip paintings, photography), ranging in its discussion from methods that have stood the test of time to the computer paintbox, taking in the rayographs and photomontages of the interwar years along the way. It considers the relationships between artists and intellectuals – from the humanists of the Renaissance to the poets, philosophers and writers of today, including those who write about art in order to encourage, inspire or commentate, from the earliest theoreticians to contemporary critics.

From this vantage point at the heart of the creative process, in the midst of the everyday lives of the artists, you will be able to 'see' and appreciate works of art more fully.

Introduction

What were the lives of painters and sculptors like in Europe during the 14th century? What are they like today, in the early years of the 21st? Do the words 'painter' and 'sculptor' denote the same social position and activities today as they did in the Middle Ages or have their similarities disappeared? Is there any link, however remote, between the illuminator of manuscripts or carver of statues and the sculptor, photographer, video artist or installation artist of today? Or are the differences so pronounced as to render

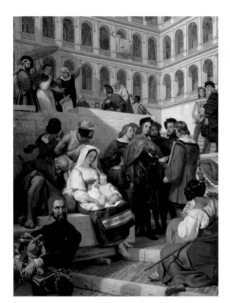

the question completely meaningless? To attempt to answer these questions presupposes a knowledge of the lifestyles and working practices of artists from the past – the (mostly anonymous) sculptors who made the statuary that we admire in our cathedrals, or the stained-glass makers and the artists and craftsmen who designed, constructed, sculpted, gilded and painted the altarpieces now consigned to our museums. Were these men rich? Were they held in high esteem? Were they subsidized? In an age before exhibitions, museums, galleries and even the notion of an art market, how did artists become famous? Why were they commissioned and why was their work sought after? What kind of demand was there from the public? Who, indeed, were the 'public' during the Middle Ages and what was their relationship with the artists of the day? How were artists trained and educated? How did they see their role?

Horace Vernet, *Raphael at the Vatican*, Paris, Musée du Louvre.

This book attempts to answer these and other questions. From anonymous craftsmen working in the *loges* (workshops) of medieval churches to 19th-century artists working alone and fêted as creative geniuses, from master craftsmen belonging to guilds to painters or sculptors who trained in the academies, the process of change was slow but radical – no less radical indeed than the subsequent break between the Prix de Rome laureates of the 19th century (who could look forward to assured careers as 'official' painters) and the revolutionary artists who created the avant-garde movements of the 20th century.

Over the ages, artists have attracted a range of reactions from their contemporaries. The work of some artists has united communities while that of others, because of its unusual or disturbing nature, has been judged unacceptable at the time of its creation. The era when art was most in tune with its time was perhaps the Middle Ages. This was also, however, a period when artists were accorded a lowly position in society. It was only after a hard struggle during the Renaissance and the 17th and 18th centuries that artists acquired a certain status and the right to create freely rather than simply respond to a patron's demands. The price of this freedom was that artists were to some extent set apart from society: adulated as geniuses and eccentrics, their whims tolerated, they acquired the image (only partially accurate) of being unconventional outsiders. One of the aims of this book is to shed some light on the relationship between artists and society at different points in time; in other words, to look at those moments of sympathy, harmony, rejection, confrontation, conversion and adulation that have determined the nature of the relationship of a particular nation, social class or state with its creative artists, whether this relationship was a tolerant one or not.

This book tells a fundamentally practical story, chronicling individuals, networks, transactions and institutions – for artists never create alone, no more so yesterday than

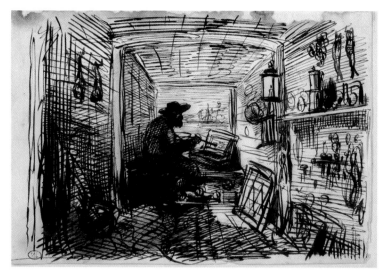

Charles-François Daubigny, *The Floating Studio*, Paris, Musée du Louvre.

today. For a long time, painters and sculptors worked in studios alongside other artists: a master during their early years; apprentices and assistants of their own if they became successful. An artist's work was defined by the work of his forefathers. More often than not he would himself be the son of an artist and therefore part of a tradition that he would accept as a matter of course. Artists were also defined by their fellow artists. They belonged to the same guild and their work was governed by a specific set of rules. In terms of quality, their work had to meet certain material and sometimes aesthetic criteria. Their remuneration and reputation depended on these criteria being observed. While these conditions did not change completely with the coming of the Renaissance, the promotion of individuality and originality did introduce a new feeling of rivalry between artists.

It would have been impossible to write this wide-ranging history spanning numerous centuries without extensive research in many areas: biographies of artists, the sociological contexts of the different periods, the status of artists, and the myths and legends surrounding artists' lives (some of which have had to be corrected if not com-pletely disregarded). While there are many studies that examine the way works of art are received and consequently focus on collections and collectors, it also makes sense to concentrate on the key players in the history of art and on the creative process itself – in other words, on the true heart of the subject. It is important to examine the working methods – in their 'dens', studios, schools

Fernand Léger examining the *Portrait of Fernand Léger* by **Alexander Calder**, c.1934.

and even museums – of those who dare to have a go, break new ground, create, even destroy, and generally marry their fate to that of a square canvas, a wooden panel, a bronze cast or a photographic print. Perhaps it is not too unrealistic to hope that the descriptions and analyses in this book will bring works of art closer to the viewer, make their meaning more accessible and encourage the viewer to take a more tolerant and analytical approach. If this book succeeds in convincing its readers that a work of art – any work of art, from any period, regardless of subject matter, materials or style – deserves their attention and trust, it will have succeeded in its aim.

Nadeije Laneyrie-Dagen

The age of the workshop
14TH–15TH CENTURIES

From the end of the 13th century, or possibly earlier, painters and sculptors carried on their trade within the framework of a guild. The guilds were bodies representing not just artists but all manual workers producing and selling their own work. They organized the way a particular trade was practised, laid down rules for training, arbitrated in any disputes and assisted those who fell on hard times. The constraints inherent in this system, society's view of those we now call artists as simple craftsmen, the importance of the specific tasks they performed to the public's appreciation of objects that had to be 'well made' (in other words whose creation was time-consuming and required great expertise) – all these have to be taken into account in any modern-day analysis of artworks of the past.

AN INHERITED TRADE

Because of the way medieval society was organized, people rarely became artists because they had a vocation for the work. Children were not free to choose their own career; it was chosen for them by their parents, who would have them apprenticed at the age of ten or eleven before they were old enough to express a preference. Sons would generally follow in the traditional family occupation. The trade of shopkeeper (or craftsman, or smallholder, or artist) was passed down from father to son. Workshops were organized around the family and were hereditary, made up of dynasties whose members either specialized in a particular activity or moved between one artistic activity and another. Dürer was the son of a goldsmith who was himself the son of a goldsmith; in Venice, Jacopo Bellini taught his sons and heirs Gentile and Giovanni; and the Lombardo family in the Doges' Palace, the Parler family in Prague and the Viguier family in the Rouergue and Albigeois regions of France had all been families of architects and sculptors for a number of generations. Women played no part in this artistic succession. Occasionally a painter's daughter might work alongside her father while she was single, but she would cease to work as soon as she married.

Talent or know-how? A long apprenticeship

The idea – so obvious to us today – that a child might have a gift for a particular career or profession was largely alien to the mentality of the time. The most Dürer says on the subject, in the notes made for a *Book of Painting* he was planning to write shortly

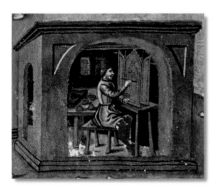 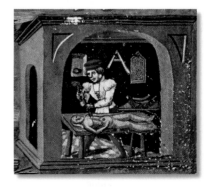

Craftsmen in Their Workshops, a miniature from *De Spherae*, c.1450, Modena, Bibliotheca Estense.

Family continuity and social renewal

Léon Bonnat, *Giotto Watching the Goats*, oil on canvas, 105 x 140cm, Bayonne, Musée des Beaux-Arts.

Social renewal was not completely unknown in the medieval workshop. Children from non-artistic families were sometimes given the opportunity to train as artists, either because their parents considered them to be well suited to this type of work or – probably more rarely – as a result of the child's personal preference.

Craftsmen's sons

Most of the time, these 'outsiders' came from backgrounds similar to the artists' own. They were often the sons of craftsmen or tradesmen. The brothers Antonio and Piero Pollaiuolo, for example, who worked as painters, goldsmiths and engravers in Florence during the second half of the 15th century, were the nephews of a poultry dealer (*pollaiolo*) who operated from the Old Market in Florence. Similarly, the father of Vittore Carpaccio, a Venetian painter active around 1500, was a trader in hides (*scarpazza*).

Giotto the shepherd

Occasionally, artists came from the non-urban classes. Giotto, who revolutionized Florentine painting in the years around 1300, came from peasant stock. Legend has it that he came to the attention of Cimabue when the Florentine painter spotted him drawing a goat. This anecdote, told by Giorgio Vasari in his *Lives of the Most Eminent Painters, Sculptors and Architects* (1550–68) and often repeated since, is significant. It was meant to convey the idea that nature (here, the countryside in which Giotto lived and the herd over which he watched) is the best master and offers a more effective way of learning than the imitation of other artists. It introduced the idea that art depended not on know-how but on innate talent that simply had to be cultivated.

Rare exceptions: artists from a middle-class background

It was far less common for adolescents from a higher social class to turn to art for a career. Examples from the very end of the Middle Ages include the architect Brunelleschi, whose father was a Florentine notary, and above all Leonardo, the son of Ser Piero, also a notary, from Vinci near Florence. It is interesting to note, however, that as the illegitimate son of a notary and a peasant girl, Leonardo's social position was ambiguous.

The age of the workshops

after 1500, is that an artist must have a 'natural aptitude'. To the medieval mind, the job of painter, goldsmith, and later engraver (and to a lesser extent architect) were trades like any other, which required a long apprenticeship as much as they depended on any pre-existing talent.

In the absence of talent, which the masters would not have thought to demand of the children entrusted to them, other qualities were looked for. Patience was the main virtue expected of the young apprentices. Around 1400, the Italian Cennino Cennini, a mediocre painter but the author of an important work called *Il Libro dell'Arte* (*The Craftsman's Handbook*), advised novices to 'deck themselves in love, fear, obedience and perseverance'. 'As soon as you can', he continued, 'place yourself under the tutelage of a master in order to learn what you can, and stay with him as long as possible.'

Training was long and complex. Apprentices would live alongside their master – their status somewhere between that of servant and child of the family – for five or six years, depending on the tradition of the workshop and town as well as on the progress they made. The apprentice would have a room, often shared with his fellow apprentices, in the master's house. He would eat at the master's table, but would generally be given more modest food than the master. His material situation would gradually improve. During the early years he would receive no remuneration and his family might even be required to pay for his keep (laundry and food). As he started to become more skilled, and therefore more useful, he would start to be paid, albeit extremely modestly as he was still only a novice.

Masters had total authority over the boys in their care, just like a father had over his children. Not only would they see to the professional training of their young apprentices, they would also, to some extent, assume responsibility for their general education. It is likely that masters sometimes became attached to their young apprentices. They also tried to ensure that once trained they would remain with the workshop. For this reason, apprentices were sometimes adopted by their masters. Francesco Squarcione, a 15th-century Paduan painter, became an expert at this: his 'adoptive sons' included the great Andrea Mantegna and other outstanding painters such as Marco Zoppo, as well as painters of lesser note such as Giovanni Francesco Uguccione. Some of these artists eventually undertook legal proceedings against Squarcione in an attempt to extricate themselves from his over-possessive guardianship.

The life of an apprentice was somewhat austere. We can only hope that it was less austere than contemporary writings on art would have us believe, however, as these emphasize the need for artists and budding artists to lead a highly disciplined life. The indispensable Cennini, for example, recommends that aspiring artists lead an almost monastic existence: 'Your life should be well regulated at all times, just as it would be if you were studying theology or philosophy or some other science. You should eat and drink in moderation, at least twice a day, consuming light dishes of good quality and avoiding strong wines. You should spare your hand by preserving it from heavy strain such as moving stones, wielding a crowbar and many other things that are not good for your hand and are liable to injure it. Another thing that can make your hand so weak that it will quiver and flutter even more than leaves in the wind is indulging too much in the company of women.'

Preparation of materials

In the workshop, the first tasks the apprentice was taught to perform – and was expected to master quickly – were practical ones. During the Middle Ages, painters bought in only absolutely essential raw materials from outside. Brushes and paints were made in the workshop, and supports (in general wood, unless the work in progress was a fresco, in which case the wall would be prepared on site) were also prepared there. As the quality of craftsmanship played an important part in how a work would be judged, the preparation of materials and other practical tasks entrusted to the young apprentices had to be carried out to perfection. Cennini, again, lists the different jobs that young painters were required to perform: 'The point of departure for all these manual tasks is

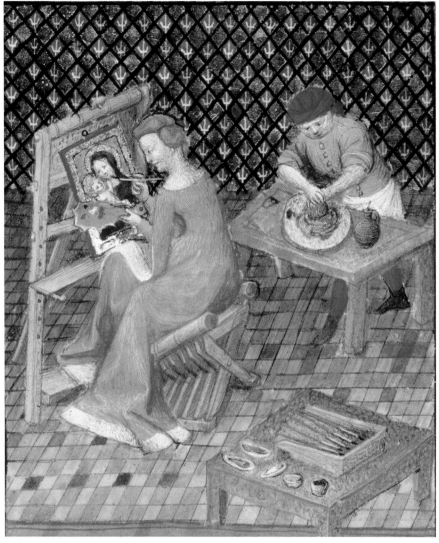

The Legendary 'Paintress' Thamar at Her Easel, miniature from a manuscript by Boccaccio, end of the 14th century, Paris, Bibliothèque Nationale de France.

drawing and painting. These two areas demand a knowledge of how to crush and grind, apply size, cover with cloth, coat with gesso, scrape and polish the gesso, make decoration in relief with gesso, lay bole, gild, burnish, make tempera, lay backgrounds, pounce, scrape, stamp or punch, draw outlines, paint, embellish and apply varnish to a panel or altarpiece. When working on a wall, it is necessary to dampen, plaster, smooth and polish the surface, trace out the design, paint in fresco, finish off *a secco*, temper, decorate and add the finishing touches to the wall.' This list is far from exhaustive. Cennini goes on to describe how to prepare parchment, rag paper and tracing paper; how to work on glass and how to lay tesserae (mosaic pieces), which could be made of coloured glass or stone or consist of tiny pieces of quill, millet or fragments of eggshell. He explains how to trim a goose quill, how to prepare squirrels' tails (known as 'little greys') or pig bristles prior to tying them together to make brushes. He tells us how to make glue 'using different kinds of fish' or with 'pieces of kids' muzzles, feet, gristle and many pieces of skin'. Most importantly, he reveals the recipes for making pigments using dif-

The age of the workshops

ferent kinds of earth, rock and plants, which are ground and then 'tempered' (mixed with a binder) to form a paste; he reminds novices how to preserve paints in small pots filled with water and carefully sealed, and he teaches them to choose the appropriate pigment, as regards composition, for the effect sought and the technique used – water and egg-based for parchment, glue or egg-based for a wooden support, or exclusively water-based on the damp surface (*intonaco*) of a wall.

Initial responsibilities

The young assistants would spend most of their time performing these practical chores. But they would also learn about the more strictly artistic aspects of their trade. As painters' workshops were production centres, they could not expect to be given theoretical instruction. It was by completing the less important parts of works commissioned from the master that they acquired the relevant skills. They would start by applying large areas of flat colour (underpainting) to frescoes, gilding panels and adding haloes. A little later, they would learn to vary tone (light and shade) and would be asked to paint the drapery on figures. They would also paint the architectural elements and rocks against which the figures, already drawn by the master, would stand out.

After a number of years, the apprentice would start to play a part in the drawing process itself. He might be given the job of transferring a composition that had been sketched out by the master in miniature onto the actual support, squaring it up to the right size. He might assume responsibility for the wide borders of frescoes decorated with stencilled motifs and for the small paintings set into the architecture of altarpieces. Eventually, commissions of lesser importance would be entrusted completely to the apprentice, giving him licence to think up and execute in full his own compositions. By this stage he would have proven his competence and would be made a journeyman. Journeymen generally continued to work for the same master (who would now pay them the wage of an experienced craftsman) for a few more years. But there would be no question yet of them developing an individual style: any inclination towards originality had to yield to the workshop style, which bore the mark of the master in charge of it.

These different stages in the development of a painter were mirrored by the career path of the sculptor. The apprentice, who would probably enter the workshop a little later (as soon as he was strong enough to work hard materials such as wood or stone), would be given only menial jobs during his first few years and would spend part of his time cleaning the workshop and running errands. Once he became more experienced, he would be given minor sculpting tasks such as chiselling out a shape marked out by his more advanced colleagues or rubbing down the surface of a sculpture with abrasives until it was smooth. A little later, he would be allowed to sculpt the less prominent parts of a piece of work, such as hair, plants and trees or architectural elements. As a journeyman, he would work on figures and eventually finish an entire work, continuing, however, to use the drawings with which he had been furnished by the master of the workshop.

The culture of the *bottega*

Although the workshop was principally a place where practical expertise could be acquired, it was by no means devoid of intellectual stimuli. Located in town centres, often in the busiest commercial districts, painters' workshops took the form of a *bottega* (shop) to which customers and other interested parties could come, either to order a piece of work or simply to watch an object being made. Depending on the workshop's importance, between three and around twenty individuals would work together. At the beginning of the 14th century, Duccio's *bottega* in Siena numbered at least eight adult assistants and several apprentices in addition to the master himself. In Florence at the beginning of the 15th century, the sculptor Ghiberti's boasted 21 assistants. It was more usual, however, for a master to work alongside one or two assistants and one or two *garzoni* (apprentices). In 1496 in Ulm, the rules governing the trade of sculptor stipulated that the head of a workshop could have no more than two apprentices but as many journeymen as he wished.

TECHNIQUES OF MEDIEVAL PAINTING

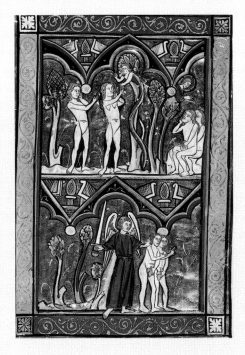

Anonymous illuminator from the Île-de-France, *Temptation and Fall*, 13th-century miniature, Paris, Bibliothèque Nationale de France.

Illumination

'Illumination' refers to the decoration of a manuscript (*codex*, plural *codices*) with paintings. These paintings were executed in the spaces left blank on the page (*folio*) by the copyist or scribe (*scriptor*): either in the margins, as an initial letter (dropped capital), in a larger area left free above the text or between paragraphs, or as a full-page miniature.

A painting that covers an entire page with no text and no white parchment showing is known as a 'carpet page'.

The support used was generally parchment – carefully prepared animal skin (sheep, lamb, kid or calf) – which was either left untreated or covered with a layer of egg white, white lead (lead carbonate) and water. The illuminator (*pictor*) would then work on this surface in tempera (see p.16), applying pigment in the form of powder bound with a moist mixture of egg yolk and egg white.

The colours applied in this way were opaque. They were generally chosen for their brightness. The term 'miniature' comes from *minium*, a Latin word that denotes an orange-red pigment obtained from oxide of lead (red lead), and 'illuminate' comes from *illuminare*, which means 'to render brilliant, luminous'. Besides red, the *pictor*, at least from the 13th century onwards, had a bright blue, yellow and various greens at his disposal. These colours were often enhanced with silver and especially gold (for which the more economical solution of tin dyed with saffron was sometimes substituted). Silver and gold were applied in the form of a powder bound with glue.

The use of egg gave these paintings a wonderful brilliance as if they had been varnished. The downside of this technique, however, was its fragility: the paint surface had a tendency to flake.

In some rare examples, including the *Utrecht Psalter* from the Carolingian period, illuminators worked with a quill. They sometimes enhanced their drawings with bright inks or discreet translucent touches of vegetable-based pigment. *Grisaille* (painting in tones of grey) was also used for a number of manuscripts, particularly at the end of the Middle Ages.

Techniques of medieval painting

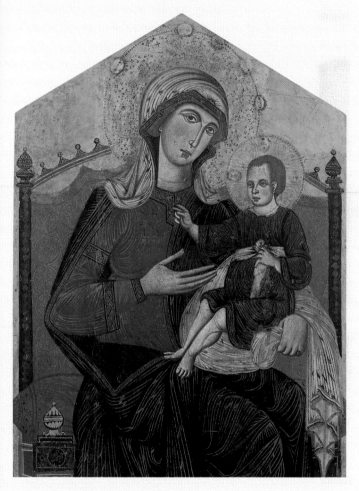

Guido da Siena, *Virgin and Child*, detail, 1265–75, tempera on wood, 125 x 73cm, Florence, Galleria dell'Accademia.

Distemper and tempera

The majority of paintings (other than wall decorations) that survive from the medieval period were executed on wood. Their golden backgrounds give them a luminosity to which the colours, as bright as those used in illuminated manuscripts, also contribute.

The techniques employed by painters varied from one workshop to another. Powdered pigments mixed with oil, glue made from animal skin or vegetable gum (distemper) or an emulsion of egg (tempera) were often used in different areas of the same work. Other elements might also be mixed into the glue or emulsion, such as honey, fig milk or casein. Distemper and tempera were the most widely used

techniques both in northern Europe until the van Eyck brothers came on the scene and in Italy until around 1460. Meticulous preparation of the support was necessary. This involved the application of a gesso ground (a mixture of gypsum and size) covered by several layers of boiling glue that were left to dry before being carefully rubbed down. This was normally the responsibility of the apprentice.

A secco painting

Until the end of the 13th century, murals were painted using distemper or tempera applied to dry plaster (*fresco secco*).

In France, for example, Romanesque frescoes were painted using pigments mixed with egg or lime-water applied to a perfectly smooth surface of mortar coated with glue.

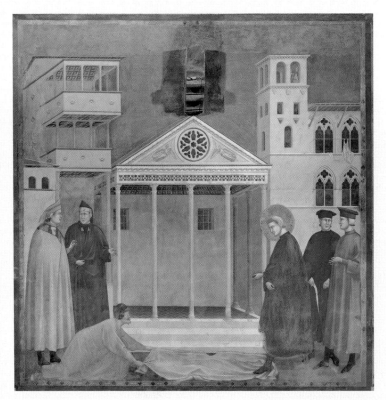

Giotto, *Legend of St Francis: Homage of a Simple Man*, c.1295–1300, fresco, 270 x 230cm, Assisi, Upper Basilica, Basilica of St Francis.

Fresco

Thanks largely to the influence of Giotto, true fresco (*buon fresco*) prevailed in Italy from around 1300 to the time of Michelangelo two centuries later.

The master of the workshop, or an experienced journeyman working from a drawing executed by the master (which he would square up to the appropriate size), would sketch out the figures and other elements of the composition onto a first layer of plaster (which had been applied to the entire area to be painted) using a red pigment known as *sinopia*. The painting stage could then begin. The painter would coat the area he was going to paint on a given day (*giornata*) with a second coat of plaster (*intonaco*). It was essential that this second layer remained wet throughout the whole time he was working (hence the name *fresco*, meaning 'fresh'). Both layers of plaster were made of sand and slaked lime. Mineral-based pigments were used – clay soils and silicates resistant to the lime – which were mixed by the painter with water. As the plaster dried, it released carbohydrates that formed a transparent crust of calcium carbonate on the surface, protecting and fixing the pigments. Paintings executed in this way have a matt appearance. Providing the wall was properly prepared and the climate is not too humid, frescoes can last a considerable length of time.

The technique was extremely involved. Painters had to make allowances for the fact that the colours altered as the plaster dried. Most importantly, they had to try to make as invisible as possible the joins between the sections painted each day on the specially laid damp plaster.

The age of the workshops

The working day would be filled with plenty of lively conversation. More often than not this would be on subjects of a fairly trivial nature – the weather, neighbours, everyday matters. Jokes would come thick and fast. The youngest members of the workshop might get up to a few pranks, and indeed a number of these have been passed down to us by writers and biographers. At the end of the 14th century, Franco Sacchetti (and after him Vasari) reported how Giotto painted a fly on a figure being worked on by Cimabue which completely fooled his master. The anecdote is significant as it likened the young Florentine artist to the great painters of the past – to the ancient Greek painter Zeuxis, for example, of whom Pliny the Elder relates that he once painted grapes so lifelike that some birds mistook them for the real thing. Giotto was duly celebrated as the first modern representative of a naturalistic style.

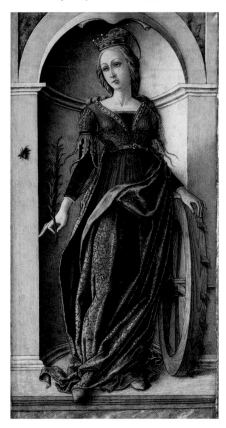

Carlo Crivelli, *St Catherine of Alexandria*, end of the 15th century, oil on wood, 37.8 x 19cm, London, National Gallery.

Wandering apprentices

Sometimes, however, the conversation would turn to more serious matters. The more experienced, older members of the workshop might talk of what they had seen further afield. One of the rules of an artisan's training was that before being made a journeyman he should travel. This tradition was certainly respected in northern Europe at least. Having spent four years in the workshop of the Nuremberg painter Michael Wolgemut, Dürer left in 1490 to explore the world, spending another four years on his travels. He is thought to have made his way to Frankfurt and Mainz, where the artist known as the 'Master of the Housebook' worked, and from there continued to the Netherlands to study the works of the founding fathers of Flemish painting. He returned via Alsace with the intention of visiting the engraver Martin Schongauer and stayed for a few months in Basle. Most painters and sculptors continued to travel even after adolescence: the haphazard nature of where work became available and the vicissitudes of their careers took them from one town to another. This provided them with opportunities to discover new works and to talk to artists from other parts. For those who remained at home, contact with customers (or patrons, as they were known) who came to commission work from the master and later returned to check on its progress, would give rise to other types of discourse.

Assorted objects

The culture that informed the output of a particular workshop depended on the breadth and scope of that workshop. If the *bottega* was a small enterprise, as was usually the case, its workers would often be content to produce works of a modest nature. In the absence of a design industry such as we have today, an extraordinary number of painters, sculptors and goldsmiths in every town were involved in the large-scale production of everyday objects – marriage chests in which the bride's linen was stored (*cassoni*), the painted birth trays (*deschi da parto*) that were given to pregnant women, headboards

Artists and Travellers

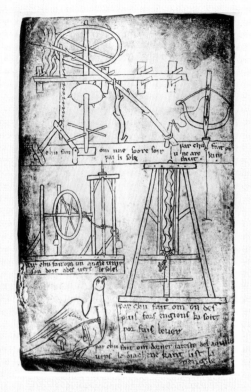

Villard de Honnecourt, *Machines and Tools for Lifting*, c.1235, drawing from a pattern-book, Paris, Bibliothèque Nationale de France.

It would be a mistake to believe – just because we are used to rapid travel nowadays – that the medieval world was a series of separate, self-enclosed spaces. Thanks to the growing power of nations, roads started to become safer in the 13th century and it became easier to move from place to place. Artists travelled from town to town. Without these journeys the Gothic style, which displayed such strong common characteristics throughout the whole of Europe, would not have been possible.

The 13th century
Around 1230, Villard de Honnecourt, a French architect (or possibly goldsmith) from Picardy, travelled all over Europe drawing whichever painted, sculpted and architectural motifs took his interest. The resulting sketchbook (which survives) served as a collection of models for the master's own use, and must subsequently have been passed on to, and have influenced, other masters.

The 14th century
Like Villard de Honnecourt, the best medieval painters and sculptors also moved around, sometimes collectively. At Assisi, a workshop originally from the Île de France was responsible for the oldest cycle of paintings in the Upper Basilica, and in

Spain the German sculptor John of Cologne worked on Burgos Cathedral in the middle of the 14th century.

These peregrinations were sometimes confined to a single country. In Italy, Giotto painted in Florence, Assisi, Padua and Naples at the beginning of the 14th century. During the same period, the Sienese painter Simone Martini travelled to Assisi and Naples and lived out his final years in Avignon, the residence of the popes from 1309. Duccio, also from Siena, travelled as far as Paris.

The 15th century
Painters and sculptors continued to travel extensively in the 15th century, as did architects, musicians (the French composer Guillaume Dufay made a career for himself in Italy) and humanists in general. The Flemish painter Jan van Eyck had a workshop in Bruges, but journeyed twice to Spain and Portugal, and it is thought that he might have crossed the Alps. The Florentine painter Masolino, Masaccio's collaborator on the Brancacci Chapel in Florence, also worked north of Milan (Castiglione Olona), in Rome (San Clemente) and in Hungary. The work of these artists acquired a following in each centre. And from each centre the artists brought back visual memories that translated into motifs which they introduced into their work.

A FLORENTINE INDUSTRY: PAINTED CHESTS (CASSONI)

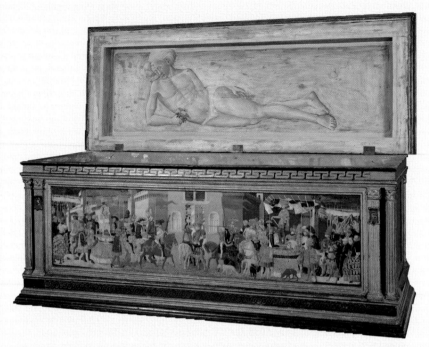

Florentine workshop, *The Story of Romulus, Tatius and Hersilia*, c.1460, *cassone* (marriage chest), c.1460, Copenhagen, Statens Museum for Kunst.

During the Middle Ages, furniture was limited to a few essential pieces. Pride of place among these items went to the chests (*cassoni*) designed to hold the household linen. Placed against the wall or alongside a bed, they also served as seats.

A profitable line

During the 15th century in Italy, and particularly in Florence, it soon became fashionable for these chests to be highly decorated. The outer panels, framed by ornate moulding or other types of gilt relief work, were often adorned with paintings of scenes from mythology, ancient history, social life or contem-porary fables. The inside of the chest, which was generally lined with velvet or damask, could also feature paintings, this time of a more private nature, on the inside of the lid and elsewhere.

The involvement of the major workshops

Certain workshops specialized in the production of these chests, the decoration of which did not gen-erally bear the artist's signature. It is known, how-ever, that famous painters occasionally accepted commissions to paint *cassoni* as well as other pieces of furniture: Domenico Veneziano, for example, or Paolo Uccello, whose famous battle scenes were painted as decorative panels (*spalliere*) to adorn the bedroom of Lorenzo de' Medici.

illustrated with a variety of scenes, trompe-l'oeil wall-hangings, friezes depicting child dancers, landscapes painted on the walls of bedrooms or reception rooms, and carved or inlaid furniture. All these tasks, of a fairly intricate nature and reasonably well paid, would be executed swiftly without excessive care being devoted to their execution. A small number of renowned workshops adopted a different strategy, however, going to considerable lengths to win and hold on to the favour of a rich and demanding clientele. The high quality of the items they produced – decorative objects as well as major commissions such as altar paintings, frescoes and large sculptures – testified to the excellence of the master.

Tradition and innovation

The superiority of such workshops was often determined by their capacity to innovate. Not that masters strove for newness for its own sake; nothing would have been more alien to the mentality of artists of the 14th and 15th centuries than a desire to break with the past, and their experiments never sprang from a wish to run counter to what had gone before. But a desire to rationalize led the heads of workshops to adopt new techniques and procedures. Giotto's style, for example, is characterized by the very strong physical presence of his figures and by architectural or natural settings that create a greater impression of depth than any style of painting since the end of antiquity. These aspects reveal on the part of Giotto a sensitivity to the wonder of the world which is clearly in harmony with Franciscan preaching, based as this is on a celebration of the Creation. But the new rules governing the depiction of the human figure and space also answered the need to standardize the work of the many different members of Giotto's workshop. Equipped with precise instructions that established rules for the figure and guided by the simple laws of empirical perspective, the painters who worked under the Florentine master on the cycle of frescoes depicting the life of St Francis or on the Arena Chapel cycle in Padua produced works which seem to have been cast in an identical mould and which the master would have had no difficulty in recognizing as his own.

A revolution: the lure of oil

One hundred years later in northern Europe, a major development resulted from this same desire to outdo the competition, in other words to do things differently and more durably. In Bruges at the end of the first quarter of the 15th century, the mysterious Hubert and his brother Jan, about neither of whom much is known, developed a concoction, based on a blend of heated oils, that allowed them to dispense with egg or glue, the traditional media used to bind the powdered pigment. The first historian of northern art, Karel van Mander, tells the legendary story of their discovery in his *Schilderboeck* (*Book of Painters*): 'It happened one day that Jan, after finishing a panel to which he had devoted a great deal of time, put his painting in the sun to dry. But either because it had been badly joined or because the sun was too hot, the panel split. Jan, greatly annoyed to see his work destroyed, vowed that such a thing should never happen again due to the effect of the sun. Forsaking the use of egg-based paint coated with varnish, he set himself the task of manufacturing a coating that would dry without having to be left in the open air and would thus allow painters to dispense with the drying action of the sun. He tested a number of different oils and other materials in succession and concluded that linseed oil and walnut oil were the most effective drying media. By heating them and adding other ingredients, he ended up creating the best possible varnish. And as it is the way of inquisitive minds not to rest until their quest is over, he was finally, after much experimentation, able to assure himself that colours mixed in oil cohered marvellously, that they acquired a great robustness as they dried, that they were impermeable to water and, last but not least, that the oil added lustre without the assistance of any varnish.'

This story of the ruined painting and indignant artist is now considered inaccurate and exaggerated. It is nevertheless true that after much trial and error and unsuccessful ex-

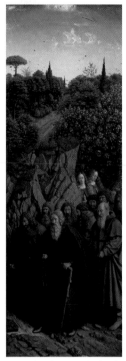

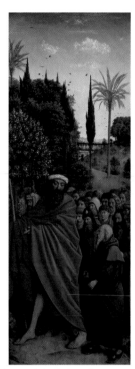

perimentation, the VAN EYCK BROTHERS were the first painters to develop an oil binder of satisfactory quality. Their experiments provided an answer to their quest for a technique that would allow them to improve the way they painted not only the mass of the human figure, by employing gradations of flesh tones, but also landscapes of convincing depth in which the land is bathed in delicate light. Oil enabled them to paint pictures whose colours have hardly changed over the course of time and whose softness and glossy appearance astonished their contemporaries.

Jan and Hubert van Eyck, *The Holy Hermits and The Holy Pilgrims,* two panels from the Ghent Altarpiece, 1426–32, oil on wood, 146.4 x 51.2 and 146.5 x 52.8cm, Ghent, Cathedral of St Bavon.

THE RISE OF THEORY

Early experiments with space and volume and the discovery of painting with oil were the logical result of experimentation conducted by artists whose knowledge had been sharpened by years of practical experience. But the greater frequency of innovations during the last two centuries of the Middle Ages, after almost a thousand years of practically no change at all, indicates that a new, bolder and more inquisitive spirit was beginning to permeate the workshops at this time.

These relatively sudden changes also influenced the way art was written about. Between the 8th century and the beginning of the 15th century, writings on art were produced exclusively by practitioners, taking the form of artists' manuals rather than essays on art appreciation aimed at the general public. They were of a technical nature, devoted mainly to recipes for paint, advice on making brushes and the preparation of panels, walls and colours. However, the 'laboratory' described in these treatises is not without its poetic overtones. The names of the pigments themselves are extremely exotic, evoking far-off places such as the Indies or the city of Sinopia and legends of monsters and dragons; and the process of paint production takes us into the realms of alchemy – not only because of the part played by animal, plant and mineral ingredients, but also because of the complicated nature of the preparations and the extremely precise measurements involved. There can be little doubt that mixed in with a viewer's enjoyment of a painting at this time was the feeling that the actual making of the work was shrouded in mystery. When the first Flemish oil paintings arrived in Naples during the reign of King Alfonso in the mid-15th century, viewers were surprised by the 'acrid smell' given off by the still fresh paint.

Representing the body: shading and proportions

From the beginning of the 13th century, the authors of treatises began to concern themselves less exclusively with the strictly material aspects of painting. With respect to the human figure, they pondered the question of how to depict flesh, which could not be done by the application of a single colour, and volume, which could not be rendered

THE FIRST TREATISES ON ART

The first treatises on art appeared in Europe between the 13th and 15th centuries.

The Byzantine world

It was in the Byzantine world that the earliest treatises on art originated.

De Diversis Artibus (*On Divers Arts*), by the monk Theophilus, dates from the 12th century. It is divided into three parts. The first deals with painting and is a homage to colour. Taking each colour in turn it looks at how to prepare pigments and how to mix them for each type of support. The second part is dedicated to glass, in particular the construction of stained-glass windows. Part three focuses on metalwork.

The Mount Athos manuscript, attributed to Dionysios of Fourna, is thought to have been written at some point between the 12th and 14th centuries. It is also divided into three books. The first provides technical recipes, the second looks at subject matter and the third examines the positioning of works in churches.

The first Western treatises

The first major text to appear in Western Europe was *De Coloribus Faciendis* (*On Making Colours*), written by the monk Pierre de Saint-Omer in the 13th century. As its title indicates, it was concerned exclusively with colour.

Far wider in scope is *Il Libro dell'Arte* (*The Craftsman's Handbook*) by the painter Cennino Cennini, which dates from the end of the 14th century (trecento). Written in the vulgar tongue, Italian, it was clearly aimed at artists, who would not have known Latin. In 189 short chapters it details the techniques of various arts – mainly painting, but also stained glass and sculpture (with an emphasis on casting). Most importantly, for the first time ever the book formulated a number of ideas about art (including some tentative reflections on anatomy, proportions, light and shade, relief and perspective) and artists (the author praises the supremacy of Giotto, the master of his own master).

The 15th century: Ghiberti and Alberti

Two outstanding works were written in the 15th century. The authors were both Italian.

The *Commentarii* (*Commentaries*), written by the Florentine sculptor Lorenzo Ghiberti (1378–1455) towards the end of his life, are divided into three parts. The first is devoted to the sculpture and painting of the ancient world, the second takes the form

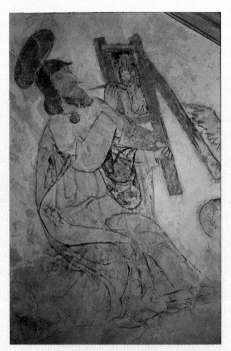

St Luke Painting the Virgin, detail from a Romanesque fresco, Canville-la-Roque, Cotentin.

of a survey of art from Cimabue (end of the 13th century) to the era in which the author was writing – and includes an autobiography – and the third sketches out a theory of art with comments on optics, anatomy and the proportions of the human body.

On Painting was written in 1435–6 by the architect Leon Battista Alberti (1404–72), who was also from Florence. It came in two versions: one in Italian (*Della Pittura*), aimed at painters, and the other in Latin (*De Pictura*), aimed at humanist art-lovers. This work neither provides technical instruction nor tells the stories of artists' lives. Divided into three books dedicated to theoretical developments, *On Painting* lays the foundations for a proper discussion of aesthetics. The first book deals with perspective; the second pays homage to the painting and painters of the ancient world and examines contour, composition and treatment of the figure (anatomy, movement and the passions); book three discusses the personality of the painter, the education he required and, in particular, the knowledge of orators and peers that he needed to have in order to devise his subjects (*inventio*).

with a simple outline. They invented the idea of chiaroscuro, the gradation of a colour from light to dark, as a way of indicating the fall of light and shade. Painters working on a face would start by applying a dark green undercoat known as *verdaccio*, onto which they would draw the facial features. This was then covered by another layer, made up of yellow, pink and white. The artist would then pick out the areas in relief (in other words, those that caught the light most) in yellow mixed with white. Finally, crimson would be added to the cheekbones and lips. Although systematic, this was nevertheless a highly effective way of rendering blood beneath the skin and of portraying rings and deep folds filled with shadow. A similar method was used for clothes. Following the application of a background colour for the entire surface of a garment, specific areas would be picked out in lighter or darker tones which would form the folds that were either catching the light or were hidden in shade.

What seems more surprising to modern eyes is that from around this time, and even earlier in Byzantium, artists considered it important to apply canonical proportions to their human figures. Their desire to create figures of ideal beauty sprang from the conviction that human anatomy was governed by a set of precise mathematical relationships. This belief was not based on actual measurements but was speculative and abstract. Numbers, seen as the key to harmony, dominated the construction of figures. These numbers were directly or indirectly inherited from the ancient world, from artists such as

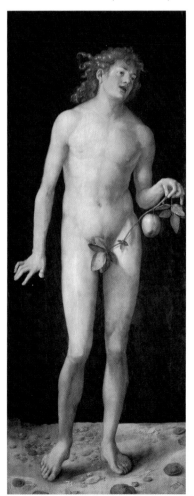

Polyclitus and Lysippus, who are no more than names to us now, and from Roman authors that have endured somewhat better, such as the architect Vitruvius. Vitruvius's work *De Architectura*, the subject of passionate discussion during the Renaissance, was quoted as early as 1244 by the Dominican friar Vincent de Beauvais in his *Speculum Majus*, an encyclopedia covering much else besides painting. In the West, *De Architectura* inspired a canon in which the head fits into the body eight times and the face is in turn divided into three equal parts: forehead, nose and chin. However, some workshops followed other rules, in which the overall height of the body was eight or nine times that of the head.

Deceiving the eye: the beginnings of perspective

The real turning point in the culture of the workshop took place later, however. At the end of the duecento and beginning of the trecento – the 13th and 14th centuries – painters in Italy started to study the rules governing space, or more precisely the rules that govern how the different forms distributed within space are perceived by a viewer positioned at a fixed point. Indeed, the transposition of a three-dimensional object onto a flat surface such as a wall, a panel or a sheet of parchment poses a number of problems as regards perspective. Each object has to be constructed in a such a way that viewers are given the illusion that they could take hold of it, and proportions need to be worked out that will give viewers a sense of the distance between themselves and the scene in front of them.

Albrecht Dürer, *Adam*, 1507, oil on wood, 209 x 81cm, Madrid, Museo Nacional del Prado.

To solve these problems, painters in around 1300 and throughout the 14th century adopted dif-

ferent techniques that varied from artwork to artwork and that were handed on from one workshop to another. During the following century, the driving force was provided by men whose trade was building rather than painting. In around 1420, the architect Brunelleschi produced paintings of the Baptistery and Palazzo Vecchio in Florence in 'legitimate' perspective, in other words with all the orthogonals, or sightlines, converging on a single point. Fifteen years later, a fellow architect, Leon Battista Alberti, also a theoretician who set himself the task of codifying the rules of painting, gave the definitive description of classical perspective – which he called *modo ottimo*, the 'best method' – in his treatise *Della Pittura* (*On Painting*). Alberti saw the painting's surface as the base of a pyramid constructed from the visual rays that lead from the object to the retina and the brain, where the image is formed. In order to obtain the necessary reference points for the shapes to be given precise measurements, all that is required is for the plan and elevation of an object to be projected onto the picture and the points thus obtained to be translated into abscissas and ordinates.

Thus tried out and theorized, the method was greeted with enthusiasm by painters. In around 1425, the brilliant young artist Masaccio tried it out in the cycle he was collaborating on with the older painter Masolino in the Brancacci Chapel in Santa Maria del Carmine in Florence. In the frescoes *The Rendering of the Tribute Money* and *THE HEALING OF THE CRIPPLE AND THE RAISING OF TABITHA*, he forces the orthogonals formed by the cornices and other edges of the buildings to meet in a single vanishing point – this he did by knocking a nail into the painted layer of plaster and attaching strings to it which could then be used to plot and mark the lines of convergence.

A decade later, the rigorously geometric treatment of space started to become an end in itself in the work of a number of painters. Paolo di Dono (better known as Paolo Uccello), who worked in Florence from the middle of the 1430s, was described by Vasari in his *Lives of the Most Eminent Painters, Sculptors and Architects* (1550–68) as being 'fanatical' about perspective and so infatuated with experiments in projective geometry that it made him 'solitary, eccentric, melancholy and poor'. A married man with children, Uccello neglected his family in order to devote himself to experiments with perspective. His wife, wrote Vasari, 'reported that Paolo spent whole nights alone in his study grappling with problems of perspective. When she called him to bed he would reply: "Oh what a sweet thing perspective is!' Uccello was in fact the first artist to attempt to apply the rules of perspective to the construction of figures rather than just buildings, as Brunelleschi and Masaccio had done. In the three panels that make up his celebrated *Battle of San Romano*, he arranges the foreshortened bodies of warriors and horses, suspended in action or frozen in the immobility of death, over a landscape divided into different planes. Uccello was also the first to paint highly complex volumes such as the multi-faceted turbans known as *mazzochi* that were worn by Florentine men

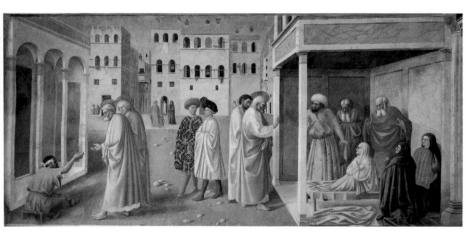

Masaccio and Masolino, *The Healing of the Cripple and the Raising of Tabitha,* c.1426–8, fresco, 247 x 586cm, Florence, Brancacci Chapel, Santa Maria del Carmine.

The age of the workshops

of fashion at the time and that also adorn the heads of the commanders in his battle scenes.

Turbans of the same shape appear in the pictures of the *Legend of the True Cross* series painted by Piero della Francesca in Arezzo, south of Florence, between 1452 and 1459. Piero, one of the most important Italian artists of the 15th century, spent the last few years of his life blind. Unable to paint, he poured all his energy into his other passion, writing works in which pure mathematics came to play a larger and larger role. *De Prospectiva Pingendi* (*On the Perspective of Painting*) is thought to have been written between 1475 and 1480, and the *Libellus de Quinque Corporibus Regularibus* (*Notebook on the Five Regular Bodies*) was completed at the end of the 1480s. Over the course of some two centuries of experimentation, a strange reversal had taken place. A science of perspective had long been desired by painters, who eventually learned it from architects, but it was artists who perfected it, who systematized its application and who developed its theory to such an extent that they were able to teach the mathematicians a thing or two. It is interesting to note that one of Uccello's friends was the mathematician Antonio Manetti, whom he included next to Brunelleschi in his portrait of a group of illustrious men. It is even more revealing that Piero della Francesca was the master of the mathematician Fra Luca Pacioli, who became famous in learned circles in northern Italy. It was whispered that his most famous work, *De Divina Proportione* (*On Divine Proportion*), was so closely inspired by Piero's own speculations that the author was no more than a plagiarist.

IMITATING NATURE ...

That a painter (described earlier as a craftsman striving to master the techniques involved in producing works of art) could, by the end of the 15th century, abandon his art in order to become one of the great mathematicians of his day is indicative of the changes that could result in members of workshops (the most remarkable of them at least) moving away from an essentially practical form of training and towards speculative pursuits. And perspective is no isolated example. At the end of the Middle Ages, artists became specialists – scholars or scientists – in other fields too.

A new science: anatomy

What had happened with perspective also happened with artists' medical, or at least

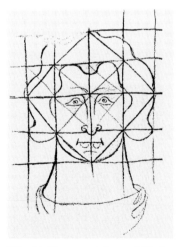

Villard de Honnecourt, *Geometric Head*, detail from a page of the *Sketchbook*, first half of the 13th century, Paris, Bibliothèque Nationale de France.

anatomical, knowledge. Throughout most of the Middle Ages, the figures created by artists had to obey the laws of proportionality (*commensuratio*), and there was little attempt to reproduce the anatomy of the body. Stylized forms were aspired to, rather than realistic ones. In the 13th century the Frenchman VILLARD DE HONNECOURT proposed a new method of drawing, an 'art de pourtraicture' that ignored the structure of the body completely. The drawings in his sketchbook, which is in the Bibliothèque Nationale, Paris, show a system of lines apparently arbitrarily superimposed on faces and figures.

From the beginning of the 14th century, on the other hand, and particularly during the 15th century, the body's physical presence became a priority. Artists examined reality by unclothing the body and studying its muscles and joints in action. They were even emboldened to peer beneath the flesh, attending the first dissections of human bodies in anatomy theatres. They were even known to dissect human bodies themselves. In *On Painting*, Alberti wrote about how important it is for painters to be familiar with the

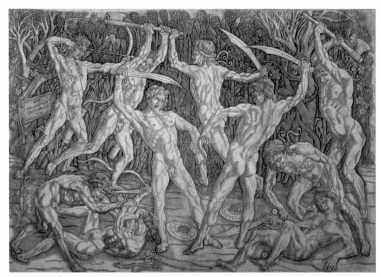

Antonio Pollaiuolo, *Battle of the Nudes*, c.1470, copper engraving,
41.8 x 61.1cm, London, British Museum.

structure of the body: 'When painting an animate being, we must first of all mentally
position the bones below the surface, because they do not bend and therefore occupy
a fixed position. Next the nerves and muscles must be set in place; finally the bones
and muscles have to be covered with flesh and skin. When painting a clothed person
it is necessary first of all to draw a nude and then to drape it in garments. Similarly,
when painting a nude, we must first position the bones and muscles and then lightly
cover them with flesh and skin so that one can tell without difficulty where the mus-
cles are.'

Written in 1435, this advice no doubt reflected what was already current practice in
artists' workshops. Fifteen years later, in around 1450, the sculptor Ghiberti wrote some-
thing similar in his *First Commentary*: 'It is necessary for sculptors wishing to sculpt a
statua virile to have observed dissections so that they know how many bones there are
in the body and are also familiar with the muscles and all the sinews [*nervi*] and their

connections.' Soon afterwards came the first eye-
witness accounts. It was written of Antonio Pol-
laiuolo, who worked in Florence between 1460
and the end of the century, that he 'dissected
many corpses in order to study their anatomy'
and indeed an engraving of his in the British Mu-
seum entitled *BATTLE OF THE NUDES* reveals what
was for the time a remarkable knowledge of the
muscles.

Just a few years later, in 1487 or possibly just be-
fore, LEONARDO DE VINCI, painter, sculptor, archi-
tect, inventor (and anatomist), took up his scalpel.
In addition to working on human corpses (his first
subject was an old man whom he had seen die
and on another occasion he dissected a pregnant
woman, exposing her foetus which was almost
at term), he also opened up animals, especially
pigs. As a result, Leonardo acquired a greater in-
depth knowledge of the inside of the body than
any doctor had hitherto possessed. His labours
yielded a vast number of manuscript notes and

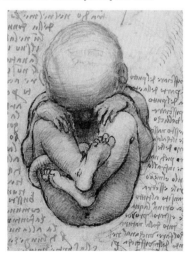

Leonardo da Vinci, *The Foetus in Utero*,
detail of a drawing, c.1511–13, Windsor,
Royal Library.

27

SOLVING THE PUZZLE OF THE HUMAN SKELETON

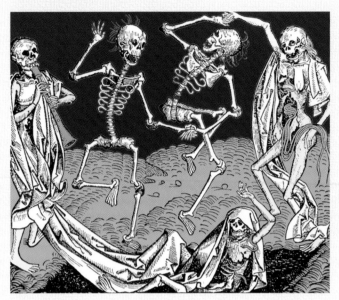

Michael Wolgemut, *Dance of Death*, 1493, woodcut, illustration for Hartmann Schedel's *Weltchronik* (published in Nuremberg), private collection.

From the end of the Middle Ages, and in particular during the 16th century, anatomical knowledge gradually increased as the practice of dissection became more widespread.

Medieval ignorance

In around 1400, Cennino Cennini wrote in his *Craftsman's Handbook* that 'men have one rib fewer than women, on the left-hand side'. The absence of anatomical knowledge was filled by imagination fed by religious tradition. The myth of man's missing rib is explained in the Bible by the creation of Eve from one of Adam's ribs – taken from the left side, the 'evil side', as Eve was the originator of sin.

The truth is that it was very difficult for people at this time to imagine what the human skeleton looked like. Dissection was forbidden as was any interference with dead bodies. Bones surfaced in old cemeteries fairly regularly, but the way they fitted together remained a mystery. In 'dances of death', therefore, and other depictions of themes relating to death (such as the 'triumph of death' and the 'meeting between the three dead and the three living'), the skeletons are inaccurate. In particular, mistakes were made with the knees (lack of kneecaps), the shoulder joints and especially the hips.

Vesalius's *Fabrica*

It was not until the 16th century, after dissection had been made legal, that knowledge of the human skeleton really began to spread. Artists wanting to depict skeletons were able to consult anatomical charts – among them the magnificent engravings printed by Titian's workshop and published by Vesalius in his *De Humani Coporis Fabrica* (*On the Fabric of the Human Body*) in Basle in 1543 – or even acquire whole, reassembled skeletons. These would adorn their workshops before finding a home much later in school science laboratories.

a multitude of drawings that are as remarkable for the quality of their draughtsmanship as they are for their accuracy of observation. This anatomical knowledge also influenced his paintings: this is strikingly apparent in his depiction of the emaciated old man at the centre of his unfinished *St Jerome* in the Vatican Museum.

... AND STUDYING THE ANCIENTS

By the end of the Middle Ages, the culture of the workshops had absorbed even more disciplines – areas that we would class today as 'arts' subjects. Seen as particularly important were an understanding of the past and an interest in ruins, history and Roman mythology.

Roman ruins

Never completely forgotten during the Middle Ages, antiquity returned with a vengeance during the 13th and 14th centuries and especially during the 15th. In their search for different forms of expression, the intellectual elite discovered in the antique model a way of reinvigorating their thinking and their everyday surroundings. Writers were the first to promote this renewal of classical ideas – a renewal that originated in Italy before spreading throughout Europe and giving rise to the Renaissance. The most important of these writers was Petrarch, who lived during the 14th century. An imitator of Latin poetry in all its forms, he was also the author of works of history and philosophical treatises in which he propagated the learning of the classical world.

Among artists, an interest in antiquity made itself felt discreetly at first and only later with greater force. Although no treatise urged them to study Roman masterpieces, 13th- and 14th-century sculptors and painters in Italy – where classical remains were numerous and well preserved – began to copy pagan models or take their inspiration from them. There were some particularly early stirrings of interest in Pisa. The Camposanto, the sanctuary in which the great and the good of the city were buried, housed a number of antique sarcophagi that had been brought back from distant lands visited during the crusades. These large marble coffins decorated with reliefs served as both inspiration and models to the Pisano family, a dynasty of sculptors. By 1260, Nicola Pisano, the father, had sculpted a marble *NAKED HERCULES* on the balustrade of the pulpit of Pisa Baptistery, carving out antique-style figures with heavy drapery and classical physiognomy. At some point before 1311, his son Giovanni used a classical statue of Venus as the model for his figure of Prudence, which he carved for the pulpit of Pisa Cathedral. Thus, over the course of two generations, from the middle of the 13th century to the early years of the 14th, this encounter with the ancients produced the spark that allowed Italian sculpture to move from the Gothic style to one resembling Classicism.

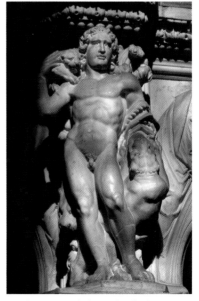

Nicola Pisano, *Naked Hercules*, also known as *Fortitude*, 1259–60, marble, pulpit of the Baptistery, Pisa Cathedral.

Sculptors were early students of an interest that was also in evidence among 14th-century painters (the Florentine Giotto and the Sienese Pietro and Ambrogio Lorenzetti). They were also the first to journey to Rome (in the first half of the 15th century) in order to examine the city's ancient remains systematically. Brunelleschi, the inventor of perspective with a single vanishing point, was one of those who undertook a proper 'study trip' to the Eternal City. Having

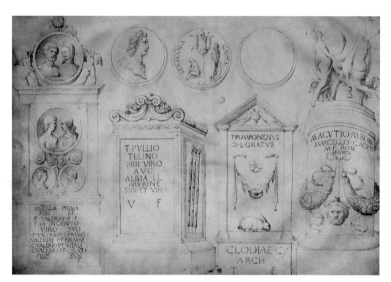

Jacopo Bellini, *Funerary Monuments and Medals*, c.1455, drawing, Paris,
Department of Prints and Drawings, Musée du Louvre.

trained as a goldsmith and sculptor, Brunelleschi had been rejected by the jury judging
the competition to design a pair of bronze doors for the Florence Baptistery (they chose
Ghiberti instead). This disappointment led to his leaving the city, apparently in the com-
pany of the great Florentine sculptor, Donatello. The two young men travelled to Rome
to study the antique marbles – but the monumental ruins of the city inspired Brunelleschi
to become a builder.

In the years following Brunelleschi's trip to Rome, the city regained its reputation after
a century of decline brought about by political upheavals and in particular by the exile
of the Curia to Avignon. Summoned by the popes and encouraged by Rome's new-found
stability, artists started to flock to the city. The first to follow in Brunelleschi's footsteps
was none other than his successful rival Ghiberti, another sculptor, who stayed in the
city twice between 1415 and 1430 and built up a 'miniature museum' of 'many bronze
and marble antiquities'. Painters also travelled to Rome. In 1427, Pisanello copied a num-
ber of classical works while painting the frescoes in the Lateran Basilica. The Venetian
JACOPO BELLINI did the same a few years later. He too made many drawings – two whole
volumes survive – including complex compositions in which sculptures in the antique
style rub shoulders with monumental ensembles, and at least two pages of precise
archaeological studies.

Imagined or reconstructed ruins

However, it was perfectly possible for artists to develop a passion for antiquity with-
out spending any time in Rome. Mantegna, Jacopo Bellini's son-in-law, trained in Padua,
a city that was traditionally open to Florentine innovation, having welcomed Giotto at
the beginning of the 14th century and Donatello and the painter Uccello in the middle
of the 15th century. Padua contained a number of classical relics, including the ruins
of a theatre or *arena* which gave its name to the chapel decorated by Giotto, and a tomb
erected at the end of the 13th century to house what were believed to be the remains
of the Trojan hero Antenor, the city's founder. Special circumstances during the first half
of the 15th century also played a part: a group of educated Greeks fleeing the Turkish
invasion of Byzantium found work teaching at the University of Padua, and Western-
ers undertook journeys in the opposite direction, to Greece and the eastern Mediter-
ranean, in search of undiscovered relics. Cyriac of Ancona, for example, an ordinary
merchant who had neglected his trade as a result of his passion for archaeology, spent
the years 1418 to 1455 (the year of his death) travelling. He visited Rome, Athens, the

Pelopponese and Egypt, drawing ancient ruins and collecting relics.

Like Cyriac, Francesco Squarcione, a curious figure who was an embroiderer and then a painter and who, as we have already seen, became the adoptive father of Mantegna, took himself off to visit the Italian cities, Rome and Florence at least, before pressing on to Greece and (if he is to be believed) Egypt. In 1430, he opened a workshop in Padua, where he enjoyed considerable success in training and retaining the services of a number of extremely promising young artists. The eleven-year-old Mantegna entered this workshop at the end of 1441. Seven years later, in 1448, the young artist was given the job of painting the *Scenes from the Lives of Saint James and Saint Christopher* in the Ovetari Chapel in the Church of the Eremitani in Padua. Using a minimum of colour in order to mimic a stone relief, he created a world which was entirely classical in style, from its monuments to its costumes and accessories. In *ST JAMES BEFORE HEROD AGRIPPA*, the scene is dominated by a triumphal arch decorated with a bas relief depicting a pagan sacrifice and medallions featuring the heads of emperors. It also bears an authentic inscription in Roman capitals, a feat without precedent in medieval painting. The figures too are classical, based in part on identifiable models.

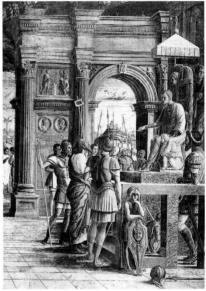

Andrea Mantegna, *St James before Herod Agrippa*, 1449–56, fresco, base 330cm, Padua, Church of the Eremitani.

THE LIMITS OF ARTISTS' LEARNING

Building on the training he received under Squarcione and the lessons he learned from the drawings of his father-in-law Jacopo Bellini, Mantegna engaged in diligent archaeological research. This is evident from his mature work, which is similarly rich in classical motifs and even resurrects certain figurative or iconographic themes that had fallen out of favour. Examples of this are the *Triumphs of Caesar* series, which was intended for engraving, and the unusual subject matter of *The Introduction of the Cult of Cybele at Rome*. This poses the question of how artists – both experts in perspective and natural philosophers (as scientists were known at the time), and familiar with the ancient remains they were so passionate about copying – were also able to acquire the knowledge needed to tackle rare subjects of this kind with such a high degree of accuracy and without any of the anachronisms that might betray a less than perfect grasp of the subject.

The spreading of knowledge

A document relating to Mantegna from the end of the 15th century provides an insight into the company kept by artists and the entertainments they indulged in and reveals how this knowledge might have been spread. The document forms part of a longer manuscript – a homage to Cyriac of Ancona written by the Paduan Felice Feliciano (an

The age of the workshops

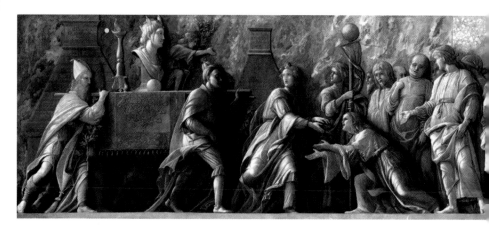

Andrea Mantegna, *The Introduction of the Cult of Cybele at Rome*, c.1505–6, tempera on canvas, 74 x 268cm, London, National Gallery.

eccentric individual who was the scribe, or secretary, of a local humanist and a lover of antiquities with a passion for the occult) – and describes a trip to the countryside made by a group of friends. On 23 and 24 September 1464, Feliciano, Mantegna, a painter named Samuele da Tradate and another learned companion took a trip by boat along the southern shore of Lake Garda, enjoying the fragrant gardens and sweet-smelling islands, but also taking time to record inscriptions and improvise a highly elaborate charade in the ancient style. The friends assumed roles: one played the '*imperator*' while the others played the '*consules*'. The first, wearing garlands of myrtle, periwinkle, ivy and other plants, sang and played the lyre in their small boat, which was decorated with carpets and laurel branches. The trip concluded with prayers and thanks to the Virgin for having granted the group of friends 'the will and wisdom to explore such enchanting locales and venerable ancient monuments'.

It was not from books, therefore, but from field trips and the exuberant acting out of whimsical tableaux with groups of learned friends that Mantegna and his fellow painter familiarized themselves with ancient modes of thought. This same Feliciano wrote a letter (dated January 1463) which sets the river trip in context by demonstrating the close connection that existed between humanists, who claimed to be experts on the subject of antiquity, and artists, who were self-taught enthusiasts. This earlier document is a fairly long letter of dedication from Feliciano to Mantegna, accompanying the gift of two albums of antique inscriptions. This beautiful gift was merited, wrote the humanist, by the fact that the painter was 'extremely desirous of pursuing his investigations into antiquities of this kind'. The rest of the letter is less favourable to Mantegna. The writer, having wished the artist 'much luck' in making progress with his Greek, adds – with what seems to us like astonishing arrogance, given that he is addressing a man of proven ability who has progressed beyond the stage of apprenticeship – 'I have no dearer or deeper wish than to see you become as cultured as possible, a man of learning accomplished in all subjects worthy of interest. I have no doubt that this will happen, providing you endeavour to ally to the pleasures of the body and the pleasures of fortune those of the mind'.

Painting and sculpture as 'mechanical arts'

Feliciano took on the role of Mantegna's protector. He may well have been kind and considerate, but he was also regarded as the knowledgeable one, whereas the painter was but a novice with much to learn. This apparent condescension can be explained by the way in which knowledge was viewed at the time.

The medieval mind had a highly compartmentalized idea of learning, putting those with practical or 'mechanical' knowledge, and those who had studied subjects at university level (*trivium* and *quadrivium*) before entering the 'liberal' professions, into opposing

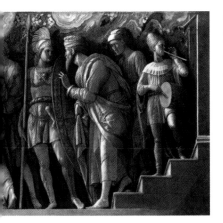

categories that rarely came into contact with one another. The difference between the two types of training lay in the specific areas of knowledge involved. It is clear that a merchant or craftsman (such as a painter or sculptor) would not be versed in the university subjects of grammar, logic and rhetoric. Also crucial was a command of Latin, which was the sole vehicle for the discussion of the more 'rarified' subjects and in particular for any area of knowledge relating to the ancient world, whether the language was used in Latin texts themselves or in writings about ancient culture. Artists did not go to university in the Middle Ages. Apprentices were taken on by their masters at the end of early childhood, when they were ten or eleven years old. In the 15th century, the luckiest of them might have the opportunity to remain at school for an extra few years at most: Botticelli left school at 13 and Leonardo da Vinci did not enter the workshop of his master Verrocchio until the age of 14 or 15. The wide provision of educational facilities in a largely urbanized Italy meant that painters could generally read, write and count. As adults, however, they could ill afford the time or the money to continue their education.

Artists' Libraries

The few artists' libraries known about today allow us to form a fairly precise idea about the scope of their owners' knowledge.

Sculptors

In Florence in 1498, the brothers Benedetto and Giuliano da Maiano, both sculptors, possessed 29 books of their own. Just half a century after the invention of printing, this was a relatively large collection. More than half of these books were religious in nature, including a Bible, a *Life of St Jerome* and a book devoted to the miracles of the Virgin Mary. The secular part of the collection was made up of the works of Dante and Boccaccio and a *History of Florence*. Classical antiquity was represented by two works of a historical nature: a *Life of Alexander* and Livy's *History of Rome*. No work of classical literature featured in the brothers' library – neither Virgil nor Ovid nor any other ancient writer who could have provided the sculptors with the subject matter for works on a mythological theme.

Leonardo, a true scholar

Around 20 years later, Leonardo da Vinci's considerably larger library is known to have contained at least 116 volumes. It included three Latin grammars, evidence of the determination with which the artist set about learning the language of scholarship. Also represented were the Church Fathers St Augustine and St Ambrose and a number of modern Italian writers including the comic poets Burchiello and Luigi Pulci and the short-story writer Masuccio Salernitano. The library list which has survived also includes books on anatomy, astrology, cosmology and mathematics. Once again, however, there is no mention of any Greek or Roman literature.

The absence of classical literature

What this tells us is that the artists of the end of the Middle Ages were certainly not ignorant of books. But they preferred religious works, contemporary literature in the vulgar language and specialist treatises that would be of use to them in their work, while they more or less completely ignored the 'sources' that would allow them to develop, by themselves, mythology-based subjects for paintings.

 # The age of the workshops

Leonardo da Vinci, whom we regard today as the archetypal 'universal man', described himself as an *'uomo senza lettere'*, an uneducated man. This declaration, made by the artist in order to provoke those in Milan (where he was living in 1487) who were jealous of his position as Duke Lodovico il Moro's engineer, was not entirely unfounded. Leonardo's father had intended his son to pursue a career as a shopkeeper and Leonardo had therefore attended arithmetic school. He did not know Latin, the rudiments of which he attempted to acquire as a mature man, and no one had introduced him to the 'humanities', in other words ancient literature and history.

The position of other cultured artists at the end of the Middle Ages was not dissimilar. Ghiberti wrote his *Commentaries* just before the middle of the 15th century in a very slightly Latinized Italian, and despite its title, Piero della Francesca's *On the Perspective of Painting* is written in an Italian that is merely enhanced by a few formulae in the learned language. If we turn our attention away from the treatises written by artists and towards the works that interested them enough for them to want to buy them, what becomes apparent is both their genuine cultural curiosity and the limits of the same. Of Brunelleschi, for example, it was reported that he was 'well-versed in the Scriptures' and that he 'knew the works of Dante well', but no record exists of his having read the classical authors.

CHOICE OF SUBJECT MATTER: THE ROLE OF THE HUMANISTS

A comment from the Venetian painter Titian, made shortly after the period we are looking at, provides us with an important clue. Addressing himself humbly to Alfonso, Duke of Ferrara, the artist writes: 'Ultimately, I will not have done any more than give form to that which received its spirit – the vital part – from your Excellency.' While we should make allowances for flattery in this instance, the statement nevertheless expresses a certain truth: that it fell to sponsors or patrons or their humanist advisers to define the intellectual content of a picture or sculpture, while the artist's job was to give to the subject an appropriate visual form.

David, St George and the horse

This division of responsibility was evident in the Italian city-states whose governments decided on the subjects of artworks. The promotion of the figures of David (sculpted in Florence by Donatello, Verrocchio and most importantly Michelangelo) and St George (present mainly in the sculpture and painting of northern Italian cities in the 15th and early 16th centuries) is explained by the favour which the cult of these heroes found with humanists of the early Renaissance period who were eager to find unifying emblems for their cities.

The equestrian statue was also revived, in response to commissions either directly from government or relayed by urban authorities growing aware of a need to enhance the

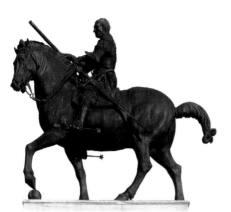

more important areas of their cities with outstanding monuments. Inspired by the larger-than-life-size antique bronze effigy of Marcus Aurelius in Rome, the most famous examples of these statues (also in bronze) were made by Donatello in Padua in 1447 (GATTAMELATA) and Verrocchio in Venice in 1482 (*Bartolomeo Colleoni*). Leonardo da Vinci was to have created an even more colossal sculpture, a 'great horse' intended to honour the memory of the Duke

Donatello, *Equestrian Statue of Gattamelata*, 1444, bronze statue, height 340cm, Padua, Piazza del Santo.

of Milan, Francesco Sforza, the father of the artist's employer Lodovico il Moro. However, the metal out of which this *cavallo* was to have been cast was seized by Louis XII's French troops when they entered the duchy's capital in 1499. It was melted down and made into cannons, while the clay model made by the artist was used as a target by the king's archers.

Isabella d'Este: an imperious patron

The intellectual development of works of art is particularly well documented for commissions at court, and from this documentation we can learn much about the collaborative nature of art. Mantegna is a good case in point. Forty years after completing the frescoes at the church of the Eremitani in Padua, the artist (who was in the service of the dukes of Mantua) was entrusted by the duchess, Isabella d'Este, with the task of producing paintings for her workroom or *studiolo*. This was a small chamber located in a tower of Castello San Giorgio that she wanted to decorate with works by the greatest living painters. Two canvases by Mantegna were completed and put in place – *Parnassus* in 1497 and *Minerva Chases the Vices from the Garden of Virtue* in 1502 – while a third was left unfinished when the artist died in 1506. Isabella provided the artist with the specifications for these works in the form of a precise, allegorical narrative outline drawn up by scholarly advisers. These scholars came up with a 'programme' (*invenzione* or *fantasia*) comprising a general theme (*istoria* or *fondamento principale*) and secondary themes (*ornamenti*).

While Mantegna was working on this commission, Isabella d'Este asked other renowned painters to contribute to the decoration of her *studiolo*. As early as 1496, she approached Giovanni Bellini, who promised her a painting but ultimately failed to provide one. In 1497, she established contact with Pietro Vannucci, known as Perugino. Although reluctant, he painted *The Battle between Love and Chastity* between 1503 and 1505. In 1501, Isabella d'Este approached Leonardo da Vinci – in vain – before soliciting the services of Francesco Francia. It seems that she also thought briefly of asking Filippino Lippi or Botticelli. In the end she accepted the services of Lorenzo Costa from Ferrara. Costa painted *The Reign of Comus* and completed the decoration of the *studiolo* with an Al-

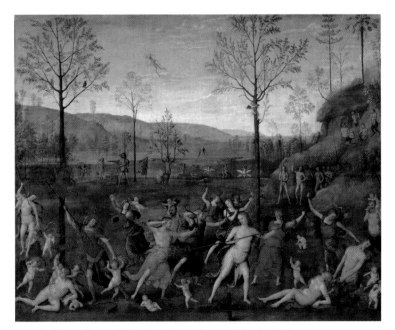

Perugino (Pietro Vannucci), *The Battle between Love and Chastity,* 1503, oil on canvas, 160 x 191cm, Paris, Musée du Louvre.

Mantegna and the humanists:
The Battle of the Vices and the Virtues

Andrea Mantegna (1430/1–1506), in the service of the dukes of Mantua from 1459 until his death, was one of the last artists to subject themselves to the exacting demands of the fearsome Isabelle d'Este. The 'programme' for *Minerva Chases the Vices from the Garden of Virtue* was elaborated by humanists at the court of the duchess, in particular Mario Equicola and Paride da Ceresara. The artist's intention was philosophical and moral: the painting is an allegory of the defeat of man's vices (carnal and otherwise) by Wisdom.

Andrea Mantegna, *Minerva Chases the Vices from the Garden of Virtue* or *The Battle of the Vices and Virtues*, 1502, tempera on canvas, 160 x 192cm, Paris, Musée du Louvre.

Mantegna's freedom can be seen in motifs that are all his own and that he uses in other paintings. One of these is the depiction of complex rock formations that seem to be exploding or erupting – an image of a living, active Nature.

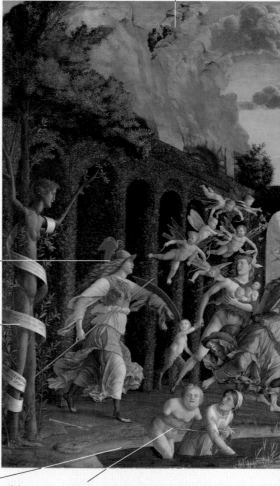

Minerva (or Pallas Athena). The goddess bears a resemblance to Isabella d'Este. She raises her shield to ward off a swarm of Cupids.

The contribution of the humanists is evident in a wealth of erudite detail – for example the inscriptions in Hebrew and Greek on the banderole wound around the tree-woman (Daphne metamorphosed into a laurel tree). These inscriptions call upon the three Virtues, shown floating on a cloud, to chase the Vices out of the Garden of Virtues.

The inscription on the edge of the pool reads: OTIA SI TOLLAS / PERIERE / CUPIDINIS ARCUS. It is a quotation from Ovid's *Remedia Amoris* (*Cures for Love*): 'Repudiate idleness and you will defeat Cupid's bow.'

Sloth (OTIUM), a figure with no arms, is incapable of working or even going anywhere without her companion INERTIA. The invention of this pair of figures points to the involvement of a theologian.

Is this clever, antiquity-inspired idea Mantegna's own invention or was it suggested to him by one of the humanists? This bank of clouds conceals a human head, a sport or accident of Nature (*lusus naturae*), itself posing as an artist.

These two female figures are Diana and Chastity.

The Three Virtues – Fortitude (holding a pillar and a club and wearing Hercules's lion-skin), Temperance (seen pouring away wine) and Justice (with sword and scales) – are enclosed in a halo-shaped cloud (or mandorla).

The banner bears an entreaty to the gods from Prudence, the mother of the Virtues.

Ignorance (INIORANCIA) is carried by minions Ingratitude (INGRATITUDO), holding Ignorance by the shoulders, and Avarice (AVARICIA), supporting the feet.

Immortal Hatred (ODIO IMMORTALE) carries sacks containing the seeds (SEMINA) of evil (MALA), severe evil (PEJORA) and extreme evil (PESSIMA).

Venus, representing sensual love (lust), stands on a centaur's back. A Cupid goes before her.

legory of the Court of Isabella d'Este. The duchess adopted the same restrictive attitude throughout the negotiations. Like many patrons, she had no faith in artists and turned to scholars at her court for the thematic programmes for the paintings. She gave artists very little room for manoeuvre and then only when she felt she had no other choice. To Perugino, for example, she made the following small concession: 'You may take things out if you wish, but you must not add anything of your own.'

JOBBING PAINTER OR CREATIVE ARTIST?

The difficulties experienced by Isabella d'Este in getting the pictures for her *studiolo* painted demonstrates that – with the exception of certain individuals such as Mantegna – artists at the end of the 15th century were no longer prepared to bend to their patrons' every whim. Instead they demanded for themselves more and more freedom as regards the intellectual conception of their work. This brings us back again to our earlier question: how were painters and sculptors who possessed few books (and fewer still by classical authors) and who had no command of Latin able to play a leading role in the development and translation into images of subjects that were often based on highly complex ideas?

The example of Sandro Botticelli

The artist Botticelli can help us in our search for an answer to this question. The greatest of his paintings – *La Primavera, The Birth of Venus, The Calumny of Apelles* and *The Mystic Nativity* – are allegories of far greater complexity than would seem to be the case at first. These paintings were not the result of thematic programmes devised for specific commissions; rather they reveal a subtle appropriation of humanist culture by the painter himself.

The last of these works, THE MYSTIC NATIVITY, painted in an astonishingly archaic style, depicts the triumph of the angels, who are seen embracing the human figures, and the defeat of the demons, who plunge into the earth, vanquished by the Incarnation. The banderoles declare the painting to be in praise of Mary, 'Mother of God', 'Bride of God'

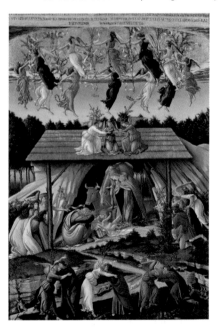

and 'Queen of the Universe', a figure of intercession who helps souls gain access to heaven – a function symbolized by the golden opening in the sky. At the top of the painting, an inscription records the date of the work and its inspiration: 'I, Sandro, painted this picture at the end of 1500 in an Italy beset by troubles ... taking my inspiration from Chapter XI of the Apocalypse of St John, which tells of the second woe, namely the unleashing of the devil for three and a half years until he was bound in chains ... as shown in this picture.' This inscription, which is unusual in a painting, leads one to suspect that Botticelli painted the picture for himself or for a close friend or relative and that after the tragic events brought about by the Savonarolan revolution and the first French invasion of Italy, he invested it with his own most intimate mystical beliefs. At the same time, the unusual choice of Greek (which Botticelli certainly did not know) for the inscription indicates that he had help from a scholar. This painting, into which the artist poured his own re-

Sandro Botticelli, *The Mystic Nativity*, 1501, oil on canvas, 108 x 75cm, London, National Gallery.

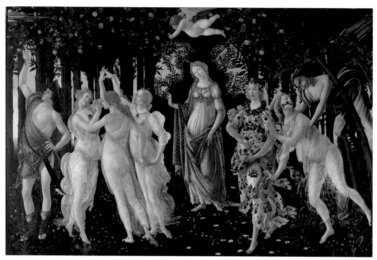

Sandro Botticelli, *La Primavera*, 1482–3, tempera on wood, 203 x 314cm, Florence, Galleria degli Uffizi.

ligious faith and knowledge while seeking scholarly help with the details, reveals a very different set of circumstances from that of the *studiolo* in Mantua.

However, the Neoplatonic context of Botticelli's two most famous secular allegories – *LA PRIMAVERA* (also known as *The Allegory of Spring*) and *The Birth of Venus* – excludes any possibility of the painter having drawn his inspiration for these works from his own knowledge. These paintings illustrate with extraordinary gracefulness ideas that were being debated by the scholarly 'Giardino' (Garden) circle in Florence. Led by the philosopher Marsilio Ficino, this group of Neoplatonists believed in the triumph of beauty, which a superior humanity – liberated from physical urges and desires (which would be sublimated into spiritual love) – would learn to adore. Neither does it seem that a thematic programme was developed specifically for these works, which were painted for a high-ranking patron in 1478 and 1485. Their immediate source was a contemporary text, Politian's *Stanzas Begun for the Tournament of the Magnificent Giuliano de' Medici*, whose genesis was independent of that of the paintings. There are also elements reminiscent of some of the ancient authors celebrated in Florentine humanist circles: Lucretius, Horace and Ovid, for example, and in the case of *The Birth of Venus*, a Homeric hymn. The mystery of how these two works came into being can no more be explained in terms of a plan imposed on the painter than the genesis of *The Mystic Nativity* can; it seems more likely that Botticelli heard comments and participated in discussions, and that he ultimately made these his own.

THE PAINTER'S IMAGE: THE PATRON'S VIEW

Botticelli's case is exceptional. He was working at the very end of the 15th century in a Florence that was undergoing massive philosophical change. One aspect of this was that intellectuals were beginning to accord the visual arts an importance they had not enjoyed since the end of antiquity. But more often than not, painters and sculptors were regarded by those who commissioned works from them less as valuable collaborators than as jobbing artists who could not be fully trusted and whose work had to be supervised from initial conception to final brushstroke.

The contract

From the very outset, artistic freedom was restricted. Works of art resulted not from the spontaneous initiative of an artist, but from a commission. The client would come to see the master painter with a plan of the work he wanted to have executed – we

Botticelli and the Learned Allegory:
The Calumny of Apelles

The Calumny of Apelles, which incorporates many of the classical themes that were fashionable in Renaissance Italy, was painted by Botticelli in around 1494. The picture tells the story, in allegorical form, of the Greek painter Apelles, who was accused of plotting against the King of Egypt and only exonerated at the last minute.

The subject matter was an appropriate choice for the artist as it tells the story of a blameless 'colleague' who ultimately triumphs over his enemies. Botticelli did not need to look far to find it. His attention was drawn to the subject by Alberti, who suggests it as a suitable theme for a picture in his book *On Painting*. Botticelli would also have been able to supplement Alberti's detailed retelling of the story with any one of a number of Italian translations of the souce text – *De Calumnia* (*On Calumny*), by the Roman author Lucian – that were published in the 15th century. The last of these was published in Florence in 1495, possibly the year this picture was painted.

Sandro Botticelli, *The Calumny of Apelles*, 1490s, tempera on wood, 62 x 91cm, Florence, Galleria degli Uffizi.

Statues in niches decorated with scallop shells serve as judges or witnesses of the scene. It is possible to identify Judith, David, St Paul, St George (heroes of the scriptures), as well as a number of mythological scenes (including a family of centaurs and the Judgement of Paris) which were popular in Florentine culture before being banished from paintings as a result of condemnation by Savonarola in his sermons.

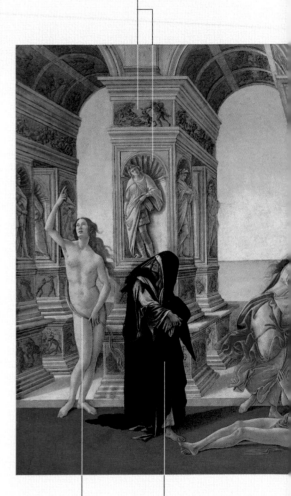

This naked young woman modestly concealing her genital area represents Truth.

Draped in a dark cloak, Remorse, an emaciated old woman, is part of the Calumny group. She turns to look at Truth, but too late.

Calumny's handmaidens are Treachery and Deceit. Young and seductive like their mistress, they are adorning her with flowers and ribbons.

Classical architecture forms an appropriate backdrop for a scene set in antiquity.

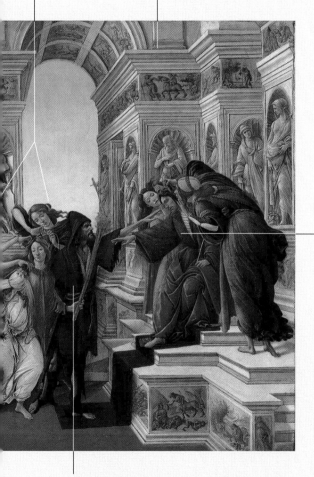

The man wearing a crown and with the long ears of an ass is King Midas. The two women on either side of the king, literally assailing him and whispering lies to him, are Ignorance (at the back) and Suspicion (in the foreground).

This pale, ugly and savage-looking man in rags is the personification of Rancour. He holds Calumny – a beautiful woman whose face nevertheless reveals that she has become 'hardened by deceit' (Alberti) – by the wrist. In her left hand she holds a lighted torch and with her right hand she drags Apelles behind her. Apelles, almost naked, clasps his hands in a vain attempt to implore the gods for help.

The age of the workshops

have already looked at the example of the paintings commissioned by Isabella d'Este. Whether they were regular patrons or occasional clients, those commissioning paintings wanted the final picture to turn out exactly the way they imagined it. To ensure this happened, they imposed all kinds of obligations on the artist and maintained control over the execution of the work.

Interference of this kind from the client is attested by a rare 15th-century document in which the Florentine painter FILIPPO LIPPI addresses various grievances to his patron, the nobleman Giovanni di Cosimo de' Medici. In his letter, Lippi claims to have 'respected [his patron's] instructions regarding the painting and [to have] paid scrupulous attention to every detail'. He complains of having been unfairly 'reprimanded' by Giovanni's representative, who has accused him of reducing the quantities of gold and silver used, and begs Giovanni to give him '60 florins to include materials, gold, gilding and paint'. In return, Lippi undertakes to complete the work 'by the twentieth of August' and assures his patron that it will conform to a drawing that he encloses with the letter.

More often than not, there is no written record of the day-to-day relationship between patron and artist. The client's right of control would be set down definitively in a written contract agreed at the time a work was commissioned. This might be either a formal document drawn up by a notary or a simple note signed by each of the parties. A number of such contracts have survived and they all contain similar clauses. To the painter they assign the task of preparing the picture, painting it in its entirety, by his own hand, in his usual manner and in such a way that the quality of the work can be independently assessed by experts. They stipulate the materials to be used (for the most expensive colours at least), specifying the weight of gold or silver or the quality of blue to be employed by the artist. They fix the time by which the work is to be completed, record the total amount to be paid and schedule the payment instalments as appropriate. Finally, with regard to the themes and motifs to be painted, they provide a description detailing the number of figures to be painted (the more figures, the more expensive the work) and sometimes specifying the inclusion of small buildings, trees, 'towns, mountains, hills, plains, rocks, clothes, animals, birds and wild beasts' – which

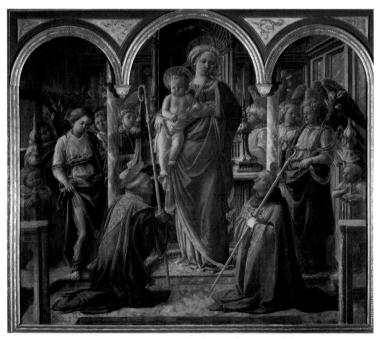

Filippo Lippi, *The Virgin and Child Surrounded by Angels with St Frediano and St Augustine*, also known as the Barbadori Altarpiece, 1437–8, tempera on wood, 208 x 244cm, Paris, Musée du Louvre.

took a long time to paint but which added interest to the background. Some of the contracts refer to a preliminary drawing made by the painter (or a three-dimensional model in the case of a sculpture) from which the actual work was not allowed to deviate without prior negotiation.

Stipulations regarding materials

As mentioned above, the instructions in these contracts follow the same pattern from document to document. During the last century of the Middle Ages, however, the relative importance of these clauses changed across the whole of Europe, pointing to a transformation in the way artists were perceived by those who commissioned them. The contracts now reveal two very different preoccupations. Firstly, references to a diagrammatic representation of the work to be completed – showing the position of the figures and sketching out the decorative elements – demonstrate that artists were not trusted to draw up an initial design by themselves even should they have felt the need to do so. This same clause is found again and again throughout the 15th century.

Secondly, meticulous descriptions of the material aspects of the work (preparation of the support, for example) and the frequently mentioned possibility of arbitration in the event of a dispute are further indications of the mistrust felt by clients who were inclined to think that craftsmen were out to cheat them. This mistrust explains the proliferation of clauses regarding the purchase and use of precious materials, in particular the rare pigment lapis lazuli. Once ground and mixed with water, this stone, imported at great expense from the Middle East, provided artists with an intense and highly prized ultramarine. Contracts stipulated that a specific amount of money had to be spent on ultramarine – and the most beautiful grade at that, obtained after the first soaking – rather than some substitute such as German azure, which is simply a copper carbonate, or any other of the many pigments mentioned by Cennini in his treatise. Stipulations of this sort were made throughout the 15th century, but as already mentioned, they were more common during the trecento and the early years of the quattrocento than in the years around 1500.

The hand of the master

However, there are other elements in artists' contracts that have nothing to do with clients' attempts to assure themselves of the craftsman's honesty. Clauses stipulating that an altarpiece must be executed in the workshop's usual manner are moving towards the notion that individual painters or sculptors possess a unique style, an idea

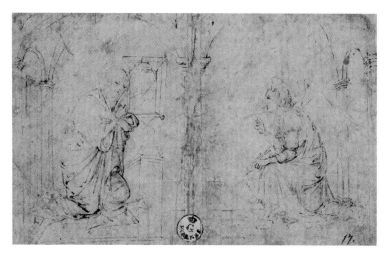

Filippo Lippi, *Annunciation*, c.1440–50, drawing, Florence, Galleria degli Uffizi.

Colours in medieval painting

An oyster shell used as a colour pan and containing traces of pigment, 14th century?, Wiltshire (England), Boyton Church.

Artists' colours – whether plant, mineral or even animal in origin – were the product of a scientific blending process. Their preparation gave painters something in common with cooks or alchemists; and indeed painters in the cities used to belong to pharmacists' or drug makers' guilds. The processing of pigments involved a considerable amount of laboratory work, including the drying, clarifying, simmering and reducing to powder of the raw materials.

Whether being used for illumination, distemper, tempera or fresco, colours were almost always bright. Towards the end of the 15th century, the philosopher Marsilio Ficino (in his *Platonic Theology*) was still stressing the importance of colour, which he said should be brilliant and pure. This fashion was supported by technical progress: the number of colours available had increased steadily from the 13th century onwards. However, the cost of pigments, some of which came from far away, could be great – a factor that helps to explain the importance of the references to colour in artists' contracts. The way painters of the past sourced and used colour deserves a corresponding level of attention from us today.

The **white** used in frescoes was made from slaked lime (St John's white). Lead white, which had to be finely ground, was used on wooden supports, usually mixed with a greasy medium (oil). It is disastrous to use white lead in frescoes as it darkens over time (as in Cimabue's frescoes in Assisi). White could also be obtained from eggshells or calcined bird bones.

Black was made from charcoal, bones or calcined vine shoots.

Red, the most widely used colour at the beginning of the Middle Ages, was obtained from minium, an oxide of lead that produced a red with an orange tinge, or from mercuric sulphide (vermilion). Sanguine comes from the stone haematite and 'dragon's blood' is a dark red made from the resin of the tree of the same name.

Blue was rare at the beginning of the Middle Ages. It started to become more widespread in the 13th century, when progress with dyes (using indigo, woad) led to its becoming a popular colour for clothing, in particular for royal gar-

ments. The blue known as 'ultramarine' comes from the lapis lazuli stone. It was the most intense and highly valued blue, but also the costliest, being imported from the Badakhshan region in the Middle East. In *The Craftsman's Handbook*, Cennino Cennini writes that 'when combined with gold ... this colour is resplendent on any wall or panel'. Its cost, though, meant that it was reserved for the most important and conspicuous parts of a painting – the Virgin's cloak, for example. A less expensive, and less intense, blue was azurite (also known as German azure), a basic copper carbonate obtained from a mountain stone. This pigment could be used on frescoes, *a secco* and on wood. It was of no more than average stability, however, and had a tendency to turn green over time. Paler still was a blue made from indigo.

Violet was made from sunflowers and replaced antique purple (from the murex shell), which had become unobtainable.

In the 14th century, bright **yellow**, which had originally been made from a highly toxic mixture of sulphur and arsenic (orpin or orpiment, otherwise known as *auri pigmentum*, pigment of gold), started to be made from tin and lead (known as massicot in northern Europe and *giallorino* or Naples yellow in the south). Many browns, yellows and reds are earth colours (clays), while yellows can also be plant-based (saffron, dyer's weld and gamboge).

Green was made from copper (verdigris, which is translucent and luminous but deteriorates over time and can corrupt adjoining colours), a clay containing iron (green earth or *terre verte*, which was used to vary flesh tones and for silvery backgrounds) or cobalt ore (malachite or *verde azzurro*). More rarely, it was made from certain berries or from irises.

Until the 15th century, **gold** was highly valued as the colour *par excellence* for enhancing pictures. It 'embellishes any work that our art can produce', wrote Cennino Cennini. Alberti, on the other hand, in *On Painting*, was the first to recommend that painters stop using it.

Preferred to silver (which darkens), fine gold was sometimes replaced by gilded tin in order to save money. Painters applied gold with a brush or in the form of gold leaf, which they stuck down with tempera (water and egg white).

Other pigments

In addition to these colours, artists also made use of colorants employed in the dyeing of clothes. They used these in the form of lacs (or lakes), which involved the addition of mineral mordants. Colours obtained in this way included: cochineal red (kermes lac, with a pink tinge); red from the Ceylonese brazil wood (called brazil wood lac or Colombine lac from the 9th century onwards); red or pink (rose) madder; parsley-seed yellow (*stil-de-grain*) or dyer's weld yellow (weld lac, which is not particularly light-fast); and blue from indigo or woad.

that did not exist in the aesthetic language of the time. And clauses demanding that a work of art must be executed in its entirety by the signatory tell us that it was not just experience that patrons were buying (which any self-respecting craftsman might acquire over time), but individual talent.

Towards the middle of the 15th century, these clauses grew increasingly common and peremptory. In 1445, the contract between Piero della Francesca and the Confraternity of Santa Maria della Misericordia for his *Madonna of Mercy* (today in the Pinacoteca of Sansepolcro) stipulated that 'no painter other than Piero may hold the paintbrush'.

A SPECIAL CASE: THE COURT PAINTER

Artists' contracts thus give us an insight into what clients – who were generally, in the city, only occasional rather than regular patrons – might expect from the master of a workshop. However, not all artists worked in urban centres. Since the 13th century, the courts had been recruiting painters there in the hope of retaining them in their service. The emergence of the 'court artist' came at a time when great lords and sovereigns, growing accustomed to a more sophisticated way of life, ceased to make do with the services that the monastery workshops (consisting mainly of illuminators) could offer them, aspiring instead to have artists (capable of creating sumptuous decorations) permanently at their disposal.

Pictor regis and 'painter by appointment'

The earliest references to a *pictor regis* (king's painter) date from 1237, when a monk, Brother Edward of Westminster Abbey, held the post in England, and 1298, when Philip the Fair of France employed a certain Étienne d'Auxerre, described in documents as a *magister pictor* (master painter).

The trend spread to central Europe in the following century. In Prague in 1357, during the reign of Charles IV of Luxembourg, Nikolaus Wurmser from Strasbourg bore the title of *pictor imperatoris* (painter to the emperor), and in Vienna, Rudolf IV of Habsburg employed a *pictor ducis* (duke's painter) sometime after 1360. By then, even comparatively lowly lords were following in the footsteps of their sovereigns: in France in 1387, Louis d'Orléans, the Duke of Touraine, had in his household one Jacquet de Lyon, a draughtsman and medalmaker; not long afterwards, Jean de Berry surrounded himself with painters, sculptors and architects, of whom the best known are André de Beauneveu, Jacquemart de Hesdin and the three Limbourg brothers (Paul, Jean and Herman). It was also during this period that a new type of artist appeared, occupying a position halfway between that of court painter and workshop painter: the 'painter by appointment to the court', who was not obliged to live with the lord, but who benefited from the titles, privileges and commissions that the court could bestow and indeed drew most of his income from that source. Melchior Broederlam and Rogier van der Weyden are typical examples of this type of artist in northern Europe during the 15th century.

In the case of artists who worked for a single patron, we are not able to examine contracts for clues as to whether it was artistic genius or craftsman's skill that caught the attention of the patron. The court painter was not remunerated on a job-by-job basis, but generally received a salary as an all-inclusive payment for his services. However, we can glean the equivalent information from lists of the tasks the artists were required to perform and of their titles and privileges, from accounts detailing the money and benefits they received and, occasionally, from written descriptions of the relationship between artist and noble employer.

Multiple tasks: the example of Leonardo da Vinci

Once again, this information provides us with a picture full of contrasts. The variety of tasks that court artists were required to perform indicates that patrons were afraid neither of squandering their talent nor of offending their sensibilities. It was perfectly nor-

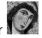

mal for a lord to ask his painter not only to paint frescoes and panels or illuminate books, but also to provide ideas or models for all occasions and for any object that might enhance the life of the court. In this respect the situation remained unchanged from the 13th century – when Brother Edward had been required to decorate the queen's apartments, the royal chapel and the Tower of London with frescoes, paint a dragon on a banner and decorate the baldric of a sword – to the 15th century, when Mantegna, in addition to the masterpieces he painted for the Gonzaga family, had to create cartoons for tapestries, decorate marriage chests and design models for pieces of gold or silver work. It seems that artists never took offence at having to perform such a wide range of duties. Their job was to glorify the reign of the prince who had recruited them and this involved the creation of what we would today call decorative objects as well as major works of art. It is even probable that artists

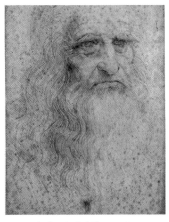

Leonardo da Vinci, *Self-portrait*, c.1515, sanguine (red chalk) drawing, 33.3 x 21.4cm, Turin, Biblioteca Reale.

welcomed the opportunity to demonstrate the diversity of their talents and that they did not regard the execution of paintings and sculptures as the only or best way to show off their skills. An extreme example is provided by a letter, dated 1482, from LEONARDO DA VINCI to the Duke of Milan, which effectively won Leonardo a commission. Engineer and architect as well as painter and sculptor, Leonardo in the letter highlights his skills

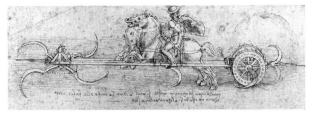

Leonardo da Vinci, *Battle Cart with Mobile Scythes*, c.1495?, detail from a sheet of drawings, London, British Museum.

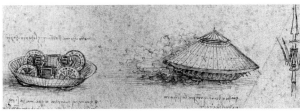

Leonardo da Vinci, *War Machines*, c.1495?, detail from a sheet of drawings, London, British Museum.

as an inventor of machines, a bridge constructor and a builder, and only mentions his artistic talents in passing at the end.

Reward for good service: ennoblement

Documents referring to the artist's position in the court hierarchy reveal the ambiguity of his situation. In principle, the king's, prince's or duke's painter was a member of the domestic staff, a simple servant. In the 15th century, the protocol established by Olivier de la Marche, master of ceremonies of Charles the Bold, Duke of Burgundy, classed the *pictor* among those artisans – such as barber, tailor, cook, jester or dwarf – whose job it was to ensure the physical and moral well-being of the prince; this position the artist shared with the musician. In reality, the painter's situation was appreciably different. The humbler daubers – assistants of the master who had actually been recruited or members of a team of mediocre painters – were allotted subordinate tasks just like ordinary workmen, and they carried these out without coming into contact with the noble

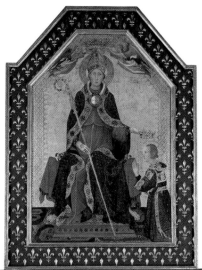

Simone Martini, *St Louis of Toulouse and His Miracles,* 1317, distemper on wood, 309 x 188.5cm, Naples, Museo di Capodimonte.

patron. But the skilled artist who had been singled out and recruited by the prince rose rapidly to become one of the *familiares* (members of his immediate entourage). The first important rank that painters regularly acquired was that of *valectus* (valet). This imposed obligations on the artist that had little to do with the creation of works of art but which had the merit in the eyes of the prince of keeping him in permanent and close proximity, thus guaranteeing regular contact between artist and lord. The most deserving painters would be given additional titles and offices. These varied from one court to another depending on local customs, finances and, no doubt, the personalities of both prince and artist. The artist in this position had of course been singled out from his fellow artists – hence the title of *pictor regis* or one of its equivalents. But he could also be singled out from the other courtiers and even from the small group that made up the prince's immediate entourage. An artist could even be ennobled. This happened to Pierre d'Angicourt in Naples at the end of the 13th century and to SIMONE MARTINI, Jean d'Orléans and André Beauneveu in the 15th. An artist could be given the title of 'counsellor', as was the case in Naples under the reign of Alfonso in the middle of the 15th century and at the court of Louis IX in France a little over 30 years later. He might be entrusted with specific tasks which, while relating to his work as an artist, also had a diplomatic dimension. In 1428, Jan van Eyck was attached by the Duke of Burgundy to the mission responsible for preparing the marriage of his heir Philip the Good to ISABELLA OF PORTUGAL. The painter went off to Portugal to paint a portrait of the princess in order to give her fiancé and the court an idea of her appearance. Fifty years later it was Mantegna's turn to play the role of ambassador. After being promoted to the rank of knight, he was 'lent' for a time to Pope Innocent VIII by the Duke of Mantua, who was anxious to maintain good relations with the pontiff.

Thus the court painter – a decorator expected to turn his hand to anything and a servant whose appointment was recorded alongside that of barbers – could also be raised to the nobility and be given the great honour and responsibility of representing his prince at the courts of the powerful and influential. The list of material and financial advantages that made up the court painter's remuneration clarifies the ambiguity of his position somewhat, indicating a person of rather higher status than might otherwise have been expected. The painter was paid a salary annually (sometimes less frequently). His income often took the form of an annuity paid for

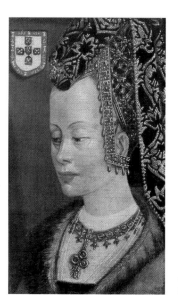

Anonymous Flemish Artist, *Portrait of Isabella of Portugal,* c.1450, Ghent, Museum voor Schone Kunsten.

life, thus guaranteeing him a retirement free from financial worries, and it was common practice for the prince to pay a pension to his widow or children for varying lengths of time after the artist's death. Van Eyck's wife and Mantegna's son, for example, continued to be paid a sum for a number of years. All these advantages clearly distinguish the artist from ordinary workmen, who were paid daily or weekly, at best.

Real 'friendships' with the great

The benefits in kind enjoyed by painters are a further indication of their comfortable circumstances. Like the other 'familiars', they were well looked after. They were fed and lodged by their prince, presented with one or two suits of best clothes each year, they received a financial bonus when they had to travel and were cared for free of charge by the court doctor when they were sick. In view of these benefits, their actual salaries were no longer that important. However, it is not so much the level of their salaries (which varied considerably from painter to painter and patron to patron and whose purchasing power is hard to assess) that suggests they were significantly higher than most other salaries, but rather the reaction they provoked from princes' exchequers. Treasurers would regularly attempt to delay payment or suggest reducing the sums payable to artists – all the more readily as these amounts were simply agreed by the prince rather than set down in a contract signed by the painter.

In trying to understand the social status of the artist in the late Middle Ages, written accounts are even more important than details of his official position at court or of the emoluments he received, for it is these accounts that reveal the nature of his relationship with the prince. Some idea of this can be gained just from the epithets that were used. From 1259 onwards, Brother Edward, painter to the English court, was assisted by William, who was described in certain documents as 'the King's beloved painter', although this may be no more than a conventional formula. Perhaps more revealing is that princes often agreed to be godfather to their painters' children, gave their painters wedding presents or even provided their daughters with dowries. But such gestures were also made to other court servants and might simply demonstrate a prince's commitment to protecting those who belonged to his *familia*. Similarly, the numerous mentions of meals taken by artists with their patron merely refer to a practice common at court, whereby the 'familiars' were regularly invited by the lord to share his table.

Nevertheless, certain relationships point less ambiguously to the special esteem princes had for their artists. The French chronicler Jean Froissart recounts that he witnessed a no less powerful figure than the Duke of Berry enjoying an extremely cordial relationship with André Beauneveu (one of the rare sculptors to become a court artist, although he was also a painter and illuminator). However, it must be said that the duke was an

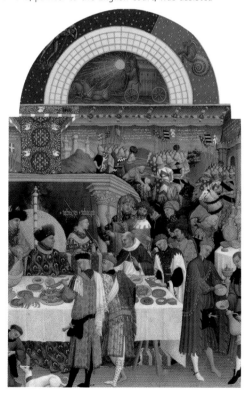

Paul, Jean and Herman Limbourg, *January*, before 1416, illumination from *The Very Rich Hours of the Duc de Berry*, 29 x 21cm, Chantilly, Musée Condé.

unusual figure. The Limbourg brothers – three miniaturists who worked for him – enjoyed just as familiar a relationship. One new year, they gave him a 'piece of wood painted to resemble a book, but with no pages and no writing' – a luxurious practical joke, but a practical joke all the same.

South of the Alps, relationships of this kind were more common. Mantegna served three generations of the Gonzaga family (grandfather Lodovico, father Frederico and son Francesco), forming an ever closer relationship with his protectors based on discussions of works of art, antique remains and various writings, as well as recommendations and instructions regarding new works. The closeness of his relationship with his last patron, Francesco, is demonstrated by a decree dated 4 February 1492 in which the duke bestows on Mantegna fiefs 'with no fiscal obligation nor any charge or servitude' and justifies this gift, which was preceded by a number of other acts of kindness, by comparing the artist to the ancient Greek painter Apelles, the sculptor Lysippus – both honoured by Alexander the Great – and the architect Archimedes, whom Hiero, King of Syracuse, declared his friend. Franceso's admiration was expressed by reference to a classical model: the painter's extraordinary skills are compared to those of the most illustrious artists of ancient times and justify the 'friendship' – for that is the word used – which binds him to a man so far removed from himself in terms of social background. And the example of the ancient kings, for whom it was natural to maintain close ties with the great artists of their day, in turn legitimized Francesco's attitude.

SELF-ASSURED ARTISTS

At the courts, therefore, while retaining the official status of servants and performing tasks that we would consider menial today, artists found themselves in an environment that allowed them free and open relationships with their patrons. We can be sure that in the towns and cities, where true connoisseurs were rare and most of the population held stronger social prejudices, the same artists would not have been able to acquire such a positive public image.

Painters in the city: a lower status?

Dante wrote his *Divine Comedy* shortly after 1300. In it he places simple illuminators as well as painters – including Cimabue and his contemporary Giotto, whom he judged to be the greatest of all – among the proud in Purgatory. Pride was regarded as a sin to which creative minds were susceptible and so artists joined the writers and poets who were also there. The puzzlement of commentators throughout the 14th century is revealing. All of them reacted to this passage, feeling obliged to explain why Dante had taken the trouble to honour these modest representatives of the *artefichi meccanichi* (the mechanical arts), these 'exponents of an inferior activity', as equals of those intellectuals who practised the liberal arts. It was in vain that Petrarch, shortly after the middle of the century, described Giotto as 'the greatest man of his time' (*princeps*) and, anticipating Francesco Gonzaga, compared the Sienese painter Simone Martini to the ancient masters Polyclitus, Zeuxis, Praxiteles and Phidias: his point of view remained in the minority among city dwellers. The Florentine Filippo Villani's attempts to establish through his *Chronicle* (written just before 1400) the idea that the activities of the painter and sculptor should be classed as *artes liberales* (liberal arts) and that an artist merited 'as much respect' as the most erudite professor met with just as little success.

The backward-looking way in which artists were perceived in the urban centres compared to the way they were regarded at court should not be seen simply as a result of the public's narrow-mindedness. A number of painters and sculptors in the towns did indeed remain artisans and jobbing artists of limited learning and with limited ambitions. The importance today of industrially produced 'designer' objects and products derived from artworks (especially reproductions) means that nowadays the word 'art' is reserved for the original creations of a few talented individuals. In the final centuries of the Middle Ages the term was not used and neither did the concept exist in such a

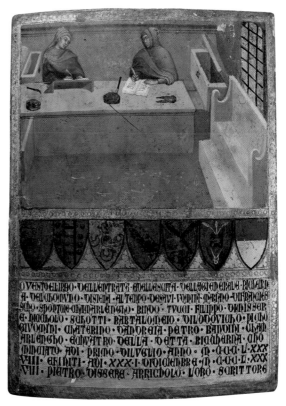

Taddeo di Bartolo, *The Camerlengo and His Secretary in Their Cabinet*, 1388, tempera on wood, 44 x 33cm, Siena, State Archives.

clear-cut way. Economic growth increased purchasing power and stimulated the demand for, and thus the production of, decorative goods. It was the job of painters and sculptors, from the most talented to the most mediocre, to create such goods. The bourgeoisie wanted items of decorated furniture but also bought inexpensive sculptures (stucco or papier mâché casts of famous works and miniature glazed terracotta replicas such as those produced around 1470 by the Florentine workshop of the Della Robbia family). Preachers such as St Bernardino of Siena, the monk Giovanni Dominici and Savonarola recommended that private individuals purchase pious works to hang on the walls of their homes: crucifixes, the speciality of a number of workshops; 'devotional pictures' (*quadri di devotione*), small works depicting the Virgin Mary or a scene from the life of a saint; and statues such as the dolls of the Baby Jesus that were given to young girls to accustom them to motherhood. Artists were also commissioned by the city authorities to make simple utilitarian objects such as book covers (those enclosing the REGISTERS OF LA BICCHERNA, THE SIENA TAX OFFICE, for example), gonfalons and the remarkable 'infamy paintings' that played a part in law-court rituals – images of rebels hanged by their heels (such as those painted by Andrea del Castagno on the façade of Florence prison in 1440) or of conspirators suffering their punishment (such as those painted by Botticelli in 1478 following the Pazzi plot).

The assertion of individuality: the signature

The production of what might be called 'shop goods' provided a living for a whole class of workaday artists who did not aspire to greater things. But at the start of the Renaissance a gap opened up between these jobbing workers and the painters and sculptors whose works we admire today, splitting them into two categories so different that

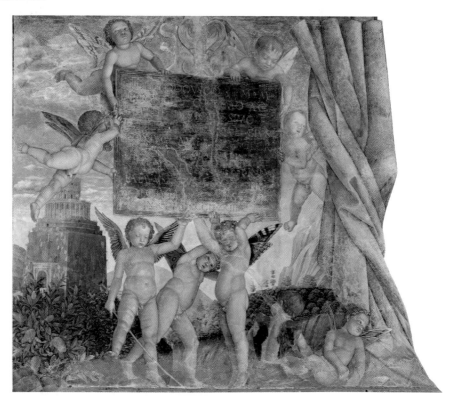

Andrea Mantegna, putti holding up the dedication, detail from the fresco depicting the *Duke of Mantua and His Court*, 1473, Mantua, Camera degli Sposi.

they could not realistically both be covered by the term 'artist'. Among the most talented artists, whose work was sought after by princes and enlightened enthusiasts, an awareness began to dawn of their own worth. After centuries of anonymity, the first and most important sign of this new awareness was the appearance and proliferation of the signature. This occurred at the end of the 13th century, when Italian works were breaking away from the influence of Byzantine art, in which the icon was too holy an image to display any signs of human intervention, even the name of the artist. The form taken by the signature is instructive: sometimes it suffered from an inflated sense of self-importance – with the artist appending his signature in large letters, as did MANTEGNA in the Camera degli Sposi (Bridal Chamber) in Mantua or Giovanni Bellini on his *Madonna and Child Blessing* in the Pinacoteca di Brera in Milan; or sometimes it was inscribed on a *cartellino*, a scrap of parchment with turned-up edges painted in trompe l'oeil in a display of virtuoso illusionism designed to show off the painter's skill.

The painter's image: the self-portrait

The existence of artists' self-portraits, which started to become increasingly common in Europe in the 14th century, also underlines the new-found self-assurance of men who valued their talent enough to impose their own image on generations of viewers to come. The first of these self-portraits that is known to us, albeit hidden among a group of figures, is that of Giotto in his fresco *The Last Judgement* in the Bargello Museum in Florence. Most of the artists who came soon after (such as Benozzo Gozzoli in the Chapel of the Magi in the Palazzo Medici-Riccardi in Florence or Luca Signorelli on the walls of the San Brizio Chapel in Orvieto Cathedral) followed his example and included their image alongside the other painted figures. Some – Cola Petruccioli in the church of San

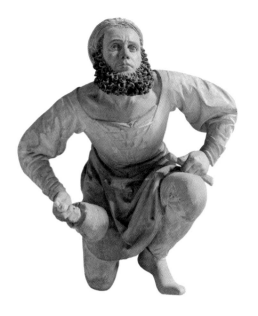

Adam Kraft, *Self-portrait*, 1493–6, stone sculpture, approximately life-size, tabernacle support, Nuremberg, Lorenzkirche.

Domenico in Perugia, for example – inserted a self-portrait discreetly into the border of a painting. The German sculptor ADAM KRAFT, in his monumental tabernacle for the Lorenzkirche in Nuremberg, treated the self-portrait as a utilitarian, if outstanding, element in a sculptural ensemble.

A number of 15th-century artists went much further. In the middle of the 1430s, van Eyck depicted himself as a reflection in the convex mirror at the centre of his famous portrait of *Giovanni Arnolfini and His Wife*. This was accompanied by the inscription 'Johannes de Eyck fuit hic' ('Jan van Eyck was here'), adding an extra dimension to the authentification of the work by giving it a historical validity: it attests to his physical presence, similar to the signature of a witness on a marriage certificate. Half a century later, in 1496, PERUGINO – who for 20 years or so from 1480 was the leading painter in Italy – painted a self-portrait in a trompe-l'oeil frame that appears to be hanging on a pilaster in the audience chamber of the Collegio del Cambio in Perugia. Beneath it he added an inscription in which he sings his own praises: 'Pietro Vannucci, known as Perugino, a most distinguished painter. If the art of painting had disappeared, he has revived it. If it had never been invented anywhere, he has brought it forth.' Five years later, his pupil Pinturicchio did the same thing in the church of Santa Maria Maggiore in Spello, but settled for a more modest inscription. Excessive displays of this kind, in which the painter combines a self-portrait with his own encomium, were not copied by other painters. Dürer perhaps went the furthest in painting a full-length (though small) portrait of himself next to a plaque in *The Adoration of the Holy Trinity*. However, the fact that representations of this kind exist at all is testimony to the fact that artists at the end of the 15th century had a sense of their own worth, which they sought to make publicly known, even if a number of uncultivated people continued to regard the artist as nothing more than an artisan.

Perugino (Pietro Vannucci), *Self-portrait*, detail from a fresco, 1496, Perugia, Collegio del Cambio.

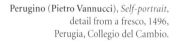

The age of the genius
16TH CENTURY

The social and institutional framework in which painters and sculptors trained and practised their art changed during the Renaissance. While most artists were still the sons of craftsmen, and continued, by and large, to work in workshops alongside other artists, they began to pride themselves on being well read and started to transform themselves into capitalist entrepreneurs. Difficulties of a hitherto unknown kind arose: now sensitive about their degree of freedom, painters and sculptors saw their liberty held in check both by their relationships with their patrons and by the prevailing religious climate, which often led to censure and sometimes even to the destruction of their works.

A MALE WORLD ROOTED IN THE CRAFT TRADITION

Artistic creation remained a male preserve to almost the same extent as it had been before. The very few women who painted generally came from families with an artistic tradition and tended to stop working as soon as their circumstances changed. Paolo Uccello's daughter, for example, whom Vasari tells us 'knew how to draw', became a nun rather than continuing to work in her father's workshop, and Tintoretto's daughter Marietta, a well-known portraitist, gave up painting when she got married.

Exceptions: women painters

There were exceptions. It was not unknown for women from aristocratic families rather than from artistic backgrounds to choose to become artists. SOFONISBA ANGUISSOLA, born around 1532 into a noble family from Cremona, is a good example. Taught to draw at her father's instigation from an early age, she led a career of such note – in Cremona,

Anthony Van Dyck, *Portrait of Sofonisba Anguissola on Her Deathbed*, 1624, oil on canvas, Turin, Galleria Sabauda.

in Rome, at the Spanish court and thereafter again in Italy – that in 1624 the young Van Dyck took the trouble of visiting the painter, by then an old lady, and listened gratefully to her advice.

Exceptional circumstances sometimes decided the professional destiny of women who would normally have led lives of leisure. One such was Artemisia Gentileschi (daughter of the painter Orazio Gentileschi), who pursued a remarkable lifelong career of painting in the tradition of Caravaggio.

Social continuity

The vast majority of painters and sculptors were men, however. They tended to come from the same backgrounds as before. Apart from a few exceptions, such as Andrea Sansovino and the painter Domenico Beccafumi, they came not from the country, where the bulk of the population lived, but from the towns and cities, and in particular from the urban artistic milieus. While the fathers of painters were not necessarily painters nor those of sculptors always sculptors, they generally practised trades that were related to the artistic professions, such as carpenter, mason, stone-cutter, cabinet-maker, goldsmith or glassworker. Dürer's father was a goldsmith, Raphael's a painter. The tradition of artistic dynasties thus lived on. In Flanders, the Bruegel family produced four generations of painters and the Solari family in Milan five generations of sculptors. Guild rules favoured family continuity. As in previous centuries, their entry criteria were lower for the children of guild members. At the beginning of the 16th century in Padua, the sons, brothers, nephews and grandsons of masters were required to pay only half the normal fees.

A NEW COMMERCIAL SPIRIT

The guild remained a very strong institution throughout the 16th century and during the early years of the 17th. It was within the framework of the guild that aspiring painters and sculptors completed their apprenticeships in workshops. Children left school to start work at just as early an age as they had in the past. Andrea del Sarto was apprenticed when he was seven years old, and Titian was a young child when he left the small town in which he was born, Pieve di Cadore, to go and train in the city of the Doges. The first years of training were sometimes paid for by the apprentice's parents (it is known that Sodoma's father paid the considerable sum of 50 ducats for his son's apprenticeship), but it was more common for the master to pay the apprentice, wages increasing with experience. Michelangelo, who became a pupil of the Florentine painter Ghirlandaio at around 14 years of age, was paid six florins in his first year, eight in his second and ten in his third.

The size of workshops and the rationalization of work

These were not the only similarities with the Middle Ages: production was organized along similar lines too. Work was generally a collective experience, the workshop remaining the most common creative unit. In the Italian towns and cities, where success in commerce was regarded as the model of excellence, painters formed alliances similar to the companies formed by merchants. In Venice, for example, the painters Giorgione and Vincenzo Catena agreed to share their expenses (rent and materials) and split their earnings. Elsewhere, particularly in the case of sculptors and large painters' workshops struggling to meet demand, work was divided up along almost industrial lines with each apprentice and journeyman responsible for performing a precise task that formed just one link in a chain of operations. As the demand for artistic goods continued to grow there was a tendency in the large cities for orders to become concentrated on a limited number of workshops; these grew larger and larger as a result. Between 1501 and 1517, the sculptor Tilman Riemenschneider, who carved huge wooden altarpieces in a Late Gothic style, employed a dozen apprentices and several journeymen in his

The Bruegels: an artistic dynasty

It may be difficult for us to accept today – when talent is regarded as something individual and innate – but the handing on of a career from father to son was no barrier to the emergence of remarkable artistic personalities over several generations. As with music (the Bach family, for example), creativity in the visual arts was enriched by artistic dynasties. Even though the members of the family might not all be outstanding at the same time, such a workshop had advantages that could ensure its success and prosperity as a commercial enterprise well beyond the lifetime of its founder. The Bruegel (later changed to Brueghel, sometimes spelt Breughel) family is a case in point.

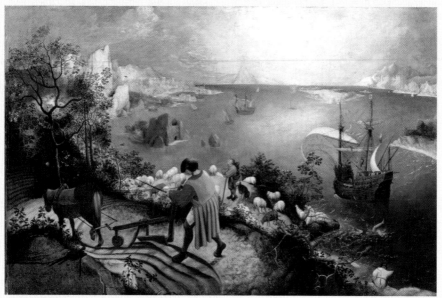

Pieter Bruegel the Elder, *Landscape with the Fall of Icarus*, c.1558, oil on canvas, 73.5 x 112cm, Brussels, Musée d'Art Ancien.

The founder: Pieter Bruegel the Elder

Born near Breda, in Brabant, sometime between 1525 and 1530, Bruegel trained under Pieter Coecke van Aelst and was admitted as a master to the Antwerp guild of painters in 1551. He then began to work for the engraver and print-seller Hieronymus Cock, who sent him to Italy to make some drawings, which he planned to engrave, of Alpine landscapes. This journey lasted from 1552 to 1555.

It is thought that Bruegel turned from drawing to painting shortly before his return to Antwerp. In 1563, he married his master's daughter and moved to Brussels, where he died in 1569.

Many of his paintings are colourful depictions of the lives of Flemish peasants – their holidays, carnivals, festivities and work – while others illustrate popular sayings (*The Netherlandish Proverbs* in the Gemäldegalerie in Berlin) or morally uplifting quotations and anecdotes from the Bible (*The Parable of the Blind* in the Museo di Capodimonte in Naples, *The Tower of Babel* in Vienna's Kunsthistorisches Museum and *Landscape with the Fall of Icarus* in the Musée d'Art Ancien in Brussels).

Second generation:

Pieter the Younger ('Hell' Brueghel)

Born in Brussels in 1564, Pieter Brueghel the Younger was admitted as a master to the Antwerp guild in 1585, having perhaps trained under the Antwerp landscape painter Gillis van Coninxloo.

During the first half of his career he limited himself to copying his father's work and producing paintings of his father's drawings and engravings. It is to this eagerness to continue the family tradition and to his lack of ambition regarding a personal style that we owe our knowledge of the lost works of Pieter Bruegel the Elder.

Jan I ('Velvet' Brueghel)

Born in Brussels in 1568, a year before the death of his father, Jan I trained in the workshop of the Antwerp painter Pieter Goekindt and spent the years 1590 to 1596 travelling around Italy. Upon his return to Antwerp he joined the guild as a master. He left the town on two further occasions, journeying to Prague and Nuremberg.

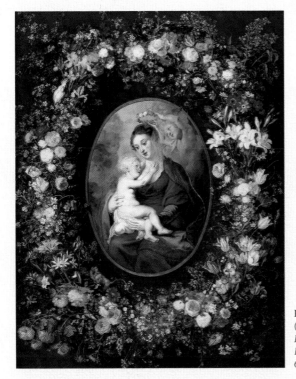

Peter Paul Rubens and Jan Brueghel I ('Velvet' Brueghel), *Virgin Mary with the Infant Jesus and an Angel in a Garland of Flowers*, c.1615–25, oil on wood, 83.5 x 65cm, Paris, Musée du Louvre.

A painter of landscapes and bouquets or garlands of flowers, his work offers a detailed, naïve vision of nature in which both animals and plants are rendered with great precision. In this respect his style differs fundamentally from that of his father and brother. It made him famous in Antwerp and also gave him the opportunity to collaborate with Rubens on paintings (such as *Virgin Mary with the Infant Jesus and an Angel in a Garland of Flowers*) in which he painted the animals and flowers and Rubens the figures.

Third generation:

Jan II ('the Younger')

Born in Antwerp in 1601, Jan II was the son of 'Velvet' Brueghel. After a stay in Italy between 1622 and 1625, he opened a workshop in Antwerp, working in the style of his father when not actually producing straightforward copies of his father's work. He died in Antwerp in 1678.

Ambrosius

Jan I's other son was born in Antwerp in 1617 and was admitted to the guild in 1645. Like his brother Jan the Younger, with whom he shared a workshop, Ambrosius painted flowers and landscapes in the style of his father. He died in Antwerp in 1675.

Fourth generation:

Abraham

The son of Jan II, Abraham Brueghel was born in Antwerp in 1631 but chose to settle in Italy after travelling there as part of his traditional artistic education. He had his workshop in Rome from 1659 to 1670 before moving to Naples, where he died in 1697. Like his father and grandfather, he painted flowers, to which he added fruit, background landscapes and figures. His pictures reveal the influence of contemporary painters (notably Frans Snyders), while being lighter in style.

Jan-Baptist

Another son of Jan II, Jan-Baptist was born in Antwerp in 1647 and – like his brother Abraham – settled in Rome, where he died in 1719. Also like Abraham, he specialized in still lifes featuring flowers and fruit.

The age of the genius

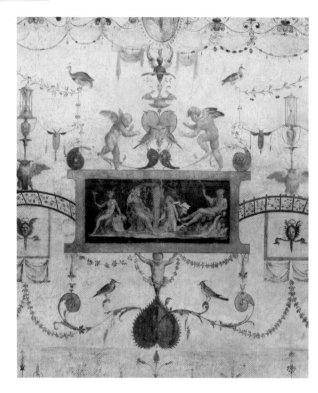

Workshop of Raphael, 'Grotesque', 1517–19, detail of a fresco. Rome, Loggias, Vatican Palace.

workshop in Würzburg. In Rome, RAPHAEL, overwhelmed by responsibilities and commissions during the last six years of his life, relied on an enormous workshop, in which for the first time ever there were fewer *garzoni* enjoying their first taste of work than experienced artists – these the master could trust to paint the large frescoes he no longer had time to complete himself. The leading figure in this group, which was by now only indirectly run by Raphael, was Giulio Romano. Once Raphael had come up with the overall scheme, his 'second in command' would design the individual paintings – for the Sala di Constantino in the Vatican Palace, for example – before showing them to and discussing them with the master. Individual painters would be entrusted with specific tasks: Giovanni da Udine was responsible for the design and execution of animals and the antique-inspired motifs known as 'GROTESQUES', while more versatile artists such as Giovanni Francesco Penni and Perino del Vaga worked on the main paintings. Painters who were not permanent members of the workshop also occasionally collaborated on the frescoes. These are thought to have included the Venetian painters Sebastiano del Piombo (Sebastiano Luciani) and Lorenzo Lotto, who brought sumptuous, unusual colour to Raphael's style in works such as *The Expulsion of Heliodorus* in the second Vatican chamber.

This flexible yet structured approach was well suited to the execution of enormous fresco sequences. It was adopted by the Italian artists summoned to France to work at the palace of Fontainebleau during the reign of François I (ROSSO FIORENTINO between 1530 and 1540, Francesco Primaticcio between 1534 and 1570 and Niccolò dell'Abbate from 1552) and also by the great Venetian painters of the 16th century, starting with the city's most important *bottega*, that of Titian, which received innumerable commissions for altarpieces and portraits as well as decorations for the walls of the city's public buildings. Established in 1539, the workshop of Tintoretto (Jacopo Robusti), which was busy with commissions from around 1545, operated a similar system based on the sharing out of tasks among painters – in this case Jacopo's children Marietta and Domenico as well as a

number of assistants from outside the family, including Aliense (Antonio Vassilacchi), Alberto d'Olanda and Andrea Vincentino. Paolo Veronese (Paolo Caliari), who opened his workshop in 1555, was also supported by family members – his brother Benedetto and before long his son Carletto – in addition to a number of painters (Montemazzano, for example) to whom he was not related.

GOOD ALL-ROUND LEARNING

While, theoretically at least, they were still humble exponents of the 'mechanical arts', successful Renaissance artists were more like modern managers than medieval artisans. The procedures they adopted reveal an aggressive and effective commercial sense far removed from the mindset of workshop masters in previous centuries. Likewise, the general level of learning of the workshop boss-cum-artist was also considerably higher than it had been.

New forms of apprenticeship: drawing and observation of the masters

Workshop apprenticeships began to change, and thereby to compensate for the lack of general training. While the preparation of materials and thus the technical aspect of the profession remained important, learning through the copying of drawings occupied apprentices to a far greater extent than it had before. A large number of drawings – by the master as well as by other artists – were available in most workshops. Giorgio Vasari tells us that the painter Domenico Beccafumi, who worked in Siena during the first half

Rosso Fiorentino and his workshop, view of the Grande Galerie at Fontainebleau, 1530–40.

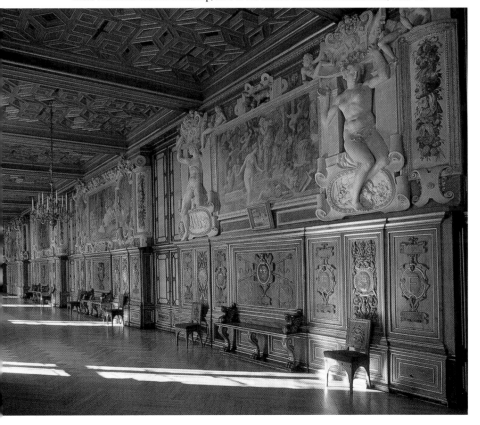

TITIAN'S WORKSHOP:
A CAPITALIST ENTERPRISE

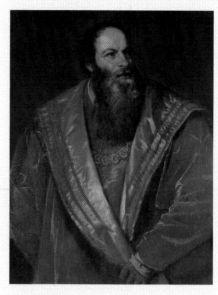

Titian, *Portrait of Pietro Aretino*, 1545, oil on canvas, 108 x 76cm, Florence, Palazzo Pitti.

A modern biography of Titian describes the artist's workshop as a fully-fledged 'holding company', which in addition to its main activity invested in financial operations that were quite distinct from painting. It had interests in wood and grain firms in the Cadore region and in salt dealing on the Fondaco dei Tedeschi (the exchange of the German merchants in Venice). From 1531, Titian's studio was based in Biri Grande, a working-class district of Venice, and was itself organized like a factory. It was capable of operating without the presence of the master, who was required to spend a lot of time away from the city – for example, when he was summoned to Rome by Pope Paul III (a trip that resulted in the portrait of the pontiff and his nephews that hangs in the Museo di Capodimonte in Naples) or when he was invited to Augsburg by Emperor Charles V.

Personnel

Titian's trusted assistants included members of his own family – such as his brother Francesco and his sons Pomponio and (most importantly) Orazio – as well as long-standing colleagues such as the modest Girolamo Dente, who was so loyal that he acquired the nickname Girolamo di Tiziano. Like Raphael's workshop, Titian's was too busy to devote time to the training of youngsters and so recruited adults – simple workmen, who were given responsibility for preparing canvases and paints, and experienced artists who had learned their trade in less prestigious workshops.

A preoccupation with publicity

The most remarkable thing about the way Titian's workshop was run, however, was the importance it attached to 'marketing'. The master set about attracting publicity in a number of ways. He welcomed foreign 'interns', young artists of modest or superior ability such as the Fleming Jan Stephan Calcar (probably responsible for the engravings for Vesalius's *On the Fabric of the Human Body*), the Dutch painters Lambert Sustris and Dirck Barendsz and the Germans Christoph Schwartz and Emmanuel Amberger. These would then return to their home countries or travel to other towns and cities in Italy spreading the word about the quality of the workshop.

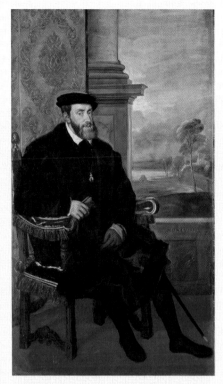

Titian, *Portrait of Charles V*, 1548, oil on canvas, 205 x 122cm, Munich, Alte Pinakothek.

Titian also used engravers – specifically Giovanni Britto, Niccolò Boldrini and later Cornelius Cott – to engrave and print multiple copies of his works, thus ensuring they were distributed far and wide. Raphael did the same thing between 1510 and 1520, availing himself of the services of the outstanding engraver Marcantonio Raimondi, and Dürer paid hawkers to sell his own engravings as far away as Rome.

In his friend Pietro Aretino, the great man of letters who took refuge in Venice after fleeing Rome in 1527, Titian found a natural 'public relations officer'. Up until his death in 1556, Aretino devoted great energy to corresponding with friends and acquaintances all over Europe, and his letters are full of enthusiastic praise for the art of Titian in general and for the merits of this or that work in particular.

The quest for wealth

Venice's greatest painter combined his organizational skill and talent for publicity with a relentless determination to secure those privileges

and rewards that went with official duties – a strategy that was to bring him extraordinary and lasting wealth. The heir to a line of minor provincial magistrates living on stipends paid by the city of Venice, Titian was employed by the government to produce a large number of works (none of which survive) for the Doges' Palace and to paint the portrait of each new doge. In return for these services, which made him the official painter of the city, he demanded privileges of the order of those bestowed by the Senate on government officials. The most remarkable of these were the salt brokerage rights at the Fondaco dei Tedeschi, which initially yielded a not inconsiderable income of 100 ducats a year (tax-free from 1516), later rising to as much as 300 ducats a year following revaluation.

A carefully preserved monopoly

The reason Titian's workshop was in such a profitable position was that it enjoyed a quasi-monopoly following the death of Giovanni Bellini in 1516.

This near monopoly was the fruit of Titian's efforts to control the Venetian art market. To this task he devoted the same energy that characterized all his other pursuits and he took ruthless action to eliminate any competitors who might pose a threat: Sebastiano del Piombo was forced to leave for Rome, where he enjoyed a good career; Lorenzo Lotto was reduced to working in Treviso, in the Marches and in Bergamo before seeking refuge in the peaceful sanctuary of Santa Casa in Loreto; Giovanni Antonio Pordenone was brutally murdered in 1539, sparking rumours that it was Titian who had killed him; and Paris Bordone was forced temporarily to seek fame in Lombardy and then in France. All were victims of Titian's malicious gossip. Also, at the start of his career, Titian fell out with the aged Giovanni Bellini, and later on he did the same with the young Tintoretto, whose success he then tried to thwart.

Titian was not the only artist to display such acrimonious behaviour during the Renaissance. While they could be glossed over with the Greek term *agon* (emulation, verbal contest), disagreements between painters – which sometimes resulted in public abuse, such as that hurled by Michelangelo at Leonardo da Vinci in Florence at the beginning of the 16th century – reflected conflicts of interest that were closer to commercial warfare than stylistic rivalry.

The age of the genius

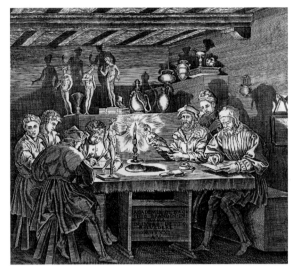

Agostino Veneziano, *The 'Academy' of Baccio Bandinelli*, 1531, engraving, Munich, Staatliche Graphische Sammlung.

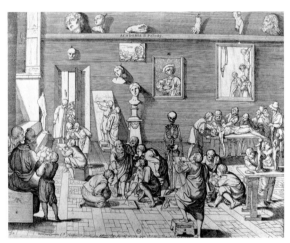

Pietro Francesco Alberti, *Academy of Painters*, c.1600, etching, Paris, École Nationale Supérieure des Beaux-Arts.

of the 16th century, learned his art not so much from his master, but by analysing the 'drawings by excellent painters that [the master] had in his workshop and used for his own purposes as necessary'. Vasari himself, who pursued a career as a Mannerist painter as well as writing his *Lives of the Most Excellent Painters, Sculptors and Architects*, prided himself on having spent many evenings carefully studying drawings lent him by Andrea del Sarto.

The importance attached to drawing and studying the great masters – past and present – explains why large teams such as those run by Raphael and Titian dispensed with *garzoni*. Where they were still wanted at all, youngsters were no longer taken on as child helpers expected to perform menial tasks, but rather as proper pupils whose training ruled out profitable work for many years. This change explains the description of those workshops continuing to accept apprentices as authentic 'schools' or, more precisely, 'academies' – that is to say, modelled on the scholarly humanist societies that had their roots in Plato's Academy in Athens and that were meeting places for those with a thirst for knowledge. In this case, of course, the knowledge was of an artistic nature and its acquisition supervised by a master painter or sculptor. During the 16th century, this description was applied to a highly dubious 'academy' said to have been organized in Florence in the 1480s around the sculptor Bertoldo di Giovanni (which attracted the patronage of Lorenzo the Magnificent) and later to the equally doubtful school that Leonardo da Vinci is supposed to have established in Milan. More legitimately, perhaps, it was used to describe the circle that the Florentine sculptor BACCIO BANDINELLI gathered around himself, first in Rome and then in Florence, from the 1530s onwards.

The importance of theoretical training: the example of Michelangelo

In reality, the first institutions set up specifically to provide artists with a theoretical training did not open their doors until the second half of the 16th century. These were

the Accademia del Disegno (Academy of Drawing) founded by Vasari and the writer and scholar Vincenzo Borghini in Florence in 1563 and the Accademia di San Luca founded in Rome in 1577.

The pictures and written accounts that we have of these early academies have a number of features in common. They all depict or describe young people not painting or sculpting but drawing and copying ancient works of art – often in artificial light, with just a candle piercing the darkness. The meaning of this cliché is clear: it proclaims studying (*studio*) – intense cerebral activity carried on late into the night – to be an indispensable element of an artist's training and more important than the trade's practical and manual aspects, which lay at the heart of the conventional apprenticeship.

MICHELANGELO is traditionally seen as being the first artist to have trained in this way, devoting the bulk of his time to studying the art of antiquity and the drawings of his contemporaries. Ascanio Condivi, one of his first biographers, describes how in 1490, aged 15, Michelangelo was taken by a friend to the 'Medici garden' at the Convent of San Marco, where Lorenzo the Magnificent's

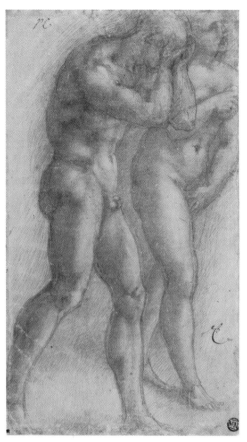

Michelangelo, *Adam and Eve Expelled from Paradise, Walking*, red chalk drawing after Masaccio's fresco in the Brancacci Chapel, 32.56 x 18.7cm, Paris, Musée du Louvre.

collection of fragments of ancient sculpture was kept. Condivi tells how Michelangelo spent the whole day working 'come in migliora scuola' ('as in the best of schools'). The privilege of being allowed to use the garden enabled the young artist – who also made drawings of Giotto's frescoes at Santa Croce and those of Masaccio in the Brancacci Chapel during the same period – to develop his own style by assimilating the methods of the ancients as well as those of the best of the latter-day masters. Furthermore, it gave him the opportunity to meet the renowned humanists who also frequented the garden – Cristoforo Landino, a scholar of Virgil and Dante; Marsilio Ficino, one of the main proponents of Neoplatonic philosophy in Florence; Giovanni Pico della Mirandola, a leading specialist on Plato and Aristotle; and Politian (Angelo Poliziano), the tutor of Lorenzo the Magnificent's children – as well as Lorenzo himself, a keen patron of the arts and an amateur poet. There can be no doubt that Michelangelo would have received his first lessons in Neoplatonic philosophy there and would also have been exposed for the first time to the attractions of poetry, which he took up himself at this time by starting to write sonnets.

Access to humanist learning

The fact that Michelangelo was able to take advantage of this opportunity and spend entire days studying the Medici sculpture collection indicates that he must have decided to break off the apprenticeship he had begun in Ghirlandaio's workshop in 1488.

The age of the genius

It is certainly true that it was not long before he was putting in no more than an occasional appearance there. This is another indication of the changes that affected apprentice artists in the 16th century: they were no longer inexperienced employees required to spend all day and every day performing workshop duties, but disciples who came to train on a part-time basis. This increase in the amount of free time available made it easier for them to fill any gaps in their learning. There are also signs that they benefited from a more thorough school education. While painters in the 15th century used to write like tradesmen, in the style taught by the rather basic 'schools of arithmetic', during the following century a number of them, including Raphael and Michelangelo, adopted the sophisticated italic style. Furthermore, certain artists now shared with the humanists an interest in a scholarly branch of learning: the knowledge of dead languages. The painter Giulio Campagnola is known to have mastered both Latin and Greek. Painter's libraries also changed. In Toledo, El Greco (Domenikos Theotokopoulos) possessed a collection of books worthy of a scholar. Alongside technical works (on painting and architecture in particular), it included the works of the Fathers of the Greek Church, St Basil and St Dionysius the Areopagite, and works of classical literature by Homer, Plutarch, Aesop, Euripides, Demosthenes, Xenophon and others.

More revealing still is the fact that 16th-century artists often prided themselves on writing not simply technical or historical works (such as those by Cennino Cennini and Ghiberti) but also poetry and texts of a speculative nature. Some were so successful at this that they gained a second reputation as writers. Michelangelo, for example, already known for his sonnets, made a name for himself as an expert on Dante, and Raphael and Bronzino wrote poetry. In Germany, Dürer, in addition to being the first artist north of the Alps to write manuals designed specifically for the use of artists (*Treatise on Measurement with the Compass and Ruler* and *Treatise on the Proportions of the Human Body*), also tried his hand at poetry. The Florentine goldsmith and sculptor Benvenuto Cellini, on the other hand, preferred prose to poetry. At the end of his life he dictated a set of memoirs that are as valuable for their literary as for their documentary qualities. Vasari, finally, is the ultimate example of the writer-artist. Thanks to a succession of protectors and patrons, he had the opportunity to acquire two types of knowledge: professional artistic knowledge in a series of workshops and scholarly knowledge from a well-known Florentine humanist. He became a famous painter but is remembered above all as the author of the *Lives*, a key text that laid the foundations of art history.

A passion for antiquity

There was one area in particular in which the great artists of the 16th century were far more knowledgeable than their predecessors of the 14th and 15th centuries. Their training (involving copying works of art from the past), the prevailing taste for classicism and the archaeological digs that were being conducted throughout Italy all orientated them towards antiquity.

Indeed a number of artists devoted as much time to the study of antiquity as they did to artistic creation. In Florence, Lorenzo de' Medici put the sculptor Bertoldo di Giovanni in charge of the Medici collections (of coins, gems, statues and sarcophagi); in Vienna, the painter Arcimboldo's chief responsibility was to look after the cabinet of curiosities of the emperors Ferdinand, Maximilian and Rudolph; and after travelling to France in 1518, another painter, Andrea del Sarto, was commissioned by François I to assemble a collection of antique and contemporary sculpture (casts and originals), but the unscrupulous artist returned to Florence with the money provided and did not go back. The supreme example of the artist-antiquarian, however, is Raphael, who was put in charge of the entire excavations in Rome by Pope Leo X. He held this responsibility from 1515 until his death in 1520.

Even artists without archaeological or curatorial duties took a passionate interest in the ancient finds. On 14 January 1506, news of the discovery in a garden near Santa Maria Maggiore, in Rome, of *Laocoon*, the Hellenistic statue depicting the death of the Trojan priest of Apollo and his sons, excited Michelangelo so much that he interrupted his

VASARI, PAINTER AND WRITER

Exceptional though it was, the career of the painter and writer Giorgio Vasari (1511–73) was also symptomatic of the widespread increase in artists' learning during this period.

Humanist and artist

Vasari was born in Arezzo in Tuscany into that section of the urban middle classes which was dominated by tradesmen and artisans – the background from which most painters and sculptors came. One of his ancestors had been a saddler and occasional painter, his grandfather and uncles were potters, his father was a fabric seller and the artist Luca Signorelli was a distant cousin. His father approved of Giorgio's vocation, and when the boy was on the verge of adolescence he had him apprenticed to the French stained-glass master Guillaume de Marcillat, who had settled in Arezzo. But he was also keen to give him a solid academic education and so sent him at the same time to be taught by local humanists, notably Giovanni Lappoli (known as Pollastra).

It was through Pollastra that the young Vasari met the papal legate Silvio Passerini, also a native of Arezzo. Thanks to the patronage of Passerini, 13-year-old Giorgio was sent to Florence, where he became the playmate and fellow student of the young Medici heirs Ippolito and Alessandro. Vasari thus benefited from the two hours a day of teaching that the two boys received from the poet and humanist Pierio Valeriano, future author of the *Hieroglyphia* (1556), one of the first 'bestsellers' of the developing printing industry. He also had time to visit the workshops of Andrea del Sarto, Baccio Bandinelli and (very occasionally) Michelangelo, and to travel further afield – in particular to Rome, where in 1532 and again in 1538 he systematically and enthusiastically set about sketching copies of famous Renaissance works.

A painting career

As a painter, Vasari worked in Venice, Rimini, Naples, Rome and above all Florence, where he became the city's leading artist thanks to the patronage of Cosimo I. In 1554, helped by numerous assistants, he started work on the remodelling of the Palazzo Vecchio, which had become the Medici family's main palace. He was also responsible for decorating a number of important churches including Santa Croce and the cathedral, Santa Maria del Fiore, whose dome frescoes were finished by Federico Zuccaro from Vasari's sketches.

Most importantly, Vasari drew. He was a champion of drawing, which he regarded as the most noble aspect of art and the foundation of painting. He co-founded the Accademia degli Arti del Disegno (Academy of Drawing) in 1563 and assembled an important collection of drawings, an art form long

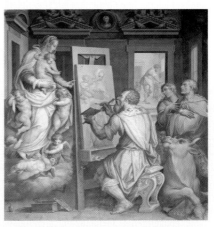

Giorgio Vasari and Alessandro Allori, *St Luke Painting the Virgin*, 1562–73, fresco, Florence, Church of Santissima Annunziata.

spurned by connoisseurs.

Author of the *Lives*

Today, Vasari is remembered less for his art than for his art history. *Lives of the Most Excellent Painters, Sculptors and Architects*, written in the vernacular, first appeared in 1550 and was reissued, revised and enlarged, in 1568. As its title indicates, the work takes the form of a series of biographies of artists (modern rather than ancient), ranging from Cimabue to the author himself. It begins with reflections on the technical aspects of painting, sculpture and architecture. The 'lives' themselves are divided into three sections: the 'Renaissance of the Arts', when the 'Greek' (or Byzantine) style was abandoned thanks to Cimabue and especially Giotto; the 'Second Age' (15th century), dominated by the architect Brunelleschi, a Florentine as were Cimabue and Giotto; and finally the 'Third Age', a high point of achievement dominated by the style of the 'divine' Michelangelo. Vasari believed that art would inevitably degenerate after this point. The book thus maps out a general history of art marked by times of weakness and real cultural catastrophe (Dark Ages), by artistic revolution (era of Giotto), by periods of continuous progress (quattrocento), by the pinnacle of artistic achievement (Michelangelo) and by anticipated decline. It also sets out fundamental aesthetic concepts. Vasari champions one particular style, according it the status of an artistic school distinct from other artistic schools: he asserts the superiority of an art based on drawing over an art that relies primarily on effects of colour – in short, he champions the art of central Italy, the Florentine School, over the Venetian School.

The age of the genius

meal to accompany the architect Giuliano da Sangallo to the site in order to examine the sculpture.

WHAT SHOULD BE THE SUBJECT OF ART?

Anonymous Venetian artist, *The Attributes of Painting*, detail from a painting, c.1520, Castelfranco Veneto, Italy.

Being well-educated, even erudite, 16th-century artists understandably regarded themselves as equals of the humanists and were no longer in any doubt that their art was as noble as philosophy.

Painting – a noble art?

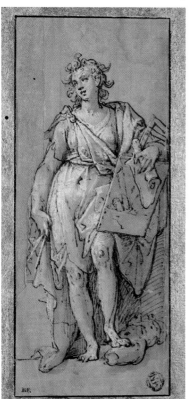

Thus when, in the Vatican in 1508, Raphael painted *The School of Athens* – a gathering of philosophers and scholars amidst colossal classical architecture – he gave Plato the features of Leonardo, Heraclitus those of Michelangelo and inserted his own likeness into a group of geometricians, geographers and astronomers. A few years later, in around 1520, the Venetian artist who painted THE ATTRIBUTES OF PAINTING in Castelfranco Veneto depicted in it an easel and a curious arrangement of sticks and maulstick, together with pencils, brushes and cups, a compass, a ruler, antique casts, books, but also globes and sextants – the tools of the scientist.

Vasari went even further. In 1542, in his house in Arezzo, he produced an *Allegory of Painting* featuring a beautiful woman in antique dress, an unprecedented figure apparently meant as an addition to the traditional nine Muses who preside over the noble activities of the human mind – Clio (history); Calliope (epic poetry): Melpomene (tragedy); Thalia (comedy); Erato (lyric poetry); Polyhymnia (sacred poetry); Euterpe (music); Terpsichore (dance); and Urania (astronomy). This theme was also taken up in a

Federico Zuccaro, *Allegory of Painting*, second half of the 16th century, drawing, Paris, Musée du Louvre.

drawing by his pupil FEDERICO ZUCCARO, and the Muse of painting was thus established. It is clear that in Italy this glorification of painting was endorsed by countless art lovers, while the common public were also more or less unanimous in their admiration of artists and recognition of their value. Dürer, finding himself in Venice at the beginning of the century, marvelled at this and expressed his regret that the situation was less favourable in Germany: 'Oh! How cold I will be when I think of the sun! Here I am a lord, there a parasite.' However, this complaint would soon cease to be valid. During the course of the 16th century, the regions north of the Alps also accepted that painters were worthy of esteem and that their work should be regarded as an intellectual or liberal profession rather than merely manual or 'mechanical' activity. This can be seen in the declaration made by Emperor Rudolph II in Prague on 25 April 1595: 'Henceforth painting should no longer be considered as an artisanal craft (*Gewerbe*), but as an art (*Malkunst*).'

A closer relationship between humanists and artists

This new image of the artist had far-reaching consequences. Now that artists were regarded by humanists as their peers, the two could enjoy friendships free from condescension. Pietro Aretino (who also knew Vasari) and Titian maintained a close, uninterrupted friendship, reinforced by mutual interests, which lasted from 1527 until Aretino's death in 1556. In the company of a third friend, the architect Jacopo Sansovino, the two men spent convivial evenings together eating, drinking, talking ... and sometimes entertaining women. It was not only in Italy that artists mixed with leading humanists. Dürer also enjoyed friendships with some of the greatest intellects of his day. By the end of his life his fame was such that he was able to meet Erasmus in Brussels on more than one occasion and Philip Melanchthon in Nuremberg. In his youth he formed a close and enduring bond with Willibald Pirckheimer, one of the most brilliant scholars in his home town. From Venice in 1505–6 he sent Pirckheimer witty letters interspersed with amusing sketches. When Dürer died in 1528, Pirckheimer lamented him as 'one of the best friends [he had known] on this earth' and wrote an epigraph for him in Greek in which he seeks consolation in the idea that the painter, beneath a burial mound adorned with flowers, is not dead, but merely sleeping peacefully in Christ's bosom. This transformation in the image of the artist affected the relationship between artist and patron. Henceforth, the role of the patron was no longer to specify every last detail of a subject, but at most to make suggestions which would then be discussed with the distinguished figure the learned artist had now become. A letter from the poet Annibale Caro to Vasari reveals the opinion of his contemporaries on this point: 'As for the subject, I leave it to you, remembering ... that poets and painters alike realize their own ideas and plans with more love and application than the plans of others.' Although the letter then goes on to give precise instructions for an Adonis posing on a crimson garment while being embraced by Venus, the principle is clearly stated: the painter is the master of his subject matter as the poet is of his. For humanists, the comparison between painter and poet had its justification in two commonplaces of the ancient world: *ut pictura poesis* (painting is similar to poetry) and *pictor fictor* (the painter as inventor of his own fiction). The elaboration and development of the subject (*invenzione*) was now an integral part of an artist's activity.

Michelangelo: fresco's final hour

This transformation of the painter or sculptor into a decision-maker necessarily changed the criteria by which the quality of a work of art was to be judged. It was no longer a question of counting the number of hours worked or of demanding that the artist use precious materials; the only remaining considerations concerning the execution of the work were those relating to the choice of technique. At the end of her life, even a patron such as Isabelle d'Este, who had been determined to have her own subjects illustrated in the manner she chose, found fault with a painting by the famous Perugino not

THE SCHOOL OF ATHENS

In 1508, at the age of 25, Raphael left Florence for Rome, having been summoned by Julius II to decorate the new apartments the pope had picked out for himself in the Vatican Palace. The suite consisted of four rooms: three of modest proportions and a fourth that was significantly larger. These were the future 'Vatican chambers' (known in Italian as *stanze*) that would make Raphael famous: the Stanza della Segnatura, the Stanza di Eliodoro, the Stanza dell'Incendio di Borgo and the very large Sala di Constantino. Most of the decoration of the last of these was completed after Raphael's death by his pupil Giulio Romano, who based his work on the master's sketches.

The Stanza della Segnatura was the first room that Raphael painted. At this point he was working alone, or at least without the large

Raphael, *The School of Athens*, 1508–11, fresco, base 770cm, Rome, Stanza della Segnatura, Vatican Palace.

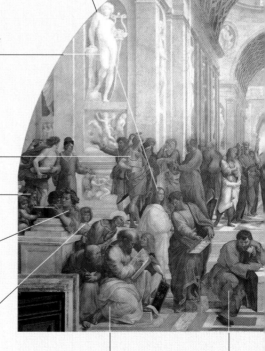

This man with a satyr-like profile and wearing an olive-coloured coat is Socrates. He is checking off arguments on his fingers, surrounded by his disciples.

The young man smiling in the manner of Leonardo da Vinci may be Francesco Maria della Rovere.

The architectural niches are decorated with statues. On this side is Apollo (god of the arts and poetry); on the other side is Athena (also known as Minerva, the goddess of wisdom).

This young man wearing antique-style armour and helmet may be Alexander or Alcibiades. The man behind him with his arm raised could be Xenophon.

This old man depicted in profile is Zeno.

Epicurus, shown wearing a garland of vine leaves, is the champion of hedonist ideas.

Indifferent to philosophical theorizing, this child staring back at the viewer must be Frederico Gonzaga.

With the help of a book, Pythagoras is explaining the principles of number symbolism to his attentive disciples, among whom Averroës, wearing a turban, is recognizable.

Heraclitus is meditating sadly, his head on his arm. In a generous tribute to the artist who was Raphael's great rival at the Vatican, the philosopher from Ephesus bears the features of Michelangelo.

workshop that assisted him in later years. The room was so named because it was where the pope signed his government's most important documents and affixed his seal. The frescoes' thematic programme is thought to have been devised by a humanist scholar at the curia – possibly Calcagnini, Inghirami or Ariosto himself – under the direction of the pope. *The School of Athens, The Dispute over the Sacrament, Parnassus, The Theological and Cardinal Virtues* and *Jurisprudence* all celebrate the ideals of Neoplatonism: Truth (natural and revealed, in other words philosophical and religious), Beauty and Goodness. *The School of Athens* thus symbolizes Truth, which mankind has attained through the power of thought and knowledge.

The gathering takes place beneath the coffered vaulting of an immense basilica inspired by the ruins of the Basilica of Constantine (the first Christian emperor) in Rome.

The sky visible through openings in the architecture is blue and the whole scene is bathed in gentle light. The impression Raphael sought to create was one of great clarity and serenity – qualities that are at the same time physical and intellectual.

At the centre of the picture are Plato (with a long white beard and the idealized features of Leonardo da Vinci) and Aristotle. Plato is holding a copy of *Timaeus* and pointing with his finger to the sky, the seat of ideas. Aristotle is carrying a copy of his *Ethics* and indicating the earth with a horizontal gesture of his hand. This encounter encapsulates the fundamental problem of Renaissance philosophy: how to reconcile the active spirit (Aristotle) with the contemplation of ideas (Plato).

Stretched out on the steps, Diogenes provokes the disapproval of one member of the academy.

This young man in black is Raphael himself. He has painted his self-portrait alongside Sodoma (draped in a white cloak), who had worked here before him.

Ptolemy, the famous geographer and astronomer, is holding a terrestrial globe. As he is often confused with the ancient Egyptian dynasty of the same name, he is shown wearing a crown. Standing opposite him and holding a celestial globe is the astrologer and magician Zoroaster (representing Pietro Bembo?).

The geometric paving and succession of ceiling vaults in the background create a deep perspective and a feeling of immense size.

Bending over a slate, Euclid demonstrates a theory with the help of a compass. He resembles Bramante, the great architect of Raphael's patron Pope Jules II, whom Raphael succeeded at St Peter's. Raphael has painted his signature – R.U.S.M ('Raphael Urbinas Sua Manu': 'Raphael of Urbino [painted this] with his own hand') – on the border of Euclid's tunic.

on the grounds of style, but because of its archaic *a tempera* execution: 'It would have brought you more honour and been more pleasing for us ... had you painted it in oil', she concluded drily in a letter dated 30 June 1505.

Exactly 30 years later, in 1535, when Michelangelo was getting ready to start work in Rome on his enormous LAST JUDGEMENT , a similar dispute broke out over what was the most appropriate medium to use for the work. Vasari reports the dispute in his *Life of Sebastiano del Piombo*: 'Michelangelo had much affection for Sebastiano. However, when [it was] decided to proceed with the painting of that wall of the Sistine Chapel which now bears Michelangelo's *Last Judgement,* a coolness developed between them. Fra Sebastiano had persuaded the pope to have Michelangelo paint in oils while Michelangelo would consider nothing but fresco. The wall was prepared according to Fra Sebastiano's wishes and, without saying anything one way or another, Michelangelo did not touch it for several months. When pressed on the matter, he eventually declared that he would only paint in fresco and that painting in oils was for women, old men and idlers such as Fra Sebastiano. He had the coating that had already been applied on the brother's orders removed, replaced it with a base suitable for painting in fresco and started work, never forgetting the affront he considered Fra Sebastiano to have dealt him.'

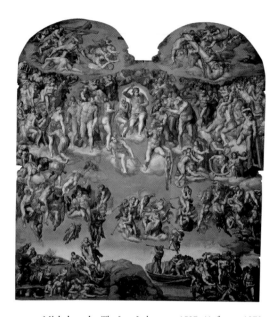

Michelangelo, *The Last Judgement*, 1537–41, fresco, 1370 x 1220cm, Rome, Sistine Chapel.

Behind all this – the heated argument, Sebastiano del Piombo's inappropriate interference in the execution of another's work and Michelangelo's stubborn resistance – there were clearly other motives at play. Ever since Leonardo's *Last Supper,* in which the artist had experimented with a mixed technique that combined tempera with oil, oil had been considered the 'modern' medium par excellence: the most effective way of achieving intense colours and rendering transparency and also the most 'noble' as it was far less physically demanding and messy than the *a fresco* technique. But these concerns meant little to Michelangelo. Beautiful colours were not as important to him as drawing, which brings out the structural form of the body. As a sculptor, he enjoyed contact with his materials and did not mind getting dirty from painting on wet plaster that had to be freshly applied at the start of each day's work.

New matter for debate: 'propriety'

The most important debate, however, had nothing to do with the choice of medium. Now that painters had responsibility if not for inventing their subject matter then at least for deciding how it should be organized, a new question arose: the appropriateness – or lack of it – of how this subject matter was treated.

It is worth stressing here that in the days when artists were required to paint religious scenes that were expected to adhere closely to tradition (or in the case of more complex subjects were guided either by thematic programmes developed specifically for the work in question or by the advice of scholars closely connected with their patrons), their responsibility for the general organization of the image and the choice of details was

minimal. As soon as their status as creators of their own subjects was recognized, however, an immense field opened up to them that was as seductive as it was dangerous. Initially, and perhaps as a reaction against the authoritarianism of their predecessors, patrons in the 16th century gave the painters they commissioned the greatest possible freedom. Only too happy to have convinced Michelangelo to abandon his sculpting activities again in order to complete the decoration of the Sistine Chapel, Pope Paul III did not request any change of subject or even ask for modifications to be made to the preparatory studies the artist had made under the previous pope: 'He wanted the cartoon commissioned by Clement VII to be executed without any changes to the design or concept because he respected the genius of the artist and bore him such affection and reverence that he could think only of pleasing him,' writes Vasari. The pope then allowed the artist to work as secretly as he liked and did not see the painting properly until it was three-quarters finished. Thereafter, his great admiration for the master and his respect for a painting that was so obviously a masterpiece prevented him from uttering any criticism of *The Last Judgement*.

Others, however, had no such scruples. Biagio da Cesena, Paul III's master of ceremonies, who accompanied the pope during the first visit to the work, immediately expressed the strongest disapproval. He exclaimed that the fresco – swarming with naked bodies whose genital areas are not just visible but highly prominent as a result of bodily contortions – 'is better suited to the public baths than to the pope's chapel'. Michelangelo, who heard his comments, took them extremely badly. While finishing off the bottom of the fresco he turned the figure of Minos (in hell) into a portrait of Biagio, showing his body being crushed in the coils of a mighty serpent. The affair might have gone no further, but a clique hostile to Michelangelo and to Paul III himself took up the cause of the outspoken prelate and alerted public opinion in Italy and throughout Europe to this 'obscene and filthy' painting in the most holy of Christian sites. They wanted nothing less than the destruction of the fresco.

The obstinacy of Pope Paul III and his successor Julius III and the obvious pictorial quality (widely recognized in spite of everything) of *The Last Judgement* led to the controversy being resolved with a fairly ridiculous compromise. In 1564, the year of Michelangelo's death, the most risqué of the figures were 'clothed' by the painter Daniele da Volterra, who thus earned himself the nickname Braghettone, the 'maker of breeches'.

The regulation of painting: the Counter-Reformation

More seriously, and more lastingly, the scandal of *The Last Judgement* raised the question of how artists should be regulated – not only by their patrons but by the Church itself. During these troubled times, when the spread of the Reformation and the accompanying iconoclasm led the Catholic Church to fear heretical contagion and a general questioning of the legitimacy of religious subjects in painting, the leaders of the Church of Rome examined the issue of how to regulate religious images. The question was formulated during Michelangelo's lifetime by the venomous Giovanni Andrea Gilio, the author of a treatise on the errors of history painters that was published in 1564. There was also an acrimonious discussion of the subject at the Council of Trent (1545–64), which ultimately took a series of measures that provided for the censorship of paintings designed to be displayed in churches.

Veronese, the most sought-after of Venetian painters during the second half of the 16th century, was one of the first and most famous artists to suffer the consequences of this censorship. He specialized in enormous paintings depicting the celebrated feasts of the New Testament – *Wedding Feast at Cana, The Feast in the House of Levi* (see p.74) and *The Last Supper* – which were commissioned by rich Venetian monasteries to decorate their refectory walls. Early in 1571, Veronese signed a contract with representatives of the convent of Santi Giovanni e Paolo to paint a *Last Supper* as a replacement for an earlier painting of the same subject, by Titian, that had been lost in a fire. Today this work, completed in just over two years, hangs in the Galleria dell'Accademia in Venice. In addition to Veronese's signature and date of completion it also bears an inscription

DETAILS CAUSING OFFENCE IN *THE LAST JUDGEMENT*

While its nudity was the pretext for the initial, and most virulent, criticism of Michelangelo's *Last Judgement*, the work contains other motifs that are just as dubious from the point of view of Christian orthodoxy, if not more so. The composition departs significantly from tradition. Christ the Judge, standing out against a circular yellow background like a sun god or the sun itself, is surrounded by the saints, who move around him like the planets around the sun in the (outlawed) Copernican system. The rest of the composition, beyond this circle, is deliberately confused. It is hard to tell from the motion of the naked bodies

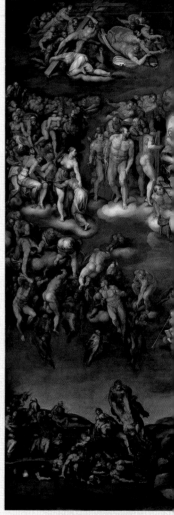

Marcello Venusti, *The Last Judgement*, copy after Michelangelo, 1549, oil on canvas, 190 x 145cm, Naples, Museo di Capodimonte.

Mary's fear ▶

The Virgin Mary, a figure of intercession in Catholic theology, has stopped interceding with her son on behalf of the sinners. Impotent, sad and possibly afraid, she averts her eyes from the terrible sight of Christ's anger.

Solidarity among souls ▶

The souls who have been raised from the dead come to one another's aid by hauling each other heavenwards. While this is a clever idea, in Catholic theology it was the job of the angels to help souls ascend to heaven.

A gradual resurrection ▶

Some of the bodies are depicted as skeletons, while others have regained their skin and muscles. The resurrection, in other words, is taking place gradually, a spectacular idea which Michelangelo borrowed from Luca Signorelli (his *Last Judgement* in the Chapel of San Brizio in Orvieto Cathedral). This contradicts St John's account of the Apocalypse, in which the resurrection occurs all at once.

which are ascending and which are descending; this rules out any clear balance between right and left and top and bottom. It is impossible for the viewer to know for sure who are the righteous and who are the damned. This anxious uncertainty seems to have been Michelangelo's own: at the end of his life he was greatly troubled by the question of salvation. Venusti's copy (shown here) presents the painting as it was before Daniele da Volterra made those changes (1556) that were designed to bring the *Last Judgement* within the bounds of propriety.

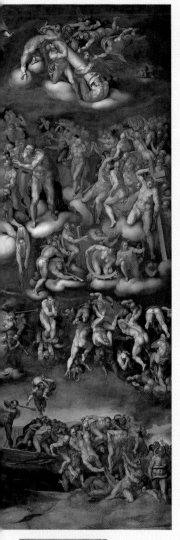

The ardent kisses of the righteous

The traditional 'kiss of the righteous' (as depicted for example by Fra Angelico in his *Last Judgement*) is interpreted more sensually by Michelangelo.

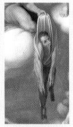

Self-portrait as a flayed man

St Bartholomew, who was flayed alive, is one of the few saints to have been depicted with their attributes (all should have been), in this case his own skin. Michelangelo has painted his own face among the folds of the skin.

Blaise and Catherine: ambiguous activity

Before Daniele da Volterra's interventions, St Catherine, who is recognizable from her attribute (the wheel on which she was martyred), was naked. In the original (from which this copy was made), St Blaise, with his attributes (wool combs), leant over her from behind in a very odd posture. Not only has Braghettone clothed St Catherine, he has also turned St Blaise's head towards Christ the Judge in order to avoid any ambiguity.

An inappropriate gesture?

One of the damned is pulled towards hell by the genitals: this motif was later covered up by Daniele da Volterra.

Personal revenge

According to Vasari, Minos has the facial features of Biagio da Cesena, the pope's master of ceremonies and Michelangelo's personal enemy.

The role of mythology

Charon ferries the damned across the River Styx and threatens them with his oar. Neither Charon nor the Styx belong to a Christian context, however, being motifs from pagan mythology.

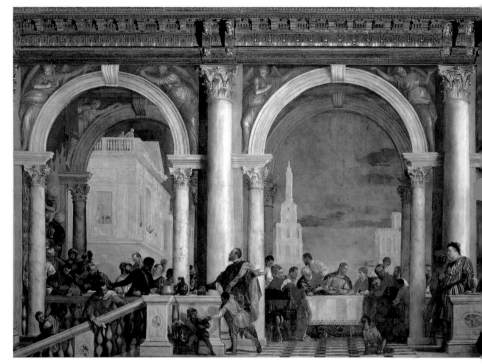

Veronese (**Paolo Caliari**), *The Feast in the House of Levi*, 1573, oil on canvas, 555 x 1310cm, Venice, Galleria dell'Accademia.

in capital letters stating the subject. Curiously, this is not *The Last Supper* but *The Feast in the House of Levi*.

The reason for this change was the scandal the painting provoked when, completed in the form it is in today, it was announced as a depiction of Christ's last meal. Showing a grand banquet and involving many more characters than just the twelve apostles, the painting includes a number of very curious details: a black page, male and female dwarves, two large dogs – all secular motifs whose presence in a *Last Supper* are difficult to justify. Another trivial detail that is equally incongruous in a religious painting is a guest picking his teeth. More seriously, given that this is the event on which the Eucharist (the transformation of wine and bread into the blood and body of Christ) is based, Veronese has painted a valet or rather a *landsknecht* – an armed figure recalling the Protestant army rabble that drove out the pope and ransacked the city in 1527 (the Sack of Rome) – who is tasting the wine and holding a plate with a small piece of bread on its rim. Worst of all, on the opposite flight of steps is a man leaning over the balustrade, handkerchief in hand, having left the meal 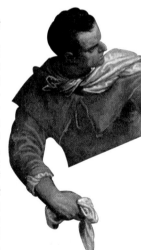 with a nosebleed. In the suspicious climate of the Counter-Reformation (also known as the Catholic Reformation), such inventions could not fail to be regarded as provocations. The censors in Venice looked upon the case with some indulgence, however. Summoned before the Inquisition on 18 July 1573 to defend his painting, Veronese put forward as an excuse the necessity of 'embellishments' and pleaded the cause of artistic freedom. Like 'poets and madmen', he argued, painters also needed to be able to take licence with history. He reconciled himself to a compromise, by which the title of the work was changed from *The Last Supper* to *The Feast in the House of Levi*. He carried out no modifications other than the addition of a predated inscription.

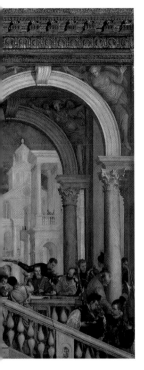

THE OTHER SIDE OF THE COIN:
ARTISTS AS VICTIMS OF THEIR TIMES

Michelangelo, Veronese and Titian were far too famous as artists and far too powerful as personalities for anyone to contemplate curbing their imaginations or exerting control over their creative freedom. Any criticism that was made was voiced only after the completion of their works and emanated from circles unconnected with their commissioning. However, these artists were very much the exception in the artistic world of the 16th century. The majority of painters and sculptors were modest artists – no more than artistic craftsmen – in the pay of their customers. They sought to continue a tradition created by others rather than to be innovative.

Destitute artists

Artists fell into very different categories. At the bottom of the ladder were the painters, sculptors, goldsmiths and engravers of modest talent who considered themselves artisans, were reasonably well established and handled small commissions from clients of limited means as best they could. At the top of the ladder were the artists with high ambitions and considerable learning who enjoyed a lavish lifestyle, addressed powerful lords as equals and made potential patrons ask several times before honouring them with a painting. Between these two extremes every kind of variation was possible, and it was not uncommon for artists who had experienced fame to end up destitute or for others to achieve recognition after a difficult start.

All too often, however, it did not pay to be an artist. Even before the end of the 15th century, the Sienese painter Benvenuto di Giovanni declared unambiguously: 'In our profession the rewards are few and small: we produce little and earn even less.' Things did not change very much in the 1500s. Although Vasari never experienced poverty himself, he was aware of it all around him: 'These days, artists spend their time struggling to avoid hunger rather than trying to make a name for themselves. This destroys their talent and ensures that their name falls into oblivion.' Is this just a routine complaint? Almost certainly not, as even such brilliant artists as El Greco (at the beginning of his career) and Lorenzo Lotto (in his prime) were reduced to organizing 'charity' sales of their paintings as a way of raising money.

Many artists pursued a second, parallel trade as a way of supplementing their income. The main and most obvious trade was that of salesman. As the art market expanded following an increase in demand for decorative domestic objects, the less well-off artists no longer waited for people to commission work from them but went in search of clients. In addition to offering their small paintings, devotional statues, woodcuts and so on for sale in their own shops, they became hawkers, wandering the streets, posting themselves in church porches and taking stands at fairs. A number of artists, however, exercised professions less obviously connected with their principal activity: Giovanni Francesco Caroto, of Verona, had an apothecary's stall; Vincenzo Catena, Giorgione's associate, sold medicine and spices for a while (activities not unrelated to art, as it was from pharmacies that artists obtained their pigments); Giorgio Schiavone sold salt and cheese; Mariotto Albertinelli was an innkeeper for a while; and Niccolò dell'Abate was a soldier.

Misfortunes of the day

In addition to the foreseeable vicissitudes of an artist's career, there were other hardships that had to be endured. The Sack of Rome in 1527 by Swiss and Spanish troops led by the Constable of Bourbon created real panic and resulted in the exodus of the

The age of the genius

Anonymous German artist, *Standard Bearer*, detail from an engraving depicting the Sack of Rome by German *landsknechts* in 1527.

colony of artists working for Pope Clement and the leading Roman families. Benvenuto Cellini and Rafaello da Montelupo, both goldsmiths, served, appropriately enough, in the artillery and evidently took pleasure in playing soldiers on the ramparts of Castel Sant'Angelo. In his *Life of Benvenuto Cellini Written by Himself*, the former gives an amusing account of his experience of military action. However, a number of their fellow artists were far more badly affected by the disaster of spring 1527. The engraver Marco Dente died during the raid, the façade painter Maturino succumbed to the plague after fleeing the city, and others were arrested, held to ransom and forced to carry out work that was beneath them. The painter Rosso Fiorentino narrowly escaped losing his life as well as all his worldly possessions. He was arrested and only managed to save his skin by serving the enemy, barefoot, as a porter. Nevertheless, it was in the countries affected by the Reformation that artists suffered most. In a France torn apart by the wars of religion, the ceramist Bernard Palissy, a Protestant, saw his studio in Saintes destroyed. All his work was broken and he was arrested and thrown into prison. When he was eventually released, having been lucky to escape the stake, he was demoralized and in disgrace. He left the Saintonge region for good, moving with his family to Paris at the age of 50 to start up again. Ten years later he had to flee for a second time, to Sedan, when violence erupted once more. This time it was more terrible still – the St Bartholomew's Day Massacre of 23 and 24 August 1572.

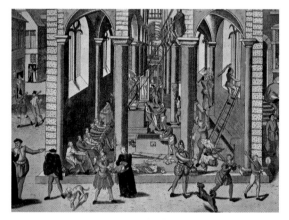

Protestants Destroying Works of Art in a Church, coloured engraving, detail, 1566.

In the German-speaking lands the situation was even worse. In 1524, fired by the ideas of Martin Luther, peasant discontent developed into a revolt that spiralled into an immense, violent protest against established power. A number of artists who supported the peasants' cause were imprisoned or even executed after the revolt was crushed. Tilman Riemenschneider, Würzburg's most prominent sculptor, was one of those incarcerated. This respectable citizen, who had held municipal office and run an important workshop since the beginning of the century, was tortured and eventually left prison a broken man. His workshop produced no major works during the remaining six years of his life. The Stuttgart painter Jörg Ratgeb was more unfortunate still: this descendant of serfs, whose sympathy with the peasants' cause led him to fight alongside them, was publicly quartered on the market square in Pforzheim.

In the years following this paroxysm of violence, an ultimatum was issued according to which dissidents had to convert or keep quiet. This diktat applied to both sides. When Basel was swept by the Reformation in 1529, Erasmus left the city to its fate. The painter and fervent Catholic Hans Herbst, on the

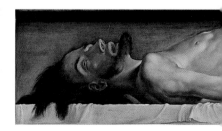

other hand, protested against the new order in the name of his guild, of which he was one of the leaders, and was imprisoned as a result. He was released following a public retraction, but produced no more paintings after this painful experience. Matthias Grünewald, painter of the wonderful Isenheim Altarpiece and far better known than Herbst, was seduced by Luther's ideas while in the service of the young Albrecht von Brandeburg, the archbishop of Mainz. In 1525, he incurred the disfavour of the powerful prelate, who had hesitated for a long time before deciding to take action against the heretics. Forced to leave his home in Selingenstadt and abandon all his possessions, Grünewald travelled to Frankfurt, Magdeburg and Halle, wretchedly trying to earn a living by selling soap before finding employment in 1528, the last year of his life, as a hydraulic engineer.

Painting in Protestant countries: the example of Holbein

The religious situation had disastrous consequences even for those artists in Protestant countries who were of the dominant faith. While no doctrinal stance against works of art was adopted by Luther at the beginning of the Reformation, Erasmus expressed his disapproval of the cult of religious statues as early as 1511 in his essay *In Praise of Folly*, and Karlstadt (in 1522), Zwingli (in 1524) and most importantly Calvin came out vigorously against all representations of God and the saints. The range of subjects available to painters and sculptors was thus drastically reduced, while the new mistrust of images led to Protestant churches with bare walls. Artists' workshops were deprived of the large and lucrative commissions on which they depended.

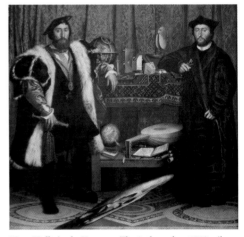

Hans Holbein the Younger, *The Ambassadors*, 1533, oil on wood, 207 x 209cm, London, National Gallery.

HANS HOLBEIN is a case in point. Born in 1497 or 1498 and known as 'the Younger' because he was the son of a German painter by the same name, Holbein sympathized with the Reformation from an early stage. After leaving Augsburg, his home town, in 1515, he settled in Basel, where he continued to paint religious works. When a trend towards iconoclasm developed in the city in 1524 and gained ground from 1526 onwards, major commissions dried up and the 29-year-old painter left Basel for England, where Henry VIII had not yet broken with Rome. Even in London, however, where Holbein lived for two years, the movement towards church reform prevented him from painting works with a Christian theme that would have allowed his poetic genius to express itself. Introduced to the court by a letter of recommendation from Erasmus to Sir Thomas More, speaker of the House of

Hans Holbein the Younger, *The Body of the Dead Christ in the Tomb*, tempera on canvas, 30.5 x 200cm, Basel, Kunstmuseum.

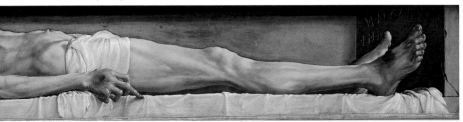

A NEW TECHNIQUE: ENGRAVING

The two types of engraving most widespread at the beginning of the modern age take their names from the type of support used. The resulting image, known as a print (or by extending the name of the procedure to the end result, an engraving), is produced by pressing a sheet of paper against an incised, inked plate. This plate can either be of wood (wood cut) or metal (metal engraving).

Until the 19th century, when steel became more widely used, metal plates were generally made of copper. In the case of woodcuts, the parts that receive the ink are those remaining proud after the areas that are to appear white on the paper are cut away. This is known as the relief method. Where metal is used, the ink is held in the incised, or engraved, furrows. This is known as the intaglio, or copperplate, method.

Engraving on wood and metal

In the West, the technique of engraving on wood has been practised since around 1300. The images produced are characterized by thick lines and strong contrasts between black and white (see top illustration by Burgkmair).

Engraving on metal involves the creation of a design using a rangeof metal gouges with different cross sections. Where acid is used to corrode the support, the process is termed etching. This allows a finer image to be obtained, with precise lines and a range of light and dark tones (see bottom illustration by Dürer). Although Giorgio Vasari attributes its invention to the Italian artist Maso Finiguerra (1426–64), the technique seems to have emerged at more or less the same time (around 1430) in various parts of Europe, notably the Rhineland (the Master of the Playing Cards, Master E.S., Martin Schongauer), Burgundy and Italy. Its development was assisted by technical progress (the adoption of the cylinder press) and centred on goldsmiths' workshops – Dürer, one of the first great engravers, was the son of a goldsmith.

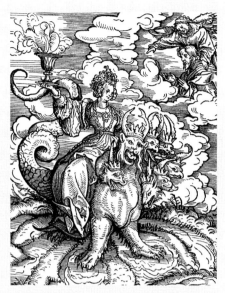

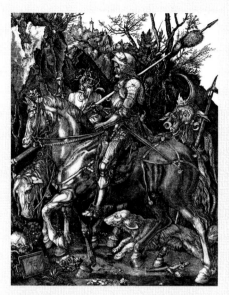

Hans Burgkmair, *The Whore of Babylon*, 1523, woodcut illustration from an edition of the Book of Revelation of the New Testament published in Augsburg by S Othmar.

Albrecht Dürer, *The Knight, Death and the Devil*, 1513, copperplate engraving, 24.6 x 19cm, London, British Museum.

Engraving as a tool in the 'war of images'

While their mistrust of the image led Protestant theologians to ban paintings with a religious theme, they were quick to see the potential of engraving as a tool for the dissemination of ideas, initially in the form of inexpensive loose sheets. From the beginning of the 1520s, the painter Lucas Cranach (who had converted to Protestantism and was a friend of Luther) and Hans Holbein the Younger created simple, striking images denouncing the temporal power of the pope and comparing Rome to a new Babylon and the pope to the Antichrist, or else depicting the impending end of the world as a way of persuading people to convert as quickly as possible.

The Catholic Church also understood the importance of the engraved image as a way of getting its message across to the faithful. The Jesuits, founded in 1540, promoted engraving both in the form of illustrated sheets that Catholics were encouraged to hang on the wall and perform their devotions to (pictures of the Virgin and Child, the Crucifixion, the martyrdom of saints) and in the form of well-illustrated devotional books.

A new means of expression and dissemination

By the end of the 15th century, artists had developed a passion for engraving. Among those who practised the new technique were the Florentine painter Antonio Pollaiuolo (*Battle of the Nudes*) and, most importantly, Andrea Mantegna at the Mantuan court.

During the first few decades of the 16th century, Dürer created a masterly body of work. Working with wood (*Apocalypse, Great Passion, Life of the Virgin*) as well as copper (*Coat of Arms of Death, Adam and Eve, Large Fortune, St Jerome in His Study, Melancholia I, The Knight, Death and the Devil*), he created engravings that were quite different from his work as a painter.

The most important engraver in Italy during this period was Marcantonio Raimondi. Unlike Dürer, he concentrated on engraving the work of famous painters of the day, notably Raphael. These were the interpretative prints that were to become so popular over the following centuries, appreciated both by painters (whose work was thereby brought to a wider public) and by art lovers (who were able to acquire inexpensive copies of the works of painters they admired).

Commons and an influential member of the King's Privy Council, Holbein spent the rest of his life (he died in 1543) painting fine portraits of courtiers, diplomats (*THE AMBAS-SADORS*), merchants and the landed gentry, but produced no more examples of the mystical paintings (the *Solothurn Madonna*, the *Darmstadt Madonna* or the wonderful *BODY OF THE DEAD CHRIST IN THE TOMB*) with which he had made his name.

A NEW MODE OF BEHAVIOUR: THE 'GREAT ARTIST'

Confined to secular art as a result of the religious developments in Basel and England, Holbein was nevertheless the very model of an admired and sought-after court painter receiving handsome rewards for his portraits. There was an enormous gulf between artists of this kind and the vast majority of painters and sculptors who did no more than eke out a living. Those figures who did achieve success were fully aware of this, but far from demonstrating any solidarity with their less fortunate fellow artists they took pains to emphasize the distance that separated them.

Money matters: the myth of disinterestedness

The main difference between the two groups was their relationship with money. Although the most highly valued artists earned incomparably more than the heads of modest workshops and amassed considerable fortunes while their counterparts led a poor or mediocre existence, these rich and successful artists were quick to declare that they cared nothing for the money their work could command. For those in the service of influential patrons, being paid by a prince – as a noble and devoted servant rewarded by sinecures, perhaps – was very different from running a *bottega*. Leonardo, it is said, once refused a sum of money that someone offered him in an envelope; he was offended at being treated like a 'jobbing painter'. Michelangelo refused to be his own shopkeeper: 'I have never been one of those painters or sculptors who open a shop. I have always refrained from doing so out of consideration for my father and brothers.' Similarly Vasari, who worked for and was paid by the Medicis for a time, dismissed Perino del Vaga's first master as 'one of those mediocre artists who kept an open shop and carried out work of a mechanical nature'.

Generally speaking, the artists who amassed the largest fortunes liked to create the impression that they were motivated by love of their art rather than by a desire to earn

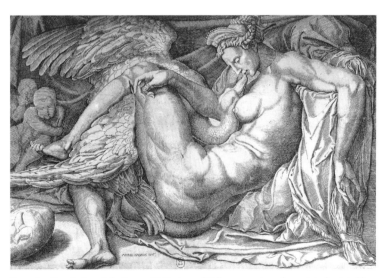

Cornelius Bos, *Leda and the Swan with Castor and Pollux*, engraving of an original painted by Michelangelo in 1529–30, Paris, Bibliothèque Nationale de France.

money. The reality was very different. Giotto, in the 14th century, put his earnings to work by offering secured loans; Dürer was continually pestering his patrons for more money and earlier payment; and a certain Giovanpiero, Taddeo Zuccaro's first master, was renowned for his miserliness. Yet during the 16th century, biographers stressed their subjects' lack of interest in money. In his *De Sculptura* (*On Sculpture*) of 1504, Pomponio Guarico (Guaricus) writes that the sculptor Donatello showed such contempt for money that he suspended a basket full of coins from the middle of his studio and allowed everyone to help themselves. Pontormo preferred to give his paintings away to ordinary people rather than see them bought for vast sums by rich collectors who cared little for them. And it would seem that Michelangelo, upset at hearing his painting LEDA AND THE SWAN described by Alfonso d'Este, Duke of Ferrara, as a 'trifle' (*poca cosa*), chose to give it to one of his servants rather than hand it over to the duke, who had been coveting one of his works for a considerable length of time and was ready to pay whatever the artist asked.

Painting versus sculpture

This contempt for anything that might link artistic creation with commercial activity was closely related to a desire on the part of artists to be seen as lords engaging in an intellectual pursuit rather than as craftsmen labouring with materials.

This gave rise to a debate that may seem futile to us today but which aroused considerable passion in its day: the comparison between sculpture and painting and the argument as to which was the nobler of the two arts. Although the debate took certain technical aspects into consideration – sculpture, in the eyes of its champions, had the advantage of being able to show a figure in all three dimensions, while painting had colour in its favour and was the only art form capable of depicting a landscape – the discussion centred not on the individual properties of each art form but on the material conditions in which they were practised. In

Michelangelo sculpting, detail of an engraving, 1527.

short, the criticism levelled at sculpture was that it involved exclusively physical work and that it was a dirty job better suited to labourers than to men of lofty ideals. As early as the beginning of the 15th century, Cennini had found a way of expressing the notion that anyone who carved stone or soiled their hands modelling clay was not worthy of praise: 'Let me tell you that painting a panel is a job fit for a gentleman, as you may do what you will dressed in velvet.' Similarly, Leonardo da Vinci, a century later, described the painter as an intellectual who tires his mind rather than his body. He compared the sculptor covered in stone dust, extracting a figure from a block of marble through sheer physical effort, to a baker covered in flour. However, Leonardo had nothing to say about those who worked with wax, plaster or clay. In Milan in 1493, he himself had made a clay model of a horse for an equestrian statue of Francesco Sforza. He considered this aspect of sculpting, where a feat of engineering was then required in order to transform the *modello* into the finished statue cast in bronze, to be the only one that involved any obvious degree of intelligence.

This prejudice against sculpture was shared by most of Leonardo's contemporaries. MICHELANGELO, his junior by 23 years, met with strong opposition from his father when he revealed his intention to become a sculptor. Never, his father declared, would a son of his become a 'hewer of stone'. He only changed his mind when Lorenzo the Magnificent intervened on the young man's behalf. Many years later, in 1547, the dispute

came to the fore once again when the Florentine scholar Benedetto Varchi conducted a 'survey' of artists on the subject. And in 1568, the sculptor Cellini, in the epilogue of his *Treatise on Sculpture*, listed seven ways in which he believed the art was not only a perfect discipline but also the 'father' of painting.

The ideal of lordly living

This obsessive desire to distance themselves from the world of the artisan led most successful artists to seek to acquire the speech and manners of those who moved in more elevated social circles. Prime examples of this are Leonardo and Raphael (who was a friend of Baldassare Castiglione, author of *The Book of the Courtier*, a treatise on the art of living at court in the 16th century). Vasari revels in a description of Leonardo's beauty, refined sociability and fondness for shining in company: 'His physical beauty defied praise; infinite grace resided in the slightest of his actions ... He had some musical ability and, as befits a noble and charming spirit, did not delay in learning to play the lute ... His conversation was so pleasing that none could fail to be charmed by it ... He always had servants and horses of which he was fond ... In his generosity he lodged and fed any friend, rich or poor, providing they had talent and merit.' A century later, another biographer, the Frenchman André Félibien, painted the following extremely flattering portrait of Raphael: 'As well as being handsome of face and body, he had about him a grace, a kindness and a gentleness that won the hearts of all who set eyes on him.'

Proving the accuracy of these posthumous panegyrics of Leonardo and Raphael would be very difficult. However, there is far greater certainty about the circumstances of Titian's life. While residing at the courts of Ferrara and Mantua between 1523 and 1525, this notary's son, who had been brought up in the mountainous region of Cadore, devoted considerable effort to abandoning the dialect he had spoken up to then. As well as an elegant vocabulary he acquired a gentleman's wardrobe, thanking Frederico Gonzaga for the gift of an embroidered tunic. It is probable that the following assessment by the historian Claudio Ridolfi, written in the 17th century and far more restrained than Vasari's description of Leonardo or Félibien's description of Raphael, is a fairly accurate description of the level of education of a painter – Titian as well as others – who was used to spending time at European courts: 'He had courteous manners and, although he was not highly

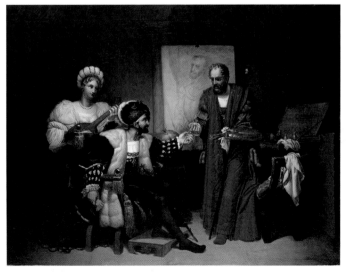

Pierre Nolasque Bergeret, *Charles V in Titian's Studio*, oil on canvas, Bordeaux, Musée des Beaux-Arts.

educated, possessed natural ability. He picked up elegant phrases through his familiarity with life at court.'

It was only natural that such painters and sculptors, possessing not just talent but also refined manners, should experience success. Already the friends of scholars, those artists best placed could now dream of great riches, high office and honours, and even the friendship of princes. Inspired by the story of great friendships between artists and monarchs of the ancient world, Renaissance princes made it their duty no longer to treat their court painters with disdain but to show them understanding and respect.

It could be said that accounts of such mutual infatuations appear far too frequently in artists' biographies to be totally convincing. Emperor Maximilian goes to watch Hans Burgmair work (or, even better, orders a courtier to get down on his knees so that Dürer can use him as a stool); Charles V picks up a paintbrush dropped by TITIAN; Leonardo dies in the arms of François I of France at the Château of Cloux; Pope Leo X visits Raphael in his studio – these anecdotes all bear a marked resemblance to one another. It is nevertheless true that it was far more common for the princes, kings, popes and emperors of the 16th century to maintain close, almost affectionate relationships with painters and sculptors than at any time previously.

At the beginning of winter 1548, for example, Charles V wrote to Titian – who had become his portrait painter in 1518 and whom he had therefore known for 30 years – asking the painter to join him in Augsburg in Germany, where he was preparing to hold an Imperial Diet. This summons from the emperor astonished Aretino, who wrote to Titian that no artist had ever been shown such an honour before. Upon his arrival in Swabia, Titian was indeed shown great consideration. Charles V gave him apartments next to his own – 'rooms so close to one another...', wrote the painter, 'that it is possible to pass from one to the other without being seen'.

Grand titles and fine dwellings

The benevolence of princes manifested itself not only in the warmth of their relationships with artists, but also in the riches and honours they bestowed on them. It was not new for painters and sculptors to be ennobled, but this now became more common, and higher-ranking titles were awarded. During the course of the 16th century, and particularly during the second half, no fewer than 60 artists joined the ranks of the aristocracy. Half of these were Italians; the remainder acquired their titles at various courts throughout the rest of Europe, in particular at the Habsburg courts. Following in the footsteps of Gentile Bellini and Andrea Mantegna, Sodoma, Titian and Arcimboldo became Counts Palatine (*Comes Palatinus Sacri Laterensis*). The sculptors Leone Leoni and Baccio Bandinelli joined the highly prestigious Order of the Knights of Santiago, while Cranach and possibly Dürer, more modestly, were given the right to bear coats of arms. Elevation to the nobility was an honour greatly valued by painters and sculptors. It fulfilled their wish to make people forget their humble backgrounds, and the automatic exemption from taxes that came with it brought them substantial material advantages. Although they wanted to appear uninterested in money, artists took pleasure in accumulating wealth. Raphael, Titian and (somewhat more discreetly) Michelangelo and Leonardo were all extremely wealthy, while Holbein and even Dürer also earned considerable sums of money. During their lifetimes – and despite Michelangelo priding himself on living like a pauper – the fortunes of these artists could be seen in the trappings of the social status they were so keen to acquire. In his self-portraits (see p.84), Dürer painted himself dressed not in his work clothes, which were those of an artisan, but in the finery of a nobleman.

Even more important were the houses in which artists lived. By building monuments in stone to their new status, painters and sculptors sought to give a permanent basis to their change of fortune. On 22 March 1538 in Mantua, where he served the Duke of Gonzaga after leaving Rome in 1527, Giulio Romano purchased (for the sum of one thousand gold crowns) a house built at the beginning of the century not far from the dwelling Mantegna had occupied – a dwelling that had already become famous. He immediately

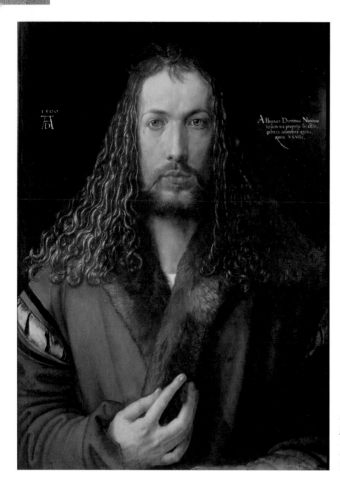

Albrecht Dürer, *Self-portrait in a Fur Coat*, 1500, oil on wood, 67 x 49cm, Munich, Alte Pinakothek.

undertook major building work to transform the house into a kind of Roman villa with a painted façade featuring motifs based on the classical orders, and he displayed his extensive private collection of ancient artefacts, plans, medals and contemporary paintings in its sumptuously decorated rooms. The sculptor Baccio Bandinelli's house in Florence, Leone Leoni's in Milan (a palace decorated with a row of caryatids) and Vasari's home in Arezzo were also substantial properties fulfilling what their owners believed to be an essential symbolic function. The same was true of the house (topped with a showy gable) of the Antwerp painter Bartholomeus Spranger, who had been summoned to Prague by Emperor Rudolph II, as well as that of Frans Floris de Vriendt in Antwerp, which according to Carel van Mander 'swallowed up the five thousand florins that Frans had deposited with the Schetz bank and all the money he could manage to borrow'.

As a result of this desire to lead a glamorous existence so that people would forget their true origins, a number of artists got their fingers burnt. Fortunes spent on acquiring and decorating palaces, high prices paid for all sorts of rare collectables, lavish entertaining in order to show off the opulence of their homes – these dragged more than one painter or sculptor into financial difficulties, from which the steady demand for their work and the high prices it commanded should have preserved them. Having arrived in Toledo in around 1576, El Greco died in debt at the age of 69 in a house that had once been sumptuously decorated but whose 24 rooms were by then empty save for a storeroom containing 200 more or less completed paintings, a luxurious four-poster bed, the books in his library and a well-appointed kitchen. Changes in taste, which meant that the public had turned away from the painter's ecstatic style during the last few years of his life, were no doubt partly to blame for his near-destitute old age, but the role

played by the artist's own behaviour should not be overlooked. In around 1675, a Spanish biographer, Jusepe Martinez, wrote that 'he had earned many ducats but had spent them all on ostentatious living, even employing musicians to play to him during meals so that his enjoyment of them might be increased'.

Precarious fame

Extravagance was not, however, the only reason for the disappointments experienced by artists. Newly ennobled, with newly acquired wealth and often enjoying special treatment at court as favourites of the powerful, successful painters were the object of intense, predictable jealousy. The roles they found themselves playing sometimes made their heads spin.

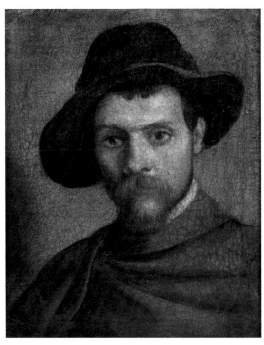

Annibale Carracci, *Self-portrait*, 1593, oil on canvas, Parma, Galleria Nazionale.

Raphael, overwhelmed with responsibilities as well as honours, chose an apt metaphor for this when he wrote to a friend that he felt like Icarus flying too close to the sun and therefore destined to fall. On the other hand, the Bologna-born ANNIBALE CARRACCI, the son of a tailor and nephew of a butcher and a sought-after painter like his brother Agostino and his cousin Ludovico, could not bear to see artists playing at being gentlemen. One day when Agostino was strutting around with courtiers at the Farnese Palace in Rome, Annibale whispered in his ear: 'Do not forget, Agostino, that you are the son of a tailor.' The historian Giovanni Bellori, to whom we owe this anecdote, continues the story as follows: 'Annibale returned immediately to his room, took a piece of paper and drew upon it a picture of his father wearing spectacles and threading a needle and his mother holding scissors. He sent this drawing to his brother, who was so unsettled by it, so stung by it, that soon afterwards, when other reasons had presented themselves that reinforced his decision, he parted from his brother and left Rome.'

However, the greatest danger came not from any doubts experienced by artists, but from external factors. Even if it did remain constant, the favour of a patron lasted only as long as he was alive. Supported by Emperor Maximilian, Dürer saw the annual pension of 100 florins he had been granted in 1515 dry up when the emperor died in 1519. In order to get it reinstated, he had to make a journey (in the company of his wife and a servant) from Nuremberg to Aachen, where the new emperor, Charles V, was staying. The affair ended well, with Charles V responding favourably to Dürer's petition, but the journey would have kept the artist away from his studio for a whole year. In some other cases, the disappearance of a patron had dramatic consequences. Vasari, for example, was severely affected by the deaths within the space of two years of the two princes he had known since adolescence and who had shown him great favour: Ippolito, possibly poisoned, in 1535, and Alessandro, assassinated on 5 January 1537 by the notorious Lorenzino (the Lorenzaccio of Alfred de Musset). After the second murder, the painter – distressed by the events – wrote a despairing letter to his uncle and finally came to the sensible decision to leave Florence and never again to seek glory in the volatile environment of the courts, where (he wrote) 'there is no escape and no means of extri-

The age of the genius

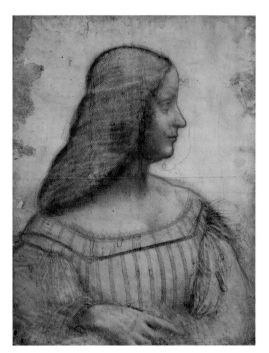

Leonardo da Vinci, *Portrait of Isabella d'Este*, drawing in black, red and ochre chalk, 61 x 46.5cm, Paris, Musée du Louvre.

cating oneself for those who get caught up there'.

Withstanding pressure from patrons

Cherished by his patron and envied by the court, the painter or sculptor who entered a prince's service had to sacrifice a certain amount of freedom in exchange for the comfort of a secure career. In the same letter to his uncle, Vasari writes of the 'severity of the chains of servitude'. Ever since the beginning of the 16th century, artists had been displaying an ever greater sensibility that was difficult to reconcile with such a sacrifice of freedom. There was one area in particular where they refused all interference from their patron – the creative process. Naturally, refusal here was easier for those painters who ran successful, well-known workshops in the urban centres. They could afford to be less accommodating of the desires of princes and other influential figures, since their livelihood did not depend on them. During the early years of the 16th century, Giovanni Bellini for a long time resisted the approaches of formidable ISABELLA D'ESTE, who wanted him to paint one of those pictures on complex themes of which she was so fond. Although the humanist Pietro Bembo had warned her that it was the custom of the by then aged painter 'to work on his own terms and follow his own fancy in his pictures' ('vagare a sua voglia nelle pitture') and despite being warned by another intermediary that Bellini would only deign to produce a painting if he were given the 'freedom to paint what he wanted', Isabelle continued to demand a 'history painting or an ancient myth'. What she got in the end was a nativity. Having learnt from this failure, the duchess then employed Lorenzo Costa, who was not in a position to disobey her instructions since he was entirely dependent on her. But when she subsequently tried to acquire a work from no less an artist than Leonardo da Vinci, she made it clear that he could 'choose the subject and decide on the completion date'. The work in question – a portrait of the duchess in profile – remained unfinished, however.

A few years later, Isabella's brother Duke Alfonso I was also taught a lesson in how to treat artists. Between 1517 and 1520, he tried to persuade Raphael to paint a *Triumph of Bacchus* for him. The overstretched painter led Alfonso a merry dance with one promise after another. Some time after 1519, Alfonso tried the same tack with Titian, again asking for a Bacchanal. This time he got it (in all likelihood the *Bacchus and Ariadne* in the National Gallery, London), though very late. Finally, with Michelangelo, whose frescoes on the ceiling of the Sistine Chapel had dazzled the duke when he had seen them for the first time in 1512, Alfonso adopted a more relaxed and jovial approach. When the artist stayed in Ferrara for a few days in 1529, Alfonso personally showed Michelangelo his collections and then, at the moment of leave-taking, joked: 'Now you are my prisoner. If you wish to be set free, you must promise me that you will make something for me with your own hand, a sculpture or painting as you see fit'. As the duke was prepared to accept a subject of Michelangelo's choice and there was no discussion of price, it seemed that the matter was settled, but as we have already seen, Alfonso would never receive the *Leda and the Swan* that Michelangelo had earmarked for him.

ROSSO FIORENTINO: A TRAGIC END

By far the greatest danger confronting painters who worked for princes was not a change of ruler but the baseness of the courtiers. Indeed, the plotting in which the 'real' noblemen indulged was sometimes so bad that it resulted in the moral and physical destruction of artists. The fate of Rosso Fiorentino ('the red-haired Florentine' [1494–1540]) is perhaps the most tragic illustration of this.

Superintendent of works at Fontainebleau

Invited to France on the recommendation of Aretino, whom he had almost certainly met in Venice at the end of his period of wandering caused by the Sack of Rome, Rosso (whose real name was Giovanni Battista di Jacopo) entered the service of François I in 1530. Over the following years he worked intensively on various decorative projects commissioned by the king for Fontainebleau. The impressive François I Gallery (see p.59) is all that remains at Fontainebleau of an extensive series of murals that was greatly valued by the monarch. Fortunately, a number of panel paintings survive, dating both from before Rosso's time in France, such as the strange *Virgin and Child with St John, St Anne and Angels*, and during it, such as the *Pietà* (Musée du Louvre, Paris).

A life of luxury

Rosso Fiorentino rapidly won royal favour and started to lead a privileged and luxurious life at court. In May 1532, François I signed letters-patent granting him the same rights as his other subjects, and not long after made him a canon of Sainte-Chapelle in Paris. With a monthly income of four hundred crowns, a luxurious apartment at his disposal at Fontainebleau and the loan of a house in Paris, Rosso was able to live in considerable style. He made the most of it. This well-educated young man (he was 35 years old when he arrived in France) was – according to Vasari, who knew him – tall with flaming red hair and refined manners and 'lived like a prince,

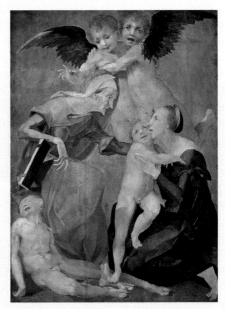

Rosso Fiorentino, *Virgin and Child with St Anne, St John and Angels*, c.1519–20, oil on wood, 161 x 152cm, Los Angeles, County Museum.

with staff and horses, holding sumptuous receptions and banquets for all his friends and acquaintances, mainly Italians who were passing through'.

Suicide

On 14 November 1540, the painter – for whom things were apparently going so well – suddenly took his own life. According to the planned epitaph recorded by Vasari: 'Rosso, a painter from Florence … / Preferring poison to snares / By an act as magnanimous as it was fatal / Perished wretchedly in Gaul.' The circumstances of the suicide are obscure, as are the reasons behind it, and it has sometimes been doubted whether Rosso took his own life at all. Vasari, however, mentions libel, false accusations, a trial, a question of honour – indeed, a whole patchwork of incidents in which jealous painters may well have had a hand, with the delighted approval and clandestine support of many at court.

The age of the genius

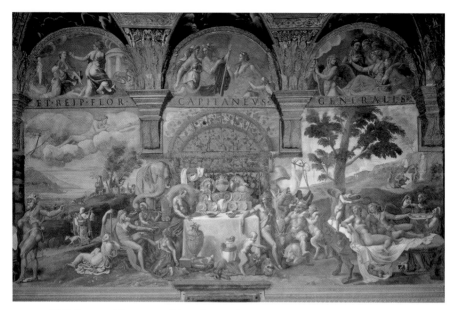

Giulio Romano, *The Banquet of the Gods*, 1528, fresco, Mantua, Palazzo Te.

A new requirement: the right to take one's time

The question of completion dates was one of the major stumbling-blocks in the rela-
tionship between patrons, who were impatient to see works finished, and artists, whose
work patterns were starting to be dictated by inspiration rather than by a timetable of
the client's devising.

At the beginning of the 16th century, a number of artists were still prepared to suffer
humiliation at the hands of the princes on whom they depended. In 1528, GIULIO RO-
MANO was reprimanded by Duke Frederico Gonzaga of Mantua (the son of Isabella d'Este,
for whom the artist built and decorated the Palazzo Te) as follows: 'We are displeased
that you have once more failed to respect the dates by which you had anticipated fin-
ishing.' The painter replied obsequiously: 'The greatest distress I could possibly know is
that Your Excellency should be angry ... If you so please, have me locked up in the room
until it is finished.' By this time, such kowtowing seemed to belong to another age.

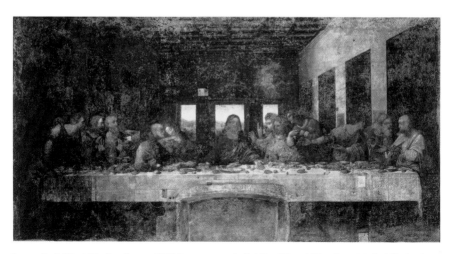

Leonardo da Vinci, *The Last Supper*, 1497–8, tempera and oil, 460 x 880cm, Milan, Santa Maria delle Grazie.

A commonly held view of artists during the 1500s was that they had an irregular working pattern and that clients could wave goodbye to agreed deadlines as there was nothing they could do to force the painter or sculptor to increase his rate of production. In the dedication to one of his tales (*Novelle*), Matteo Bandello describes Leonardo da Vinci's working method while painting his large *Last Supper* in the convent of Santa Maria delle Grazie, emphasizing the notion of artistic whim or fancy (*capriccio, ghiribizzo*): 'He frequently climbed his scaffolding to *THE LAST SUPPER*, which was fairly high up on the wall, at an early hour – I observed him do so many times. It was his custom, I tell you, not to put down his paintbrush from sunrise until dusk and to paint without interruption, neglecting to eat or drink. Then two or three days might pass without him so much as touching the work. At other times, he would spend an hour or two by himself studying his figures, thinking about them and meditating upon them. I also saw him (taken by a whim or sudden idea) leave Corte Vecchia, where he was modelling that astonishing horse [the equestrian statue of the Duke of Milan], in the bright midday sunshine, and make straight for the Grazie. There, mounted on his platform, he would take up the paintbrush, apply one or two strokes to this or that figure and then immediately take himself off somewhere else.'

The ultimate whim: artistic creation as a secret process

Other conflicts were caused by the refusal of artists to let patrons intervene during the creative process or even to let them view a work prior to its completion. Vasari describes the dispute between the painter Piero di Cosimo and the director of the Foundling Hospital in Florence over a painting which the institution had commissioned from him. The director, who was also a friend of the painter, asked to see the work while Piero was still engaged on it. Piero refused. The director insisted, threatening to suspend payments if the artist did not comply, but Piero got his own way by swearing that he would destroy the painting rather than let the director see it before it was finished.

At around the same time, so Vasari tells us, the painter Franciabigio was less lucky. He was working on a fresco, the *MARRIAGE OF THE VIRGIN*, in the church of Sanctissima Annunziata in Florence and also wanted the painting to remain unseen until it was finished. However, the work was unveiled by a group of priests impatient to admire – and

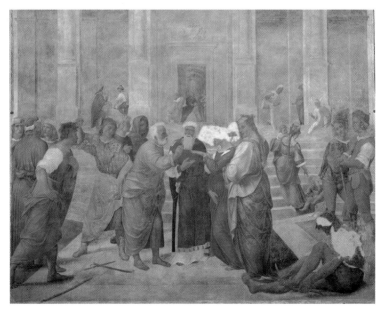

Franciabigio, *Marriage of the Virgin*, detail of a fresco, Florence, Sanctissima Annunziata.

The age of the genius

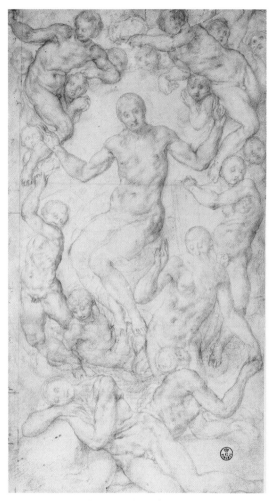

Jacopo Pontormo, *Christ the Judge and God the Father Creating Eve from One of Adam's Ribs*, c.1554–5, black chalk drawing, 32.6 x 18cm, Florence, Galleria degli Uffizi.

show off – the church's new decoration. In a fury, the painter climbed onto his scaffolding and mutilated several of the figures with a stonemason's hammer, causing damage which can still be seen today.

Far better known than these brief anecdotes is the tension between Michelangelo and Pope Julius II during the painting of the ceiling of the Sistine Chapel. This is also reported by the voluble Vasari: 'Determined to paint the whole work himself, Michelangelo brought it to a successful conclusion, calling upon all his strength and diligence and without seeing anyone, so as not to be obliged to reveal what he was doing. This excited the public's desire to see the ceiling even more. Pope Julius also wanted to know how work was progressing. The fact that the ceiling remained concealed gave him a great desire to see it and when one day he attempted to do so, he was not admitted, as Michelangelo did not want to show him it.' This account reveals that it was not just the patron's gaze and judgement that were at issue. Michelangelo did not allow assistants to be present (except, no doubt, those who played an indispensable technical role) while he was painting the ceiling of the Sistine Chapel. He was still refusing help when he painted *The Last Judgement* almost 30 years later.

This determination to work alone, which was perhaps not completely divorced from a desire to gain publicity for himself, contrasts strongly with the division of labour in artists' workshops of the period, notably that of Raphael, Michelangelo's main competitor in Rome. It provided an unusual and prestigious model for a number of artists, in particular the Florentine painter JACOPO PONTORMO, in the years that followed. When Cosimo de' Medici, Duke of Florence, commissioned Pontormo to decorate the choir of the church of San Lorenzo in 1545–6, the painter saw this as an opportunity to create a painting which would stand as his artistic legacy. For eleven years, until work was interrupted by his death, he devoted himself to the depiction in fresco of themes similar to those treated by Michelangelo, including a *Flood*, a *Resurrection* and a *Last Judgement*. Obsessed by the idea that people might be able to see what he considered to be his masterpiece before he had put the finishing touches to it, he had the chapel closed off with the aid of 'partitions, planks and drapes' and allowed no one to enter except a valet, who brought him the materials he required, and a mason, who helped him prepare the

ANTAGONISM BETWEEN ARTIST AND PATRON: MICHELANGELO AND JULIUS II

The most serious conflict between an artist and a patron occurred between Michelangelo (1475–1564) and his first major patron, Pope Julius II.

Plans for a tomb

In 1504, the pope (elected the year before) commissioned the artist to build and sculpt a magnificent tomb for him. Michelangelo, who claimed throughout his life that his true passion was sculpture and that he greatly preferred this to painting, was enthusiastic about the idea. During the months and years that followed, however, the sovereign pontiff's plans changed. He gave priority to other projects – notably the construction of a new basilica to replace the old St Peter's, whose size and style no longer met the needs of the modern capital of Christianity. Michelangelo took umbrage at this and in 1506 he abruptly left Rome without seeking the pope's permission and returned to Florence.

Compromise and rapprochement

Initially, Julius II was furious at such an act of disobedience. He dispatched five riders in pursuit of Michelangelo as soon as he learned of the artist's departure. They caught up with him at Poggibonsi, near Florence, and handed him a letter from the pope threatening him with disgrace and dishonour if he did not return to Rome immediately. Instead of complying, Michelangelo continued on his way.

Julius was also anxious, however, not to lose an artist whose talent he greatly admired, being fully aware of how Michelangelo could enhance his own reputation. Therefore, despite his anger, he was prepared to treat him gently. To Cardinal Soderini, who offered lame excuses for Michelangelo, saying that he had 'sinned through ignorance', the pope retorted that it was the car-

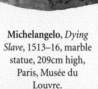

Michelangelo, *Dying Slave*, 1513–16, marble statue, 209cm high, Paris, Musée du Louvre.

dinal who was the ignorant one. After this he dictated the following astonishing letter to the Florentine authorities: 'The sculptor Michelangelo, who has left us without good reason and on a sudden impulse, fears, as far as we have been able to ascertain, to return. We do not blame him as we are well acquainted with the temperament of his kind. However, in order to allay any suspicion he may have, we appeal to your goodwill towards us to promise him on our behalf that if he returns he will be neither humiliated nor harmed and that we will show him the same apostolic favour that he enjoyed before his departure.'

The patron's triumph

Michelangelo never had the opportunity to finish what he considered to be his masterpiece. His reconciliation with the pope came at a price: the artist had to agree to be placed in charge of the building works at St Peter's and to prioritize the painting of the Sistine Chapel ceiling – a task that occupied him fully between 1508 and the autumn of 1512. Finally, the death of Julius II in 1513 ensured that the tomb project sank to the bottom of the Vatican's list of priorities once and for all. Pope Leo X, a Medici, set Michelangelo to work on the façade (which was never completed) of the church of San Lorenzo in Florence and on the Medici tombs destined for the church's new sacristy, for whose construction the artist was also responsible. The next two popes, Clement VII and Paul III, kept the artist busy on other tasks, including architecture (the Laurentian Library in Florence) and, most importantly, painting (*The Last Judgement*, 1536–41, and the frescoes in the Pauline Chapel, 1542–50). There can be no doubt that it was the patrons who set the agenda for the artistic activity of the day.

walls. 'A number of young people who were practising drawing in Michelangelo's sacristy climbed the spiral staircase onto the church roof and, after lifting several tiles and the gilded boards of the ceiling rosette, saw the whole painting. Jacopo noticed and took it very badly, but instead of showing it, he merely shut himself away even more carefully. However, there are those who maintain that he persecuted the young people and sought revenge.'

Curiously, it seems that patrons were gradually becoming used to the idea that they had to keep out of the way while works of art were in progress and that they would not be permitted to see them until they were finished. If, as was rumoured, Julius II went to the lengths of donning a disguise and bribing workers, this was because he preferred trickery to an authoritarian gesture that would have antagonized Michelangelo for good. Forty years later, Cosimo de' Medici made no attempt to see Pontormo's paintings before they were finished. The artist's journal mentions at least two occasions when the duke attended mass at San Lorenzo. This means he would have found himself just on the other side of the sheets and barriers closing off the choir. Yet there is no indication in the journal that Florence's leading figure asked for this screen to be moved so that he could view the work in progress.

ARTISTIC ECCENTRICITY

Michelangelo and Pontormo offer extreme examples of artists' behaviour. Everything known about them (from their own writings, the accounts of their contemporaries and the stories told by Vasari) shows these two geniuses to be the very opposite of the type of painter and sculptor previously described – the dashing or at least beautifully dressed gentleman aspiring to a noble, elegant lifestyle. Passionate, hypersensitive and easily offended, Michelangelo was renowned for his ugliness. He cared nothing for refined manners. During his younger days at least – between the ages of 20 and 25 in Rome – he chose to live in isolation from sophisticated company, leading such a wretched, filthy existence that his father grew worried about him and wrote to reproach him for his conduct. This form of behaviour, which might be described as eccentric, represents the other side of artistic life in the 16th century.

Neurotics and ne'er-do-wells

While figures such as Leonardo, Titian and Raphael – despite the occasional misgiving – integrated well into Renaissance court life, there were other artists who did not feel

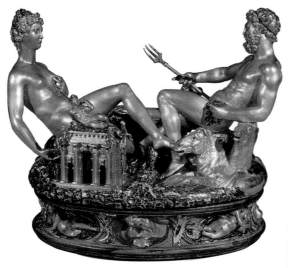

Benvenuto Cellini, *Saltcellar of King François I*, 1540–3, gold and enamel, 26 x 33.5cm, Vienna, Kunsthistorisches Museum.

at ease in the finery they were expected to wear. These took refuge, either by way of provocation or driven by their own impulses, in behaviour that placed them at the margins of society.

Indeed, seen in the context of Rosso Fiorentino's suicide (assuming he really did take his own life) and the peculiar ways attributed retrospectively to 15th-century painters such as Paolo Uccello (who was passionate about perspective to the point of obsession) or Hugo van der Goes (who is supposed to have died insane), certain strange facts in the lives of artists – whether recorded by documents or gleefully reported by historians – create a far odder and occasionally more tragic picture than that which we have so far described.

There were certainly a few unsavoury types among 16th-century artists. The German sculptor Veit Stoss, who was born near Nuremberg and died in Cracow, was a quarrelsome forger who had several spells in prison, being subjected to the terrible ordeal of punishment by branding iron (applied to his cheeks after a conviction in 1503). Forty years or so younger than Stoss, the goldsmith BENVENUTO CELLINI also had a number of brushes with the law and ended up in jail on several occasions. In 1534, he fled after deliberately stabbing to death a loathed rival, the goldsmith Pompeo de' Capitanis. And, a few years younger than Cellini, another goldsmith, Leone Leoni, was sentenced to the galleys in Milan in 1540 for assault and forging coins.

The psychological stability of certain other artists was at best precarious, giving rise to a tradition whereby neurosis and creative talent were for a long time associated in the public mind. Pontormo, who worshipped and modelled himself on Michelangelo, far surpassed his spiritual master in terms of eccentricity. Towards the end of his life, this painter – of whom Vasari wrote that 'he feared death to the point where he could not bear to hear it mentioned and shunned any encounter with it' – kept a journal from 7 January 1554 to 23 October 1556, while he was working on the San Lorenzo frescoes. In this journal he gives his progress on the paintings the briefest of mentions while providing an incredible wealth of detail on mundane matters that were important to him, since they affected his physical wellbeing: changes in the weather, indispositions, disputes with his concierge or his assistant, medicines taken (together with a note of whether they were effective or not) and, most importantly, lists of what he ate and descriptions of his urine and stools.

Revellers and lovers

There were also artists who – in complete contrast to Pontormo – became known for their conspicuous joie de vivre and extrovert temperament, indulging in love affairs, revelry and a jocularity which was often directed against the bourgeoisie. This gave rise to a new notion of gangs of 'bohemians' – a stereotype that the public imagination was only too happy to apply to creative artists. Filippo Lippi, a monk of joyful disposition, who was supposed to have seduced and abducted a beautiful nun at the end of the 15th century, was the prototype for a long line of amorous painters, of whom Raphael (see p.94), with his lover La Fornarina, is perhaps the prime example. A great painter of Madonnas, Raphael died at the age of 37, supposedly from fatigue following excessive indulgence in amorous pleasures, about which his doctors were kept in the dark.

Stories of this type doubtless owe more to legend than to history, yet it is known with certainty that Titian had two sons out of wedlock before marrying his concubine, and that he liked to entertain Venetian prostitutes at his house. Holbein, who had a wife and family in Basel, had a far from platonic liaison with a beautiful aristocrat, while at the same time keeping a mistress who bore him more than one child.

Other relationships were even more illicit, if not illegal. While nothing is known for certain about Leonardo's sex life (and psychoanalytical profiling cannot fill in all the gaps left by rumour-based historical research), there can be no doubt about Michelangelo's homosexuality, which he celebrated in his sonnets, or Pontormo's, which led the artist to enslave himself to his valet-catamite Battista. Neither can Cellini's predilection for sodomy be denied (he is also known to have kept a mistress, practised partner-

The age of the genius

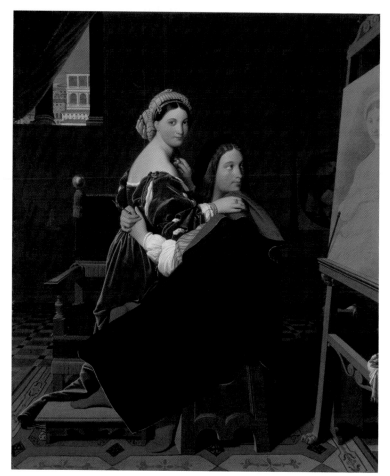

Jean Auguste Dominique Ingres, *Raphael and La Fornarina*, 1814, oil on canvas, 66.3 x 55.6cm, Cambridge (Mass.), Fogg Art Museum.

swapping and liked attractive transvestites), nor the reasons behind the nickname 'Sodoma', which the 'licentious' and 'unscrupulous' Giovanni Antonio Bazzi earned from his contemporaries early in his career, be casually dismissed.

Such dissolute or capricious behaviour, bouts of rage, cultivated uncouthness or, at the opposite extreme, a strong desire to shine in company, love of revelry and recklessness (spilling over into dishonesty and violence) were all symptomatic of an age in which artists had difficulty finding their proper place in society. Having escaped the straitjacket of mere artisanship, painters and sculptors sought to assert themselves. The cultivation of a strong, distinct and unusual personality was a means of flaunting their genius. They fashioned their lives in the same way that they created their works: both were artistic products.

Artists and Pornography: The Erotic Print

The infamous reputations of certain 16th-century artists were based not only on their lives but also on a portion of their output. These artists painted erotic scenes in the secret corners (predominantly the bathrooms, or *bagni*) of the palaces of great lords – including a number of cardinals and even the pope himself – and in particular used the new technique of engraving as a way of distributing pornographic images.

Rome, 1524: *The Positions (I Modi)* by Giulio Romano

In 1524, Giulio Romano made 16 drawings of different lovemaking positions. Inspired by the tokens (*spintriae*) used in ancient Rome as a means of payment in brothels, they represented a kind of Renaissance *Kama Sutra*, in which eroticism rubbed shoulders with ironic detail. Created to accompany a set of verses (the *Sonetti Lussuriosi*) by the humanist Pietro Aretino (or, conversely, they might have been the inspiration for the poems), the drawings were made into woodcuts by the engraver Marcantonio Raimondi. The engravings were published as a collection and distributed clandestinely, meeting with considerable success at the Italian courts. They also gave rise to a major scandal. Giulio Romano and Aretino had to flee the city in order to escape punishment. The poet settled in Venice and the painter in Mantua, where Duke Frederico II Gonzaga had greatly enjoyed the engravings. Raimondi, who had not been able to escape in time, was imprisoned. He was unable to save the original plates, which were destroyed.

Variations and forgeries: a runaway success

A number of forgeries of the *Modi*, often of mediocre quality, as well as original works inspired by them were published in the wake of the collection's success. Among them was a series of prints entitled *The Loves of the Gods* by the engraver Jacopo Caraglio, based on drawings by the Mannerist painters Perino del Vaga and Rosso Fiorentino. This was published in Rome in 1527 – the year of the sack of the city. Another col-

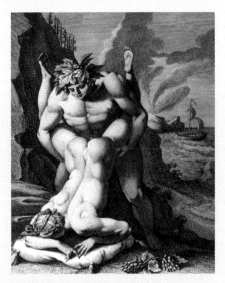

Jacques Joseph Coiny, *Bacchus and Ariadne*, engraving no.10 in *The Aretino of Agostino Carracci*, 1798, published in Paris (Didot), collection of Roger Peyrefitte.

lection, entitled *The Loves, Angers and Jealousies of Juno*, was engraved by Giulio Bonasone in 1568.

Venice, 1595: *Le Lascivie* by Agostino Carracci

Probably working in Venice, where the Inquisition during the Counter-Reformation was one of the more tolerant in Italy, the Bolognese painter Agostino Carracci designed and engraved (on metal) 15 prints which again gave rise to both scandal and admiration. Although these works, called Le Lascivie, were condemned by the ecclesiastical authorities, the large number of copies of them produced all over Europe is an indication of their enormous success. This success was no nine days' wonder. The engravings came to the attention of collectors of erotic images (who were prepared to pay a small fortune to get their hands on them) though they remained inaccessible to the general public. Artists got to know them, and they continued to influence painters until the 19th century.

The illustrious academies
17TH AND 18TH CENTURIES

During the two centuries following the Renaissance, the rest of Europe, taking its cue from Italy, gradually came to see sculptors and painters as free, intelligent individuals with unique gifts. This change in attitude required no small effort on the part of artists. In order to show how different they were from simple manual workers, they turned themselves into scholars. In a display of erudition, they formed academies along the lines of the learned societies that were dominating intellectual life at the time. And in order to merge with the elite, they adopted the manners of the elite, even though this meant discarding the image of the artist as melancholy, eccentric genius that had so appealed to their predecessors in the 16th century.

ECCENTRIC LIVES

Around the turn of the 17th century, the concept of the artist as a melancholy figure, brilliant but accursed, found its final expression for a long time to come in the shape of Michelangelo Merisi, nicknamed Caravaggio after his place of birth. Caravaggio's life dramatically combined the brilliance of genius and the dark squalor of crime.

A commitment to debauchery: Caravaggio and the Caravaggisti

CARAVAGGIO died of malarial fever on 18 July 1610, aged 39, in the small town of Porto Ercole, about 100 kilometres south of Rome. The painter – who in two decades had taken Italian painting from a rather bland Mannerism to a vibrant, rugged realism – had spent the previous four years on the run in Naples, Malta and Sicily, having been sentenced to permanent banishment for killing one Ranuccio Tomassoni da Terni in a brawl. This

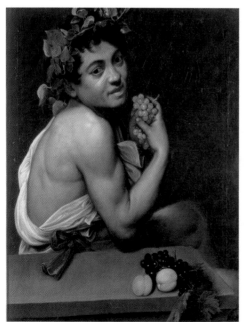

was a terrible punishment that gave anyone, anywhere, the right to kill him. It came after a series of convictions for criminal damage, wounding and assault and battery. Michelangelo Merisi (or Amerighi or Merighi) had been known for his dissolute lifestyle ever since his youth in Lombardy and had squandered his inheritance before he was 20. In Rome, protected by powerful art lovers including a number of prelates, he continued to lead a dissipated life. Homosexual and living with a young adolescent, Francesco Boneri (better known by the nickname Cecco del Caravaggio), who appears in several of his paintings,

Caravaggio, *Sick Bacchus*, c.1593–4, oil on canvas, 67 x 53cm, Rome, Galleria Borghese.

Caravaggio insulted his fellow painters, threw a plate of artichokes at the head of a waiter who would not attend to him, wounded a notary in the face, smashed the shutters of his landlady (who had the temerity to complain about not being paid for six months) and finally murdered Ranuccio after a game of tennis.

Caravaggio's life was divided between violent episodes like these and periods of intense work on pictures that sometimes caused a scandal but were greatly appreciated by art lovers (who valued them for their originality). This way of life soon became a model (though a short-lived one) for other artists. Between 1610 and 1620 in Rome and Naples, the two artistic centres in which he worked, a number of so-called 'Caravaggesque' painters consciously or unconsciously adopted a lifestyle similar to that of the master. During his lifetime, one of his acquaintances, the architect Onorio Longhi, was, like Caravaggio himself, regularly involved in fights, the trading of insults and moral scandals that often ended up in court, while another, the painter Orazio Gentileschi, shared Caravaggio's reputation for constantly quarrelling with and abusing his peers. Furthermore, Gentileschi's two sons, also painters, both sampled prison life on more than one occasion, and his daughter Artemisia, who was taught to paint by her father and eventually became one of the first well-known female painters in history, was raped at the age of 15 by another notoriously debauched painter and friend of her father, Agostino Tassi. Her assailant was convicted but the young girl, humiliated and subjected to rigorous questioning during the trial as it was assumed she was lying, remained affected by the incident for the rest of her life. Her paintings, many of which feature bareheaded, semi-naked women, hint at the violence she suffered. Two of her works, dark pictures lit only by discrete flashes of light and splashes of blood, deal with the story of Judith, the seduced heroine who slit the throat of Holofernes. These paintings were perhaps the artist's way of exorcizing her past.

A free-living fraternity of artists

Foreign artists who settled in colonies in Rome at the beginning of the 17th century (principally from Flanders, the Dutch Republic, Germany, Lorraine and France) led a similarly dissipated and violent existence. Young men who had only recently left the care of their masters congregated in the city's artists' quarter near the Piazza di Spagna at the foot of the church of Trinità dei Monti. With no income other than from whatever modest jobs they managed to pick up or the occasional generosity of a better-off compatriot, they lived in cramped conditions in furnished rooms.

These expatriates sought an escape from their near poverty in revelry – extravagant banquets or crude drinking sessions as circumstances allowed. The police records for the period are full of accounts of their squabbles, fights and pranks, along with details of the ensuing arrests and punishments. For some artists this bohemian adventure would have unfortunate consequences, as deprivation and foolhardiness not infrequently led to illness. Unable to work as a consequence, an artist would become totally destitute. If he did not meet a sudden end after just a few days, death would almost certainly follow as a result of being sent to hospital. Simon Vouet, who lived in Rome intermittently between 1614 and 1626 following spells in London and Constantinople, was one of the lucky ones. Aided by a pension from the regent Marie de Médicis and the rapid success of his work, he was able to survive the life of a bohemian artist in Rome. Nevertheless, the self-portrait he is thought to have painted before leaving Italy shows a man so exhausted that the painting should perhaps be read as a deliberate warning to himself, a reminder of why he decided to return to a quieter existence in France. His face is framed by abundant curls and there is a dandyish moustache above his sensuous, slightly open mouth, but his skin is tinged with blue and his eyelids are red with tiredness, hinting at nocturnal excesses.

Having arrived in Rome in 1612 or 1613 aged just 20 and having become a member in 1624 of the convivial fraternity of artists known as the Bentveughels (Dutch for 'birds of a flock'), the French painter Valentin de Boulogne, who was nicknamed l'Innamorato, was not as sensible as Vouet. This specialist in tavern scenes, who portrayed his own

CARAVAGGESQUE SUBJECT MATTER: CHOOSING NATURALISM

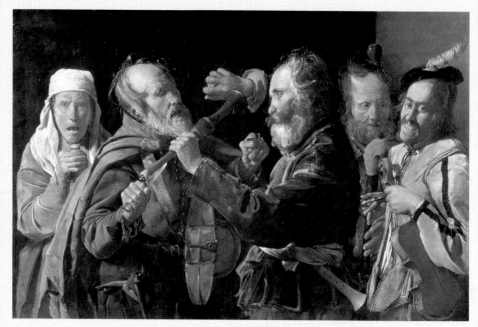

Georges de la Tour, *Musicians' Brawl*, c.1625–30, oil on canvas, 86.5 x 142cm, Malibu (California), J Paul Getty Museum.

During the 16th century, artists had depicted an ideal world rather than reality. They treated noble subjects, painting religious or mythological scenes filled with handsome heroes dressed in timeless clothes and often set against classical (in other words ancient Greek or Roman) architecture that corresponded to a dream rather than to the settings in which real life was lived.

A realistic style

The style of Caravaggio (1571–1610) and his pupils and followers departed radically from this tradition. The pictures they painted showed life as it was lived in the places that they frequented – which were seldom the most reputable. Their settings are the humbler districts of Rome, Naples or other European cities, and the figures they portray are from the lower classes, often poverty-stricken, shabbily dressed and marked or disfigured by hard work or illness.

The rejection of 'noble subjects'

This refusal to transform real life into something else (in other words their preference for naturalism over idealization) can be seen in their choice of subject matter. Caravaggio and his followers rejected the traditional distinction between noble and humble subjects. They also

rejected mythology, which in their eyes was too learned and too far removed from the preoccupations of ordinary people.

Everyday life and genre scenes

They chose instead to paint genre scenes – a completely new development in southern Europe. Their paintings might depict trivial events (teeth being pulled, a candle being blown out, people selling vegetables, delousing themselves, peeling fruit, eating, and so on) but more often than not they had a strong moral message. Their numerous tavern scenes, for example, can be interpreted as a denunciation of vice or as a warning to be on one's guard against it – particularly when the central figure represents the prodigal son (the naïve boy seen being robbed while in pursuit of pleasure in de la Tour's *The Cheat* and *The Fortune Teller*). In paintings by Caravaggio and his followers we also often meet the characters who inhabit these places of ill repute: card players, drinkers, gypsies and street musicians – some of the latter pretending to be crippled. In the *Musicians' Brawl*, for example, Georges de la Tour, a Caravaggesque painter from Lorraine, shows a fight breaking out between two poor musicians. One of them is squeezing a lemon in his right hand before squirting the juice into the other's eyes in order to check whether he really is blind.

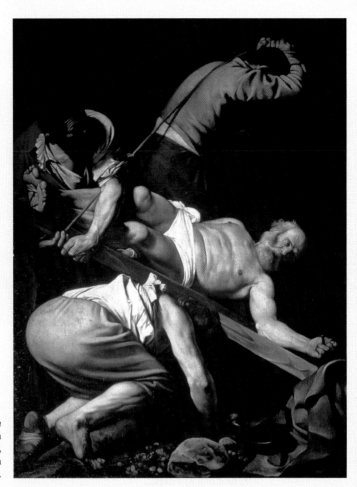

Caravaggio, *The Crucifixion of St Peter*, 1601, oil on canvas, 230 x 175cm, Rome, Cerasi Chapel, Santa Maria del Popolo.

Religious subjects revisited

Like all artists of their day, the Caravaggisti received commissions for religious works. A remarkable feature of their religious paintings was that they chose to represent sacred figures as ordinary people. This was in keeping with the concern of the leaders of the Counter-Reformation (or Catholic Reformation) to bring religion closer to the masses, to touch their hearts rather than to attempt simply to win their admiration. It has been claimed by the French academic Marc Fumaroli that Caravaggio painted 'in dialect', in the so-called 'vulgar' idiom of the people, a language ideally suited to the portrayal of great religious dramas.

However, those who commissioned pictures from Caravaggio sometimes had difficulty accepting the consequences of his approach. What they found shocking about his paintings was their apparently trivial detail, which they believed to be out of keeping with the subject matter. In *The Crucifixion of St Peter*, for example, art lovers and artists were astonished, or shocked, by the working-class appearance of the figures and by the artist's decision to place in the foreground the sizeable behind, clad in tightly stretched breeches, of a workman kneeling down to lift the cross. This rump, the dirty soles of the same workman's feet, the still life of the spade, the face of St Peter turned towards the activity of the executioners rather than towards God – these are characteristic of a style of painting the purpose of which was to remain alert to the material aspects of human existence as well as to convey the mystery of the soul's emotions.

The illustrious academies

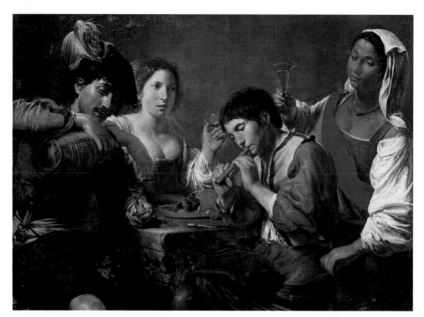

Valentin de Boulogne, *Gathering in a Tavern*, c.1622–5, oil on canvas, 96 x 133cm, Paris, Musée du Louvre.

life in his paintings, finally managed to achieve some degree of recognition after many years of poverty. However, he died on 20 August 1632 after an illness that lasted just a few days: 'It was in the heat of the summer and, having gone off to amuse himself with some friends, Valentin, who had taken much tobacco (as was his habit) and drunk an immoderate quantity of wine with his companions, suffered a violent inflammation whose burning he could not endure. On his way home that night, he reached the Babuino fountain and, beside himself with the fire that was exacerbated by his walking, he threw himself into the cold water and, hoping to find relief, found death. The cold served only to intensify the pain even further and produced a fever so malignant that within a few days he was seized by the icy, unpitying grasp of Death.'

THE WELL-BEHAVED PAINTER:
THE ANTI-BOHEMIAN REACTION

Giovanni Baglione, Valentin's contemporary biographer, concludes his account of the painter's sad end with the following moral observation: 'We should not let ourselves be carried away so easily by our senses, which tend to lead us to ruin and cause us to lose in an instant that which we have acquired at great effort over the course of many years.' In other words, Valentin brought about his own premature death as a consequence of his excesses.

Choosing an orderly life

Baglione's disapproval is representative of a trend – which started at the precise moment that Caravaggio and his like adopted their bohemian lifestyle – towards open criticism of the eccentricity of artists. At the end of the 16th century, the theoretician Giovanni Paolo Lomazzo, a painter by profession, stated in his work *Idea del Tempio della Pittura* (*Thoughts on the Temple of Painting*, 1590) that 'above all else the real painter should be a philosopher in order to fathom the true nature of things ... He should also take care to be modest, humane and prudent in all his actions ... And this quality appears to be all the more necessary on the part of artists, and would be all the more

conspicuous in them because the common people, who in general judge things in a haphazard way and without any reasoning, see them as capricious and mad in almost equal measure.'

Nicolas Poussin, a contemporary of Valentin de Boulogne, arrived in Rome too late to fall under Caravaggio's influence (in 1624, 14 years after his death). It seems likely, however, that during the early years of his stay in Italy his life was just as turbulent as that of the Bentveughels and other fun-loving members of the artistic community. It is known, for example, that he caught a venereal disease during this time which nearly killed him. This disease, from which he never fully recovered, gave rise to the only remotely intimate self-portrait of the artist that has come down to

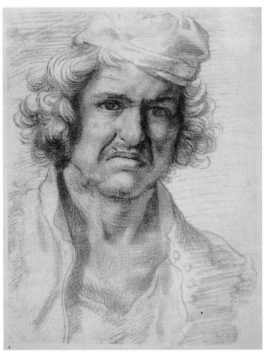

Nicolas Poussin, *Self-portrait*, c.1624–5, red chalk drawing, 37.5 x 25cm, Paris, Musée du Louvre.

us. The red chalk drawing shows POUSSIN at the start of his convalescence, wearing a nightcap and open shirt. His features are drawn, his skin is still moist with fever, and he has tousled hair and several days' growth of beard. It was this painful episode and, at a more fundamental level, the emerging desire within society to see artists return to a more moderate form of behaviour that encouraged the young Poussin to adopt a quieter lifestyle. In 1630, at the age of 36, he married and shut himself away in his house in Rome. From this point on, his biography comprises a succession of commissions and business trips, intellectual relationships and correspondence of a semi-personal, semi-professional nature conducted with his most loyal clients and collectors.

The Flemish painter Peter Paul Rubens did not participate in the dissipated lifestyle of the young artists living in the Trinità dei Monti area during the years he spent in Italy (1600–8). A bachelor, he is not known to have had a mistress in Rome, Mantua or any of the other cities in which he lived during his long stay in the country, nor to have been associated with any violence or libertinism. This is not to say that the young Rubens, who was not yet 30, remained chaste or lived the life of a saint during this time; simply that he exercised self-restraint and, as a result, his reputation remained unsullied. When he returned to Antwerp he continued to lead a life free of scandal, enjoying two happy and apparently uncomplicated marriages. Tall and good-looking with fair hair and a ruddy complexion, Rubens evidently liked younger women. When he was 32, he married his 18-year-old neighbour Isabella Brant, and in 1630, aged 53, after three years of being a widower, he married the pale-skinned, rosy-cheeked Helena Fourment (an adolescent not yet 17) in the middle of Lent, for which a special dispensation was required. These nuptials afforded him a period of intense sexual fulfilment – his last, in fact, as he died five years later. Some historians suspect that he had an affair with his sister-in-law Susanna Fourment, Helena's elder sister, a young woman with a high forehead, dainty chin and enormous eyes whose portrait Rubens painted at least seven times. It is not known what, if anything, Helena or anyone else in the household thought of this, however, and the 'ménage à trois' does not seem to have been the subject of any malicious gossip: there are no accounts, either contemporary or later, that touch on the

The illustrious academies

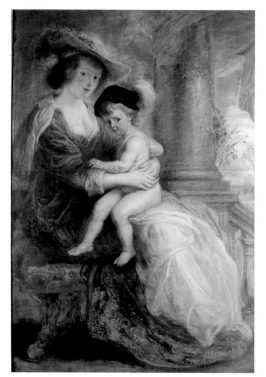

Peter Paul Rubens, *Portrait of Helena Fourment with Her Son Francis,* c.1635, oil on wood, 165 x 116cm, Munich, Alte Pinakothek.

relationship between Rubens and Susanna.

An irreproachable private life

Vermeer's life was characterized by the same restraint, thus depriving lovers of gossip of any lurid stories. Vermeer was a faithful husband, a model son-in-law and a prolific father (he had eleven children); or to put it another way, he was a man whose self-control was the counterbalance to his only passion; painting, upon which he concentrated all his efforts. The life of Tiepolo, in the following century, is equally disappointing for anyone seeking a counterpart to the insouciance and occasional sensuality of his paintings. This highly successful Venetian painter, who was in demand throughout the whole of Europe and swamped with commissions, was too busy painting his large-scale works (in the Veneto region, Germany and Spain) to have mistresses. Having married Cecilia Guardi, sister of the soon-to-be-famous Francesco Guardi, in 1719, he went on to have ten children with her, seven of whom survived to adulthood. It is not difficult to imagine the painter's house in the parish of Santa Ternità in Venice, where he lived until 1736, filled with cradles and cots and the cries and screams of the Tiepolo brood – and occasionally plunged into mourning by the death of one of the children.

The private lives of Velázquez and Goya, in Spain, were just as settled. Velázquez married Juana Pacheco (the daughter of his master in Seville, Francesco Pacheco) in 1618 and they had two daughters, born in 1619 and 1621. Fully occupied by his work and his increasingly onerous official duties, he did not 'stray' until his trip to Rome in 1649–50. There, far from Madrid and the courtiers who kept watch over his every move, Philip IV's court painter allowed himself to take a mistress, who bore him an illegitimate son, Antonio. This escapade had no further repercussions following his return to Spain and he is not known to have had any other amorous adventures.

Goya married Josefa Bayeu (the sister and daughter of painters) in 1773. They had at least one daughter and five sons together, including Javier, of Goya's fondness for whom the painter spoke on more than one occasion. In 1795, old beyond his 50 years and deaf, Goya had the opportunity to paint the portrait of the beautiful Duchess of Alba. Spurred on, no doubt, by mid-life lust, he developed a passion for the fun-loving duchess. If their relationship remained platonic, this was because she wished it to be so. Goya's personal correspondence is a good source of information, not only about his infatuation for the duchess but also about his preoccupations beyond painting: financial investments, on which he consulted his friend, the merchant Martin Zapater, and phenomenally successful hunting trips – or so the passionate hunter would have us believe.

Rembrandt's life departed rather more from convention, but this was largely due to circumstances. Living in Amsterdam, the city which was also home to Descartes, the painter took more pleasure in the ghetto and the port area than in the company of the city's learned men. In 1634, he married Saskia van Uylenburgh, a rich relative of the art dealer

Hendrick van Uylenburgh, for whom he was working. They were a well-matched couple – he was 27 and she was 21 – and in love. Rembrandt used his young wife repeatedly as a model over a number of years, painting her portrait (and sometimes a double portrait of them both) in a wide variety of attitudes, getting her to pose as Minerva, Esther or Danae. But in 1642, Saskia died shortly after giving birth to the only child of theirs who would survive infancy, a boy named Titus. Rembrandt found it difficult to live alone. The first to share his bed was the widow Geertje Dircks, nursemaid to Titus. The painter lived with Geertje for seven years before sending her away, but Geertje dug her heels in, claiming that the painter had promised to marry her, and the matter went to court. Next it was the turn of Hendrickje Stoffels, Titus's second nurse, to arouse Rembrandt's passion. Their liaison lasted until the young woman's death in 1663 and resulted in the birth of a daughter named Cornelia. This relationship also caused him problems, as cohabitation was frowned upon in the Calvinist United Provinces. Having been reported by their neighbours and summoned to appear before the consistory, the couple were forced to shut themselves away in the house before eventually moving to another district of the city. Rembrandt did not legitimize their relationship as this would have meant losing his inheritance from Saskia, who had left him the income from her estate providing he did not remarry.

The greater freedom of the 18th century

All things considered, Rembrandt's love life was fairly innocuous. It seems certain that he would have legitimized his relationships with Geertje and especially with Hendrickje, who had borne him a child, had remarriage not brought with it such serious financial consequences. It was not until the 18th century – first of all in Regency France, where a rigid morality was no longer in fashion, and then throughout Europe, where emotion and sensibility were starting to be seen as positive – that artists not only allowed themselves to take liberties in matters of 'virtue', but also admitted (with evident self-satisfaction) to taking these liberties. There are grounds, however, for believing that the dissolute behaviour in which artists indulged was of a fairly mild nature and more often

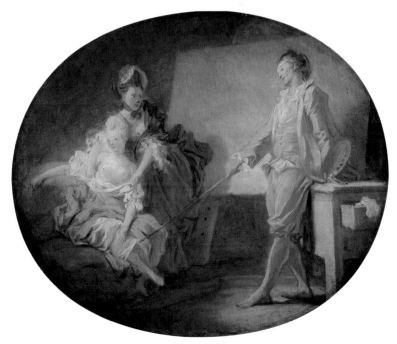

Jean Honoré Fragonard, *The New Model*, c.1778, oil on canvas, 52 x 62cm, Paris, Musée Jacquemart-André.

PORTRAIT OF THE PAINTER AND HIS WIFE : A CAREFULLY CONSTRUCTED IMAGE

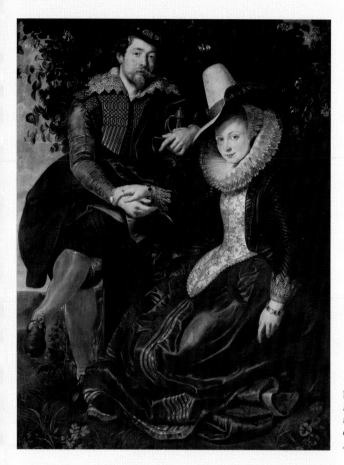

Peter Paul Rubens, *The Artist and His First Wife, Isabella Brant, in the Honeysuckle Bower*, 1609, oil on canvas, 174 x 143cm, Munich, Alte Pinakothek.

It was common for artists to paint self-portraits in the 17th century. These portraits not only provided an opportunity to experiment with different styles but also allowed the painter to set down his lifestyle on canvas – and thereby make a social statement. This is especially true of self-portraits in which the artist is shown as part of a group (in the company of workshop assistants, friends, fellow citizens or his patron), or with his wife in a double portrait.

Rubens and Isabella: an affluent, well-matched couple

After his first marriage, to Isabella Brant, in the autumn of 1609, the Flemish painter Peter Paul Rubens (1577–1640) portrayed himself with his young wife in the symbolic setting of a garden (garden of love) in the springtime (the season of youth and joyfulness) beneath an arbour of honeysuckle (an emblem of enduring love) whose heady scent fills the pleasantly shady spot. The couple have dressed in their finest clothes, probably their wedding outfits, for the occasion. The brightness of the colours (Rubens's orange stockings) and the delicacy of the lace (much in evidence here in spite of its cost) speak of a desire to please and of their considerable wealth. The painter nonchalantly holds a sword to which he was not entitled, as this was the prerogative of

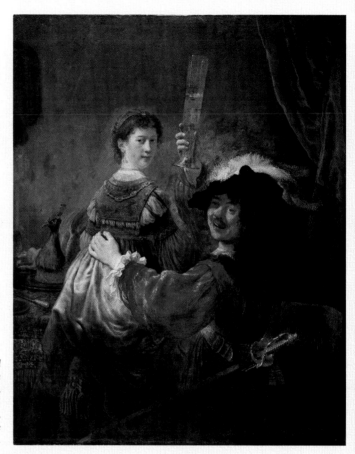

Rembrandt, *The Prodigal Son in the Tavern (Rembrandt and Saskia)*, c.1635–9, oil on canvas, 161 x 131cm, Dresden, Staatliche Kunstsammlungen.

the aristocracy. Its function here is to underline the nobility of his talent. The couple's affection for one another is restrained, but evident nonetheless. Isabella rests her hand gently on the right hand of her husband, who sits casually on the backrest of the bench. This raises him slightly above the level of his wife, suggesting protection and gentle authority. The young married couple look back confidently at the viewer – or perhaps they are gazing into the future.

Rembrandt and Saskia: an intimate celebration

A quarter of a century after Rubens painted his joint portrait with Isabella, the Dutch painter Rembrandt (1606–69) portrayed himself with his wife Saskia shortly after their marriage in 1634. He chose to set the portrait not in their home in Amsterdam, but in a tavern or brothel. The two figures are seen from the rear, turning their heads to look at the viewer. Rembrandt is laughing in a gesture devoid of nobility. He raises a glass of beer as if inviting the viewer to join in the party. Rembrandt also has a sword; not so much the weapon of a nobleman, however, as that of someone always on the lookout for a fight. Saskia sits on his knee and he rests his hand on her lower back, fondling her. On the table a stuffed bird waits to be eaten. In contrast to Rubens, who portrayed the pleasures of living as a couple in terms of social success and the planning of a joint future, Rembrandt has approached the subject from the point of view of the pleasures of the senses. This choice can be seen as perverse or as deliberately provocative, given the puritanical atmosphere of Amsterdam at the time.

than not a pose. Evidence for this is the emergence and commercial success of a slightly risqué type of image depicting the painter with a model in a setting more like a boudoir than a proper studio. The viewer is clearly meant to think that the modelling session is merely a prelude to a little amorous activity. FRAGONARD, (see p.103) Badouin and Schall all liked to paint light-hearted trysts of this kind, which were widely distributed thanks to the engravings of Gabriel Jacques de Saint-Aubin and Jean-Michel Moreau. The popularity of pictures like these indicates how much things had changed. A century before, Rembrandt, suspecting one of his pupils to have exchanged rather more than glances with a young woman who was modelling nude, had sent them both home.

During the Age of Enlightenment, the myth of the painter of questionable morals crystallized around the figure of François Boucher. Boucher was accused by Diderot of 'consorting with cheap prostitutes' and even of acting as a procurer by making his wife available to his friends – or, at any rate, undressing her shamelessly in his paintings. Diderot also accused the painter of presenting a very young model – the 13-year-old Miss O'Murphy, whom some believe to have been the model used for *Nude on a Sofa (Reclining Girl)* – to Louis XV in order to make her his mistress. The reality was very different. A lover of banquets, a regular at the opera and the favourite artist of Madame de Pompadour, Boucher certainly enjoyed his pleasures – those of society, the table and the senses – but he was happily married and never gave cause for scandal. He and his wife had a son and two daughters, whom it seems they brought up happily and securely.

THE MODEL OF THE ARTIST–SCHOLAR

Having traded the image of the free-living genius for the less flamboyant but more reassuring one of the serious-minded, moderate individual, artists did not stop there, but continued down the same path. Well-behaved, they now wanted to be thought of as erudite, and in a far more systematic way than had been the case during the 16th century. In this they were aided by their basic education: painters and sculptors of the 17th and 18th centuries in general enjoyed a far better standard of schooling than their predecessors.

A more rounded education

In social terms, recruitment into the profession changed appreciably during this time. Many artists were still the sons (or nephews) of artists: Le Sueur, Vouet, Subleyras, Boucher and others continued the trade of their fathers, with far greater success. So too did Jacques Sarrazin, the son of a cabinet-maker, and Bernini, the son of a sculptor. Others came from the wider world of crafts and trade: Rembrandt was the son of a miller; La Tour was the son of a baker; Vermeer's father was an innkeeper for a while, having earlier been a weaver; Fragonard's father was a glover's apprentice who subsequently became a haberdasher's assistant; Watteau was the son of a roofer; and Chardin was one of nine children borne to a manufacturer of billiard tables.

But these artisans, often better off than their predecessors, encouraged their children to continue their studies. In Leiden, Rembrandt attended the Latin school and then joined the literature faculty of the university for a few months. Having learned to read and write at his local school in Delft, Vermeer began to attend the modest school of drawing and painting run by a local Catholic painter when he was nine or ten; here he received a grounding in theory. He did not start his apprenticeship proper until 1644 or 1645 (aged 13 or 14), when he entered the workshop of a local painter.

More importantly, a number of painters and sculptors now came from backgrounds that could be described as 'bourgeois', where children were encouraged to study the classics until a relatively advanced age. This was the case for Rubens and Poussin at the end of the 18th century. The former was the son of an Antwerp alderman who for political reasons had taken refuge in Cologne, where Rubens spent his early years. He was educated at home and was taught French and Latin in addition to Flemish, his mother tongue, and German, which was a practical necessity. His mother brought him back to

Antwerp after the death of his father and between the ages of ten and 13 he attended the best school in the town, that of Rumboldus Verdonck. Here he received an excellent education, extending his knowledge of Latin and the humanities in general and becoming proficient at reading aloud and reciting by heart classical authors such as Cicero, Virgil, Terence and Plutarch. He concluded his education as a page in the service of the Countess of Lalaing, née Princess of Ligne-Arenberg (a friend of his mother), living at the castle of Audenarde for a year – a brief stay, perhaps, but long enough for him to acquire refined manners. Only after this did he choose to become a painter, in all likelihood as a result of personal preference rather than at the insistence of his mother. He started his apprenticeship at the age of 15, passing through one workshop and then a second before completing his training with a Catholic painter named Otto Venius, whom he left shortly after turning 23.

Poussin was born in the town of Les Andelys in Normandy. He was the son of a former captain in Henri IV's army, who was from a noble family of limited means, and a young widow whose first husband had been a public prosecutor. The couple had only this one son and they were well enough off to send him (it is thought) to the Jesuit college which had been founded in Rouen not long before. Here Poussin acquired a knowledge of classical literature and an elegant, if somewhat ponderous, style of writing. Here too, perhaps, he discovered his true vocation during one of the drawing classes given to students. He certainly continued his classical studies until he entered the rhetoric class (normally taken at the age of 16 or 17 if schooling had not already been abandoned at 15). It is known that in 1612 he was working as an assistant to the painter Quentin Varin, a native of Picardy who had settled in Normandy. It was during this time that he decided to make painting his career. He left his family abruptly and took himself off to study in Paris.

The ideal of erudition

From Rubens's and Poussin's careers it can be seen that the world of art encompassed a wide variety of lifestyles. In 17th-century France, it was possible to find both a Pierre Pointel and a Charles du Fresnoy. The first was a painter of delicate landscapes who was totally illiterate, and the second a celebrated artist who read Greek and composed Latin verse. One thing that can be said for certain is that connoisseurs held scholarly talent in higher regard than uncultured genius. More than ever before, society required its artists to be not only gifted but also educated and able to speak well.

Henceforth more and more painters and sculptors attempted to conform to this model of the erudite artist. On the one hand they sought to widen their knowledge, tending

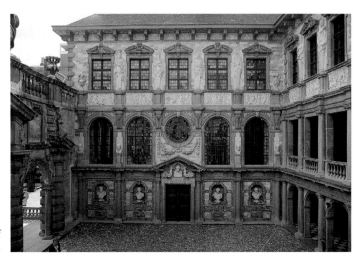

The façade of
Rubens's studio.

The illustrious academies

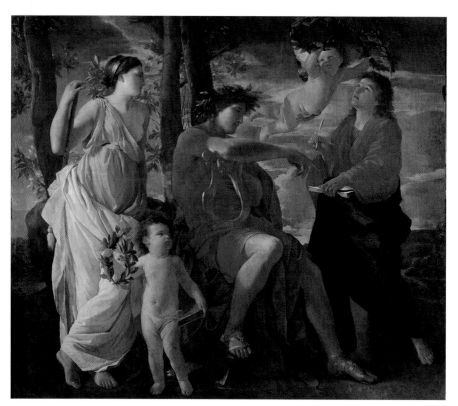

Nicolas Poussin, *The Inspiration of the Poet*, c.1630, oil on canvas, 182.5 x 213cm, Paris, Musée du Louvre.

to produce works with a clear intellectual or scientific content, and on the other hand they themselves (through their self-portraits) or their biographers acted as apologists, deliberately creating an image that emphasized their intellectual or scholarly qualities. RUBENS from Flanders and Poussin from France represent this heroic model of the painter-scholar. Stories spread of how Rubens used to have works of classical literature read aloud to him while painting in his Antwerp studio (whose façade and garden frontage were decorated, symbolically, with statues of Mars, Jupiter, Juno and Vesta and busts of the great philosophers). The same was later said of the sculptor Canova. There is also a story that one day, while Rubens was staying in Mantua, Vincenzo Gonzaga entered his studio unannounced and found the Flemish painter reciting Virgil. Out of a sense of mischief, so the story goes, the duke addressed him in Latin and the painter replied in kind, thereby demonstrating his mastery of the language.

Stories about Poussin are less revealing of any love of classical literature. If not as ostentatious as Rubens's, his learning was certainly no less real or extensive, however. Having arrived in Paris, probably in 1613, Poussin befriended a number of learned men capable of helping him fill in any gaps in his knowledge of anatomy or perspective; among these were doctors, architects and mathematicians. In Rome, which he made his home just over ten years later, he developed his knowledge of these subjects still further, applying himself to a study of geometry and optics (based on the writings of Father Matteo Zoccolini) and the structure of the human body (taking as his guide Vesalius's *On the Fabric of the Human Body*). He also performed dissections under the supervision of the surgeon Larcher. Most importantly of all, Poussin met the highly cultivated patron of the arts Cassiano dal Pozzo, who was barely six years older than the painter but who helped to introduce him to various new areas of knowledge. Cassiano commissioned Poussin (and a number of other artists) to draw Rome's ancient ruins, a formative experience for Poussin that immersed him in the world of archaeology. Poussin also painted

POUSSIN'S TWO SELF-PORTRAITS

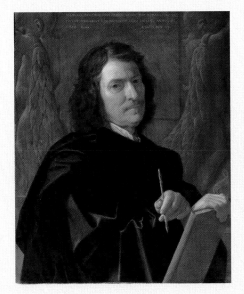

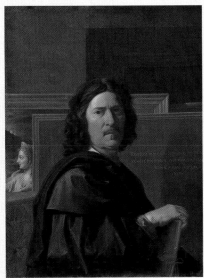

Poussin – whose education made it easier for him to digest and appropriate a vast amount of knowledge – seems to have felt it was his mission to embody the triumphant figure of the erudite painter and to pass this model on to posterity. A writer as well as a painter, he considered for a while composing a treatise on painting, but instead confined himself, throughout a vast correspondence, to a series of comments on the means and ends of his art. He painted history subjects, allegories and, later in life, landscapes. He eventually consented to paint his self-portrait (twice in fact) at the insistence of loyal patrons and probably also from a desire to leave behind an image of himself with which he was content.

The majesty of man

The two portraits were painted in around 1650, when Poussin was 56. Both are painted in a sober palette of browns and blacks and show a full-faced man with a neatly trimmed moustache and shoulder-length hair parted in the middle. He is dressed in a black toga that makes him look like a magistrate or a university professor. He has the merest hint of a smile on his face in the Berlin portrait, but he wears an austere expression in the Louvre painting.

Nicolas Poussin, *Self-portrait*, 1649, oil on canvas, 78 x 65cm, Berlin, Staatliche Museen, Gemäldegalerie (left), and *Self-portrait*, 1650, oil on canvas, 98 x 74cm, Paris, Musée du Louvre (right).

Concealing the messy business of painting

Remarkably, in neither of these two paintings does the painter depict himself with a palette and brush or in front of a canvas he is working on. In the first portrait, Poussin poses with a pencil holder in one hand and a book on light and colour in the other (the words *De lumine et colore* can be made out on its edge) in front of a bas-relief decorated with a garland held up by two putti. In the Louvre painting he is holding a portfolio of drawings and appears to be in the storeroom of his studio in front of a stack of finished, framed paintings.

It is clear that the artist did not want to show himself engaged in the messy business of using materials and pigments. Of his actual activity as a painter he suggests only the preliminary stages: the rough sketch that establishes the overall design and the science behind the visual phenomena on which the work depends (the treatise in the Berlin portrait). Of the works themselves he reveals only the finished product – canvases that have reached the point of perfection rather than paintings in the making.

ornithological pictures for Cassiano. These were part of a larger project designed eventually to form an illustrated classification of birds. Dal Pozzo gave him Leonardo da Vinci's *Treatise on Painting* to read, which he himself was copying with a view to publishing a new edition of it, and asked Poussin to illustrate this with drawings. The painter was disappointed by the work, however, concluding that 'all the book's good points could be written out in large letters on a single sheet of paper.' Finally, Cassiano introduced Poussin into the extremely exclusive Accademia dei Lincei (Academy of the Lynx), a circle of heterodox, freethinking scholars and scientists whose researches influenced his famous painting *THE INSPIRATION OF THE POET* (see p.108). It is thought that this work was intended as a posthumous tribute to the young poet Giambattista Marino, who had been a member of the Academy before his premature death.

A NEW NOTION OF ART

As one might expect, this notion of painting as a spiritual rather than material activity influenced artists' styles as well as the content of their works. Poussin's paintings are made up of a very fine and rather 'dry' layer of pigment without any impasto or oily accumulations. Outlines are drawn in an extremely precise manner, and each work is based on exhaustive sketches. Looking at these pictures, it is impossible to imagine that they might have been conceived in a hurry or on a sudden impulse, or executed without careful thought.

Scholarly subject matter

The subjects of Poussin's paintings were also conceived in such a way as to bring out a richness of intellectual association. Painting nature was not enough for Poussin. He refused to be a portrait painter, no still life is known by him, and the landscapes he painted during the last years of his life hide their true purpose behind an allegorical veil (*The Four Seasons*) or a mythological intent (*Blind Orion Searching for the Rising Sun*) that justify the inclusion of figures in the countryside.

This growing emphasis on the intellectual content of paintings also explains the proliferation of works depicting historical subjects, erudite fables and allegories (the latter were valued particularly highly during the 17th century). By this time, painters would have considered themselves unworthy of the task had they needed a client or patron to explain how a particular subject should be treated (as their predeccesors had often done). They expected to rely on their own culture and learning. However, there was nothing to stop them consulting books, and artists' libraries began to contain works that would help fill any gaps in their knowledge. These included heavy folios whose engravings were a source of visual inspiration, dictionaries and other scholarly works that provided them with mythological subjects, and books of symbols which were indispensable for the invention of allegories that were both erudite and comprehensible to a well-educated public.

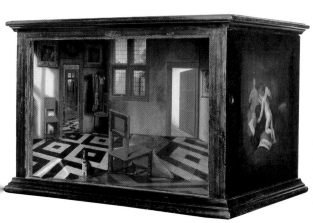

Samuel van Hoogstraten, *Peepshow with Views of the Interior of a Dutch House*, c.1662–5, wood, 58 x 88 x 63.5cm, London, National Gallery.

A BOOK OF ARTISTS' EMBLEMS:
CESARE RIPA'S *ICONOLOGIA*

One of the most valuable works of reference available to painters wishing to produce erudite pictures was the *Iconologia* by the Italian Cesare Ripa (1560–1645).

A dictionary of symbols

The *Iconologia* was a dictionary of symbols in the tradition of the *Hieroglyphica* by Horapollo (1505) and the 'books of emblems' published in Italy during the 16th century by Pietro Valeriano and André Alciat (*Emblemata*, 1531). It was an alphabeticallly arranged codification of symbols and allegories deriving from the Christian tradition, Greek and Roman mythology and the Renaissance world. Each article describes the elements that make up the symbol and give it its meaning, lists iconographical variations and clarifies the symbol with an illustration.

Music and Virtue

Music is thus defined and illustrated as 'a woman who looks intently at an open book held in one hand, while in the other hand she holds a pen with which to correct her tablature'. At her feet she must have 'a lute, a viol and flutes to join with the voice in sounding its music'. And *Virtue*, we learn, 'is generally shown as a comely, agreeable maiden with wings on her back, a spear in her right hand and a crown of laurels in her left hand. A sun shines forth from her attractive bosom. She is painted young for she never ages and her strength increases from day to day for as long as man shall live.'

A great and lasting success

First published without illustrations in 1593, but furnished with engraved plates for the 1603 edition, the *Iconologia* met with enormous and immediate success. Although it was written originally in Italian, a tongue with which almost all painters were familiar (since the majority of them had visited Rome), it was soon translated into a number of other languages, thus providing artists with valuable models on which to base abstract ideas. Used right through to the 19th century (by Delacroix, for example), the book eventually sank into oblivion. It was rediscovered by the French historian Émile Mâle, a specialist in iconography, in the 1920s.

Jacques de Bie, frontispiece to the French edition of the *Iconologia* published in 1643 by I Badouin, Paris, private collection.

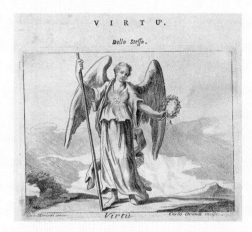

Cesare Ripa, *Virtue*, a plate from the French edition of the *Iconologia* published in 1644 by Guillemet, Paris, Bibliothèque Nationale de France.

The illustrious academies

The science of perspective

The belief that, from now on, the hand needed to be guided by the mind also influenced composition, both in terms of space and the treatment of bodies.

More than ever before, therefore, perspective became the key to the way pictures were organized. A number of artists were passionate about perspective to the point of obsession. In Classical France, the engraver Abraham Bosse, professor of perspective at the Académie (or to give it its full name, the Académie Royale de Peinture et de Sculpture) and who later opened his own school of perspective, produced numerous scholarly treatises in defence of this entirely mathematical art as well as lampoons of his less than rigorous colleagues. The titles of his works – *Monsieur Desargues' Universal Method of Employing Perspective in Easy Steps, Like Flat Projection* (1648), *The Painter Converted to the Precise and Universal Laws of His Art* (1667), and so on – say a lot about the author's earnestness, as does the scientific character of the plates that illustrate his theories.

In 17th-century Holland, the fruits of the research into geometry and optics conducted by a cosmopolitan scientific community were also reflected in works featuring complex perspective. Samuel van Hoogstraten in Dordrecht and Gerard Houckgeest and Carel Fabritius in Delft painted astonishing views of interiors and panoramic landscapes that presuppose the use of scientific instruments such as lens systems or the *camera obscura* (dark chamber). Another Delft painter, the great Vermeer himself, must indeed have used the *camera obscura*, a box with a tiny aperture in one of its sides through which the rays of light emanating from a scene placed in front of it would enter – this is the only reasonable explanation for certain striking visual effects in his work, such as the tiny droplets of paint that accentuate the reflections of light or the shaded-off outlines of certain objects that seem to escape from the depth of field.

Anatomy and the passions

The depiction of the human body was another area in which artists could employ their scientific knowledge. Artists made it their business to know the 'human machine' inside out. Painters and engravers were increasingly called upon to illustrate anatomical atlases, a task they performed with enthusiasm. In time, many such works acquired an artistic function in addition to their medical one. While exciting the curiosity of the general public (who were often disturbed by them), they were also used by aspiring and experienced artists alike as tools to help them render the human figure as accurately as possible. From the 17th century onwards, skeletons can frequently be seen in pictures of artists' studios, showing that the study of anatomy now formed part of the training of any artist worthy of the name.

The science of the human body was also the science of the emotions. The body was considered a theatre in which the 'passions of the soul' were enacted through gesture and

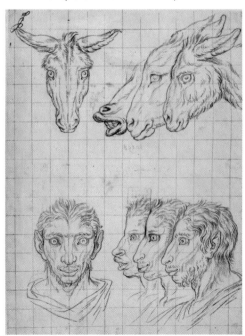

Charles Le Brun, *Physiognomical sketch: a comparison between human and asses' heads*, Paris, Cabinet des Dessins, Musée du Louvre.

expression. Artists saw it as their job to decipher these gestures and expressions and recreate them with the paintbrush or chisel. A supposedly scientific discipline known as physiognomy came into existence, possibly invented by artists, but at the very least popularized by them. Influenced by the treatises of the wide-ranging Neapolitan writer Giambattista della Porta and the theories of the French doctor Marin Cureau de la Chambre, CHARLES LE BRUN, court painter to Louis XIV, devised a system for decoding facial expressions. This was based on a comparison of the structure of the head and face of a person with that of a particular animal, also on an extensive catalogue of facial movements that linked each human emotion to the contraction of specific facial muscles, in particular those that control the eyebrows.

THE BIRTH OF THE ACADEMY

The desire of 17th-century artists to proclaim the nobility of their art led to the creation of a new institution. Being highly cultivated people with impeccable manners (or at least aspiring to be such), painters and sculptors now had one main ambition: to achieve proper recognition of the differences that separated them from the world of craftsmen, whom they regarded as uncouth and illiterate.

Monsieur de Charmois petitions the king

In France, at the end of the 17th century, Antoine Furetière's *Dictionnaire Universel* recommended that a clear distinction be made between the terms used to describe 'the painter, who employs colour with artistry in order to depict objects of all kinds' and those used to describe 'the dauber, who paints crudely with the brush, coating walls and ceiling with paint'. Furetière was a member of the Académie Française before being expelled in 1685. His great work was published 36 years after the founding of an academy devoted to the fine arts, and the distinction he established between 'those who worked with paint' and 'artists' in the proper sense of the word made an important contribution to consolidating the position of this institution.

This academy, the Académie Royale de Peinture et de Sculpture, opened its doors in Paris in 1648, 13 years after the founding of the Académie Française (which was, and is, devoted to literature). Enshrined in letters-patent granted by Louis XIV, the statutes of the new institution replaced the corporation, which had been dominant since the Middle Ages, with a completely new way of organizing the professions of painter and sculptor. Those who wished to devote themselves to these professions were no longer required to complete a craftsman's apprenticeship or earn the right to be admitted to a guild.

This meant that in Paris at least (the new law applied only to the capital at first) any young man – regardless of background or whether or not he had spent time in the workshop of a Parisian master – was now free to accept whatever commissions he might be offered. This was a complete reversal of the previous situation, where the right to paint or sculpt was reserved for Parisians (usually themselves the offspring of painters or sculptors) who had trained in the workshops of Parisian masters and been admitted to the corporation. The approval for such a profound change had been elicited from the young king, or rather from the regency council, by a spokesman from outside the profession – a certain Martin de Charmois, who was a nobleman and a lover of art. The new circumstances answered the demands of a large number of painters and sculptors who had come to Paris from the provinces or from abroad and were determined not to allow themselves to be 'persecuted' or 'oppressed' (such were the words used by Charmois in his petition) by guild laws from another age whose aims were mainly protectionist.

'Liberty restored to the arts' – the end of the guild

Indeed, ever since the beginning of the 17th century, an extremely bitter conflict had pitted those artists who had trained under the traditional rules of the Parisian craft guilds against those who had come from outside. The tension was aggravated by the

The illustrious academies

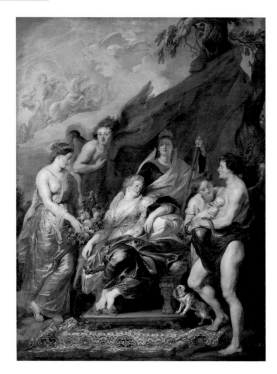

Peter Paul Rubens, *The Birth of Louis XIII*, 1622–5, oil on canvas, 727 x 394cm, Paris, Musée du Louvre.

growing centralization of the kingdom, which had the effect of concentrating the commissioning of works in the capital, where the king and court were based. During the first half of the 17th century, artists from the French provinces as well as painters and sculptors fleeing the religious upheavals in southern Europe came to Paris to try their luck. These newcomers used two methods to circumvent the ban on their practising their trades. The first was to set up in the suburbs or in the precincts of monasteries (which enjoyed historical exemptions) rather than within the city walls, where they would never be permitted to open or run a workshop. In the 1620s, for example, Marie de Médicis entrusted the decoration of the Palais du Luxembourg to a group of German, Swiss and Flemish artists (including Rubens) living in the suburb of Saint-Germain-des-Prés. The second method was to obtain special warrants, either from the king himself or from those close to him, authorizing them to work without the usual guild affiliation. This is how the Le Nain brothers were able to work in the capital, although to be on the safe side they also set up in Saint-Germain-des-Prés, in other words outside the geographical zone in which the corporatist rules applied. As the extravagant needs of the court increased, so the number of special dispensations (granted free of charge) proliferated, provoking the anger of the guild members. At the meeting of the States General in 1614, they demanded the revocation of all franchises awarded to painters and sculptors from outside Paris. From then on, the guild did not rest until those permits were abolished that allowed artists who had not been admitted as masters to practise their trade freely.

The creation of the Académie Royale de Peinture et de Sculpture thus resolved a difficult situation that had grown acute over the course of the century: the existence of large numbers of artists carrying on their trade within a legal framework that was dubious to say the least, while being subjected to the complaints of their Parisian colleagues who considered themselves wronged by this. Because the Académie's charter provided that artists no longer needed to be masters of the guild in order to work freely in the capital, the new institution adopted the motto *Libertas artibus restituta* ('Liberty restored to the arts'). This did not put an end to the Parisian guild of painters, however. In an attempt to attain a respectability comparable to that of the royal institution, it renamed itself the Académie de Saint-Luc and survived under

this new name until 1776. During the 17th and 18th centuries it had some prestigious members. Simon Vouet, who was ill when the Académie Royale de Peinture et de Sculpture was established and was excluded from its membership, was the leading figure of the Académie de Saint-Luc from the end of 1648 until his death in June 1649, and Chardin was a member between 1724 and 1729 before being accepted into the royal institution. Overall, however, the prestige of the guild was considerably reduced and its members found themselves increasingly confined to less important, private commissions.

A new training 'curriculum'

Apart from the specific circumstances that led to its creation, the founding of the Académie was a positive step in another sense: it proposed a solution to the problem of how to bring training into line with artists' new preoccupations. The royal institution turned the traditional method of training artists upside down, replacing the old system of apprenticeships under a master with a combination of technical training in studios (which now functioned as private art schools) and theoretical classes at the Académie. The institution saw itself first and foremost as a place of learning and a centre for reflection. Significantly, it did not see providing aspiring artists with an introduction to the material aspects of the arts as one of its responsibilities. Young people had to seek instruction on how to use a paintbrush or chisel elsewhere. Those lucky enough to be selected paid an enrolment fee and came to the Académie to learn to draw. Working together in classes and advised and corrected by their teachers (who were themselves academicians), they began by copying the drawings of the great masters before moving on to plaster casts and finally life drawing, known as *académie* (only male mod-

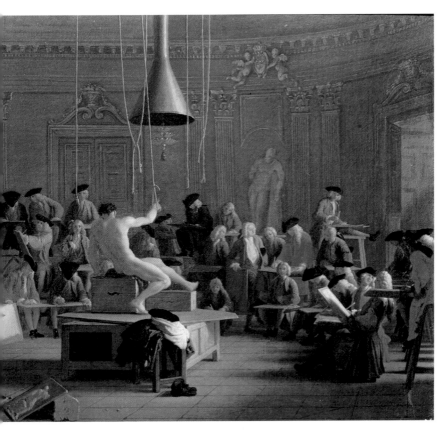

Michel Houasse, *The Drawing Academy*, 1715, oil on canvas, Madrid, Palacio Real.

115

The illustrious academies

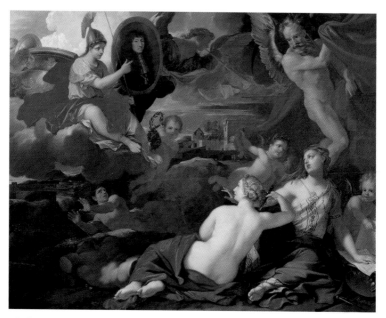

Nicolas Loir, *Allegory of the Foundation of the Académie Royale de Peinture et de Sculpture,* also known as *The Progress of the Art of Drawing in France during the Reign of Louis XIV* and *Minerva and the Arts,* 1666, oil on canvas, 141 x 185.5cm, Musée National du Château de Versailles.

els were used – female models were ruled out for reasons of decency until the end of the 18th century). The students' progress was assessed by means of monthly examinations (from 1689) and termly competitions in which the winners were awarded medals. The Académie thus provided its student artists with a theoretical grounding. Until 1749, when the foundation of the École Royale des Arts Protégés (forerunner of the École des Beaux-Arts, which would come into being at the time of the French Revolution) brought with it a systematic training programme, its teaching was limited in the main to lessons in perspective, geometry and anatomy. In 1654, the Académie started holding monthly public lectures, in which academicians would talk about the principles of painting and sculpture with reference to their own work.

Although probably inadequate from a pedagogical point of view, this teaching nevertheless marked a significant leap forward for theory in terms of both the training of artists and the education of public taste. The Académie was celebrated not only as a means of 'restoring liberty to the arts' but also as an institution that helped art to triumph over ignorance. In 1666, the painter Nicolas Loir rather craftily based his candidacy for acceptance as an academician on a painting, or reception piece, entitled ALLEGORY OF THE FOUNDATION OF THE ACADÉMIE ROYALE DE PEINTURE ET DE SCULPTURE, OR THE PROGRESS OF THE ART OF DRAWING IN FRANCE DURING THE REIGN OF LOUIS XIV. Minerva, goddess of wisdom, holds aloft – assisted by Fame – a portrait of the king, which she shows to Painting and Sculpture, two beautiful young women who have just been released from the veil of ignorance by a winged Father Time. At the bottom left of the painting, two naked men, personifying ignorance, can be seen fleeing in great haste.

A HIERARCHY OF GENRES AND ARTISTS

The introduction of academic lectures had significant consequences. For the first time ever, a body of teachings set out an ideal aesthetic with which both artists and their potential clients were supposed to identify. This system suited the court and it suited the statesman Colbert, who supported the Académie enthusiastically because it gave French art a new sense of coherence. If Classicism was not actually born out of this in-

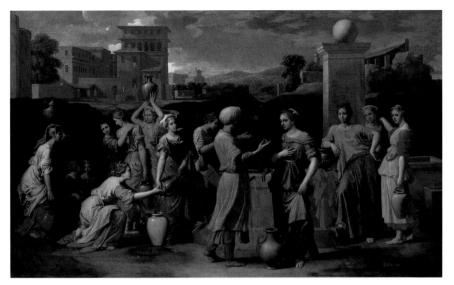

Nicolas Poussin, *Eliezer and Rebecca*, 1648, oil on canvas, 118 x 197cm, Paris, Musée du Louvre.

novative institution, it was at least given a substantial boost by it. It became the hallmark of the century of Louis XIV, an orthodoxy to which artists felt compelled to submit for fear of being passed over for public commissions and spurned by private collectors.

The codified rules of artistic creation

Paradoxically, the main consequence of this orthodoxy was the curbing of artists' freedom (greater freedom of another kind having been one of the reasons the Academy was created in the first place). In keeping with the nobility of painting, artists were advised against portraying humble or ridiculous objects, as their inclusion, so the rigorists believed, would detract from the grandeur of the work.

In response to an analysis by Philippe de Champaigne of Poussin's painting ELIEZER AND REBECCA, Le Brun praised the painter for having cleverly avoided depicting any camels – curious but prosaic animals that seemed to have been called for by the story, which tells of Rebecca giving water to the tired traveller Eliezir and his camels at the well. On another occasion the same Le Brun criticized the Italian painter Annibale Carracci for having placed an ox and an ass ('vile objects') in the foreground of a nativity.

At a more fundamental level, the Classical principle had a decisive impact on the commercial value of paintings and the esteem in which painters were held. Academicians established the notion that when a painting was being appraised, the 'dignity' of the subject matter had to be taken into account just as much as the quality of execution. The Classical principle created a distinction between genres and a rigorous hierarchy between subjects. As André Félibien, the Académie's secretary and theoretician, put it: 'those who paint perfect landscapes are superior to others who paint only fruit or shells. Those who paint living creatures are worthy of greater esteem than those who portray dead things and things without movement. And as the human figure is God's most perfect earthly creation, there can be no doubt that painters who imitate God by depicting mankind are more excellent by far than all these others ... Nonetheless, painters who only make portraits cannot yet be said to have attained this high perfection of art and are not deserving of the honour accorded to their more learned colleagues. For this they must progress from the depiction of single figures to the painting of large ensembles; they must treat historical subjects and fables; they must depict great actions in the manner of the historians or agreeable subjects as the poets do; and climbing higher still, through allegorical compositions they must be able to describe the virtues of the great

The illustrious academies

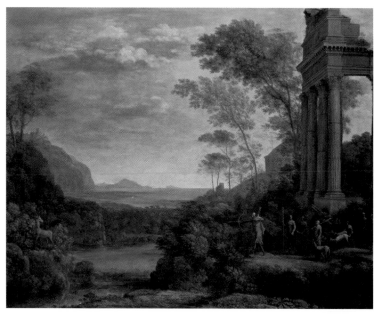

Claude Lorraine, *Landscape with Ascanius Shooting the Stag of Sylvia*, 1682, oil on canvas, 120 x 150cm, Oxford, Ashmolean Museum.

as well as mysteries of a most elevated kind under the veil of fable. A great painter is one who is proficient in such tasks as these.'

Strategies and dodges

Such beliefs, central to the Académie's existence, naturally resulted in a rigid hierarchy of artists. Portraitists and landscape painters were relegated to a 'subsidiary category' of painter, while the 'generalists' – in other words, the history painters – made up the elite. Only the latter could become officers of the academy such as treasurer, professor, assistant professor, rector, chancellor or director – highly prestigious posts that brought with them a wide range of advantages such as studios, accommodation, honours and pensions.

It comes as no surprise, therefore, to learn that painters who worked in speciality genres regularly sought to be accepted by the Académie as history painters. Louis XIV's portraitist Hyacinthe Rigaud, admitted to the academy as a portrait painter in 1687, subsequently angled for the honour of being accepted as a history painter, eventually becoming a 'painter of history and portraits' in 1700. His strategy paid off: he was appointed assistant professor in 1702, professor in 1710, and subsequently rose through the ranks until he was finally made director in 1733. In the meantime he had been given a pension by the king and ennobled (Order of St Michael). As a simple portrait painter he would have qualified for none of these honours.

The hierarchy of genres also influenced the market value of paintings. Private individuals were doubtless less mindful than the Académie of the argument in favour of historical compositions, all the more so as they often had neither the room to exhibit them nor the learning to understand them. They were keener to commission portraits, still lifes, genre scenes and landscapes instead. The prices they were prepared to pay were also far lower than the amounts a historical scene or an allegory of the same size could command. A still life would only be worth around a quarter of the value of a painting in the 'grand manner', and a portrait, belonging to a genre held in slightly higher esteem, would earn a painter 'just enough to keep the pot boiling'.

Once again, painters developed subtle strategies in order to circumvent these discrep-

ancies. In order to increase the value of his landscapes, CLAUDE LORRAINE (or a collaborator) added small figures to them, thereby transforming them into historical scenes. Similarly, painters of flowers and hunting trophies would happily add a candle, an hourglass or a skull to a painting in order to turn a still life into a *vanitas* and therefore a form of allegory (along with history painting one of the most highly prized genres). Similar tricks were employed by painters working in the specialist genres in order to gain access to the Salons, the public exhibitions instituted by the Académie in 1667 (held infrequently at first but later every two years). Works exhibited in the Salons were grouped together by genre, with history paintings being given the best positions. In the exhibition catalogue it would therefore be common to find a tavern scene posing as a *Calling of St Matthew*, a rainy landscape transformed into a *Flood*, or a woman holding a baby converted into a *Virgin and Child*.

TRAVELLING TO ITALY AND THE INFLUENCE OF THE FRENCH MODEL

Another way of distinguishing the more prestigious from the less prestigious artists was in terms of whether or not they had spent some time in Italy.

The first great migrations

The steady migration of artists from all over Europe to Italy began around the turn of the 16th century. A certain Jan – of whom no other personal details are known – was sent from Holland to Venice by his patron Frederick the Wise in 1494; Gaspar Dias was sent to Rome by the king of Portugal in 1520 in order to train with Raphael and Michelangelo; Francesco de Hollanda, another Portuguese artist, was sent to Rome in 1537; and Barthel Beham, court painter in Munich, journeyed to Italy in 1539. These are just a few of the foreign artists who went there to train. During the 16th century, travelling to Italy was an almost obligatory stage in the training of young Flemish artists. Those who had travelled south were known as the 'Romanists'. They remained bound by strong ties of friendship and formed brotherhoods upon returning home.

The phenomenon received a boost at the end of the 16th century when more and more French artists began to participate. By the beginning of the 17th century (in other words well before the founding of the Académie), the bulk of the French colony in Rome was made up of young men who had come to complete their training through the study of both classical art and the painting and sculpture of living Italian artists. Their intention was generally to return after a number of months or years – although some did not stick to this plan – in order to make a career for themselves at home.

Antoine Laffrey, *Artist Drawing an Antique Statue*, Dijon, Musée des Beaux-Arts.

The illustrious academies

A pioneering institution: the Académie de France in Rome

It was the creation of the Académie de France in Rome, however, or at least a decision taken a few years after it was founded by Colbert in 1666, that changed the whole nature of trips to Italy. The Italian experience stopped being an optional staging post of variable duration for painters and sculptors with inquiring minds or lucky enough to have a patron infatuated with the country, becoming instead the glorious climax to the studies of any ambitious young sculptor or painter. Coming at the end of several years of hard work at home, it took the form of a stay in the Italian capital, the details and duration of which were all fixed in advance and which led to the near-certitude of the artist in question receiving public commissions, making a good career for himself and being promoted to high office at the Académie Royale.

Designed to form a natural extension to the ablest students' studies at the Paris Académie, the new institution, financed and directed by the French state, was located for the first century and a half of its existence in the Palazzo Mancini on the Corso. Those seeking an award had to enter the most prestigious and fiercely contested of all the competitions organized by the Académie: the 'Prix de Rome'. This comprised three parts: a sketch, a painted *académie* (nude) and a large picture that had to be executed in just a few days *en loge* (in other words, confined to a studio) on a historical, mythological or Biblical subject given to the candidates by the jury of academicians at the last minute.

During the 17th century and at the beginning of the 18th, the successful candidates would leave immediately for the Eternal City, which would be their home for the next three years. The state took care of their travelling expenses and provided them with a stipend while they were there. From 1749, the scholarship winners had to spend three years completing their training in classical theory and drawing at the École Royale des Arts Protégés (which opened that year) before leaving for Rome. Once there, these painters and sculptors – aged around 25 and often with ten years or so of combined specialized study and practical experience behind them – were subjected, during the early days of the Académie de France at least, to a strict regime. Officials who were merely part of a hierarchy served as mentors and imposed a programme of work that was for a long time rigorous and precise. The main thing expected of the artists during the 17th century was that they should spend their time tirelessly copying masterpieces. This was a dry task, but in the eyes of the institution's founders it possessed the double merit of helping the students to round off their classical education while also enriching the collections of the state, as the copies remained not in the possession of the students who made them but were sent to Paris. During the early stages of its existence, Colbert issued the following instructions to the rector of the Académie de France: 'Have the painters copy all the most beautiful things in Rome, and when they have copied everything, have them start all over again, if you can.'

During the 18th century, discipline was somewhat more relaxed and students were given greater freedom, although their work was marked in situ by the director of the Académie de France and sent to Paris to be assessed by the academician-teachers there. Students like Fragonard and Hubert Robert, who won trips to Rome in the second half of the 1750s, produced drawings of landscapes in which ruins were included more for nostalgic reasons than for any archaeological information they might provide; a painter such as David, however, winner of a Prix de Rome scholarship in 1774 (after several successive failed attempts), saw his style undergo a transformation upon contact with classical sculpture and under the influence of various archaeologists working in Rome, in particular the young Quatremère de Quincy, with whom he made a formative journey to Herculaneum and Pompeii.

In thrall to antiquity: the passion for Neoclassicism

The importance of trips to Italy for ambitious young artists was something that Europe's various artistic schools were all agreed upon during the 17th and 18th centuries. In Italy,

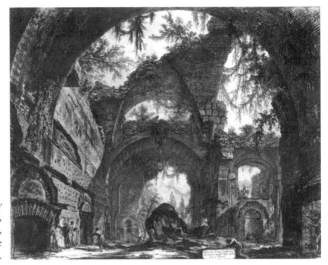

Piranese, *Ruins of a Gallery in the Villa Adriana at Tivoli*, engraving, Paris, Bibliothèque Nationale de France.

however, where the first academies had opened their doors in the 16th century, a lack of political unity prevented the creation of a national institution capable of setting an agenda. Italian artists, in Rome at least, were naturally keen to develop links between classical culture and their own art. Rather than limiting themselves to the servile reproduction of antique statuary, decoration or architecture, artists such as Giovanni Paolo Pannini (whose work influenced Hubert Robert) and Piranese (a Venetian artist who settled in Rome in 1744 and who was a source of inspiration for David) offered up an imaginative vision of them.

Such art could not be created without a long study of the treasures of Rome or of some other major archaeological centre, such as Naples. Written accounts all tell us the same thing: generation after generation of artists of all nationalities spent many hours examining and copying the art of the past. Joseph-Marie Vien (in the second half of the 1740s), David (in the second half of the 1770s) and the sculptors Houdon (in Rome between 1764 and 1768) and Clodion (also in Italy in the 1760s) – all of them scholarship students at the Académie de France – were inspired by the presence of young students from other countries as well as masters of international repute.

The German Anton Raphael Mengs – a personal friend of the archaeologist Johann Joachim Winckelmann (author of the influential *Reflections on the Painting and Sculpture of the Greeks*, published in 1755) – lived in Rome between 1755 and 1761, and again after 1777. He represented a style of painting modelled on Raphael and influenced by antiquity.

The Scot Gavin Hamilton, a painter like Mengs (albeit more limited in scope) as well as an archaeologist and picture-dealer, came to prominence in the 1760s with large-format paintings based on Homeric themes. Engraved reproductions of these paintings spread the image of an antiquity influenced by Poussin's version of Classicism throughout the whole of Europe. Hamilton's work would later influence David. Younger artists who developed a similar passion for archaeology during sojourns in Rome, achieving varying degrees of fame, included the Swede Johan Tobias Sergel, the Englishmen Joseph Nollekens and Thomas Banks, the Americans Benjamin West and John Singleton Copley, the Dane Nicolai Abraham Abildgaard, various Germans including the Hackert brothers, the Irishman James Barry, and the Swiss artists Angelika Kauffmann and Johann Heinrich Füssli (Henry Fuseli). The Swede Johann Christian von Mannlich, who arrived in Italy with Sergel in 1767, gives a description of his daily routine in his memoirs. Having arrived in Rome from France, and anxious to forget what he had learned from Boucher and to invest his work with a greater seriousness, he took himself off each morning, together with Houdon, to study anatomy with the surgeon Séguier, or he would go and

The illustrious academies

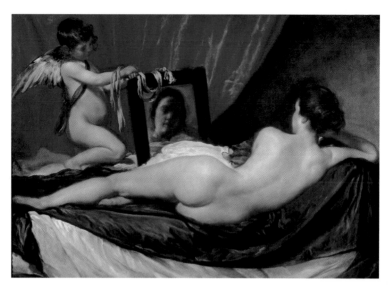

Diego Velázquez, *Venus at Her Mirror*, also known as *The Rokeby Venus*, c.1650, oil on canvas, 122 x 177cm, London, National Gallery.

draw at the Farnese Gallery. In the afternoon, either alone or in the company of English painter friends, he would visit churches and collections of art. He would spend the evenings drawing from life at the Académie de France. An admirer of Annibale Carracci, Domenichino and, among the older artists, Raphael and Michelangelo, von Mannlich copied their works enthusiastically in order to learn the secrets of their style.

RESISTANCE TO THE CLASSICAL MODEL

Although an important point of reference, Rome was not the only centre of artistic life in Italy. Many European artists chose to remain there for only a short while, favouring other cities and therefore other artistic schools.

The Spaniards and the Flemish

To the Flemish, for example, Venice (like Florence and Naples) was just as important a place of artistic pilgrimage as the Eternal City. Although Rubens made a lengthy stay in Rome, assiduously copying antique statues and frescoes by Raphael and Michelangelo, he by no means neglected modern Venetian painting. Towards the end of his life, in particular, he developed a passion for Titian's work that had an important influence on his style.

Velázquez, whom Rubens met in Spain, was persuaded by the Flemish painter to travel to Italy. Once there, he was more impressed by Venetian painting than by the work of the Roman school (then undergoing a revival). His masterpiece VENUS AT HER MIRROR, dating from the 1640s, shows a clear debt to Titian.

Not all artists who stayed in Rome for substantial periods of time developed a passion for historical monuments or the masterpieces of the 16th century, however. Van Dyck stayed in the city from the beginning of 1622 until the autumn, when he travelled to Venice, and recorded in a sketchbook everything that caught his interest, particularly street scenes and colourful costumes. He also copied the work of famous Italian painters – but usually Titian rather than Raphael or Michelangelo. Ancient ruins interested him far less, and he never seems to have been tempted to undertake a systematic study of them.

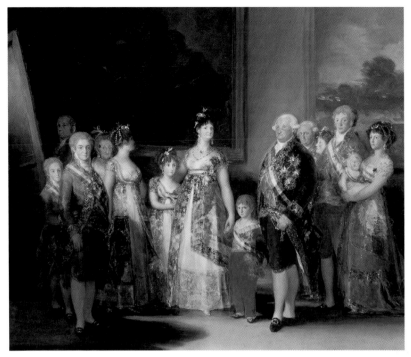

Francisco de Goya, *The Family of Charles IV*, 1800, oil on canvas, 280 x 336cm, Madrid, Museo Nacional del Prado.

Spain: the late triumph of the Academy of San Fernando

In some countries it took far longer than it did in France or Flanders for artistic success to be linked with a trip to Italy. Spanish artists before Velázquez, for example, felt no need to leave their own country, and at the beginning of Philip IV's reign none of the king's six painters in Madrid had made this pilgrimage.

The situation in Spain had always been different from that in Italy, France or the Spanish Netherlands. The Church, for a long time the country's principal artistic patron, favoured adherence to tradition and opposed the development of new ideas. It blocked all theoretical discussion of the status of the artist and of the possibilities of art. The training of Spanish painters, who generally came from more modest backgrounds than those in the rest of Europe, was still governed by ancient apprenticeship rules that prevented them from acquiring any real learning. They were engaged to fulfil extremely precise commissions – religious paintings whose detailed subject matter was set out in a contract – and often asked to use as their model the engraving of another (frequently foreign) work of art to which the patron had taken a liking. In other words, artists were regarded as no more than underlings and treated as artisans. Most of them, indeed, were artisans in all but name. A very small minority of artists felt the need to change this state of affairs. Francisco Pacheco, Velázquez's master in Seville, can be seen as something of a trailblazer. He spent almost 40 years writing a famous book called *El Arte de la Pintura* (*The Art of Painting*), which was finally published posthumously in 1649. This was the first treatise on the theory and practice of art to have been written on the Iberian Peninsula. In it the author defends the notion that painting is a liberal art, in other words an intellectual pursuit, and that painters should cultivate their minds in addition to acquiring technical expertise. Although sustained by an extraordinary renewal in Spanish painting during the time of Velázquez, Ribera, Zurbarán and Murillo, and supported by writers close to the seat of power such as the poet Calderón de la Barca, Pacheco's efforts only bore fruit a century later, when King Ferdinand VI founded the Real Academia

The illustrious academies

de Bellas Artes de San Fernando, the Spanish equivalent of France's Académie Royale de Peinture et de Sculpture, in 1751.

In his painting FAMILY OF CHARLES IV, a variation on Velázquez's famous painting *Las Meninas*, Goya depicts himself facing the viewer alongside members of the royal family (whom he portrays harshly), thereby proclaiming himself to be one of the great figures of his century – the king's equal, if not his superior.

England: the route to the Royal Academy

For very different reasons – political struggles, the lack of centralization and the Puritan mistrust of the image – the artist's struggle for recognition occurred even later in England than in Spain.

Until around 1740, when remarkable collections were being assembled and a commercial boom led to an increase in the price of European old masters as well as contemporary European artists, English painters had spent their time working on lesser tasks: the painting of landscapes representing this or that corner of a country estate, and stereotyped portraits of aristocrats or members of the middle classes (portraitists were also known as 'face-painters'). The purchasers of these paintings regarded them more as commemorative objects than as works of art and they were frequently sold on for derisory amounts. The artists' guild – the Painter-Stainers Company – regarded the painters of such works no differently from painters of carriages or buildings.

In order to remedy this situation, a connoisseur turned art critic named Anthony Ashley Cooper called upon artists to improve and broaden their knowledge. It was largely due to him that painters, taking their cue from similar journeys made by young aristocrats, increasingly made the 'Grand Tour' of France and Italy. The next stage in boosting the reputation and status of artists would normally have been the founding of an

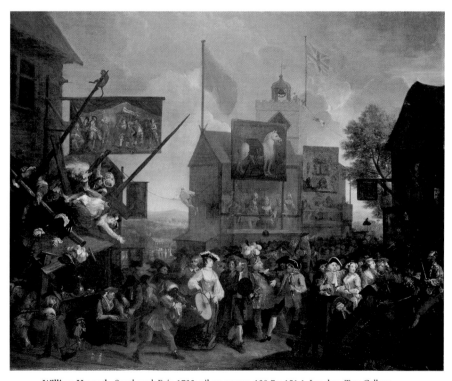

William Hogarth, *Southwark Fair*, 1733, oil on canvas, 120.7 x 151.1, London, Tate Gallery.

ITALY AND ENGLAND

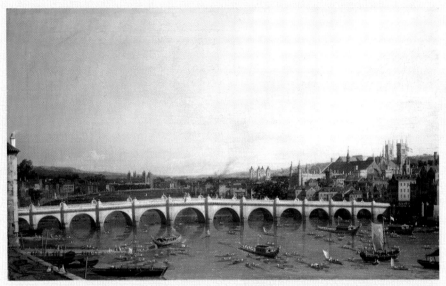

Canaletto, *Westminster Bridge*, 138 x 96cm, London, Spink & Son Ltd.

After a difficult start, English art experienced its first golden age in the 18th century. While architecture took its cue from Palladian models, the decorative arts were given a new stimulus by the beginnings of the Industrial Revolution. Mass production of high-quality pottery began at the Chelsea and Wedgwood factories, that of silverware in Sheffield, and Thomas Chippendale set up a successful furniture business based on his famous catalogue.

The landscape

All these arts borrowed from antique models. Painting did so to a lesser extent, despite an underlying Italian influence. While William Hogarth (1697–1764) championed an anti-Classical aesthetic based on modern subject matter (social satire with a moral message) and formal rules far removed from those of antiquity, the Italian painter Antonio Canal (1697–1768), known as Canaletto, who lived and worked in London between 1746 and 1755, reinvigorated the local concept of the landscape. Bathing the English capital and countryside in an almost Mediterranean light, he invented 'vedutism' (from *veduta*, Italian for 'view'), which was soon to influence the English landscape painters Richard Parkes Bonington and John Constable.

The portrait

The art of the portrait was also transformed by the Italian influence, experienced in Italy itself, often in Rome. The education of young British aristocrats included a 'tour' to the Continent, and particularly to Italy, where the travellers metamorphosed into art lovers, acquiring the beginnings of a collection that they would spend the rest of their lives adding to. In Rome, Pompeo Batoni (1708–87), a native of Lucca, specialized in painting these 'tourists'. He combined the allegorical portrait style that had developed in Holland and become popular in France with the British 'conversation piece' (a genre in which the subject or subjects are shown either in a landscape setting or in an interior, either conversing or engaged in some other activity). His portraits are characterized by a light tonality and depict elegant, full-length figures, sometimes in symbolic garb, against a backdrop of ruin-strewn Roman countryside, or else meditating next to a statue. His work was admired by, and inspired, the English painters Joshua Reynolds and Thomas Gainsborough and the American Benjamin West (who lived in Rome between 1760 and 1763).

academy. However, although called for by a group of painters and sculptors in 1755, the Royal Academy was not created (by George III) until 1768. This delay was caused by the resistance of a minority of determined individuals at the heart of the artistic community who believed that the creation of a national school of art should owe nothing to foreign models, least of all to a French one based on an aesthetic dictated by Italy and governed by the notion of a hierarchy of genres. The leader of this minority, the painter WILLIAM HOGARTH (see p.124), turned theoretician in order to defend his views. In *The Analysis of Beauty*, his treatise on aesthetics published in 1753, he pleads for an art founded not on the Classical doctrine of idealization of nature and the primacy of history painting, but on the aim of achieving a realistic pictorial representation of the modern world complete with its all its vices and ugliness. Full of didactic intent in their

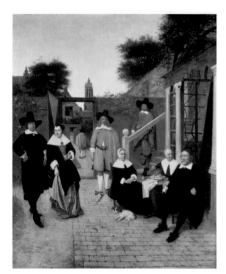

criticisms of contemporary society, the series of engravings that Hogarth made from his own paintings – *A Harlot's Progress, A Rake's Progress, A Midnight Modern Conversation, Marriage à la Mode* and *The Four Stages of Cruelty* – offered a model for the type of art he wanted to see being made: a satirical, moralizing art set in an everyday reality far removed from academic preoccupations.

A SPECIAL CASE: CALVINIST HOLLAND

It was in northern Europe, however, in the Calvinist Netherlands, that the situation of artists and their aspirations differed most of all from those of painters and sculptors in France.

Pieter de Hooch, *Dutch Family*, c.1657–60, oil on canvas, 114 x 97cm, Vienna, Akademie der Bildenden Künste.

Frans Hals, *Banquet of the Officers of the Civic Guard of St George*, detail, 1627, oil on canvas, Haarlem, Frans Hals Museum.

Pre-eminence of the portrait

The decisive factor was the influence exerted by religion. Religion represented an

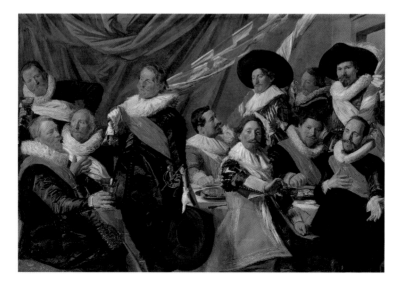

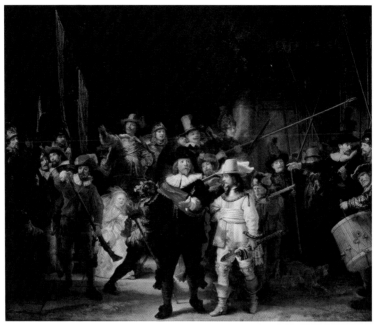

Rembrandt, *The Company of Captain Frans Banning Cocq*, also known as *The Night Watch*, 1642, oil on canvas, 363 x 430cm, Amsterdam, Rijksmuseum.

obstacle to the notion of a hierarchy of genres, even if it did not actually reverse the hierarchy that the Classical pictorial doctrine was beginning to establish. As in England, and if anything more so, Calvinism debarred Dutch artists from that category of history painting which portrayed the great episodes of Christianity. The walls of the churches were bare – devoid of the great mural decorations, enormous painted altarpieces and stained-glass windows that elsewhere brought painters and sculptors fame and material benefits.

This lack of opportunity was only partially compensated for by public commissions for scenes from national or municipal history. Otherwise artists were forced to turn to private commissions; these at least made up in numbers what they lacked in scale. The subjects of these commissions were sometimes landscapes or still lifes, but more usually portraits. As in England, the middle classes, who were experiencing a remarkable rise in economic and political status, liked to have their pictures painted. The success of Pieter Fransz de Grebber, Cornelis Engelsz, Johannes Verspronck, Pieter Claesz Soutman, Thomas de Keyser, Michiel Janszoon van Mierevelt, Jan de Bray, Ferdinand Bol and many others was based for the most part on their work as portraitists in Haarlem, Amsterdam and other Dutch towns and cities. They painted hundreds and thousands of portraits – small or large, oval or rectangular – depicting merchants or engineers or administrators, alone or accompanied by their wives and children, with the men on one side and the women on the other.

Tired of painting what was inevitably a repetitive type of portrait, a number of bolder artists made their solemn sitters assume the poses and attributes of mythological figures. A tradesman and his wife, for example, might be transformed into Ulysses (or Paris) and Penelope (or possibly Venus). Artists of greater talent, such as Frans Hals, painted dynamic and natural group portraits to mark the special occasions of various organizations – as in *THE BANQUET OF THE OFFICERS OF THE CIVIC GUARD OF ST GEORGE*, painted in 1616 and again in 1627, or *The Banquet of the Officers of the Archers of St Adrian in Haarlem* (1633) – or else depicted his sitters frozen dramatically in the austere dignity of

The illustrious academies

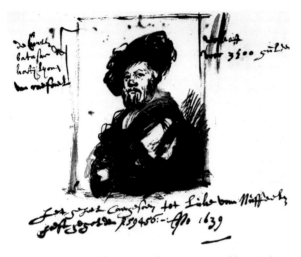

Rembrandt, *Baldassare Castiglione*, 1639, pen and brown ink, after Raphael, 16.8 x 20.7cm, Vienna, Graphische Sammlung Albertina.

office, as in *The Governors of the Hospital of St Elisabeth* (1641) or *The Lady-Governors of the Old Men's Almshouse at Haarlem* (1664). And Rembrandt, although generally following the tradition of rigorous austerity appropriate for the moral tone desired by most of his patrician sitters, experimented with original compositions for his group portraits, thereby lending them something of the character of history paintings. This is true of his two paintings with the title *Anatomy Lesson* and also of THE COMPANY OF CAPTAIN FRANS BANNING COCQ, better known as THE NIGHT WATCH – in reality a painting of the daytime patrol of the civic guard of Captain Cocq and his lieutenant Willem van Ruytemburgh.

A more specialized form of learning

In matters other than the contents of paintings, the relationship between artists and their art also seems to have been very different in the north from the way it was in the Latin countries. At first, as in Spain and England, the trip to Italy was far from essential to an artist's career in the Calvinist Netherlands. Rembrandt in Amsterdam and Vermeer in Delft (who married into a Catholic family) seem never to have felt the need to leave their country and travel south. This did not prevent them from appreciating either ancient masterpieces or the work of contemporary Italian artists. Rembrandt, in fact, had a good knowledge of them, as he possessed a collection of Italian engravings and also bid at auction for paintings of this type. At the same time he would make drawings of the most remarkable paintings in the auction rooms. One of the works he sketched was Raphael's portrait of BALDASSARE CASTIGLIONE, painted around 1515, which was too expensive for him to buy. But geographical distance also created a sense of intellectual distance, which meant that these artists felt freer and not bound by the rules of ancient art or the decorum of Classicism.

Generally, the whole attitude of Dutch artists to the question of 'learning' seems to have been different from that of artists further south. While Rubens, Poussin, Philippe de Champaigne and Pacheco during the 17th century and Hogarth and Reynolds during the 18th were keen writers, neither Rembrandt nor Hals nor Vermeer sought to set down in words what, presumably, they felt their paintings and craft already adequately expressed. Having no desire to see themselves as writers, these artists were also, by and large, less avid readers than their southern colleagues. Vermeer, at his death in 1675, and Rembrandt, at the time of his bankruptcy in 1656 (as we know from an inventory of his possessions), possessed only modest libraries. Both had a passionate interest in certain practical aspects of their art (Vermeer in optics and Rembrandt in anatomy), but their approach to learning seems to have been based less on the consultation of treatises than on applied knowledge and experimentation.

In the absence of a large library, Rembrandt possessed a collection of disparate objects which provided both information and aesthetic inspiration. As well as works by contemporaries and predecessors, he accumulated items that could be used by his models

as accessories: pieces of armour, such as the helmet that gives its title to the painting *The Man with the Golden Helmet* (Gemäldegalerie, Berlin) and the metal collar worn in his 1629 self-portrait. But he also liked rare objects capable of provoking scientific speculation: for example, a shell with a check pattern (of which he made five different engravings), casts of animals and even stuffed animals. Rembrandt's knowledge of human emotions seems remarkable. He may not have made systematic drawings of facial movements like Le Brun, or taken his inspiration from pictorial or written treatises on the emotions, but he nevertheless liked to capture expressions and movements that convey a given psychological state. It seems he may have taken his inspiration from the theatre, making his pupils and assistants act out playlets in the studio, or he may have got them to use a mirror – as he must have done himself – in order to gain a better sense of the impact of an emotion by observing exaggerated facial expressions.

Impasted or smooth? The importance of technique

The techniques employed by northern artists – both VERMEER'S smooth, meticulous finish and REMBRANDT'S uneven, impasto-encrusted one – reveal another difference between north and south: that of their fundamental approach to the act of painting. In his two self-portraits, Poussin is anxious to show only finished, framed paintings in the background, so as to give the viewer the impression that his pictures spring fully formed, as if by magic, from his mind. His decision to apply a thin layer of pigment to a fine-grained canvas serves the same end: to minimize the importance of the physical process involved and to maximize the element of intellectual invention. The painstaking work that allowed Vermeer and his contemporary Gerard Dou to give their pictures an impeccably precise finish had a different intention behind it: it emphasized the part played by material processes in the creation of the picture, conveying the impression that an extremely long time had been needed to achieve such perfection. In short, in order to appraise the painting one had to take into account those purely craft-related criteria – the care taken to produce the object and the number of hours put in – that Poussin rejected outright.

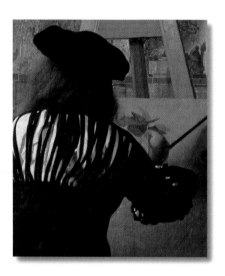

Jan Vermeer, *The Artist in His Studio*, also known as *The Art of Painting*, detail, c.1670, Vienna, Kunsthistorisches Museum.

Using different means, Rembrandt's paintings rehabilitate the artist's handiwork in exactly the same way as those of Dou and Vermeer, emphasizing the importance of 'craft'. However, far from giving his pictures the same smooth finish as these two artists (paradoxically, Dou was his student), Rembrandt takes care to leave the physical construction of each painting visible. Going one step further than Titian and Rubens, he makes prolific use of impasto. Even a brief

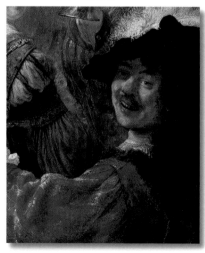

Rembrandt, *The Prodigal Son in the Tavern (Rembrandt and Saskia)*, detail, c.1635–9, Dresden, Staatliche Kunstsammlungen.

A FAVOURITE SUBJECT: THE PAINTER'S STUDIO

Dutch artists enjoyed depicting work in the studio. Such paintings had a number of meanings. They could be genre scenes, allegories of painting or more personal reflections on the difficulties of art. They all had one thing in common, however: unlike his southern counterpart, the Dutch painter emphasized the everyday, material character of his occupation. Instead of showing himself surrounded by works of art or learned treatises, he presented an image of himself as an artisan in his place of work – a painter working at his easel in the room of the house he used as a studio.

Contemplation and silence

In Vermeer's painting the atmosphere is serious. The painter works contemplatively and silently in a setting that is extremely comfortable, if not luxurious. He is probably in his own house, as that is where Vermeer had his studio, but nothing gives away the presence of the many children who lived under the same roof. The artist is alone with his model, a young woman wearing a crown of laurels (an attribute of Fame). She is holding a trumpet (another of Fame's attributes) and a work by the Greek historian Thucydides. The artist is seen from behind. The figure represents any painter, rather than being a self-portrait of Vermeer. Indeed the picture is intended as an allegory of Painting, an activity which contributed to the country's greatness just as much as the other so-called 'liberal' (in other words, intellectual) disciplines: History, represented by the young woman, whom we should see as the muse Clio; and Geography, represented by the map. This map, hung according to custom with west at the top, is a representation of a real one, that of Claes Jansz. Vischer. It shows the seven Protestant provinces that had seceded and the ten Catholic provinces that were still under Habsburg rule. This detail perhaps reflects Vermeer's own unusual position as a convert to Catholicism and therefore a marginal figure within the very Calvinist town of Delft.

In this canvas, Vermeer again asserts the superiority of painting over sculpture, symbolized here by a marble head lying on its side on the table, as if abandoned.

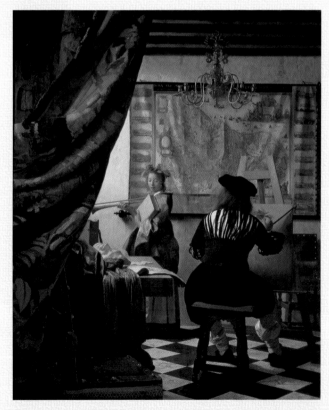

Jan Vermeer, *The Artist in His Studio*, also known as *The Art of Painting*, c.1670, oil on canvas, 119.4 x 99.8cm, Vienna, Kunsthistorisches Museum.

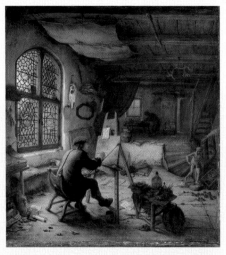

Adriaen van Ostade, *The Painter in His Studio*, 1663, oil on wood, 38 x 35.5cm, Dresden, Gemäldegalerie.

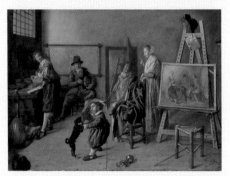

Jan Miense Molenaer, *A Painter in His Studio, Painting a Musical Company*, 1631, oil on canvas, 86 x 127cm, Berlin, Staatliche Museen, Gemäldegalerie.

The artist's studio as a pretext for a genre scene

In the painting shown here, Adriaen van Ostade has turned the artist's studio into a genre scene, inventing a vast, chaotic barn-like building, at the back of which an assistant can be seen preparing pigments.

Jan Miense Molenaer did something similar with the scene (albeit a more mundane one) shown here: a shared studio that reverberates with the laughter, chat and music of models who are not so much posing as having fun together.

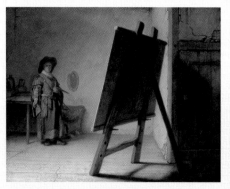

Rembrandt, *An Artist in His Studio*, also known as *The Easel*, c.1629, oil on wood, 24.8 x 31.7cm, Boston, Museum of Fine Arts, Oliver Sherman collection.

The artist confronts his canvas

Despite producing numerous self-portraits, several of which depict him in the act of painting with a scarf round his head and a brush in his hand, Rembrandt painted very few pictures of the studio itself. In *The Painter in His Studio*, we are shown a young painter of Rembrandt's age (23), possibly Rembrandt himself, either contemplating a blank canvas or appraising a painting in progress.

There is nothing to distract his attention in the bare room with its cracked walls. Every object has a practical use: the artist prepares his paints on the stone on the tree stump leaning against the back wall; on the table to the left are bottles containing oil and varnish; and hanging on the wall, ready for use, are two palettes of different sizes. The painter is wearing a work smock. The wooden easel bearing the canvas is old: the horizontal bar on which the artist rests his feet when working is worn on both sides from overuse.

Such simplicity and rigour in the choice of details makes the confrontation between the man and the work he has created all the more striking. It suggests far more effectively than a display of treatises that painting is a mental activity and that a successful work is the product of intelligence just as much as it is a product of manual skill.

Despite their differences, these images all depict the painter as a man engaged in demanding work. By way of evidence they show the artist with his tools – palette, brushes, knife and maulstick (to help the painter maintain the position of his hand during long hours of work – Vermeer's painter rests his hand on his, while Rembrandt's holds his with his little finger). These accessories have become the symbols of the art of painting, replacing Poussin's pencil, portfolio of drawings and learned theoretical treatises.

glance will allow the viewer to follow the artist's brush strokes (and occasionally finger tracks) on the surface of the painting. Specks of dirt will be evident here and there, along with dust or hair that the painter has not taken the trouble to remove, and the viewer will also be able to see the relief effect formed by the superimposition of paint layers.

This method of painting astonished, seduced and occasionally outraged Rembrandt's contemporaries. It became a trademark of his studio, a kind of three-dimensional signature on works produced by the master or his assistants. Rembrandt's unique touch thus had a 'promotional' effect, of whose value he was no doubt well aware. In addition to this 'trademark' effect, however, Rembrandt's method of handling the painted surface had another important justification. Although it clearly precluded his works from being valued for their meticulous finish or for the length of time it took to create them, it did emphasize their plastic, material dimension and reveal something of the process involved in their making, thus prompting the viewer to appreciate the incomparable skill of the hand that created them.

THE APPARENT TRIUMPH OF THE ARTIST–COURTIER

Artists differed in more ways than in their attitude towards the purpose and means of their art. Just as important were contrasts in lifestyle – not only between individuals but also between regions and cultural climates.

Official positions: court painters and other salaried artists

The tendency among artists towards greater erudition and more respectable behaviour compared with the previous era led to the role of court painter or court sculptor becoming even more closely associated with the role of courtier. Conscious of the advantages of having at their disposal talented individuals who could glorify their reign through art, princes went to great expense to attract the best artists. Popes, emperors and kings

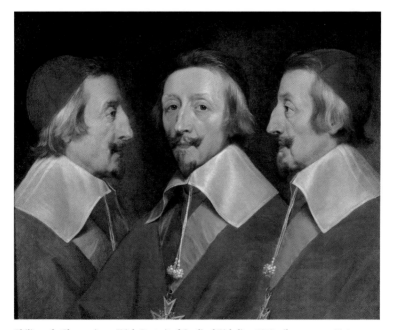

Philippe de Champaigne, *Triple Portrait of Cardinal Richelieu,* 1642, oil on canvas, 58.4 x 72.4cm, London, National Gallery.

managed to retain their services through a variety of means: ennoblement, gifts of great material or symbolic value, generous allowances and other special favours of one kind or another.

The Antwerp painter Anthony Van Dyck, who had been presented by Archduchess Isabella Clara Eugenia with a gold chain worth 750 florins and paid an annual salary of 25 florins while still in his twenties, entered the service of Charles I of England in 1632. Provided with board and lodging by the Crown and paid a salary of £200 a year (not including the fees for the pictures he painted both for the king and for various private individuals), Van Dyck was showered with honours. He was knighted less than four months after his arrival, awarded the title 'principalle Paynter in Ordinary to their Majesties', invited to the king's summer residence at Eltham and visited on several occasions by the sovereign at his London home.

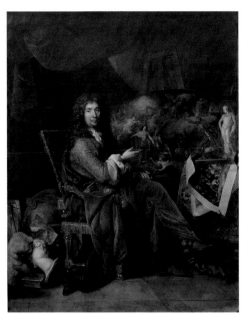

Nicolas de Largillière, *Charles Le Brun*, 1686, oil on canvas, 232 x 187cm, Paris, Musée du Louvre.

Incredible as it may seem, the sculptor Bernini enjoyed an even more enviable position. At barely 25 years of age, he was showered with privileges by Pope Urban VIII, who had already noticed his talent and encouraged his early efforts when still Cardinal Barberini. Monarchs and statesmen throughout Europe vied for Bernini's favour. To thank the sculptor for a marble bust that he made for him (based on Van Dyck's triple portrait), Charles I is supposed to have slipped a handsome diamond ring from his finger and given it to Bernini's representative with the words: 'Crown the hand that has made such a fine work.' Mazarin, a rising star at the court of Louis XIII, considered summoning the sculptor to Paris. He took the initial step of commissioning from Bernini a bust of his political patron Richelieu, based on a triple portrait (front view and left and right profiles) by Philippe de Champaigne. Bernini was eventually brought to the French court by Colbert under the reign of Louis XIV. He was commissioned to produce designs for an extension of the Louvre and was showered with more honours during his stay in the French capital than any other artist had been.

A few years later, CHARLES LE BRUN also enjoyed remarkable success at the court of the Sun King. He came to the monarch's attention in 1660 with *The Family of Darius before Alexander* and soon became the king's favourite painter. He was given a generous salary, promoted to the position of 'First Painter to His Majesty' in 1662 and ennobled the same year, made secretary (1661) and then director (1683) of the Académie Royale de Peinture et de Sculpture, made director of the Gobelins tapestry works and put in charge of decorations for the new palace at Versailles.

The example of Velázquez

Velázquez's career at the Madrid court provides another example of the brilliant success of a painter who chose to enter the service of a royal patron.

Velázquez, who belonged to the gentry, trained in the humanist workshop of Francisco Pacheco, where he was given a grounding in classical culture by his master. Filled with a sense of the dignity of his art and familiar with the Italian tradition thanks to a stay in Italy from autumn 1629 to the beginning of 1631, Velázquez was valued greatly as

The illustrious academies

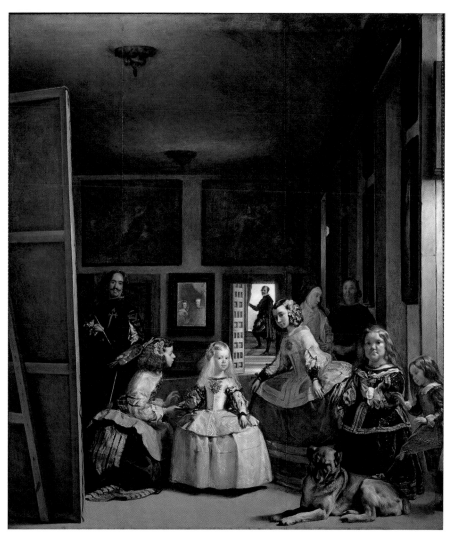

Diego Velázquez, *Las Meninas*, 1656, oil on canvas, 318 x 276cm, Madrid, Museo Nacional del Prado.

a conversationalist by the king, Philip IV, who had a lifelong passion for the arts. Indeed, given the stagnation into which Spanish painting had fallen at that time, the young painter was the king's only contact of any quality with the art world. Made 'Painter to the King' in 1623, it was not long before he acquired honours, offices and wealth. Magnificently accommodated (from 1655 in apartments that occupied three floors of a wing of the Alcazar Palace) and looked after free of charge by the king's physician, Velázquez accumulated titles that placed him on familiar terms with the monarch: Gentleman Usher in 1627, Gentleman of the Wardrobe nine years later, Gentleman of the Bedchamber in 1643, Superintendent of Royal Works in 1648 and eventually Palace Chamberlain, one of the most important appointments in the royal household.

This exceptional career, together with the artist's unique skills, earned Velázquez an elevation to the prestigious Order of Santiago in 1659 (at the end of his life), in the face of bitter opposition from the nobility. In *LAS MENINAS*, Velázquez shows himself at work painting the young Infanta, Margarita, and her attendants. He positions himself next to the princess almost as if he too were a member of the *familia* of Philip and Maria Anna (who are reflected in the mirror on the back wall). Tradition has it that the red

Bernini, *Bust of Louis XIV*, 1665, marble, life-size, Musée National du Château de Versailles.

cross of the Order of Santiago was added by the king himself after the artist's death 'in order to encourage other practitioners of this extremely noble art'.

Reality: disillusionment with the model of court artist

Van Dyck, Velázquez, Bernini and Le Brun, who died in 1641, 1660, 1680 and 1690 respectively, were the last great artist-courtiers. After them, David alone (and then only for part of his career) briefly resurrected the model of the court painter who received almost all of a ruler's commissions – Napoleon I's in this case – and reaped the honours and rewards that came with them.

During the 17th century there developed a disaffection with the notion of a career in the service of a princely patron. The reasons for this could be found in the life and experience of those very artists who were most pampered by the great and good. The price paid by Van Dyck, Velázquez, Bernini and Le Brun for their dazzling careers was a loss of freedom that affected what was most dear to them: their art. Being a superintendent of works may have been Le Brun's true vocation, but the others suffered as a result of having their genius channelled in specific directions. Nevertheless, Bernini must have benefited from the rapidity with which the papal throne changed occupants, since this gave him fairly wide room for manoeuvre. Only under the reign of Urban VIII (1623–44) did he have to submit to the demands of an overbearing patron who granted him permission to work for others only on rare occasions.

Indeed, Bernini had only one disappointment in life: his trip to France. Envied by the French artists whose talent he called into question (in particular the architects Louis Le Vau, François Mansart and Claude Perrault, who was also a physician), he failed to win acceptance for his designs for the remodelling of the Louvre (which Colbert himself considered too expensive). And while his *BUST OF LOUIS XIV*, with its billowing cloak, received official acclaim, it was quietly criticized by spiteful courtiers and artists. The engraver Robert Nanteuil found fault with the pupils of the eyes in the bust, which he claimed gave the king a squint, and with what he considered to be the excessively large curve of the left cheek. Others expressed surprise that the sculptor had not shown the king's hair, where it falls onto his forehead, as he actually wore it. After this 'defect' had been put right by removing several centimetres of marble around an added strand of hair, they expressed their indignation that Bernini had made the arch of the king's eyebrows too prominent. Bernini's equestrian statue of the Sun King, delicately modelled in clay before being finished in marble by his assistants after the sculptor's death, met with even less success. Having been transformed into a statue of the mythical Roman

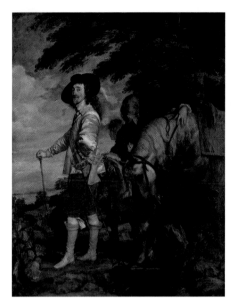

Anthony Van Dyck, *Charles I at the Hunt*, c.1635–8, oil on canvas, 266 x 207cm, Paris, Musée du Louvre.

hero Marcus Curtius, who rode his horse into a chasm, it was relegated in 1687 to a distant corner of the gardens at Versailles.

More serious than these snubs – suffered by a stranger who had arrived in France for a few months to teach the local artists a thing or two – were the pressures that forced Van Dyck in England and Velázquez in Spain to take their art down a route they did not necessarily want to pursue. A history painter as much as a portraitist prior to settling in England, Van Dyck came to the attention of Charles I with his romantic allegory *Rinaldo and Armida* (clearly inspired by Torquato Tasso's *Jerusalem Delivered*), which had been commissioned by the king's agent, Endymion Porter. After arriving in London, however, the king's "principalle Paynter" spent his time almost exclusively painting portraits. These included: the major collection of engraved portraits of the most eminent politicians, scientists, painters, engravers and sculptors of the day, popularly known as the *Iconography* (published in 1641 and 1645); portraits of the king himself, including the highly sophisticated CHARLES I AT THE HUNT (1635–8); and portraits of members of the royal entourage, who belonged to the extremely elegant English aristocracy. Towards the end of his life Van Dyck desperately sought opportunities to paint large-scale historical works. In 1640, a commission for cartoons for four large tapestries for the walls of the enormous Banqueting House (designed by Inigo Jones in 1622) was cancelled by Charles I due to lack of funds. Back in Antwerp, Van Dyck lost out to another artist for the commission (given by the Guild of Arbalesters) to paint a monumental altarpiece for Antwerp Cathedral, and after travelling to Paris in 1641 to try to secure a commission for paintings to decorate the Grande Galerie of the Louvre, he again saw the work go to someone else. After his death Van Dyck was celebrated as an outstanding but specialist artist. The writer on art André Félibien, in his work on the most famous 'ancient and modern' painters, describes Van Dyck as a painter who 'excelled in portraiture'.

Philip IV's patronage influenced not so much the direction taken by Velázquez's art as the volume of work he produced. Throughout his life the painter had a tendency to work slowly. Even in his most productive years, the 1630s, only a small number of paintings came out of his studio. During the last 20 years of his life, the artist worked more slowly than ever. The pictures he painted during this period were all of remarkable quality (for example *The Spinners* and *Las Meninas*, which were among his last works), but they are extremely rare. It seems that in some years the painter did not pick up his paintbrush at all. On average he completed just two works a year during this part of his life.

The reason for this drop in productivity seems to have been the number of administrative responsibilities that Velázquez felt obliged to accept in order to retain the king's esteem and to rise through the hierarchy of the court. At the end of the 1640s, the artist transformed himself into a courtier and a decorator in order to keep the king happy. Between November 1648 and June 1651, another trip to Italy took him to Venice, Modena, Parma, Florence and Rome. His task was to assemble a collection of casts of antique sculpture and original modern works to enrich the royal collections. After returning to Spain, he was required to help the sovereign organize his treasures in the Alcazar and Escorial Palaces rather than resume painting full time. The title of Palace Chamberlain, bestowed on him in 1652, may have been welcome as a formal acknowledgement of

this role, but it also imposed additional obligations. Responsible for every aspect of the royal apartments, Velázquez had to manage the household staff in that part of the palace, anticipate needs and order wood to last through the winter, and oversee the removal of furniture and the comfortable installation of Philip and his entourage whenever they moved from one palace to another.

CHOOSING FREEDOM: ARTISTS OUTSIDE THE COURT

A number of other artists – contemporaries of Van Dyck and Velázquez or their seniors by a generation at most – achieved success without relinquishing their freedom. Peter Paul Rubens and Nicolas Poussin are two examples.

Rubens: independence above all else

Rubens, who was recognized as a man of culture and refined manners and who had a fondness for fine clothes and comfortable living, had several opportunities to take up a permanent position in a royal household. Early in his career he served the Duke of Mantua for a number of years. He was then approached by Archduke Albert and his wife the Infanta Isabella Clara Eugenia, who invited him to Brussels, gave him a gold chain hung with a medallion struck in his honour and paid him an annual salary. Later he attracted the favour of Marie de Médicis, mother of the French king, who commissioned from him a series of paintings to decorate the gallery of the Palais du Luxembourg. He was also held in high esteem by the courts of Spain and England, having served as a diplomatic intermediary between the two countries on an issue of considerable political importance (the restoration of peace) – not sent simply to paint the portrait of a princess considered a potential spouse, as a painter of the 14th and 15th centuries would have been.

On none of these occasions, however, did Rubens seek to extend his stay at court beyond what was strictly necessary. He preferred to be lord of his own manor (the house he bought in 1616 on the Wapper in central Antwerp), surrounded by his collection of carved precious stones, statues and paintings. It seems likely that the painter's reservations concerning the life of a courtier stemmed from unhappy experiences that had wounded his pride early in his career. As a young painter, he was sent to Spain for the first time in 1603 by Vincenzo Gonzaga to accompany some paintings that the duke wished to present to the king and his family. Rubens was offended at being treated like a simple messenger and being refused an audience with King Philip III. Later, when on a diplomatic mission between August 1628 and March 1630, he came up once again against the reservations of the Spanish nobles and the king himself, who were loathe to regard a painter as a genuine political intermediary. Perhaps he had got wind of Philip IV's letter to his sister Isabella, in which he reproached her for her choice of chargé d'affaires: 'I find it appropriate to inform Your Highness of my deep regret that a painter has been chosen to handle such important matters. It is a cause of great discredit to this monarchy and loss of consideration that a man of such little consequence should be appointed as the minister to whom ambassadors are required to put propositions of such import' Aware that neither services rendered nor his artistic genius counted for anything in the face of aristocratic prejudice against humble birth and the stain (as the nobility saw it) of a manual occupation, Rubens remained extremely wary for the rest of his life of becoming too closely involved with the nobility. Unburdening himself to his friend, the scholar Peiresc, in 1630, he explained why he was marrying a merchant's daughter: 'Finding myself not yet ready for the celibate life of a bachelor, I resolved to marry again ... I have taken a young wife from a respectable but middle-class family despite the attempts of all to persuade me to marry into the nobility. I feared the vanity which is the common vice of the nobility, above all among the fairer sex, and therefore chose a woman who would not blush to see me pick up my paintbrush. And to tell the truth, I would have found it difficult to trade my beloved freedom for the embraces of an older woman.'

Poussin: the attractions of Italy

Poussin was even keener than Rubens to avoid the hustle and bustle and pomp of court life. He chose instead to live in a modest house on the Via Paolina in the artists' quarter of Rome with his wife, who was the daughter of a cook, and their one and only servant, a modest and discreet attendant who was preferable in Poussin's eyes to the crowds of servants that thronged round the mighty.

This home-loving man was in the habit of turning down commissions for altarpieces that would result in too much exposure. Nevertheless, he found himself obliged, at the age of 45, to obey orders from Louis XIII, his minister Richelieu and the Superintendent of Buildings, Sublet de Noyers, to return to France to serve the Crown. After months of prevarication – during which he objected in vain that he was in frail health, that he had a young wife, that it was the wrong time of year or else too hot or too cold to undertake the journey – he finally had no option but to comply. Accompanied by two cousins of Sublet de Noyers, Roland Fréart de Chambray and Paul Fréart de Chantelou, who had been sent to Italy with the express purpose of making sure he set off for France, Poussin finally arrived in Paris in mid-December 1640 after a journey of just over two weeks. He was enchanted during the first few weeks of his stay by the consideration he was shown and the honours bestowed on him (elegant and comfortable apartments and the title of 'First Painter in Ordinary', which gave him precedence over Simon Vouet, his former fellow student in Rome) as well as by the financial rewards he was paid, the value of which he appreciated only too well as a son of Normandy.

After a while, however, the sheer volume of tasks he was given and the modest character of most of the commissions, unsuited to a talent such as his, started to displease him. Having adopted the custom years before, in Rome, of working alone and at his own pace on easel paintings of fairly small dimensions and with a sophisticated intellectual content, he found himself in Paris burdened with commissions as diverse as painting large altar pictures, decorating ceilings and chimney breasts, and designing tapestries and frontispieces to books. It was not long before Poussin felt overwhelmed. His enthusiasm dwindled. He began to complain that he had no time to himself and was producing nothing of quality. It is thought that he was considering leaving as early as summer 1641, but it was not until July 1642 that he summoned up the courage to ask for permission to absent himself from the court. At the end of September, giving the excuse that he wished to go and fetch his wife (whom he had left behind in Rome), he left Paris never to return.

THE PAINTER IN SEARCH OF HIS PUBLIC: THE COMMERCIALIZATION OF ART

Rubens and Poussin are, exceptionally, examples of artists who managed to preserve their independence from patrons without suffering materially as a result of lost commissions.

Volume production or rarity value?

The secret of Rubens's success lay in the way he organized his studio. Systematizing the technique used by Titian, the Antwerp master gathered a large number of talented painters around him (including Jacob Jordaens, Frans Snyders, the three Teniers and even, for a while, Van Dyck) who 'mass-produced' paintings from the master's sketches and in the master's style. Otto Sperling, physician to King Christian IV of Denmark, who visited Rubens in 1621, described the process as follows: '[In the studio] were a good number of young painters, each working on a different painting for which Mr Rubens had provided them with a pencil sketch with a few coloured highlights here and there. The young people were expected to work up these models to a state of completion, at which point Mr Rubens would add the finishing touches, altering this or that detail. Each of these paintings was then held to be a Rubens, and not content to accumulate a vast fortune by

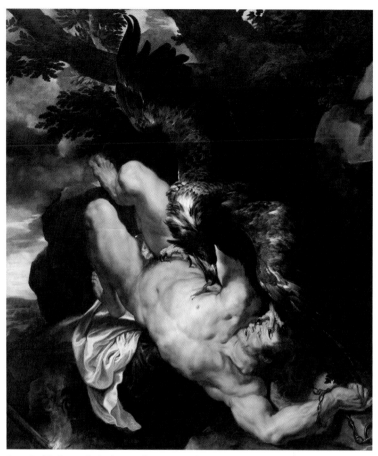

Peter Paul Rubens, *Chained Prometheus*, 1612, oil on canvas, 242.9 x 208.6cm, Philadelphia, Philadelphia Museum of Art.

these means, this man saw himself showered with honours and extravagant gifts by kings and princes.'

This highly organized undertaking was clearly extremely efficient. Uniformity of style was achieved by the use of sketches in the master's hand, by using autography to make precise reproductions of the figures, which RUBENS often chose to paint himself, by the adoption of a common bodily canon (notably fleshy women) and by the employment of a special technique involving the application of pigment over warm brown grounds in thick, oily layers with wide brushes, while restricting the palette to a few main colours: white lead, yellow ochre, madder, ultramarine and bitumen, plus occasional highlights in light, opaque yellow, vermilion and black. The work's quality was guaranteed by the careful selection of assistants, who were always highly talented. The master's own rapidity (he is supposed to have painted *Village Fair*, which hangs in the Louvre, in a single day) increased his studio's ability to respond quickly to commissions. Productivity was great, demand even greater. Between Rubens's earliest completed works, dating from 1599, and his death in 1640, no fewer than 1,300 oil paintings came out of the master's studio, not to mention a vast number of engravings, sketches and drawings.

Poussin, by contrast, produced relatively little and worked alone, resembling Vermeer rather than Rubens in this respect. Having stopped accepting major commissions that would have allowed him to exhibit in public places, and having learned his lesson from his unhappy time as a painter-courtier in Paris, he maintained a remote relationship with his clients, particularly where his French collectors were concerned. This remoteness was

The illustrious academies

further increased by geographical distance (from these French collectors) and the slowness with which he worked. However, this slowness and his withdrawal to a distant city only served to increase his prestige and whet the appetite of *les curieux* (the curious) – as French art lovers were known at the time – for his rare paintings. Poussin had a tight-knit, well-informed group of enthusiastic admirers in Paris and Lyons. In addition to the two Richelieus (the cardinal and later the duke, his grandson), this circle included Louis Phélypeaux de La Vrillière, Etienne-Charles de Loménie de Brienne, Paul Fréart de Chantelou and, after the artist's trip to Paris, Jean Pointel and Serisier. Although these men (royal advisers or members of the haute bourgeoisie with important public positions) generally possessed works by other painters too, their main passion was for the work of Poussin, the Norman in Rome, whose paintings and drawings they considered to be the gems of their collections. The enthusiasm of these admirers was further fed by a long correspondence that Poussin carried on with certain members of the group, who over the years became friends rather than patrons. After his death, Poussin's reputation was enhanced even further due to praise from the pens of writers such as Bosse (1649) and Félibien (1685) – and this at a time when there was no tradition in France of public eulogies for artists.

The pitfalls of freedom: Rembrandt's bankruptcy

Poussin's strategy – based on the rarity and hence the increased value of works that he designed at his own pace and executed entirely by his own hand – contrasts markedly with Rubens's equally successful strategy of *fa presto* (rapid execution) and mass production (albeit a high-quality form of mass production). Doubtless reflecting the temperaments of the two artists, these radically different approaches allowed both of them

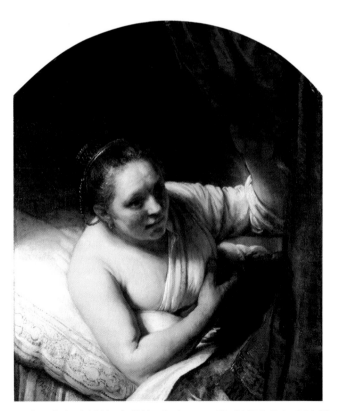

Rembrandt, *Sarah Waiting for Tobias*, also known as *Hendrickje in Bed*, c.1649–50, oil on canvas, 81.1 x 67.8cm, Edinburgh, National Gallery of Scotland.

to escape the restrictive life of a court artist while at the same time avoiding the need to sell their work or have intermediaries do so on their behalf. Remarkably little is known about the price of Poussin's paintings, while Rubens's prices were discretionary – he named a price and there was no question of a potential client trying to haggle. One of the agents of the English collector Sir Dudley Carleton wrote to his master in 1620: 'I broached the subject of price with him with the greatest possible discretion, but his demands are like the laws of the Medes and Persians, which cannot be repealed.'

Rubens and Poussin were exceptions, however. Their backgrounds – a long line of tradesmen in the case of Rubens and the atavistic Norman instincts of Poussin – probably helped them to avoid the dependence of the artist-courtier on the one hand and the 'vulgarity' of being a salesman for their own work on the other. But for the majority of artists the dilemma of choosing between the freedom to paint and dependence on a clientele could not be resolved so easily.

Rembrandt, like Rubens, was for many years the head of an important studio. Just as socially ambitious as the Flemish painter, in 1639 he bought a fine house on Breestraat, into which he crammed his collection of objects. But conditions in the Calvinist United Provinces were very different from those in Catholic Flanders, where Rubens lived. The lack of religious commissions and of the opportunity to attach himself – even temporarily – to the princes and sovereigns of Catholic Europe who would be able to provide him with such commissions meant that Rembrandt found himself restricted to a type of painting whose limitations were a cause of frustration. Masterpieces such as his two paintings with the title *Anatomy Lesson* or *The Night Watch* (see p.127) were the results of his attempts to infuse these portraits with a sense of myth. This may have been difficult for the Dutch burghers who commissioned the paintings to understand; after all, they simply wanted to be portrayed as accurately as possible. It is not hard to imagine the awkward situations that must have arisen on occasion – as, for example, with the difference of opinion between REMBRANDT and a Portuguese client named Andrada, who demanded in vain that the painter retouch a portrait which he considered bore only a slight resemblance to him. Little by little, partly as a result of the economic depression into which the country fell in 1650 and perhaps partly because of the damaging effect of his cohabitation with Hendrickje on his reputation, commissions started to dry up. Rembrandt was unable to curb his extravagance and was pronounced bankrupt in 1656. He was banned from engaging in business and from taking on any sort of financial responsibility. He did not end his days in poverty, however. He moved into a more modest home, and a special financial arrangement within the family allowed him to claim to be employed by Hendrickje and his own son, Titus, in a business they had set up dealing in artworks and curios. This permitted them to carry on selling the painter's work.

Northern European painters: the first art dealers

Rembrandt's situation is revealing in two ways. It shows that however great an artist's talent, the profession of painter or sculptor did not guarantee success, and in particular financial success, on a permanent basis. In northern Europe more than anywhere else, the extraordinarily large number of painters and the particular nature of the demand – which was enormous but limited to the production of small-format pictures in specialist genres (portraits, landscapes and still lifes) – all too often made the artist's existence a difficult one. Competition was fierce, prices low and major commissions rarer than in southern Europe. While Rembrandt had been wealthy before his financial setbacks, Vermeer led a modest existence, living in a comfortable house, but one he did not own (it belonged to his mother-in-law before passing to his wife).

The career of Frans Hals, a portrait painter and member of the Protestant elite of Haarlem, ended dramatically in poverty. Until the mid-1640s, Hals thrived on major commissions for group portraits and held various high-ranking positions in the guild of painters, but in the 1650s his fortunes changed. He was ruined by the mismanagement of his financial affairs, his effects were seized in 1654, and in 1662 he had to ask for help from the municipality. The following year he was awarded an annual stipend of

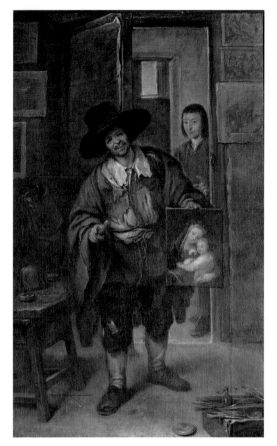

José Antolinez, *The Picture Seller*, after 1670, 201.5 x 125.5cm, Munich, Alte Pinakothek.

200 florins for life. Other artists were reduced to supplementing their meagre incomes by carrying on other trades. Joris van Lier was a Delft painter a generation older than Vermeer. After starting his career with a trip to Italy in the time-honoured way, he eventually came to specialize in still lifes. In addition to painting he worked as a notary's clerk. The enormous difficulty he encountered in selling his paintings disheartened him in the end and he abandoned art altogether to become a tax collector.

It is worth noting that Rembrandt, despite being a painter and the head of a workshop, never felt any shame in dealing in art. At the beginning of his career he worked for the dealer Hendrick van Uylenburgh, becoming so close to him that he married his cousin. Rembrandt collected objects not only because they appealed to him personally but also because he could sell them. The setting up of an art business by his mistress Hendrickje and his legitimate son, Titus, towards the end of Rembrandt's life underlines this commercial aspect of his career.

In northern Europe, most artists were dealers as well as painters or sculptors. In 1627, Rubens, a great collector of both antique and modern works of art, sold almost his entire collection of ancient statues to the Duke of Buckingham and invested the money in land and rental property. It is also known that Vermeer worked as an art dealer, albeit on a small scale.

An alternative to the shop:
private showrooms and galleries

In southern Europe and in England during the 17th and particularly the 18th centuries, the situation was more varied. On the one hand, the aristocracy remained a greater force than in the United Provinces, with the result that patronage continued to play a key role, at least during the early stages of an artist's career. On the other hand, the Catholic Church continued to be an important client. This meant that the ambition of most painters was not to sell one small work after another but to land themselves a commission for a large altar painting or some other religious painting which would occupy a prominent position in a busy church and thus attract further commissions.

Furthermore a change was occurring, particularly in France at around the time that the Académie was founded, whereby the distinction between artists who 'peddled their own wares' and those who (at least in an ideal sense) painted or sculpted out of love for their art (receiving the thanks of delighted clients who were able to appreciate their talent and the time they had devoted to their work) became even more clear-cut. Thus, in his

petition to the king, Martin de Charmois asked that anyone who ran a shop be prohibited from calling himself a painter or sculptor. There was doubtless a good deal of hypocrisy in this. Whether they belonged to the guild (whose members were allowed to deal in art) or the Académie, artists had to earn a living, and in reality it was fully acknowledged that they had no need to limit themselves to salaries and privileges – which were growing in number but still only benefited a minority of artists – provided they sold only their own paintings and went about it discreetly. In 17th-century France, therefore, transactions tended to be carried out not in workshops that opened onto the street, but in the upper rooms of the house in which the artist worked or in a room disguised as a sitting room adjoining the artist's studio (as in the room in which Poussin painted himself in the Louvre self-portrait, which was probably at the back of the courtyard of a private mansion or at the top of a building).

The same arrangement was usual in 18th-century England. The most famous artists maintained a showroom – a sitting room or private gallery – next to their studio. During the second half of the 18th century, Joshua Reynolds had his studio in Leicester Fields in London. The painter showed his own paintings here, taking care to recreate the hushed atmosphere of a private apartment. He also offered curios and old masters for sale, the latter in order to increase the prestige and therefore the price of his own work. Angelika Kauffmann, a Swiss painter who settled in London in 1766, also maintained an exhibition room next to her studio in Suffolk Street, not far from where she lived. She described the arrangement as follows: 'I have four rooms, one in which I paint, another in which, in keeping with the custom here, I hang my finished paintings ... People come and sit here – to visit me or to see my pictures; it would be out of the question to receive the public in a room which was not handsomely decorated.'

Art dealing in its early days – to be exploited or scorned?

In these salerooms disguised as private exhibition spaces, the works on sale were principally those of the artist himself but could also include the work of other painters or sculptors, particularly the old masters. Even the most famous artists, who occupied the top positions in the various academies, engaged in commercial activities of this sort, whether by exhibiting in their own 'sitting rooms' or by some other means. In France, Le Brun, 'first painter' to the king, played the role of intermediary in the sale to Louis XIV in 1684 of a *Circumcision* attributed to Giulio Romano. A few years later, Pierre Mignard formed a discreet partnership with the painter-dealer François Garrigue for the purpose of selling paintings by the Carracci brothers and Guercino to aristocratic art lovers. In England, in one year alone (1686) the landscape painter Thomas Maby sold 168 paintings which he had bought in Italy expressly to sell on at a profit. There are many other cases in which it is suspected that artists were indulging in commerce on a similarly large scale, even if there is no direct proof. Inventories of the possessions of Nicolas Loir and Claude Deruet after their deaths show that they each owned several hundred pictures by other artists – hoards too large to be simply their own private collections and more likely to be stocks of goods destined for sale.

Nevertheless, those artists who were furthest removed from mercantile activities gradually started to assert themselves. In the 18th century, a small number of reasonably prominent artists chose to market their works directly, availing themselves of the latest publicity and sales techniques. In 1726, the animal painter Jean-Baptiste Oudry put an advertisement in the press announcing that he had presented the king with a number of paintings by his own hand, that the king had liked them and that prints were to be made of the said pictures. Later, at the end of the century, Joseph-Marie Vien, a member of the Académie, announced, also through a newspaper advertisement, that art lovers could come and admire a canvas ceiling-piece depicting Zephyr and Flora as well as a number of small paintings designed to please collectors. Van Loo in 1763 and Greuze in 1777 did something similar, inviting the public to come and admire their work (two paintings featuring perspective in the case of Van Loo; *The Father's Curse* in the case of Greuze). In 1800, David took an even bolder step. Having decided to exhibit his paint-

ing *The Intervention of the Sabine Women* publicly, he advertised the event in the press, warning that an entrance fee would be charged.

Generally speaking, however, it was only artists of lowly status who adopted commercial techniques of this kind to sell their work. The purpose of most advertisements of an 'artistic' nature was to inform potential clients that a specialist was employing a rare and interesting technique (painting on silk velvet or on hair, for example) or to tell them about a remarkable invention (a new type of pencil, perhaps). The workshops and stalls of humbler artists were often located on bridges and at fairs, where there was plenty of passing trade, and were often manned by the artists themselves. In the worst cases, they resorted to hawking their works on the street and in taverns.

The Salons: bringing art to a wider public

These, then, were the practices of lowly artists. They were openly despised by 'real' artists, and their work and ambitions had little in common with those of the more sophisticated painters and sculptors who were thirsty for official recognition. Public art exhibitions, held at regular intervals in France (the Salons) before gradually spreading to other countries, provided an opportunity for this distinguished group, whose members were not necessarily wealthy, to show their works to a wide public.

During the same period, the proliferation of private collections, which might fill several large rooms in a gallery or take up somewhat smaller amounts of space within private dwellings, created the need for a system of marketing works of art. A change in mentality had led to private collections becoming more widespread. In the 17th century, a number of great lords, including Gaston d'Orléans, the Duc de Richelieu and Chancellor Séguier, enlightened financiers such as the businessman Nicolas Fouquet (whose career ended in disgrace) and the German banker Jabach (famous for having bought up some of the paintings of the deposed Charles I), as well as other members of the elite such as the scholarly Paul Fréart de Chantelou, were keen to forge close links with the artists whose work they collected. In the 18th century they were joined by a great number of the bourgeoisie. These middle-class collectors decorated their homes with paintings because it was the fashion rather than out of a love of art. They were happy to go and see works on show in the gallery at the Louvre, where the first Salons were held,

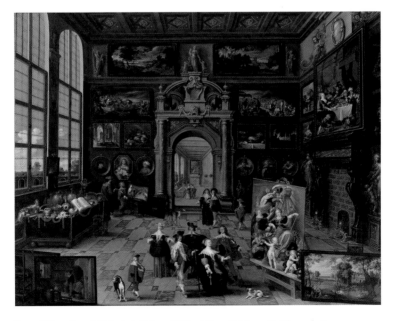

Frans II Francken, *A Collector's Gallery*, 115.5 x 148cm, Salzburg, Residenzgalerie.

The Salons and the beginnings of art criticism

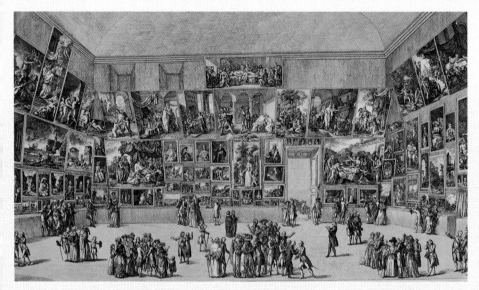

Precise View of the Arrangement of Pictures at the Salon du Louvre in 1785, engraving, Musée National du Château de Versailles.

The term 'Salon' refers to the periodic exhibitions of work by living artists held in France from the 17th century to the beginning of the 19th. It was taken from the name of the room in the Louvre Palace (the 'Salon Carré') in which these exhibitions were held during the 18th century.

A regular event

Originally called for by Colbert at the time of the Académie's founding, the event – known initially as the 'Exposition des Peintres et Sculpteurs de l'Académie Royale' – was officially instituted in 1663 and held for the first time in the gallery of the Palais-Royal in 1667. The Salon was held every two years until 1675, then only intermittently before becoming a regular event again in the 18th century (annually from 1737 to 1748, excepting 1744, then biennially from 1748 to 1791). Entry was free.

A growing success

Up until 1791, the Salon opened on 25 August and lasted for a month. The number of works on display gradually increased over the years. Around 800 paintings and sculptures were shown at the Salon of 1791, organized by the Assemblée Nationale. The exhibited artists were either members of the Académie or specially approved by it. Only later, from 1798 onwards, was access to the Salon open to everybody, subject to selection by a jury. Painters and sculptors could submit more than one work. A committee was set up in 1748 to assess the submitted work's moral suitability and to attempt to uphold the tradition of history painting in the light of a proliferation of genre subjects and smaller-format pictures.

The first catalogues

The Salon laid the foundations for the modern-day art exhibition. The 1673 exhibition saw the publication of the first catalogue (known as a *livret* or booklet), which provided 'explanations' of the works on show. This was an enormous success despite not being free. In 1787, almost 22,000 copies were sold, providing further proof of the enormous popularity of the exhibition – it is thought that four times as many as this number may have visited the show in total. The hanging of pictures is a job requiring much care and thought, and in the 18th century it was entrusted to painters. The idea of the Salon caught on in England too, but not until much later: the Royal Academy did not hold its first exhibition until 1769.

The beginnings of art criticism

The Salon also led to the first examples of art criticism. Following on from the seminal essay *Réflexions sur l'État Présent de la Peinture en France* (*Reflections on the Current State of Painting in France*) composed in 1747 by La Font de Saint-Yenne, Denis Diderot wrote reviews of the nine Salons held between 1759 and 1781 for the *Correspondance Littéraire*, edited by his friend Melchior Grimm. Taking pains to describe the works as precisely as possible, as he was writing for readers outside Paris, who therefore could not see the paintings and sculptures in question, Diderot invented a language appropriate to his subject and created a framework for the judging of art based on the following criteria: 'unity, variety, contrast, symmetry, organization, composition, figures and expression'.

The illustrious academies

Petronella de la Court's Doll's House, detail, c.1670–90, wood with miniature objects, Utrecht, Centraal Museum.

but they had neither the time nor the inclination to seek ongoing relationships with artists. In order to provide a link between painters and sculptors and this new public, a group of specialist middlemen emerged and gradually grew in number. The 'painter-salesmen' or dealers in second-hand goods to whom the most modest artists were sometimes forced to entrust their work were replaced by elegant businesses – specialist firms that often built up considerable resources and sometimes operated internationally.

Specialist dealers

It was initially in northern Europe – in the United Provinces (especially Amsterdam, where Gerrit van Uylenburgh dealt in art on a large scale before eventually going bankrupt in 1675) and Flanders (particularly Antwerp) – that dealers succeeded in making their fortune. Further south, particularly in France, the art trade was slower to develop. The first dealers of any substance in Paris were Flemish and emerged in the 17th century. One

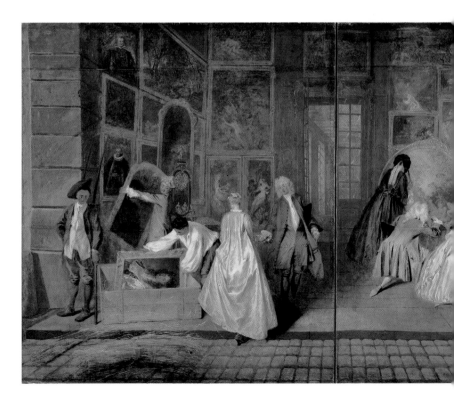

such was Jean-Michel Picard (1600–82). Picard was a true entrepreneur and one of the most active picture dealers in the French capital. He bought work from artists in their studios, imported paintings from abroad and employed artists to paint pictures of particular subjects, both originals and copies of older works. His merchandise was varied, extending from small devotional images via landscapes and genre scenes of mediocre quality to religious or history paintings by artists as famous as Van Dyck and Rubens. Picard was linked to the art world by his original occupation (he was a flower painter), but many other dealers of the day were not themselves artists. Alfonso Lopez, a Spanish Jew who settled in Paris in 1604, was a diamond cutter and dealer in gold and silverware who diversified over the years and ended up acting as an intermediary for some very prominent figures. It was he who bought Raphael's portrait of Baldassare Castiglione when it came up for auction in Amsterdam in 1639. The picture subsequently passed into the collection of Cardinal Mazarin.

It was in the 18th century, however, that art dealers truly came into their own. These unashamed capitalists – for example, Gersaint and Mariette in Paris – had considerable resources at their disposal and gradually replaced artists not only as marketers of their art but also as experts on works from the past. It is significant that one of the most important French works of the 18th century depicts a business of this kind: GERSAINT'S SHOP SIGN, painted by Watteau in 1721 for the dealer in prints and paintings of the same name, who opened his shop 'Au Grand Monarque' on the Pont Notre-Dame in 1718. Finished just a few months before Watteau's death, the work has assumed the status of an artistic legacy. By inviting the viewer to enter an art dealer's well-stocked premises, it is setting out the new reality of an artist's life – a life which for better or worse would now be lived out almost exclusively in the studio, devoid of contact with customers who were no longer patrons and whom the painter or sculptor would only rarely get to know.

Antoine Watteau, *Gersaint's Shop Sign*, 1721, oil on canvas, 166cm (an 11cm-wide strip has been added to the top) x 306cm (originally curved and of a different format), Berlin, Charlottenburg Palace.

Salon stalwarts and 'refusés'
19TH CENTURY

At the beginning of the 19th century, artists were seen predominantly as men of learning whose role was first to acquire, and then to pass on, the principles of beauty and good taste. During the second half of the century, this image became muddied. The emergence of artistic personalities who enjoyed scandal and cultivated a Bohemian existence resurrected the figure of the unconventional genius whose talent thrives on a disordered life and sometimes on poverty – an archetype almost forgotten during the centuries that had passed since the Renaissance. During this same period, new technology and advances in existing technology led to more and more activities being considered artistic. It was no longer just painters and sculptors who called themselves artists, but also picture and poster engravers (whose services were much sought after by both the press, then undergoing a major phase of development, and the 'advertising industry'), inventors of various objects, designers (although not yet actually called such) and above all photographers, who claimed to rival painters in their ability to imitate reality.

STUDIOS AT THE ACADÉMIE

A major change took place during the course of the 19th century. At the beginning of the 1800s, Academies still reigned supreme throughout Europe. They determined the whole career of a painter or sculptor from training through to success and recognition; they awarded prizes, accepted or refused submissions to the Salons, and assisted with the selection of artists for specific commissions and with the allocation of medals at exhibitions.

The early days of the École des Beaux-Arts

In France, the Académie Royale de Peinture et de Sculpture was dissolved in 1792 at the instigation of a number of its members, including the painter Jacques-Louis David, and reconstituted three years later. During the First Empire (1804–14), it took the form

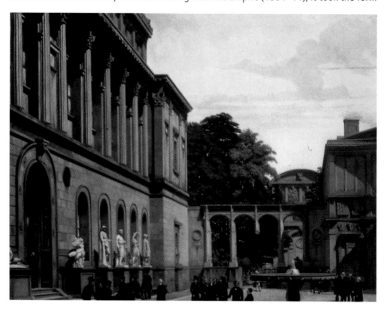

Charles-Léon Vinit, *The Courtyard of the Beaux-Arts in 1840*, oil on canvas, Paris, ENSBA.

of a 'department' of painting and sculpture, which was soon integrated into the new Institut de France – this also comprised departments of history, natural sciences and politics. Despite a succession of different names – Académie des Arts, Académie de Peinture et de Sculpture (under the Second Restoration, 1815–30) and Académie des Beaux-Arts – it remained essentially the same. Made up of members who were elected for life and chosen for their conservative outlook as much as for the perceived greatness of their work, it was the guardian of a notion of art characterized by adherence to tradition. As a result, its roll-call of members includes more names that have fallen into oblivion than great artists, although Antoine-Jean Gros, Jean Auguste Dominique Ingres and Delacroix (who had great difficulty getting himself elected) were academicians.

The Académie continued to play an important role throughout the 19th century. It appointed the juries (composed of its own members) that controlled the Salons, the Prix de Rome and the allocation of public commissions. It therefore directed public taste, formed a link between artists and the state and held the keys to both career and access to the art market.

Officially, the Académie was not in charge of the École des Beaux-Arts. This new state-controlled teaching institution, which was free of charge and obligatory for anyone wanting a successful career, opened its doors in 1819 in the building on the Rue Bonaparte in Paris that had previously housed Alexandre Lenoir's Musée des Monuments Français. It comprised departments of architecture, painting and sculpture. The Académie's member artists prepared pupils for the entrance exam to the École des Beaux-Arts in their private studios. They also, in the same way, provided the practical instruction that was lacking at the École.

During its first few decades, the École des Beaux-Arts was not a place where student artists and sculptors could actually practise their art. They were simply taught there: drawing (of a very rigid kind), theoretical anatomy, perspective and ancient history. Students also came to the École to take the various exams leading to the ultimate honour of the Prix de Rome. It was not until 1863, when reforms were initiated by Viollet-le-Duc, that studios were installed in the school's premises (extended by the architect Félix Duban shortly before) and that the requirement for students to complete their training in a private studio was abolished.

Life drawing in the studio

Up to the 1860s, therefore, a master's studio was still central to a young painter or sculptor's training. It was here that they learned the technical aspects of their art, spending most of their time drawing and painting nudes (male as well as female), an activity that was regarded as the key to success. The models, ordinary individuals whose names for the most part are not known, were paid by the 'pose', which could extend over several days with sessions of up to five hours. The students, who were already paying the master to teach them, clubbed together to remunerate the models. In order to save money, it was not uncommon for newly arrived students to be asked to pose, or for existing students to take it in turns to disrobe, thus acting as free models. Until the middle of the century, the students were all male and so there was no embarrassment attached to these modelling sessions. However, when young ladies gradually began to join the men as students, the question arose of whether only the men should be allowed to draw male models or whether models should be forced to cover up so as not to appear totally naked in front of the women. The atmosphere of the studio, although serious when work had to be done, was also very easy-going. Cheerful disorder would sometimes break out, friendships would be formed, arguments would develop and conflicts arise. The master would look in periodically, comment on the work of the students and then disappear again to get on with his own work. Until 1804 DAVID had three studios at his disposal in the Louvre (shortly to become the Musée Napoléon). Two were reserved for his own use. The one in which he painted *The Intervention of the Sabine Women* overlooked the River Seine; the other, known as the 'Atelier des Horaces' (after his painting *The Oath of the Horatii*), was located in the corner of the colonnade and the northern façade (the current Rue de Rivoli) and directly below it was the students' room.

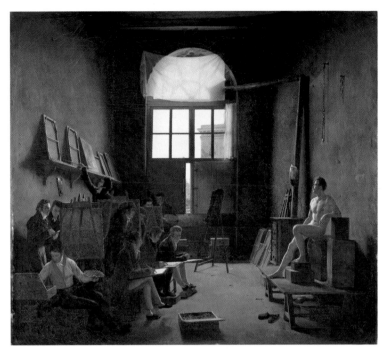

Léon Cochereau, *The Interior of David's Studio*, 1814, oil on canvas, 90 x 105cm, Paris, Musée du Louvre.

Crowning glory: the Prix de Rome

The young people in every studio had a common dream: to win the Prix de Rome at the end of their studies. Almost a hundred years old by the beginning of the 19th century, and destined to survive until 1968, this prize, which granted the winner a stay in the Eternal City, was awarded on the basis of a competition with a set subject. It assumed an exceptional knowledge of ancient history and culture on the part of the students, who had to understand what were often extremely complex subjects. They had to devise a setting for the given subject and enrich it with appropriate accessories that would stand up to the scrutiny of an antiquarian.

After a gap when it was not held and then irregularly held during the Revolutionary period, the Prix de Rome was held annually from 1800. It consisted of three stages. Painters, for example, first of all had to submit to the jury three canvases measuring 130 by 97 centimetres. The best painters were selected and shut away in individual studios for four days and nights, where they had to paint a sketch measuring 81 by 65 centimetres. The finalists, a maximum of 15, then had to complete the decisive test, which was to turn this sketch into a finished painting within the space of three months. The winners were selected by a jury of academicians at a public exhibition of the completed works.

The lucky winners were rewarded with a five-year stay in Rome (reduced to four at the end of the 19th century). In 1803, the Académie de France moved from the Palazzo Mancini, which had become dilapidated, to the Villa Medici, bought especially for the purpose by Napoleon I, on Monte Pincio. It still occupies these premises today. Given free board and lodging and an allowance to cover their day-to-day expenses, the Prix de Rome winners were obliged to follow a work programme almost as demanding as that in force under the Ancien Régime. Like their predecessors, they were expected to make countless drawings of works of antique or Renaissance art in order to become completely immersed in the Classical tradition. They were also required to send back to Paris more substantial pieces of work – paintings or sculptures – to be judged and criticized by the jury assessing their progress.

J A D **Ingres**, *Le Casino de l'Aurore de la Villa Ludovisi*, 1806, oil on wood, 17 x 17.5cm (irregular tondo format), Montauban, Musée Ingres.

The majority of artists, including the very greatest, willingly accepted this programme of work. INGRES, for example, who had trained in David's studio and won the Prix de Rome in 1801 (although he did not actually leave for Rome until 1806 because of the state of the public finances), sent two 'despatches' from Rome in 1808. These were *The Bather of Valpinçon* and *OEDIPUS AND THE SPHINX*.

He later reworked the second of these. The two paintings got different receptions. The *Bather* was highly regarded for the delicacy of its execution, but *Oedipus* was criticized for portraying a naked figure without the moral justification deemed necessary for antique nudes.

Other artists, less convinced of the virtues of Classicism and of a more rebellious temperament, took a few liberties. Indeed, Jean-Baptiste Carpeaux, who won the Prix de Rome in 1856 at the age of 29, spent his entire time in Rome doing the very opposite of what was required of him. In 1858, he sent back the sculpture *YOUNG FISHERMAN WITH A SHELL*, which was obviously, even though freely,

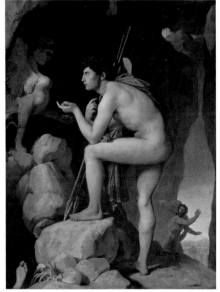

J A D **Ingres**, *Oedipus and the Sphinx*, 1808–25, oil on canvas, 189 x 144cm, Paris, Musée du Louvre.

inspired by the *Young Neapolitan Fisherboy Playing with a Tortoise* (1831) by François Rude, the academicians' bête noire. In 1861, he reoffended by taking the subject for what was to be his first great masterpiece, *Ugolino*, from Dante. Stylistically, this work paid tribute to Michelangelo, who in the eyes of the traditionalists was even more heretical.

England and Germany: working from nature

Elsewhere in Europe – in Germany and especially in England – the education of artists was considerably less strictly regulated.

In London, the Royal Academy of Arts took the form of a body of artists who were elected by co-option. The English academicians organized exhibitions in which they showed their own works and also decided whether to accept works submitted by other artists. In addition they provided courses of a mainly theoretical nature. Henry Fuseli (Johann Heinrich Füssli), a Swiss artist who had settled in London in 1779, taught the history

Jean-Baptiste Carpeaux, *Young Fisherman with a Shell*, 1857–8, plaster, 92cm high, Paris, Musée d'Orsay (in the Louvre).

of painting from 1799 to 1819, and Turner, appointed Professor of Perspective, lectured on this subject between 1811 and 1824 with, it must be said, much difficulty and little success. Unlike its French equivalent, the Royal Academy, although granted a royal charter, was a private institution. This made it less dependent on the artistic policies of the state, but also less influential. As a result, much of the training of future artists fell outside its control.

Turner and Constable, for example, took courses of theoretical instruction at the Royal Academy, but most of their training was done away from any official institution. Turner was taught how to use watercolours by the topographical draughtsman Thomas Mal-

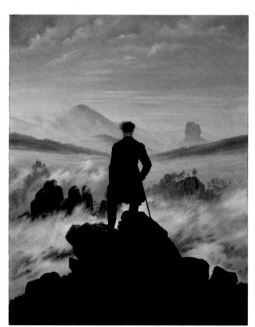

ton, and Constable learned his trade from the little-known painter Joseph Farrington. The two men completed their training by assiduously copying the old masters in the national collections or in the private ownership of their patrons (Sir George Beaumont in the case of Constable). Finally, they both displayed an early desire to work from nature, which they believed was where the eye truly learns to see. Their artistic education was a personal one, in which practice did not replace theory and the antique model but restored them to their proper place as necessary tools rather than ends in themselves.

Caspar David Friedrich, *The Wanderer above the Sea of Clouds*, c.1818, 98.4 x 74.8cm, Hamburg, Kunsthalle.

THE TRAINING OF ARTISTS IN FRANCE: AS CONSERVATIVE AS EVER

At the beginning of the 19th century in France, a number of voices spoke out against the system of training to which artists were subjected.

An ongoing concern: the training of artists

Géricault in particular criticized this training for stifling original talent by subjugating artists to a Neoclassical dogma the influence of which was in any case on the wane. No one disputed, however, that a curriculum of some kind was necessary for training artists. While running counter to the idea of the 'learned painter', the myth (born of Romanticism) of the naturally inspired painter or sculptor, the genius inhabited by the 'queen of faculties', as Baudelaire described the imagination, was certainly not incompatible with the notion of artistic apprenticeship. Even Delacroix, the leader of the Romantics, insisted that his ability to capture his ideal depended on the rigorous training of both eye and hand.

The abiding prestige of the Académie

In terms of training, artists in France were slow to strike out on individual paths. A number of great sculptors, including Rodin and Emmanuel Frémiet, trained outside the École des Beaux-Arts (both of these attended the École Gratuite de Dessin, known as the 'Petite École', a craft and design school), but they nevertheless dreamed of attending this more prestigious institution on the Rue Bonaparte. Frémiet was from a poor family, however, and had to go to work at a relatively young age as a scientific illustrator for osteology books: it was from the scientific ideas of the day that he received his true education. Rodin applied to the École des Beaux-Arts twice and was twice rejected. Among painters, even Courbet (who prided himself on being self-taught) could not dispense with an academic training. He first attended the École de Dessin in Besançon and then enrolled in the Parisian studio of Baron de Steuben, a medal-winner at the 1819 Salon who worked in the Classical style. Manet studied in the studio of Thomas Couture, a Prix de Rome winner and painter of the conventional, grandiloquent *Romans of the Decadence*. Degas trained with Louis Lamothe, who continued the teaching tradition of Ingres and his disciple Hippolyte Flandrin. And Monet attended the Académie Suisse in Paris, where he made friends with Pissarro, who had previously studied at the École des Beaux-Arts.

Classical training: a guaranteed career

The inescapable fact was that the situation of the nonconformists – those rare painters and sculptors who refused to submit to the rules of the schools and competitions – was extremely precarious. In an environment in which artistic activity was thought of in terms of a structured career with rules and rewards, success was for a long time reserved for those who had undergone a rigidly Classical training. This is borne out by the fact that of the 21 winners of the Prix de Rome between 1840 and 1860, 19 were awarded medals in the years following their return from Italy and more than half had work bought from them by the Musée du Luxembourg in Paris, France's first museum devoted to living artists.

In 1806 a great revolution in subject matter took place in Britain. The Scottish artist David Wilkie, friend of Constable and rival of Turner, exhibited 'dangerous' paintings of vernacular life at the Royal Academy. The Prince Regent, whose taste dominated British Art, preferred Dutch 'low life' subjects. He bought two of Wilkie's works – *Blind Man's Buff* and *Penny Wedding* – thus confirming a market for subjects that demonstrated the effect of national events on the lives of ordinary people. This type of subject emerged as a major theme in 19th-century European art.

In Germany, CASPAR DAVID FRIEDRICH was born in Greifswald (northern Germany) in 1774. Not having access to good-quality training locally, he left for Copenhagen, where he studied at the Academy of Fine Art from 1794 to 1798. The same institution also trained Philipp Otto Runge and Georg Friedrich Kersting. Friedrich attended classes in freehand drawing, drawing from antique casts and life drawing. In 1798 he settled in Dresden, taking a studio that he left only to go and draw from nature in the surrounding countryside.

THE TRIUMPH OF OFFICIALDOM

In the 19th century, France was the country to which the rest of Europe looked in matters relating to the visual arts, and the high point of its artistic life was the Paris Salon.

Artists' Journeys : Opening Up New Horizons

Eugène Delacroix, *Encampment on a Plain with a Mountain Range and Studies of Arabs*, drawing, Travel Diary, Paris, Musée du Louvre.

The main change affecting the training of European artists concerned not the way they were taught but the traditional journey they undertook before embarking on their careers. Ever since the 16th century, the main destination of these journeys had been Italy. Those from the southern Netherlands who had made this pilgrimage called themselves 'Romanists' and formed brotherhoods. Artists made these journeys alone, sometimes (as in the case of Rubens) with the aim of entering the service of a nobleman. It was only in Protestant countries that this journey was not obligatory. During the 18th and 19th centuries, the Académie de France in Rome enabled Prix de Rome winners to remain in Italy for a number of years. In the 19th century, however, Italy ceased to be the only possible destination for artists.

Delacroix, Manet and Wilkie

Delacroix, who had trained in the studio of the Classical painter Pierre-Narcisse Guérin and at the academic École des Beaux-Arts, was an admirer of Géricault's Romantic art. In 1825, he decided to travel not to Italy but to London, where Géricault had stayed in 1820–1. Later, in 1832, he travelled through Morocco and Algeria. These countries provided him with visual references of a very different kind to those that inspired preceding generations. In Africa, the Orient came as a revelation to him. He saw it as a direct contrast to Rome, and instead of ruins he believed he had discovered a living antiquity that was the very opposite of the cold, archaeological antiquity that dominated the work of David's disciples. Following his example, a number of other artists travelled to northern Africa. Manet, on the other hand, looked to Spain for inspiration. Although he did not actually visit the country, he spent a long time studying the paintings in Louis-Philippe's 'Spanish Gallery' in the Louvre. One of the greatest experiences in his life was a journey he made to Rio de Janeiro as a sailor, between December 1848 and June 1849, before embarking on his career as a painter. Elsewhere, the Scottish artist David Wilkie revolutionized religious painting by using local Jews and Persians (Iranians) as models for Christ and other biblical figures in his paintings of the Judgement of Pilate and the Supper at Emmaus (although he drew the line at depicting Christ eating his Last Supper sitting on the ground).

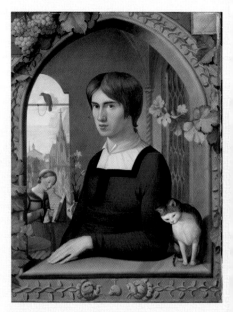

John Constable, *Cloud Study*, 1821, oil on paper laid on board, 25.5 x 30.5cm, New Haven, Yale Center for British Art, Paul Mellon Collection.

Friedrich Overbeck, *Portrait of Franz Pforr*, c.1811, oil on canvas, 62 x 47cm, Berlin, Nationalgalerie.

Constable: an Englishman in the countryside

For all those artists who embarked on journeys of apprenticeship, however, there were others who categorically refused to leave their home countries or even to venture out of their local regions. For example, John Constable, a miller's son, chose to live in the Suffolk countryside at East Bergholt, the village where he was born, and most of his work depicts this area.

When he had to come to London, he chose to live in Hampstead to the north of the city. There he painted not the metropolis laid out at his feet but the clouds around and above it. Later he visited Petworth, home of the art lover and patron Lord Egremont, hoping to indulge his passion for botany in the park. However, he refused to travel to Paris in 1824 or to Lille in 1825 to collect medals he had won for his paintings. He was not reacting to a slight or anything of that kind. He was simply convinced that his art should be forged in the solitary confrontation between nature and canvas, far away from those places where art was merely a social activity. He wanted his day-to-day existence to be filled with domestic events and art in its down-to-earth sense: looking, drawing, painting, correcting, and starting again.

The Nazarenes in Rome

For others the artist's journey – including the trip to Italy – took on a new meaning. In Germany, six young men, motivated by their strong Catholic faith, founded a group that would become known as the Nazarenes. In 1809, Friedrich Overbeck, Konrad Hottinger, Franz Pforr, Joseph Sutter, Ludwig Vogel and Joseph Wintergerst decided to travel to Rome, where they named their group the Brotherhood of St Luke (Lukasbund). Inspired by the example of the Dominican monk Fra Angelico, they decided to adopt a quasi-monastic lifestyle and took up residence in the cells of a disused monastery. Their ambition was to practise art as a form of collective prayer, reviving the art of the fresco, a technique that had fallen into disuse centuries before, and painting altarpieces – both forms of art that harked back to Christianity's most fervent age. Their vision of Italy was very different from that of the painters from various European academies who went there to complete their training. For the Nazarenes it represented an ideal, a place where they could live at a remove from society and where they believed it might be possible to establish a new, purer form of art.

Salon stalwarts and 'refusés'

The only equivalent in any other country was the exhibition held by the Royal Academy in London, which gradually became less influential. As a result, all artists dreamed of having work accepted for the Salon – the Classicists (Ingres and Flandrin, for example), the Romantics (Delacroix) and even the Realists (Courbet longed for this as soon as he arrived in Paris in 1840 and achieved his wish in 1844 with *Self-portrait with a Black Dog*, painted two years earlier).

The Salon

Whereas, for a long time, rejection by the exhibition jury meant the end of an artist's hopes of making a successful career, acceptance represented a major step on the road to success. The careers of the painters Couture, Gérôme, Paul Baudry, Léon Bonnat, Ernest Meissonier, Alexandre Cabanel and William Bouguereau, for example, owed much to their success at the Salon, and the sculptor David d'Angers, winner of the Prix de Rome in 1811, became famous overnight when his marble statue *Le Grand Condé* was universally acclaimed at the 1817 Salon. It was no surprise, then, that works specifically aimed at acceptance for the Salon ('Salon pieces') began to be produced. These were generally large-format sculptures or paintings to which their creators had devoted a great deal of their time in the hope of having a piece of work bought by the state – the only purchaser capable of paying for and exhibiting large works of this kind. It was also hoped that such a sale would lead to future commissions.

At the beginning of the 19th century, the Salon was still held every two years, at least officially. From 1833 onwards, it was an annual event except for the period 1852–63, when it reverted to its biennial pattern. Each Salon lasted for three months with one or two periods of closure, during which time the exhibition rooms were reorganized. It was shut on Mondays and a charge was made one day a week (Saturday), with free admission the rest of the time. Having initially been held in the Louvre, where works belonging to the museum sometimes had to be taken down in order to accommodate the temporary exhibition or for temporary picture rails to be installed, it moved during the Second Empire (1852–70) into the Palais de l'Industrie, which had been built to house the 1855 World Fair.

The Salon was a showcase for official taste, setting an example for artists to follow. By no means could just anyone exhibit there: after a brief interlude during the Revolutionary period when it was open to any artist, the exhibition was placed back under the control of an official jury in 1800. During the First Empire (1804–14) the jury was made up of five members (three artists and two connoisseurs) and chaired by Baron Dominique Vivant Denon, an engraver and diplomat and the first director of the Louvre museum. Under the Restoration of the Bourbon monarchy (1814–30) and the July Monarchy (1830–48), the jury was composed of between eight and fifteen members, including representatives of the government and academicians (who made up the majority). During the week before opening, these judges would spend whole days pacing up and down the exhibition halls selecting works to be exhibited and rejecting the rest. The rejected pieces were marked by an assistant with the fateful letter 'R', and the relevant artists were asked to come and collect their work, which was now almost impossible to sell. Due to the large number of works submitted and the rapidity with which the judges had to make up their minds (one minute per item, on average), unfortunate mistakes were occasionally made and paintings or sculptures by academicians were sometimes rejected. For a number of years artists were able to take advantage of certain loopholes in the jury's practices, avoiding the selection process by delivering their work after the Salon had opened. This was done by Anne-Louis Girodet-Trioson in 1819 with *Pygmalion*, and by François Gérard in 1827 with *St Theresa*. After this, tighter controls were introduced to prevent any further breaking of the rules. Some of the greatest artists of the 19th century were rejected by the Salon. Delacroix' *Hamlet* was turned down in 1836 and his *Battle of Taillebourg* was only accepted the following year thanks to Louis-Philippe's intervention, the king having commissioned the painting for the history museum at Versailles. Others whose work was rejected include Théodore Rousseau in 1842 (*AVENUE OF*

Étienne Carjat, *Charles Baudelaire*, photograph.

Under the July Monarchy, art criticism became an important element in the country's cultural life, helping to form public opinion by providing information on what was going on in the art world. Critics tended to be writers and poets of merit, such as Baudelaire. Connections developed between the disciplines and ideas began to be fiercely debated.

The new role of the press

From 1830 onwards, the newspapers – *La Presse* run by Émile de Girardin, *Le Journal des Débats*, *Le Constitutionnel*, *Le National*, and so on – devoted more and more space to each successive Salon. Specialist periodicals illustrated with prints, lithographs and etchings also helped to publicize artistic developments. Among the main publications were: *L'Artiste*, which was illustrated with engravings and was started in 1831 by the art lover Achille Ricourt before passing into the ownership of Arsène Houssaye in 1844; the *Gazette des Beaux-Arts*, founded by Charles Blanc in 1859; and *L'Illustration*. *La Lumière*, which appeared in 1851, was the first magazine dedicated to photography. Those who wrote for these magazines included artists (Delacroix and others), authors (Balzac, Mérimée, George Sand, Musset, Baudelaire, Théophile Gautier) and the first professional critics (Jules Jonin, Arsène Houssaye).

Baudelaire, champion of Delacroix

The poet Charles Baudelaire (1821–67), who contributed to *L'Artiste*, wrote his first Salon review in 1845 at the age of 24. While one of the first to denounce the academicism (which he called 'the clinic of fine arts') that weighed on the age and while lauding colour and 'modern beauty', his taste was eclectic: he praised David and Ingres as well as the Romantics and Realists, in particular Courbet, in whom he saw a 'vigorous spirit'. The artist he admired the most, however, was Delacroix. He praised Delacroix in 1845 as the 'most original painter of ancient or modern times', hailed him in 1846 as a 'revolutionary' and the deliverer of a 'new gospel', and in 1863 devoted an essay to him entitled *The Life and Work of Eugène Delacroix*. Baudelaire was also interested in new, less conventional art forms: the American painter George Catlin's portraits of Native Americans (shown in Paris), popular prints, theatre decoration and dioramas – artistic spectacles in which large scenic elements were brought to life by the use of light. The modern painters of his day recognized Baudelaire's importance and paid due tribute to him: Courbet included a portrait of the poet in his painting *The Painter's Studio*, and he is also represented by one of the figures in Manet's *Music at the Tuileries*.

Salon stalwarts and 'refusés'

Théodore Rousseau, *Avenue of Chestnut Trees*, 1837–42, oil on canvas, 79 x 144cm, Paris, Musée du Louvre.

CHESTNUT TREES), Achille Devéria in 1843 (*Odalisque*) and Louis Boulanger (*Death of Messalina*).

Famous 'refusés': the severity of the Salon

Until the Second Empire, the Salon remained the main forum for aesthetic debate. Academic painters made up the majority of the exhibitors and it was their works that won the big prizes – the medal of honour and the medals of the first, second and third classes. Even the professional critics – a growing band due to the increasing number of periodicals being published – were quick to censure artists whose work was not strictly traditional. Thus, in 1846, Baudelaire himself, the first great writer since Diderot to turn his attention to art criticism (Stendhal too, though to a lesser extent), condemned Horace Vernet's mildly Romantic style as 'improvised art', 'chic' and 'brash', describing his *Battles* as 'regular, rapid masturbation, an irritation on French skin'. Under the Second Empire, however, there was a growing discrepancy between official taste and the work that talented young painters and sculptors were producing in their studios. After 1848, exhibition juries started to comprise more artists than government representatives, but this did nothing to lessen the extraordinary severity of the selection process. On the contrary, the co-option of artists ensured the continuity of academic taste because the artists that the judges invited onto the jury were chosen from the previous Salon's prizewinners. Even in the case of an exceptionally 'liberal' jury such as that of 1849, which included Delacroix, Corot and Rousseau, the conservatives remained in the majority.

As a consequence, the list of rejected artists started to grow implausibly long: Courbet

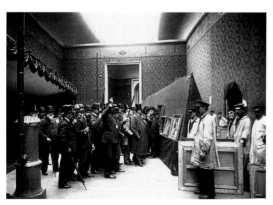

The Jury of the 1903 Salon, contemporary photograph.

and Manet found themselves on it, as did most of the landscape painters of the Barbizon school, who were condemned for notdevoting themselves to the 'grand genre' of history painting. Even the highly Classical painter Flandrin nearly had a picture rejected. A portrait he submitted in 1843 was only accepted after Ingres exercised his influence on his pupil's behalf. As the century wore on, 'moral' arguments as well as formal ones were used by the jury to justify their

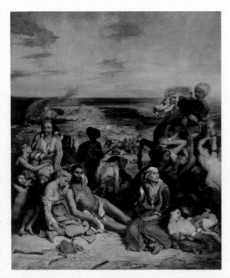

Eugène Delacroix, *The Massacre at Chios: Greek Families Awaiting Death or Slavery*, 1822–4, oil on canvas, 419 x 354cm, Paris, Musée du Louvre.

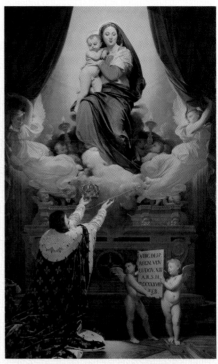

J A D Ingres, *The Vow of Louis XIII*, 1824, oil on canvas, 421 x 262cm, Montauban Cathedral.

1824. The first major confrontation: Delacroix versus Ingres

The history of the Salon has been punctuated by disputes and confrontations. The first major conflict occurred in 1824.

Delacroix, who had come to public attention two years earlier with *The Barque of Dante* (castigated by the critic Étienne Delécluze as a 'tartouillade', a 'mere daub'), had a painting on a contemporary subject, *The Massacre at Chios*, accepted in 1824. This work, which depicts the violent acts committed by the Turks on the Greek island of Chios in 1821–2, drew spontaneous crowds and even attracted a favourable response from certain critics. But most of the representatives of tradition, among them Antoine-Jean Gros, whose *Napoleon Bonaparte Visiting the Plague-stricken at Jaffa* had inspired the younger painter's work in the first place, regarded it as a 'massacre of a painting'. The naturalistic rather than idealized bodies, the lack of hierarchical composition and the visible brushstrokes were found by the establishment to be even more shocking than the work's subject matter, which was taken not from ancient history or religion, but from contemporary events.

The ideological battle that raged around Delacroix was concerned with more than just *The Massacre at Chios*. For the upholders of Neoclassicism, success for Delacroix would be tantamount to applying a seal of approval to the rise in influence of the new Romantic school that was already a force in literature. They therefore nominated their own champion, Ingres (who submitted his own large canvas, *The Vow of Louis XIII*), in opposition to the Romantic artist.

The Salon of 1824 thus highlighted, for the first time, the divide between the Romantic and Classical sensibilities in the visual arts. It also made the reputations of the two painters, whose careers had been unremarkable up to then: Ingres at 44 years of age and Delacroix at just 26 became the leaders of opposing schools whose confrontation dominated French art for a whole decade.

1827. The second scandal: *The Death of Sardanapalus*

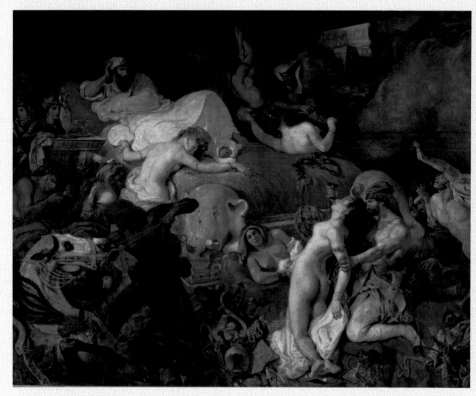

Eugène Delacroix, *The Death of Sardanapalus*, 1827, oil on canvas, 392 x 496cm, Paris, Musée du Louvre.

The second scandal in the history of the Salon erupted three years after the furore over the *Massacre at Chios.*

Unable or unwilling to finish his painting for the opening of the 1827 Salon, Delacroix submitted *The Death of Sardanapalus* in time for the third hanging. It immediately provoked storms of anger from jury and critics alike. In a letter to his friend Soulier he wrote: 'I have effectively finished my second *Massacre*. But I have had to endure the tiresome criticism of those great fools on the jury.' Delécluze (again) gave the work an inevitable panning: 'Monsieur Delacroix' *Sardanapalus* has found favour neither among the public nor among artists. One has tried in vain to discern what ideas may have been behind the painting of this picture; it is impossible for even the most intelligent viewer to unravel a subject whose every element is isolated, whose confusion of lines and colours the eye is incapable of untangling and in which a conscious decision seems to have been taken to violate the basic rules of art. With *Sardanapalus* the artist has committed an error.' Hardly any voices were raised to contradict this assessment, and Ingres went on to enjoy another success with *The Apotheosis of Homer*, a typical example of the kind of Classical art that Delacroix reviled. Although the outcry again brought Delacroix fame, this time it also brought some very real problems. *The Massacre of Chios* had ultimately been bought by the state for 6,000 francs despite only earning its author a second-class medal, but *Sardanapalus* remained unsold and was awarded no prize at all. This wiped out a year of artistic effort and caused Delacroix major financial difficulties. Worse still, Sosthène de La Rochefoucauld, Director of Fine Arts to the royal household, came to inform the painter in person that he could expect to receive no further commissions from Charles X.

1834. The triumph of Romanticism: Delacroix crowned

Eugène Delacroix, *The Women of Algiers in Their Apartment*, 1834, oil on canvas, 180 x 229cm, Paris, Musée du Louvre.

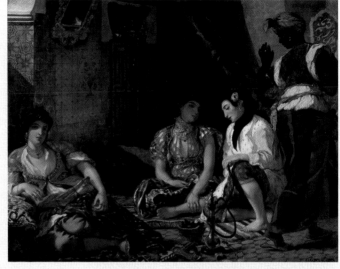

The revolution of 1830 and the change of regime that followed brought about a decisive change in Delacroix' fortunes.

Delacroix the Romantic finally triumphed at the Salon of 1834 with *The Women of Algiers in Their Apartment*. Europe's fascination with the Orient, which went back to the early 1700s (Montesquieu published his *Persian Letters* in 1721), intensified during the 19th century as a result of various historical events: Napoleon's Egyptian campaign (1798), the Greek insurrection (1822) and the conquest of Algiers (1830). Delacroix bewitched the public when he came back from his trip to Morocco (in the retinue of the ambassador to the Sultan) and Algiers (see page 154). He offered them views drawn and painted from nature (in sketchbooks preserved in the Louvre) that smack of real-life experience and radiate exoticism – an exoticism in which the painter saw a form of antiquity more authentic and more alive than that hinted at by Italy's ancient ruins: 'It is there that the Romans and Greeks are to be found,' he wrote.

Ingres exhibited his *Martyrdom of St Symphorian* at that year's Salon. This large canvas, which had taken six years of hard work and was based on no fewer than a hundred studies, confronts the viewer with the martyr and his mother and celebrates, through its rich use of emphatic gesture, the faith of the early Christians. It met with a cool reception, however, and was even the target of some gibes. Full of indignation, Ingres decided to leave for Rome, where he had applied for, and been offered, the post of director of the Académie de

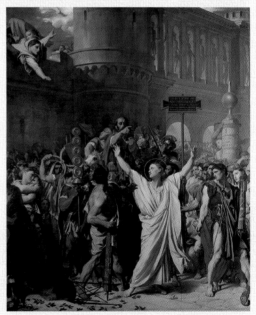

J A D Ingres, *The Martyrdom of St Symphorian*, 1834, oil on canvas, 407 x 339cm, Autun, Saint-Lazare Cathedral.

France. He stopped submitting work to the Salon. The next exhibition he contributed to in France was that held by the Bazar Bonne-Nouvelle in Paris in 1846, an exhibition of older, Neoclassical work in which his paintings were shown alongside those of David, Gérard, Guérin and Gros.

Salon stalwarts and 'refusés'

choice of artworks. Paintings championing 'dangerous' ideas (political criticism or a perceived offence against morality) were rejected as well as those that failed to live up to the Classical aesthetic and to use Classical techniques.

The paradox was that despite these limiting factors, the Salon lost none of its importance as a social event – quite the opposite in fact. The public rushed to the exhibition in droves, creating an almost continual hubbub, and the number of works exhibited rose at an incredible rate, forcing paintings to be hung edge to edge and floor to ceiling: 1,124 works (including 872 paintings) in 1810; 2,412 (1,833 paintings) in 1846; 4,213 (2,587 paintings) in 1868; and 5,434 (2,991 paintings) in 1870.

The revenge of the 'refusés': alternative salons

During the heyday of the Paris Salon, the omnipotence of the jury was such that a talented artist of the calibre of Antoine-Jean Gros was driven to commit suicide in 1835 after suffering setbacks with two paintings, *Acis and Galatea* and *Hercules and Diomedes*. During the Restoration and the July Monarchy, it was quite simply impossible to achieve recognition outside the framework of the Salon. During the period 1824–34, the battle between Classical and Romantic artists, lined up behind their respective champions Ingres and Delacroix, was conducted by critics actually inside the exhibition.

Under the Second Empire, by contrast, the severity of the jury was responsible for crises that this time compromised the institution itself. The first of these occurred in 1863. That year the censors rejected nearly 3,000 of the 5,000 works submitted. Feelings ran so high and there were so many complaints that Napoleon III, having come to see things for himself and judging that a good proportion of the paintings that had been accepted were no better than those that had been rejected, decided that an additional exhibition should be held, reserved for any of the rejected artists who wished their work to be shown in it. This 'Salon des Refusés', nicknamed by some the 'Salon des Vaincus' (the Salon of the Defeated), was held, like the official exhibition, in a wing of the Palais de l'Industrie on the Champs-Élysées. It did nothing to calm emotions, however. While Cabanel triumphed in the official exhibition with THE BIRTH OF VENUS, which single-handedly resurrected all the old features of academicism, the crowds rushed to the Salon des Refusés to laugh at the paintings exhibited by Pissarro, Whistler, Jongkind and above all Manet, whose *Déjeuner sur l'Herbe* (then called *Le Bain*) provoked hilarity and jeers. Even though the works exhibited in it initially aroused curiosity and amusement rather than admiration, this second salon, by its very existence, dealt a severe blow to the authority of the official jury and therefore to the Académie itself. A number of artists decided to take their fate into their own hands and exhibit outside the official framework.

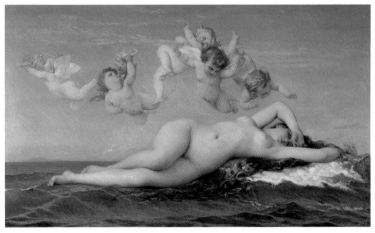

Alexandre Cabanel, *The Birth of Venus*, 1863, oil on canvas, 130 x 225cm, Paris, Musée d'Orsay.

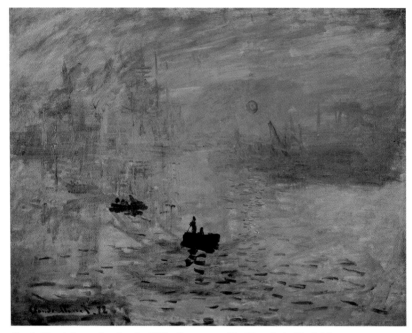

Claude Monet, *Impression: Sunrise*, 1872, oil on canvas, 48 x 63cm, Paris, Musée Marmottan.

The Impressionists, calling themselves at the time the Société Anonyme des Peintres, Sculpteurs et Graveurs (Company of Painters, Sculptors and Engravers), organized a major exhibition in 1874 in the studio of the photographer Félix Nadar at 35 Boulevard des Capucines in Paris. The exhibition was held from 15 April to 15 May, in other words starting before the official Salon in order to avoid any confusion between that exhibition and this new 'salon des refusés'. It included works by Monet, Renoir, Pissarro, Sisley, Degas, Berthe Morisot and Cézanne. Manet, who had achieved an unexpected success at the 1873 Salon with his *Bon Bock*, refused to participate in this independent venture.

The Salon was no longer the place where history was made. The critics understood this and focused their praise or invective on these new exhibitions. It was at the exhibition in Nadar's studio that Louis Leroy, a columnist for *Le Charivari*, coined the derisive term 'Impressionists' to describe the new movement and in particular Monet's painting *IMPRESSION: SUNRISE*. The rest of the press, more closely associated with the young painters who frequented (as it did) the Nouvelle Athènes district of Paris, greeted the event more favourably. In an attempt to halt the decline of the Salon, the State withdrew its support in 1880, leaving the organization of the Salon exclusively in the hands of artists. The selection procedure was liberalized but rifts became more common. In 1884, the 'refusés' from that year's Salon founded the Société des Artistes Indépendants, which organized a regular exhibition at the Tuileries, dispensing with jury and awards. Five years later, another salon was held at the Tuileries under the aegis of the Société Nationale des Beaux-Arts. This became an annual event in 1890, when it moved to the Champ-de-Mars.

Artistic life outside France

Outside France, where the Salon system – the system of official selection and recognition – either did not exist or existed in a far less restrictive form, artists began to promote their own works at a much earlier period. In England, where the Royal Academy exhibitions in London were of only limited importance, Turner and even William Blake (who pursued his own solitary path) resorted to 'modern' methods in order to reach their public. In 1807, Turner published a *Prospectus* announcing the imminent appearance of a volume of engravings and launching a subscription. Two years later, Blake

Caspar David Friedrich, *The Cross in the Mountains*, also known as the *Tetschen Altar*, 1808, oil on canvas, Dresden Staatliche Kunstsammlungen.

organized an exhibition of his own work and paid for the publication of a brochure called *Public Address*, in which he set out his programme. The venture ended in financial disaster. In Germany, artists also explored various ways of reaching their public. Caspar David Friedrich competed for several prizes. In 1805, he won the Weimar prize awarded by Goethe and this success helped to launch his career. He also regularly submitted work to exhibitions that were far more numerous (due to the country's lack of centralization) and less absurdly selective than those in France. The annual exhibitions of the Dresden and Berlin academies helped him to get his work known, and King Frederick William III of Prussia became one of his collectors. Finally, at the end of 1808 (anticipating Blake), Friedrich organized an exhibition in his Dresden studio in order to show his

CROSS IN THE MOUNTAINS, a painting that would cause a sensation. Although resembling a medieval altarpiece, the work depicts a landscape rather than a religious scene.

The *Cross in the Mountains* was exhibited in a theatrical manner. This unusual piece, with its carved and gilded wooden frame, stood on a draped table away from the wall, enabling visitors to walk around it as if it were some sort of monument. The painter covered the windows so that the studio was plunged into almost total darkness with just a single light illuminating the painting. The work was a huge success. Visitors packed into the studio and the press, as in France, relayed visitors' comments to the outside world. An unfavourable article published in the *Zeitschrift für die Elegante Welt* (*Journal of the Elegant World*) by the Neoclassical critic Basilius von Ramdohr sparked off the kind of 'succès de scandale' that Delacroix later sought with *The Massacre at Chios*. Suddenly Friedrich found himself the figurehead of German Romanticism.

THE ARTIST AND PUBLIC COMMISSIONS

During the 19th century, and particularly during its first half, the state remained the preferred client of artists, at least in France. For painters and even more so for sculptors, the opportunity to create large works – which made money and got their name known – depended on them winning public commissions.

Bringing artists into line: the Empire style

This dependence explains the major role played by governments in the development of style. At the beginning of the 19th century, for example, Napoleon set his own, restrictive

stamp on French art, giving rise to what became known as the 'Empire style'. The emperor's influence over the arts extended to every area of artistic activity: architecture (the renovation of Paris), furniture and the decorative arts, as well as painting and sculpture.

Conscious of the important role played by visual images during the Revolution (propaganda images, illustrated political pamphlets, and so on), Napoleon adopted an artistic policy governed by a system of commissions, controls and rewards. Under him, the state became the largest source of commissions, far bigger than the church or any private individual. Napoleon regarded the artist, like the soldier, as an instrument. He used artists to prepare people for political acts or to justify these after the event.

This practice reached its peak in 1810. That year the Empire's leading apologists – who included David, Girodet and Gros – were rewarded with 'decennial prizes', while the Salon was given over almost entirely to the glorification of the Empire. A whole generation of artists – either responding to commissions or trying to win them – submitted works that sang the praises of the regime. These works included some remarkable paintings (David's *The Distribution of the Eagles,* Girodet's *The Revolt of Cairo* and Gros' *The Taking of Madrid*) as well as many others destined to sink quickly into oblivion (few people nowadays know the names of Gautherot or Boisfremont) as a result of paying more attention to propaganda than form. It was not their style that was at fault but their ambition: while Neoclassical history painting strove to raise its subjects above the ephemeral and into the realms of the eternal, the artists who produced these works, anxious above all to please, strayed into the merely anecdotal.

The July Monarchy and living art: the new museums

Under the Restoration and the July Monarchy, artistic policy was less personalized. Although the Académie and the most rigorous Salon jury of the century helped the state to maintain its influence over production and the market, art was no longer reduced to illustrating the deeds of one man. Anxious to achieve national reconciliation, Louis-Philippe in particular tried to use painting as a means of uniting the people, regardless of their partisan differences.

The acquisitions policy of the 'Royal Gallery Dedicated to Living Artists', founded and installed in the Luxembourg Palace by Louis XVIII in 1818, reflected this desire for openness. Although many pictures were bought from mediocre artists at this time, the large number of commissions ensured that the most important painters of the day also benefited from the institution's purchasing power. By 1830, works by Delacroix, Paul Delaroche, Devéria, Joseph-Nicolas Robert-Fleury, Ingres, Ary Scheffer and Xavier Sigalon already featured on the new gallery's list of acquisitions. Four years later, work by Adrien Dauzats, Hippolyte Poterlet and Alexandre Steuben had also been added to the list, and the gallery now owned no fewer than three paintings by Delacroix, each purchased at a Salon: *The Barque of Dante, The Massacre at Chios* and *Women of Algiers in Their Apartment.* Ingres, by contrast, was only represented by a single work, *Roger and Angelica.* Over the following years, works by Boulanger, Couture, Charles Gleyre, Paul Huet and many others were also bought.

This desire to promote art that would appeal to the whole country was also evident in the way that the new history museum at Versailles was conceived under Louis-Philippe. Yearning for legitimacy, this constitutional monarch rehabilitated history painting, a genre to which Romanticism seemed to have dealt a knock-out blow. In 1837, the history museum was opened in the palace built by Louis XIV – a symbol of the Ancien Régime now transformed into a monument to the glory of French history. In the central gallery, the Galerie des Batailles, 33 specially commissioned paintings portrayed glorious moments from the country's past. These included episodes from the distant past as well as more recent victories such as those at Valmy and Jemmapes. Baron François Gérard (*Austerlitz*) and Delacroix (*The Battle of Taillebourg* and *The Entry of the Crusaders into Constantinople*) were each commissioned to paint works in this series, but the best commissions (a whole cycle on the conquest of Algeria) went to HORACE VERNET, whose

THE CONSECRATION OF NAPOLEON

From the eve of the Revolution to his death in Brussels, the politically committed art of Jacques-Louis David (1748–1825) celebrated the history of his times in a Neoclassical style designed to glorify his subject matter. The painter's eventful existence led him from Jacobinism to support for Napoleon and finally, in 1816, into exile following the restoration of the monarchy. Painted between 1805 and the end of 1807, *The Consecration of Napoleon* (or, to give it its full title, *The Consecration of the Emperor Napoleon I and the Coronation of the Empress Josephine in the Cathedral of Notre-Dame de Paris on 2nd December 1804*) commemorates Napoleon's

The upper tier contains various 'dignitaries' of the time, including David and (front row, third from left) his wife.

Jacques-Louis David, *The Consecration of Napoleon*, 1805–7, oil on canvas, 621 x 979cm, Paris, Musée du Louvre.

Napoleon's mother observes the ceremony from the rostrum. This is pure make-believe as she had quarrelled with her son and left Paris the day before.

Caroline Murat, Queen of Naples. To her left, Pauline Borghese. This group of women comprises Napoleon's sisters and brothers' wives.

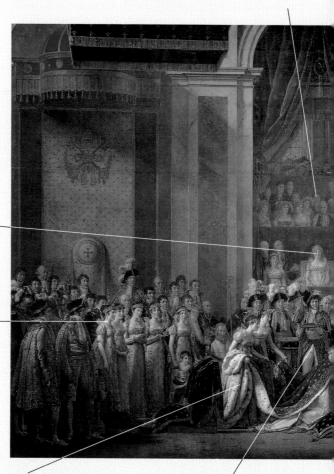

Carrying Josephine's train are Madame de La Rochefoucauld (foreground) and Madame de La Valette.

Joachim Murat, a vain young 'parvenu', occupies an excellent vantage point just behind the empress.

transformation from First Consul into Emperor. It was one of two large canvases that David completed out of an original commission for four: *The Consecration, The Enthronement, The Distribution of the Eagles* and *The Arrival of the Emperor at the Hôtel de Ville*. The other one of the four that David finished was *The Dis-tribution of the Eagles* (Versailles, Musée National du Château). This state of affairs was the result of an unfortunate dispute over the price of the works; this brought into the open other tensions between the emperor, a tyrannical patron, and the painter who was best able to immortalize his reign.

The white and red marble pilasters are artificial. They were decorative elements created by the architects Charles Percier and Pierre Fontaine and positioned in front of the Gothic architecture of Notre-Dame specially for the occasion.

The soft reddish-brown light, copied from Rubens, gives the painting an element of mystery which worked its magic even on the Romantic Géricault.

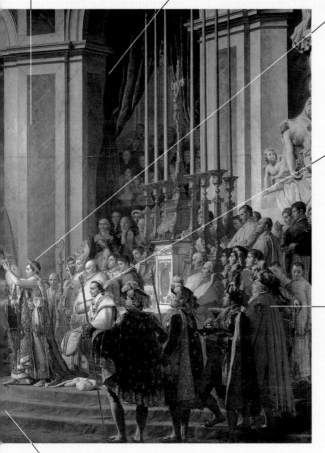

The moment that the artist has portrayed has been carefully chosen. Napoleon, who has already crowned himself, is about to place a crown on his wife Josephine's head. David has deliberately painted the emperor in full profile, giving him the appearance of a Roman cameo.

Pope Pius VII (made younger by the painter and shown with darker hair than he actually had) is seated farther back. In accordance with Napoleon's instructions, he observes the ceremony as a mere witness – the emperor was keen to avoid any suggestion that the power of the Church was superior to his own.

Portrait of Talleyrand. The 'Grand Chamberlain', who as minister for external affairs negotiated the details of the ceremony with the pope, watches the scene with an ironic smile. To his left is Marshall Berthier. The painting contains over 200 life-size figures. Each portrait has been painted with great care so as to be recognizable.

Using an idea borrowed from *The Coronation of Marie de Médicis*, one of Rubens's most famous Parisian paintings, the composition gives viewers the impression that they can enter the scene or 'walk into the painting', to use Napoleon's expression.

Salon stalwarts and 'refusés'

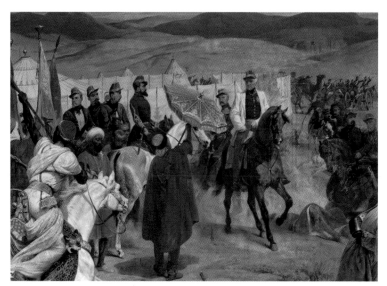

Horace Vernet, *Marshall Bugeaud and Colonel Yusuf during the Conquest of Algeria*, Château de Versailles.

style was everything the king was looking for.

Many artists of some merit but lacking real stature were able to make a living – sometimes a fairly handsome one – from state commissions. This was because commissions usually went to those artists whose lack of aesthetic or political boldness suited both public taste and the caution of governments that preferred to be shown a flattering reflection of themselves. The Académie des Beaux-Arts, filled with pupils of David, continued to defend the notion of a hierarchy of 'noble' and 'lesser' genres, distributing rewards according to criteria that immediately excluded a good number of artists. It favoured history painters over portraitists and portraitists over painters of genre scenes, while generally looking down on landscape and still-life specialists. Similarly, it encouraged painters whose work displayed the smooth finish characteristic of the Neoclassical style rather than the Romantic painters with their visible brushstrokes, showing a preference for artists who followed the rules of antique-style idealization rather than those who adopted the Realist style inspired by Courbet.

The slow acceptance of modernity

Ultimately, however, changing tastes affected even the preferences of government officials and representatives of the Académie. From 1832 onwards, Delacroix, whose work had been considered shocking in 1824, became one of the main recipients of public commissions. He had begun working hard to rid himself of the scandalous image his first successes had earned him. After his journey to the Orient in 1832, his work displayed a balance between originality and tradition, Classical heritage and new subject matter. He did not have to wait long for results. Between 1833 and his death 30 years later, in addition to a *Pietà* for the church of Saint-Denis-du-Saint-Sacrement (1843–4), Delacroix was commissioned to decorate the Salon du Roi (1833–7) and library (1838–47) of the Assemblée Nationale, the library of the Chambre des Pairs in the Luxembourg Palace (1841–6), the ceiling of the Galerie d'Apollon in the Louvre (1850–1), the Salon de la Paix (1852–4, destroyed by fire in 1871) in the Hôtel de Ville in Paris, and the Chapel of the Holy Angels (1849–61) in the church of Saint-Sulpice, where he was obliged to tackle what for him were rare religious subjects: *Heliodorus Expelled from the Temple* and *JACOB AND THE ANGEL*.

At the end of the century, under the Third Republic, the Realism introduced by Courbet, which had eventually enjoyed great success with the general public, also received of-

ficial approval. In the 1880s, depictions of everyday life, in particular the lives of ordinary people, formed the subject of many commissions, becoming the new 'art of the Republic'. Noting this change of direction, a number of opportunistic artists switched styles. In 1880, Victor Champier, who had had several works shown at the Salon, boasted of having left 'the academic camp when he had started feeling honour-bound to celebrate the lives of the humbler people of this world'. During this same period, Emmanuel Frémiet, whose prehistoric and historical reconstructions had been mocked under the Second Empire, saw himself showered with honours. He entered the Académie in 1892 and received a great many commissions, from *The Hunter of Bear-cubs* at the Jardin des Plantes (1885) to his *Horses* on the Alexander III Bridge (1900). During this time the winners of the Prix de Rome, whose training had immersed them in Classicism and who by rights should have been the new official artists, were abandoned by the state.

A NEW OUTLET FOR ARTISTS: THE TRIUMPH OF COMMERCE

Fortunately for artists, the state was not the only outlet for their work. During the 19th century there was a dramatic rise in the number of paintings and sculptures: around

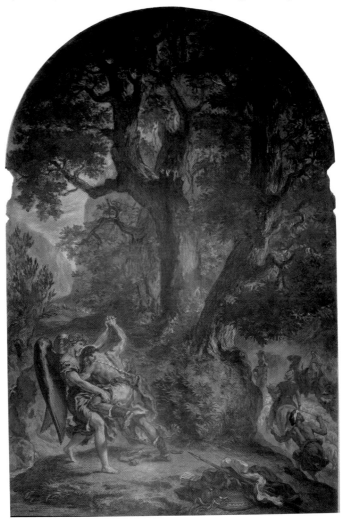

Eugène Delacroix, *Jacob and the Angel*, 1854–61, oil and wax wall painting, 751 x 485cm, Paris, Church of Saint-Sulpice.

200,000 paintings were produced in France between 1850 and 1860. For reasons of style or subject matter, much of this artistic production was not acceptable to public institutions (museums, town halls, law courts, and so on). The development of a commercial distribution network around 1850 provided artists with another way of selling their work.

A new customer: the middle-class collector

Up to the 18th century, most private collectors of art had been aristocrats, but from the 19th century onwards the middle classes – a social group that continued its rise to dominance at the expense of the aristocracy – formed the largest category of private buyer.

These new clients, important in terms of their numbers rather than in terms of how many paintings they bought, were generally anonymous. They bought works from exhibitions and dealers without ever meeting the artist. Sometimes transactions were even conducted by means of a lottery. This practice emerged in Germany in 1820 with the creation of the first *Kunstverein* (art society), whose members paid a subscription and were entered into a draw each year. It spread to northern Europe and even as far as America. The new state of affairs deprived artists of their traditional contact with collectors just at a time when the spread of the jury system also deprived them of any contact with important patrons such as princes and other rulers. Artists did not even gain extra freedom in return for this isolation, as bourgeois taste had certain tacit rules that had to be obeyed. Private individuals generally collected out of conformism – because fashion and notions of status dictated that they should have art in their homes – and only rarely out of passion. Works of art had to conform to certain requirements and dimensions. The middle-class collector favoured easel paintings, busts and mantelpiece decorations (bronze reductions of works that had been successful at the Salon) which they could fit into their homes without sacrificing too much space. Their subject matter had to reflect the bourgeois mindset and suit the rooms for which the works were destined. Licentiousness was out, as was anything too mystical. What was popular were subjects that were easy to understand and attractive to look at, simple mythology rather than history paintings, still lifes (for the dining room), landscapes and most definitely family portraits – a reversal, in other words, of the official hierarchy of genres. It is hardly surprising that this demand, like that of the state (though in a slightly different way), gave rise to standardized production. This was underlined by the painter Alexandre Descamps: 'Works of art that are too original or too bold in their execution offend the eyes of our bourgeois society, whose narrow minds can no longer comprehend either sweeping works of genius or humanity's great outpourings of love. Opinion creeps along the ground; anything that is too vast, which rises above its head, is lost to it.'

Artists' strategies: appealing to the collector

Artists who refused to respond to a demand that could provide them with a living were few and far between. Considering that the average production in the 1850s was around 50 pictures a year and that painters could only hope to show two or three at the Salon, it would have been suicidal on their part not to make concessions to middle-class taste. A number of artists who are considered distinctly second-rate today achieved considerable fame by flattering bourgeois taste: Meissonier, for example, whose slightly insipid genre paintings were highly sought after, or the sculptor Jean-Auguste Barre, whose small portraits enjoyed lasting success under the July Monarchy and the Second Empire.

Other artists, of greater calibre, devised a strategy that divided their career into two parts. This was Chassériau's modus operandi. In 1840, at the age of 21, he declared: 'First of all I want to paint a large number of portraits in order to get my name known and then earn some money in order to acquire the independence that will allow me to fulfil the obligations of a history painter.' For others, the portrait turned out to be the genre in

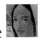

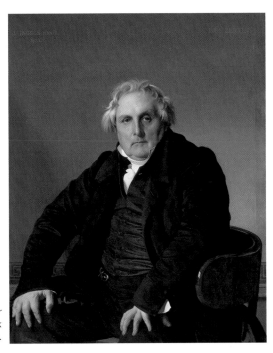

J A D Ingres, *Portrait of Monsieur Bertin*, 1832, oil on canvas, 116 x 95cm, Paris, Musée du Louvre.

which their art blossomed. For example, Ingres, most of whose income came from painting members of the middle classes or the aristocracy, produced masterpieces such as the extraordinary PORTRAIT OF MONSIEUR BERTIN (François Bertin the Elder, the formidable founder and owner of the *Journal des Débats* and an emblem of his age – a 'Buddha of the bourgeoisie' in Manet's famous words).

The dealer: the artist's indispensable middleman

A middleman, the dealer, formed an essential link between the artist and his middle-class public. In France, the first open-access galleries – where the public could simply walk in and wander around freely in order to view and buy works of art – opened in the capital around the middle of the century. The most popular location for these galleries was the Rue Laffitte, which became the centre of the Parisian art market for a number of years.

Courbet, who might have wished to reject traditional systems like the Salon, yet exhibited there regularly, receiving both a gold medal in 1849 and bitter criticism of his work. He had to make a living, and he was one of the first artists to make systematic use of this commercial network. His dealers were Alexis-Eugène Détrimont; Louis Martinet, a former engraver who also edited an art review; Jules Luquet from 1860 onwards; and in the 1870s Paul Durand-Ruel, who later became the Impressionists' great supporter. With Luquet, the painter fixed a minimum price – between 250 and 300 francs for small landscapes and several thousand francs for Salon pictures. The dealer was free to double or even triple this base price and pocket the difference. Luquet succeeded in selling *The Quarry*, for example, to an American for 25,000 francs. This record amount shows the high prices the painter's work could command towards the end of his life, a fact Courbet acknowledged in a letter to his sisters Juliette and Zélie, written in 1872: 'Although it has brought me a lot of trouble, the Commune has also increased my sales and my prices by half.'

Outside France, artists gravitated towards the commercial scene considerably earlier. During the first half of the 19th century, TURNER relied for his living on the close relationships he maintained with a small number of private collectors. He was supported

REALITY AND LIMITATIONS:
HOW FAR WAS COURBET A REVOLUTIONARY ARTIST?

A number of 19th-century artists rejected both the role of 'official' artist – competing for medals at the Salon and carrying out public commissions – and the role of purveyor of furnishings for middle-class apartments. They remained faithful to a personal vision of art born of subversion. This image of the revolutionary artist is probably best embodied by Gustave Courbet (1819–77). Courbet never fully accepted the Salon system. Chronologically situated between Romanticism and Impressionism, he received the support of neither group and did not take part in any collective exhibition of 'refusés'. But in 1855, the year of the World Fair in Paris, at which he showed eleven paintings, he also organized a private exhibition of his own. On the pretext that two of his works, *The Painter's Studio* (which now hangs in the Musée d'Orsay) and *Burial at Ornans*, had been rejected, he had a private pavilion constructed next to the Palais de l'Industrie, the site of the main exhibition. At the entrance to his show he displayed a sign which read: 'Realism. Courbet. Exhibition of forty of the artist's works.' He charged an entrance fee and sold a pamphlet entitled *Realism*, in which he set out his artistic aims: 'Free from bias or aesthetic prejudice, I have studied the art of the ancients and the art of the moderns. I have attempted to copy neither one group nor the other … Instead my intention has been to draw a reasoned and independent sense of my own individuality from a knowledge of the whole tradition.'

Courbet kept to this strategy over the following years. In 1863, after the rejection of his extremely anti-clerical *Return from the Conference*, he noted: 'I painted the picture with the intention that it would be rejected. I succeeded. That is how it will earn me money.' In 1867, he showed four paintings at the Paris World Fair … and 132 others in a specially erected pavilion on the Pont d'Alma.

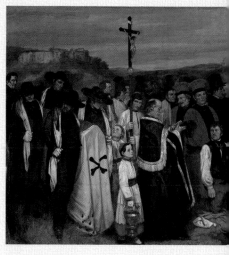

Gustave Courbet, *Burial at Ornans*, 1849–50, oil on canvas, 315 x 668cm, Paris, Musée d'Orsay.

A provocative painter

Courbet was a subversive painter in terms of his friendships, his subjects and even his technique. He was a painter whose moral, social and political beliefs could only displease the conservatives of the day. A friend of the socialist Pierre-Joseph Proudhon (author of an essay entitled 'The Principles of Art and Its Social Destiny' who famously declared: 'Property is theft!'), Courbet placed his art at the service of his republican convictions. His *Burial at Ornans* is a democratic counterpart to David's *Consecration* (see page 166): in Courbet's huge painting (the format of a history painting) the 'parvenus', the members of the new aristocracy and David's beloved antique gods and heroes have been replaced by the common people (the inhabitants of Ornans, the artist's native village in Franche-Comté). Worse still, Courbet dared to tackle highly unorthodox subjects, including an embrace between naked women in *The Sleepers* (Paris, Musée du Petit Palais) and female sexual organs offered up directly to the viewer's gaze in *The Origin of the World* (1866, Paris, Musée d'Orsay). Courbet – this 'unsophisticated plasterer's mate', in Cézanne's admiring words – also attacked the very substance of painting. There is no elegant finish with Courbet, no smoothness of surface as with Ingres, no attempt to hide the fact that the final object is the product of the painter's hand. He presents the viewer with thick matter whose raw energy echoes the primitive energy of nature.

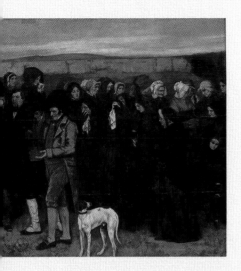

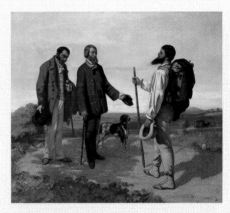

Gustave Courbet, *The Meeting*, also known as *Good Morning, Monsieur Courbet*, 1854, oil on canvas, 129 x 149cm, Montpellier, Musée Fabre.

For all these reasons, Courbet was a revolutionary of whom society was keen to rid itself. After the events surrounding the Paris Commune it almost succeeded. In the revolutionary council, the painter had accepted the position of president of 'the artistic commission in charge of the conservation of the national museums and art objects'. On 27 April 1871 he called, in his official capacity, for the implementation of the Commune's decision, taken a few days earlier, to demolish the Vendôme column. This was duly carried out on 16 May. At the end of the month the Parisian insurrection was bloodily suppressed. Courbet was quickly arrested and imprisoned in the Conciergerie and later in the prison of Sainte-Pélagie. Freed in March 1872, he left Paris for Ornans. In 1873, he was ordered by the Assemblée Nationale to pay for the re-erection of the column, but he chose exile in Switzerland (at La Tour-de-Peilz) instead. He remained there until his death on 31 December 1877.

Concessions and compromise

Courbet as revolutionary and martyr? The image is appealing, perhaps too appealing, and requires some modification. After 1855 – the year of *The Painter's Studio*, in a sense a summation of his life's work – he made an effort to satisfy the tastes of the bourgeois public, who were potential purchasers of his work. His nudes became more appealing and sellable, he began to paint landscapes, the preferred genre of the middle classes, and he added flowers and animals to the landscapes. He attracted art lovers and was supported by them – the collector Alfred Bruyas, for example, whom he met in 1845 and who helped to finance the construction of his pavilion in 1855. His famous painting *The Meeting*, also known as *Good Morning, Monsieur Courbet*, commemorates what would develop into almost a friendship. On one side of the painting are the future client and his servant; on the other is the painter, artistically dressed as a vagabond, pointing his chin proudly at the man who was to provide him with the necessary support for his work – responding to his new client's greeting by doffing his hat in return. The situation is almost traditional: that of a painter depending on the benevolence of a patron in order to survive outside the official system.

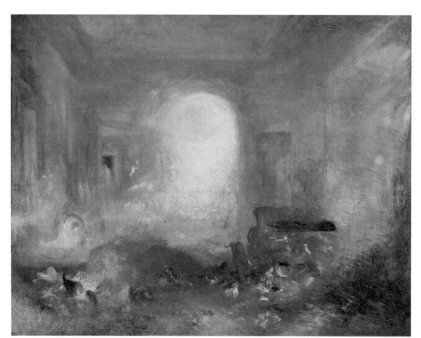

J M W Turner, *Interior at Petworth*, 1835, oil on canvas, 91 x 122cm, London, Tate Gallery.

by the patron of the arts Lord Egremont, who welcomed him to his house at Petworth, purchased one or two paintings from him each year (thereby guaranteeing the painter a minimum income) and introduced him to other rich art lovers who also bought pictures. Turner supplemented this income by also producing and selling more affordable work: engravings and, above all, large-format watercolours that had the additional merit of giving interested art lovers a taste of what he could do for them in oil provided they were prepared to pay the price.

Like Turner, Constable dedicated himself to landscapes. As a result (given the prevailing taste for history painting), he encountered similar difficulties to Turner in gaining official acceptance. In his own country he made use of the services of Jean Durand, one of the first big French dealers, while he owed his initial contacts with collectors in France to a dealer of English origin, John Arrowsmith. It was Arrowsmith who exhibited a few of his pictures in his Paris showroom in 1824, thereby giving Constable his first exposure in France. Later, a number of his works presented at the Salon in Paris would win him the admiration of painters such as Delacroix.

The triumph of the dealer: the Impressionist generation

However, it was in France – with the Impressionists after 1870 – that dealers started to play a pivotal role in the distribution of works of art.

Having learnt their lesson from the Salon des Refusés of 1863, at which their work had been subjected to visitors' gibes, the group made up of Manet, Monet and others decided, as Courbet had done, to use a dealer as a way of introducing their work to the public under conditions which they could control. The identification of their art with a single dealer helped the Impressionists to convey a sense of their distinctiveness and to present themselves as a 'school', while their dealer's personal contacts with critics and members of the public allowed people to be won over slowly to works whose stark originality had the power to shock.

Eventually, the circle of art lovers, critics and buyers that the dealer was able to introduce to the artists constituted a not inconsiderable social base. As the art historians H and C White noted, 'a painter was no longer a nobody if he could count on the support

Novelists and Poets as Supporters of Impressionism

Art criticism increasingly became the province of journalists during the 1870s. But a number of novelists, essayists and poets continued to write on art as well. After Diderot and Baudelaire, these other writers on contemporary art, who were not all famous at the time, included Zola, Huysmans, Mallarmé, Octave Mirbeau, Armand Sylvestre, Paul Bourget, Paul Adam and Félix Fénéon. On the whole they supported the 'new' or 'independent' painting (independent, that is, from the Salon) – in other words the Impressionist school – at a time when the professional critics were shouting it down.

Stéphane Mallarmé (1842–98), a friend of several Impressionist painters, including Manet, Monet, Renoir and Gauguin, was a supporter of the first of these from 1874 onwards. However, he had to turn to an English publication, the *Art Monthly Review*, to get his criticism published.

Émile Zola (1840–1902), a childhood friend of Cézanne, initially wrote about Courbet and championed those who would later become Impressionists (Monet, Pissarro, Sisley, Morisot) as early as 1866 in *L'Événement*. His enthusiasm for pictorial innovation waned towards the end of the 1870s, however. His novel *L'Œuvre* (1886, 'The Masterpiece'), which deals with art and literature, is revealing in this respect and led to his breaking for good with Cézanne and Manet.

Joris-Karl Huysmans (1848–1907) began his career as an art critic in 1867 with an article on 'contemporary landscape painters'. The son of a Dutch painter, he took up the cause of the Impressionists in a series of articles he published as collected volumes in 1883 (*L'Art Moderne*) and 1889 (*Certains*).

Félix Fénéon (1861–1944), an anarchist, wrote for the *La Revue Indépendante* and then for various publications including the *La Revue Blanche*, *Le Figaro* and *Le Matin*. A champion of modern writers and poets, Fénéon was a keen admirer of the works of Seurat, Signac and Pissaro and of Divisionism (or 'Neo-Impressionism', a term he coined in 1886) in general.

of figures such as Durand-Ruel, Zola, the publisher Charpentier ... and the financier Hoschedé as well as less well-known but nonetheless faithful friends like Choquet.'

From an economic point of view, relationships with dealers also offered artists significant financial advantages. In many cases a contract or at least a reasonably workable system of loans and advances guaranteed them a minimum income, regardless of whether their work was selling well or not.

One name dominates the early history of the art market: that of Paul Durand-Ruel. The son of a picture-dealer who had sold work by Delacroix, the painters of the Barbizon school and also (as we have seen) Constable, he was one of the first to open a proper gallery – on the Rue Laffitte in 1867 – selling nothing but paintings and prints, rather than combining these, as had been the case earlier, with either artists' materials or antiquities. A clever speculator, Durand-Ruel bought up many works from the 1830s in order to increase their value. Most importantly, he was one of the first to understand how important attention from the critics was for a young artist's career. This led him secretly to finance his own publication, the *Revue Internationale de l'Art et de la Curiosité*. Controlling the whole system from beginning to end, from production to delivery, he was the main promoter of the Impressionists. He bought, exhibited and sold their work and guaranteed their critical success, thus combining the roles of patron, publicist and middleman.

Enduring difficulties: poverty and the modern artist

Despite its efficiency, this new system did not always bring commercial success with it. Most of the Impressionists experienced poverty at some stage.

Claude Monet, for example, was supported by his parents at the start of his career, but lost this lifeline when he refused to split up with his mistress, who was expecting his child. He subsequently experienced a number of difficult years, during which he had to

Salon stalwarts and 'refusés'

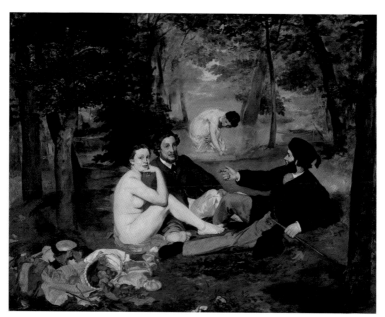

Édouard Manet, *Déjeuner sur l'Herbe*, 1863, oil on canvas, 208 x 264.5cm, Paris, Musée d'Orsay.

rely on the kindness of his friends. In August 1869, he wrote to his friend the painter Frédéric Bazille, who was from a well-off family and had previously given him financial help: 'Renoir brings us bread from his place so that we don't die of hunger. For eight days now there has been no bread, no fire to cook on, no light, it's appalling.' His situation improved only very slowly under the Third Republic, when he made his first sales at what were still very modest prices. It was only after 1890 – the year he bought his house at Giverny – and particularly after 1900 that his works sold in large numbers and for high prices. In 1899, the pictures in the *Waterlilies* series sold for more than 5,000 francs each, whereas in 1871 Durand-Ruel had bought a painting from the artist for a mere 300 francs. Monet eventually achieved a certain affluence, which developed into a fortune during the last few years of his life. He died in 1926.

MANET, who refused to take part in the Impressionist exhibitions in order to preserve his chances of being accepted for the Salon, only managed to sell around a fifth of his production during his lifetime. Recognition from the art market came too late: at the studio sale after his death aged 51 in 1883, 66 of his paintings were sold, more than Manet and his dealer had managed to sell during his whole career, and for a higher sum (89,700 francs) than the painter's total lifetime earnings from his art.

TOWARDS A NEW TYPE OF ARTIST

The slow but sure decline of official art and the promotion – by the parallel systems of selling to a middle-class clientele and support from critics and dealers – of those rejected by it profoundly affected artists' everyday lives and the public's image of them. Other developments, resulting from the far-reaching technical changes that marked the 19th century, led to new artistic practices that the age had difficulty in accepting as such.

An important newcomer: the artist–photographer

The most important of these changes was brought about by the invention of photography. The revelation to the world in 1839 of the process developed by Nicéphore Niepce and Louis Daguerre provoked lively debate among artists and intellectuals about the nature of the results. Although Baudelaire, in his *Salon of 1859*, condemned it as a me-

chanical process that could never hope to produce anything of beauty, artists took a keen interest in it.

In the early 1850s, Delacroix started to draw male and female nudes from photographs he had commissioned from Eugène Durieu. This later became a common method of working. In the 1870s, artists would often work with one or several photographers who would take pictures for them using the artist's own models in poses and settings of the artist's choice. This was of great benefit to artists as it meant they no longer had to pay for long modelling sessions. It also allowed them to work far away from their studios in places where it would be impossible to find men and women prepared to pose naked. Fortunately, photographers were not content simply to put their skills at the disposal of painters. A number of them tried to rival the work of painters. Using their equipment to take pictures of landscapes, still lifes and genre scenes, photographers such as Louis-Adolphe Humbert de Molard, Julien Vallou de Villeneuve and the much more talented English doctor, Peter Henry Emerson, tried to obtain effects as close as possible to those achieved by painting. This style of photography was known as pictorialism. Other photographers were shrewd businessmen: they specialized in portraits, which required long exposure times, and soon achieved considerable public success. One of these was Gaspard Félix Tournachon (better known by the pseudonym Nadar), a former illustrator and caricaturist, who photographed some of the most prominent literary and artistic figures of the time at his little studio in the Rue Saint-Lazare before moving to an enormous studio at 35 Boulevard des Capucines, which he lent to the Impressionists for their first exhibition in 1874. Another was Antoine-Samuel Adam-Salomon, a former painter trained in Munich, who worked during the 1860s in a more decorative style borrowed from the aristocratic portraits of Van Dyck and Lawrence, in which elegant accessories enhanced sitters arranged in dignified compositions. Even at this very early stage of photography there were some ethnologists and journalists who travelled the world taking pictures of people and events: for example, Maxime du Camp, who photographed the Orient and Egypt between 1844 and 1851; Charles Nègre, whose subjects included landscapes and the working classes of Paris and the south of France during the 1850s; Désiré Charnay, who worked in a Mexico ravaged by civil war between 1857 and 1859; and the American photographers who invented photojournalism during the Civil War of 1861–5.

These photographers, whom we readily call artists today, were not recognized as such until the end of the 19th century. The first exhibition of photography was not organized until 1891, by Baron Alfred von Liebig in Vienna. Of the 4,000 works submitted, 600

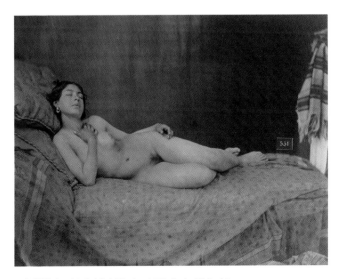

L-C d'Olivier, *Nude Model Posing*, 1855, Paris, Bibliothèque Nationale de France.

'ARTISTIC' PHOTOGRAPHY

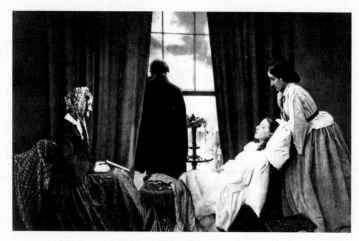

Henry Peach Robinson, *Fading Away*, 1858, Bath, Royal Photographic Society.

Following Niepce's experiments in 1816 with 'heliography' (sun drawing), which were developed further by Daguerre (the 'daguerrotype'), photography was officially born in 1839 when François Arago presented the new technique to the Académie des Sciences and the Académie des Beaux-Arts. This choice of a double audience was not without its significance, for although it was a scientific technique, photography also belonged to the realm of art.

Noble subjects?

During the second half of the 19th century, the critics tried to persuade photographers to choose specific themes and handle them in a particular way. These critics did not want them to confine themselves to capturing naturalistic situations, but wanted them to display higher feelings, to be faithful to nature and yet inspired at the same time. They were expected to create still lifes, genre scenes, portraits of models wearing allegorical costumes and scenes that could compete with paintings in the grand manner.

In England in particular, a number of photographers created narrative pieces resembling 'tableaux vivants'. These were composite images intended to be morally edifying. Oscar Rejlander and Henry Peach Robinson were representatives of this trend in the 1860s.

Capturing the landscape

Other photographers, just as incapable of conceiving of their art other than in terms of painting, were closer to the modern movements of Realism and Impressionism. Also in England, the doctor, photographer and theoretician Peter Henry Emerson claimed in his handbook *Naturalistic Photography* (1899) that the photographer's

first duty was to capture nature – something he spent eight years doing in the Fens of East Anglia.

A means of reproduction

A number of photographers saw their relationship with art strictly in terms of reproduction. From the middle of the 19th century, they began disseminating images of the masterpieces of Western art throughout Europe. Photography thus revolutionized the public's access to the world's artistic heritage, bringing this to a far greater audience than earlier forms of reproduction such as casting and engraving had been able to do. Unsurprisingly, this type of photography developed first of all in Italy, opening up the way for thriving commercial ventures such as those of the Alinari brothers in Florence and Goupil in Paris.

Peter Henry Emerson, *Life and Landscape on the Norfolk Broads*, 1886–95, Paris, Musée d'Orsay.

were shown. The experiment was repeated a year later in London, with the first Photographic Salon, which became an annual event. Until then, photography had never been shown in either specialist or general exhibitions, and the technique had been regarded as purely 'mechanical'.

Prophetic artists

In 19th-century England, William Blake experimented with printing methods and invented a form of hand-coloured relief etching which he called 'illuminated printing'. John Flaxman, a professor, writer and teacher at the Royal Academy, London, was one of the most highly regarded and eminent sculptors of his age – the purity of his refined, linear designs expressed the spirit of Neoclassicism. However, others who resurrected the art of engraving in the 19th century, including the Germans Ferdinand Olivier, Alfred Rethel and Adolf von Menzel, were often unfairly regarded as artisans rather than creative artists. Illustrators who devoted their lives to journalism and caricature were held in no higher regard. HONORÉ DAUMIER, who was from a poor family, trained in a painter's studio but had to turn to the graphic arts in order to support himself. While employing his talents as an effective cartoonist for the opposition journal *La Caricature* during the July Monarchy (a caricature of King Louis-Philippe in the shape of a pear earned him a spell in prison), he was never regarded as anything other than an ordinary draughtsman and lithographer. His sculpture, so highly thought of today, remained unknown during his lifetime.

These creative spirits remained on the fringes of the artistic world on account of the particular techniques they used. But there were a number of painters and sculptors who avoided the well-worn routes to success, although this was not always a deliberate choice: some artists were not only not recognized as such by their contemporaries but also failed to see themselves as artists. Ferdinand Cheval, a postman in the Drôme in southeastern France, collected stones and shells on his rounds. From 1879 onwards, he used these to build a fantastic architectural sculpture inspired by a personal vision of Indian art, the *Palais Idéal* in Hauterives. Cheval was the first in a line of 'naive' artists, but he certainly did not see himself in this way. The same was more or less true of Henri Rousseau ('Le Douanier'), a clerk from Angers who moved to Paris to work in the city's customs service. Armed with advice from the painter Jean-Léon Gérôme, he took himself off to the Louvre to copy the old masters before starting to produce his own work in 1885. These self-taught artists followed a path that was too far removed from the official route and produced work that was far too idiosyncratic for them to be regarded as proper artists during the 19th century.

Away from the capital

The perceptive Degas was one of a small number of avant-garde artists (others included Pissarro, Gauguin and Signac) who took notice of Rousseau at the beginning of his painting career and championed him. But he was aware of the dangers inherent in a type of art whose style and technique

Honoré Daumier, *Le Ratapoil*, bronze statuette, Paris, Musée d'Orsay.

were out of step with the times. A man of means, Degas flirted for a long time with official art despite having no pressing financial need to sell his work. Although he exhib-

Salon stalwarts and 'refusés'

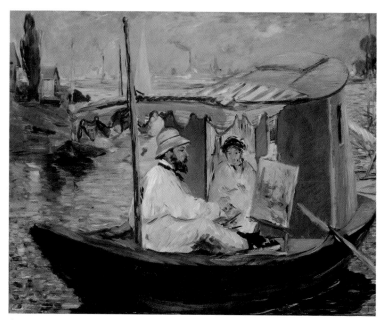

Édouard Manet, *Monet Painting on His Studio Boat*, 1874, oil on canvas, 82.5 x 104cm, Munich, Neue Pinakothek.

ited alongside the Impressionists between 1874 and 1886, he continued to show work at the Salon. After the relative failure of his *Little Dancer Aged Fourteen* (a complex creation of wax, cotton and satin admired by a few far-sighted observers such as Huysmans but censured by other critics for its 'bestial brazenness') at the Impressionist exhibition of 1881, he decided to hide his sculpture from the public. Thereafter, he presented to his contemporaries the image of a bold painter, but one who respected traditional techniques (mainly oil and pastel).

Many more artists chose to paint in complete freedom, away from Paris (and its juries). It was in opposition to the capital, where the Salon reigned supreme, that the Barbizon School was formed after 1835. This was the first group of French artists dedicated entirely to landscape painting. The physical distance corresponded to the distance between the genres: landscape painting in Barbizon, history painting in Paris. Théodore Rousseau, who started travelling to the village near Fontainebleau to paint in 1836, actually moved there in 1848. This withdrawal to the countryside was comparable to Constable's in England around the turn of the century, but it would have been unthinkable in France fifty years earlier.

A quarter of a century later, during the early years of the Third Republic, the young Impressionists also underlined their distinctiveness through a strategy of physical separation. They were aided in their desire to get out of Paris by the development of the railways, which allowed them to leave the capital without having to be away for too long at any one time. These 'open-air' painters worked from nature in unusual places: Argenteuil, which was visited, from 1868 onwards, by MANET, Renoir and MONET (who bought a studio boat there) by taking the train from Saint-Lazare Station; Giverny, where Monet made another purchase, this time a house; and the banks of the River Seine anywhere between Paris and Le Havre, where Monet painted the picture that gave Impressionism its name – *Impression: Sunrise* (1872).

The geography of Paris: districts favoured by the modern painters

Even within Paris itself, a subtle topography indicated the varying degrees of resistance to the academic model.

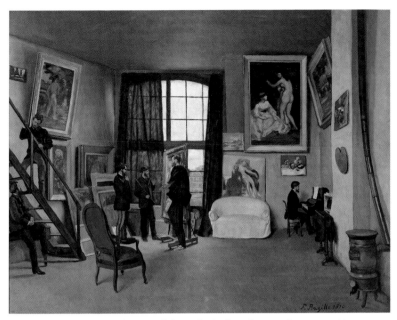

Frédéric Bazille, *Bazille's Studio: 9 Rue de la Condamine in Paris*, 1870, oil on canvas, 98 x 128.5cm, Paris, Musée d'Orsay.

After decades of uncertainty following their expulsion from the Louvre (when it was transformed into a museum at the beginning of the century), artists regrouped under the Second Empire. Most of them, whatever style they worked in, lived on the Right Bank, first of all in the Batignolles district and then in the new districts redeveloped by Haussmann between the Boulevard de Clichy, the Boulevard des Batignolles and the Pont de l'Europe. The type of art they practised determined the kind of studio they occupied: the Salon stalwarts, who had pupils and worked on large paintings, needed a lot of space, while the easel painters could make do with a room in their private apartments. In both cases, they liked to have abundant natural light, from an overhead source if possible. Their preference was for studios on the top floors of the new buildings, and the same was true for photographers. Sculptors, however, having to move extremely heavy materials around, preferred the ground floor. Rodin's first studio, on the Rue Le Brun (on the Left Bank – unusually for him – and therefore near the Gobelins factory and his parents' home), was a former stable that he rented in 1862 for 120 francs a year. In the corner was a well that gave the premises a humid atmosphere – this was probably unpleasant for the artist but very good for his clays. While some artists were happy simply to live in those districts undergoing rapid transformation, others, who regarded themselves as painters of the modern age, liked to paint them as well. Thus Monet set up his easel inside the Saint-Lazare railway station and Caillebotte set up his immediately above it on the Pont de l'Europe. Pissarro painted the thronging boulevards, Van Gogh the busy streets of Montmartre and Toulouse-Lautrec the bars and brothels of the 'quartier des Italiens'.

The centre of artistic social life was the café. In the 1860s, Courbet and his friends met at the Brasserie Bavaroise at 9 Rue des Martyrs, not far from the home of Henri Murger, the successful author of *Scènes de la Vie Bohème* (1848). A few years later, Manet held court at the Café de Bade or at Tortoni's Italian ice-cream parlour on the Rue Taitbout. Later still he used to meet his Impressionist friends BAZILLE, Pissarro and Monet every Friday at the Café Guerbois on the Avenue de Clichy and after 1875 in the Nouvelle-Athènes on the Place Pigalle, where the market for models was based. A large portion of the history of modern art was played out in the convivial atmosphere of these locations.

Salon stalwarts and 'refusés'

Painters and sculptors were not the only ones who frequented cafés. The novelist Louis Edmond Duranty, the art critic Zacharie Astruc, the illustrator Constantin Guys, the art critic Théodore Duret and the novelist Émile Zola also had their regular café meetings: groups formed and re-formed, there were differences of opinion, quarrels broke out – over art or women – and rivals were occasionally challenged to duels. In less than 30 years all the discussions that used to be held in the art schools or at the Académie or Salon had moved to the cafés. It was also a café (the one run by Monsieur Volpin within the precincts of the World Fair and renamed the Café des Arts for the occasion) that provided the avant-garde with an exhibition space in 1889. Pictures by Gauguin, Émile Bernard and Émile Schuffenecker shared the same space as the café patrons – the beer drinkers that Manet had painted a few years before.

Recluses and loners

In less than a century – in France, as we have seen, but also throughout the rest of Europe – the academy-based system perpetuated by the Salon or its equivalent was transformed from top to bottom. There was no longer a division between academic painters or sculptors and 'refusés'. Nevertheless, when they were not working secretly or at least with society being unaware of their existence, artists tended to gather into schools or circles (such as the Nazarenes, the Pre-Raphaelites or the Impressionists). These organized their own group exhibitions, supported by dealers and/or (wherever possible) writers who acted as their theoreticians – as in the case of Ruskin and the Pre-Raphaelite Brotherhood.

But the end of the century also saw the emergence of a new type of artist who did not fit into this pattern: an artist who was more determinedly solitary than his predeces-

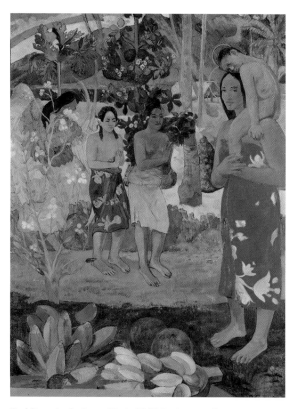

Paul Gauguin, *La Orana Maria (Hail Mary)*, 1891, oil on canvas, 113.7 x 87.7cm, New York, Metropolitan Museum of Art.

sors, choosing complete isolation (or at least refusing to associate with any group) and asserting his individuality in life as in art.

Dividing his career between London and Paris, where he arrived aged 21 in 1855, the American James Abbott McNeill Whistler belonged to this new category of artist. After studying for a while in Gleyre's studio at the École des Beaux-Arts and immersing himself in the Classical tradition by making copies in the Louvre, he initially associated with the Realist circles surrounding Courbet. His early works reflected this influence and met with a measure of success in London, where the Royal Academy showed some of his paintings in 1860. Having settled in London in 1863, the painter nevertheless exhibited work in Paris the same year, at the Salon des Refusés. Hung next to Manet's *Déjeuner sur l'Herbe*, Whistler's painting *The White Girl* (later given the title *Symphony in White No. 1*) was the result of experiments with colour inspired in part by Japanese and Chinese art. It was very different from any other work being done at the time – by either the Realists or the Impressionists. The paintings he produced over the following years – landscapes or portraits with hazy contours and employing various atmospheric and chromatic effects – were, not surprisingly, less well-received than his earlier works in British academic circles. This did not worry Whistler. In 1877, he brought a successful libel action against Ruskin, who had accused him of being an impostor and of 'flinging a pot of paint in the public's face'. He also defended his work in writings and lectures. In Paris he received support not so much from artists – his art did not have a lot in common with theirs – as from a number of important writers of the day, including Huysmans, the Goncourt brothers, Gustave Geoffroy and Mallarmé, who translated his pamphlet *Ten O'Clock* in 1885.

GAUGUIN travelled to Brittany, Provence (where he stayed with Van Gogh) and then Tahiti and the Marquesas Islands in his search for the kind of exile he felt was necessary for the development of his art. He was a different kind of solitary artist, at odds not only with the various artistic schools of his time but with the whole of 19th-century society. Gauguin was born in 1848 to socialist Republican parents, who went into exile in Latin America after the French coup d'état of 1851. He returned to France with his mother in 1855 and was an apprentice in the merchant navy before becoming a stockbroker. Gauguin took a Danish wife, became interested in art and started collecting the works of the Impressionists. He started painting and sculpting for his own pleasure shortly before 1875. His pastime soon became a passion. He showed a painting at the Salon of 1876 and then exhibited with the Impressionists between 1879 and 1886. In 1885, he gave up stockbroking in order to devote himself entirely to painting: this led to poverty and the break-up of his marriage. From this time onwards, his paintings began to be very different from those of the Impressionists. Significantly, he did not choose subjects along the banks of the Seine but went further afield, to Brittany (Pont-Aven and then Le Pouldu, which he visited regularly between 1887 and 1890), Martinique in 1887 and Arles between October and December 1888. In each place he attempted to create a community of painters, a kind of artistic colony: with Émile Bernard and a number of less talented painters in Brittany, and with Van Gogh in Provence. However, his experiences were disappointing and sometimes dramatic – his stay in Arles, for example, culminated in Van Gogh's madness and self-mutilation. Gauguin became convinced that he had to go far away – and live alone – to find inspiration. The relative success of an auction of his work on 23 February 1891 provided him with the necessary funds, and he arrived in Tahiti in spring 1891. He returned to France in 1893 but, after a disappointing stay, left again for Polynesia in March 1895. Ill and depressive, with practically no means of support (the studio sale he held shortly before his departure yielded very little), he clashed with the island's civil and religious authorities. They were extremely displeased that his paintings sang the praises of a primitive life which he portrayed as permissive and sensual, while the colonial policy of the time was aimed at bringing Polynesian civilization into line with Western standards. In 1901, when his financial situation had improved a little thanks to the continued support of his final dealer, Ambroise Vollard, he sought refuge in Atuona, on Hiva Oa in the Marquesas Islands, where he spent the last two years of his life painting and writing.

Salon stalwarts and 'refusés'

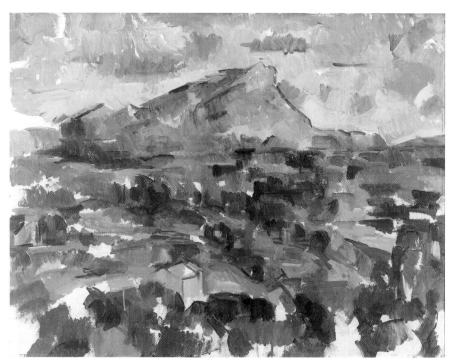

Paul Cézanne, *Mont Sainte Victoire*, 1905–6, oil on canvas, 60 x 73cm, Kunsthaus Zurich.

Less of a recluse than Gauguin, CÉZANNE nevertheless chose to live and paint in isolation, away from the large centres of art, preferring not to throw in his lot with the movements of the day. Of course, this banker's son and one-time law student from Aix-en-Provence (who, like Degas, had a fortune at his disposal, which meant that he did not need to worry about getting commissions) did not shun all social contact. He had been friends with Émile Zola since their schooldays together in Aix, but he fell out with the writer after the publication of his novel *L'Œuvre*; he associated with the Impressionists, frequenting the Café Guerbois and taking part in their exhibitions (including the 1874 show in Nadar's studio); and he also maintained a good relationship with Ambroise Vollard, the dealer with premises on the Rue Laffitte who had the perspicacity to champion Cézanne just as he had supported Gauguin and would later support Bonnard, Picasso, Derain, Matisse and Rouault. But traditional though Cézanne's career was in its early stages, it developed along original and solitary lines. When he arrived in Paris in 1861 at the age of 22, his only art training was the instruction he had received at the local school of drawing in Aix-en-Provence. Nevertheless, Cézanne refrained from training with any Parisian studio on a regular basis and did not settle permanently in the capital either at this time or later. With the exception of his final years, when he retired more or less permanently to Aix, Cézanne spent his whole life alternating between stays in Paris, trips to the Île-de-France and working in Provence at the 'Jas de Bouffan', the country house bought by his father which he spent time decorating. Socializing, which played such an important part in the lives of his contemporaries and those a few years older than him, interested him so little that he declared to his friend the painter Émile Bernard: 'To work without having to worry about anybody else and to grow strong, such is the artist's goal. The rest is not worth a damn.'

Van Gogh's madness

Vincent Van Gogh's life poses the question of whether the act of painting can be destructive. In a letter found on him after his suicide, he wrote: 'My own work, I am risking my life for it and my reason has half foundered because of it.' With their bright colours, rustling corn, distorted perspective and vibrant brushstrokes, Van Gogh's paintings sear themselves into the mind of every viewer, just as they consumed the man who painted them.

Born in Brabant in 1853, Van Gogh was the son of a pastor and in the late 1870s worked as a missionary himself among the coal-miners of Le Borinage in Belgium. He arrived in Paris in February 1886 and made the joyful discovery of the light, colourful painting of the Impressionists, Émile Bernard, Gauguin, Jean-Baptiste-Armand Guillaumin, Degas, Pissarro and Père Tanguy.

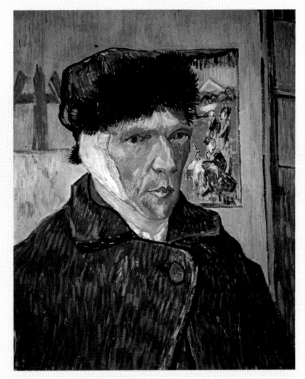

Vincent Van Gogh, *Self-portrait with Bandaged Ear*, 1889, oil on canvas, 60 x 49cm, London, Courtauld Institute Galleries.

Arles: an artists' colony?

Just two years later, however, he left Paris for Arles, seeking the light and colour of the south. Alone at first, he planned to form around him a kind of artists' co-operative and to this end he invited Bernard and Gauguin to join him. To prepare for their arrival he decided to decorate the 'yellow house' where he had been living since late spring. He painted gardens, landscapes and his famous *Sunflowers* to hang on its walls. Gauguin arrived in October 1888 but decided to end his stay in December. This setback brought on a serious bout of depression, during which Van Gogh mutilated himself, cutting off a piece of his left ear on 23 December 1888.

Hospital and suicide

Van Gogh was hospitalized and later admitted to the asylum of Saint-Rémy-de-Provence (May 1889–May 1890). He then went to stay with the art lover Dr Paul Gachet in Auvers-sur-Oise, where he continued to paint, but never regained his mental equilibrium. On 27 July 1890, he shot himself in the chest and died two days later.

Driven to suicide?

Described by the people of Arles as a 'dangerous madman' who sought oblivion in absinthe, and generally regarded as a schizophrenic, an epileptic, a 'melancholic', as 'impressionable' (to use the painter's own term) and by Antonin Artaud as a reject, an outcast, as someone 'driven to suicide by society' and 'a man society did not want to listen to', Van Gogh has become symbolic of the sometimes mortal combat an artist has to engage in if he is to produce his art. To his brother Theo he wrote: 'You do not know how disheartening it is to be confronted by a blank canvas that says: "You are capable of nothing."'

The age of the avant-garde
20TH CENTURY

Twentieth-century artists were society's exceptions, uninterested in the question of whether or not they should integrate. To varying degrees, they forcefully confronted the times they lived in, radically denied society's values and blatantly rejected the culture – or lack of it – of the majority. Throughout the century, from one avant-garde movement to another and from one generation to the next, artists were unconventional figures, expressing their individuality through confrontation. Their attitudes affected every aspect of their lives, right down to the details (or what seemed to be mere details) of their homes, their behaviour and their clothes.

By emphasizing their distinctiveness, artists defined themselves as 'anti' – 'anti' society, particularly when it was confined by an authoritarian or totalitarian regime within a system of absolute principles and prohibitions, and 'anti' the prevailing aesthetic and fashion if these were overworked and therefore no longer capable of producing anything but clichés. Sometimes the two types of struggle became intertwined – when the success of a certain style became closely associated with the dominant social class, for example, as in the case of Impressionism and the French bourgeoisie. On the other hand, there were also times – extreme times – when all that mattered was an early declaration of opposition, and then all artists, of all age and tendencies, pledged their solidarity. So it was with the political fight against fascism. In any case, as the term's military connotations indicate only too well, the 'avant-garde' movements defined themselves in terms of the historical, artistic acts of breaking away and starting again. Their enthusiasm for the new was first and foremost a desire to finish with an outdated or unacceptable order. In 1912, Guillaume Apollinaire declared in the opening of his poem *Zone*: 'In the end you have grown weary of this ancient world.'

ADVENTURES IN PAINTING

The first change, felt in a hundred different ways, was that the academy system, which had retained its authority until the end of the 19th century, suddenly collapsed. Still apparently sturdy around 1900, by 1914 it lay in ruins.

Artists and artisans: the combining of pictorial techniques

Until the beginning of the 20th century, the art world was divided into well-defined disciplines: painting, sculpture, drawing and engraving. Each one had its own tools, its own procedures and its own technical rules, which acted as guarantees of stability. The authority of these disciplines derived from their antiquity, from an accumulation of knowledge and experience and from age-old traditions. Naturally, Gauguin no longer painted in the way that Poussin had, nor Cézanne like Tintoretto, but they were nevertheless all painters. In their studios, where they now usually worked alone, in other words without assistants, painters still used brushes to apply paint to pieces of textile stretched over wooden frames. More rarely, they still painted on wooden panels or on walls (even though fresco had gradually fallen into disuse after the 16th century and the last masterpieces in the medium had been painted by Tiepolo in the 18th century). Naturally, painters of the later generations benefited from a number of innovations – the palette knife, for example, which allowed them to work with thick layers of paint, and paints

that could be bought ready-made from shops. The way in which supports (canvases, generally) were prepared also changed, becoming far simpler. Even so, the way Degas or Gustave Moreau painted did not differ a great deal from the way Ingres or Delacroix painted, and by the same token these two earlier painters could claim to be direct descendants of Raphael or Rubens. They were all united by technical continuity. In the 20th century this continuity stretched thin and then snapped.

The fact that during the Fauvist era, around 1905, Matisse and Derain were using pure colour directly from the tube – abandoning what had seemed to be one of the most noble aspects of the art of painting, the mixing of colours – may be seen simply as part of the same tradition. But in the years after 1912, Picasso and Braque began to experiment with truly outlandish combinations. They added plaster, ash and dust to their oil paints in order to thicken them and obtain more visible, and thus more effective, variations of texture. They borrowed special effects, such as imitation wood and marble finishes, from painters and decorators. They used these techniques to put on canvas barely intelligible, elliptical symbols of objects and trompe-l'œil fragments of a paradoxically impeccable illusionism.

Collage and the introduction of trade names

At the same time, in 1912, these two artists also invented a new way of working on paper: the COLLAGE. Instead of restricting themselves to charcoal, ink, red chalk, pencil (or watercolour, gouache or pastel), they stuck (or more rarely pinned) fragments of newspaper, sheet music, books, posters or some other form of printed matter onto a paper support. Instead of actually painting a representation of a wall, they now suggested it by including a piece of wallpaper in the picture. Similarly, they did not paint a violin, a guitar or a table but indicated it metaphorically with a piece of wood-effect paper. They thus introduced into art ordinary, everyday elements of no value.

This break with the past was the result of formal experimentation, but it was also, just as importantly, a response to the preoccupations of contemporary society. Picasso and Braque were recording the proliferation of new materials and the spreading of the printed word and the image into everyday life. Newspapers could be found on every table; posters on every wall. How could they not make their way into the artist's studio sooner or later? Braque later explained: 'I had developed a passion for posters. I often waited for night-

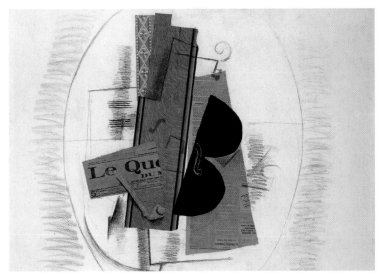

Georges Braque, *Violin and Pipe ('Le Quotidien')*, after 20 December 1913–1914, collage (charcoal, wood-effect paper, wallpaper border, black paper and newspaper stuck onto paper and fixed to cardboard), 74 x 106cm, Paris, Musée National d'Art Moderne.

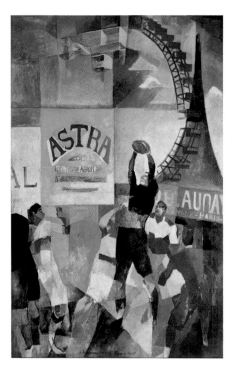

Robert Delaunay, *The Cardiff Team (3rd version)*, 1913, oil on canvas, Musée d'Art Moderne de la Ville de Paris.

fall so that I could go and take down the ones I liked. I kept one by Lautrec for years.' Newspaper mastheads and typefaces feature prominently in the still lifes and landscapes treated in the new, Cubist, manner, as do logos of products (Suze, Léon, Kub) as advertised on the sides of buildings (which Picasso painted and which Mondrian drew on his arrival in Paris). Robert Delaunay introduced a poster for an aeroplane manufacturer and another bearing his own name into later versions of his CARDIFF TEAM.

The later history of the collage: the triumph of debris

The technical changes that occurred in the studios of Picasso and Braque had far-reaching consequences.

The collage had a similar influence. Over the following years it was taken up by the Dada movement and developed further by the Surrealists. In the 1920s, the German artist KURT SCHWITTERS, close in spirit to the Dadaists, adopted it as his main technique, abandoning painting and drawing altogether. His works, both those on paper and those in three dimensions, were created in two stages. First of all he collected small pieces of rubbish, scraps of torn paper, tickets, advertisements, buttons, and so on. He then created a collage of all these scraps, transforming them into reliquaries of a society that was – already – one of mass pro-

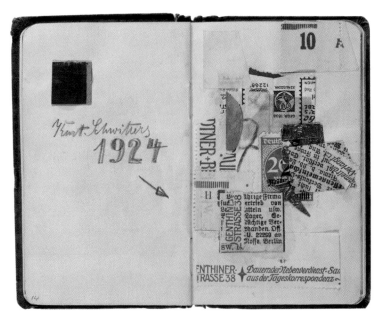

Kurt Schwitters, *Collage*, 1924, Paris, Musée National d'Art Moderne.

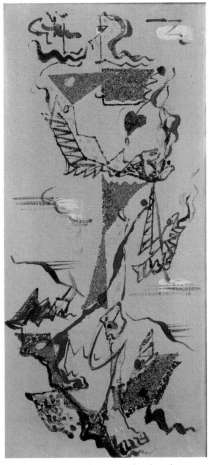

duction and rapid consumption and destruction. The collage was Schwitters's way of responding to the times he lived in.

The procedure is appealing from a formal point of view as it allows the juxtaposition of heterogeneous fragments. After World War I, the technique was used by Hannah Höch in Switzerland, Raoul Hausmann in Berlin, Otto Dix in Dresden and Max Ernst in Cologne. Ernst in particular took the collage to a new level of complexity and perfection. He drew on an unprecedented range of printed images taken from scientific journals, industrial catalogues, car manuals, electrical equipment handbooks and news photographs. The images he used included mechanical diagrams and complete and part objects. Ernst grafted them onto each other and coloured them as he saw fit, using watercolour. He used the techniques of photomontage to produce an apparently coherent and plausible image that was actually the result of artifice. For this work he replaced easel, stretcher and brushes with scissors, glue, photographic materials (in some cases) and a table on which to work.

Ernst used even more unlikely objects in his work: dead leaves, pebbles, feathers and wooden boards. He would place a sheet of paper over these objects and then rub over the paper with a piece of graphite. The grain of the wood, veins of the leaves or texture of the stone would be transferred onto the paper in an automatic 'drawing' procedure that Ernst named 'frottage'. Ernst was no

André Masson, *Lancelot*, 1927, oil and sand on canvas, 46 x 21.5cm, Paris, Musée National d'Art Moderne

less inventive when he worked on canvas, using a sponge, streaks of paint and a scraping technique to produce fantasy architecture and monstrous, petrified creatures. ANDRÉ MASSON, another Surrealist, took up the idea first employed by the Cubists of using a sand and paint mixture. However, unlike Braque, he threw it and scattered it on the canvas, thus allowing chance to play a part in the creative process.

The question of expertise: an important aesthetic issue

More generally, the inter-war period was characterized by an astonishing diversity of pictorial techniques, to such an extent that the description 'painting' became ever more inadequate and imprecise.

Piet Mondrian and Kasimir Malevich, painters of an extremely pure form of abstraction, sought to create planes of uniform colour of no discernible thickness and that gave no hint of materiality or surface. They wanted to achieve a pure, disembodied art located far beyond the constraints of matter and its sometimes unexpected nature. They passed this aspiration on to their disciples, who made it an essential feature of their work, seeking to eradicate any trace of how their pictures were made.

Pablo Picasso and Max Beckmann, by contrast, regarded the canvas as the arena for a process of technical experimentation that started all over again with each new work. The marks left by one alteration after another, the expressive gestures, the smudges and

The age of the avant-garde

Paul Klee, *Florentine Villa District*, 1926, oil on cardboard, 49.5 x 36.5cm, Paris, Musée National d'Art Moderne.

splashes, the apparent 'imperfections' were all part of the creative process. The way in which these artists painted was continually evolving. They rejected the notion of personal 'style' and refused to fix their approach once and for all or limit their art to the regular rehearsal of well-mastered techniques. This explains the occasional sense of incompleteness or perceived confusion produced by their works. It also explains Picasso's disdain for 'finish', which led him in the last two decades of his life to make 'dirty' marks, streaks of paint, highly simplified caricature and false clumsiness his preferred techniques. A similar thing could be said of the work of PAUL KLEE, whose guiding principle was diversity – both of style and materials. Other artists were at the opposite extreme of this idea of constant development, many of them scornful of it; they instead cultivated the traditions of the old masters, relishing the techniques, slowness and nostalgia inherent in such an approach. After going through a Dadaist phase, OTTO DIX switched in 1923 to a minutely detailed style directly inspired by the German primitives Lucas Cranach, Matthias Grünewald and Albrecht Altdorfer. Dogs' coats, women's hair, furs, uniforms, skies and snow-covered landscapes: Dix cultivated a style of realism that was attentive to the smallest detail,

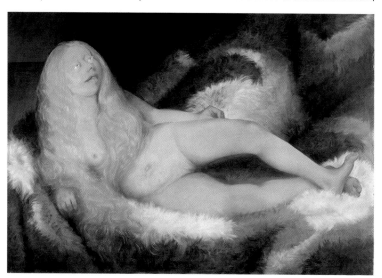

Otto Dix, *Nude with Fur*, 1932, tempera and oil on canvas laid on wood, 98.5 x 124.8cm, Edinburgh, Scottish Gallery of Modern Art.

a realism that became unbearable – as the painter had intended it to be – when applied to the naked, jaded body of a toothless old prostitute or to a soldier's mutilated, half-rotted corpse.

For many other artists, references from the past were much less a means to an end than an end in themselves. Giorgio de Chirico, André Derain and Balthus claimed to be the heirs to the 'grand tradition' of painting. They turned the question of technique into a major public issue. These upholders of tradition refused to recognize as painters those who flouted the traditional rules. The latter in turn accused their critics of excessive

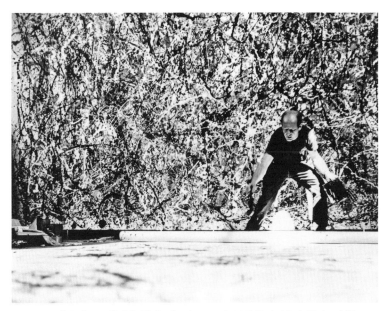

Hans Namuth, *Jackson Pollock in His Studio*, photograph, 1950, Paris, Musée National d'Art Moderne.

conservatism and a failure to move with the times. In these debates, the 'craft of paint-ing' was generally held up as something valuable by those who used the example of painters from the past as their authority for criticizing contemporary artists who had turned their backs on academic training.

After 1945: cutting, dripping and imprinting

The break with the past became even more pronounced after 1945. Admittedly, there were still a few adherents of painting in the traditional sense of the word, with every-thing this meant in terms of techniques and practices. But even Matisse, born well be-fore the turn of the century, could no longer be included in the usual definition of his art. At over 70 years of age and in poor health, he was often confined to bed and so 'painted' with scissors. He cut shapes out of sheets of paper painted with gouache in simple, bold colours and directed their glueing or pinning onto a white support that formed the background. He explained this activity as follows: '[This technique] makes me feel an intense passion for painting because by completely changing my style I be-lieve I have discovered something fundamental about the spatial aspirations and ob-sessions of our times ... Never, I believe, have I felt as great a sense of balance as I do when making these paper cut-outs. But I know it will only become clear later just how much what I am doing today is in tune with the future.'

In the USA after World War II, one artist took Masson's innovations a stage further and invented 'Dripping'. JACKSON POLLOCK placed a large canvas flat on the ground and moved around it, dripping and pouring paint (both traditional artist's paints and metallic paints), using pots, sticks and improvised tools. This resulted in a mesh of apparently random intersecting lines punctuated with patches of colour. The artist's hand did not intervene directly; rather the work was created by the choreography of his body as it danced around the surface of the painting. In France at the beginning of the 1960s, Yves Klein employed a completely new painting technique in his *Anthropometries* series (see page 192): im-ages were imprinted on canvas or paper using naked human bodies coated with blue paint.

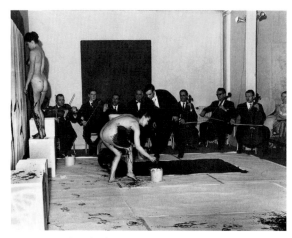

Yves Klein, *'Anthropometry' Performance Work*, photograph, 1960, Paris, Galerie Internationale d'Art Contemporain.

Scratching, scraping, rubbing, burning and weaving: the new techniques of painting

A contemporary of Pollock, Jean Dubuffet took other liberties with tradition. He worked with thick pastes that he then incised, scratched and raised in relief. His work prefigured many later experiments, notably those of the Spaniard Antoni Tàpies.

The appearance of new products – glues, complex coatings and chemical compounds – encouraged artists to experiment in ways that had previously been inconceivable. With their polymers, acrylic binders and foams, painters' studios resembled laboratories even more than they had before. In Tàpies's studio, the traditional tools of the trade were greatly outnumbered by those designed for splattering, vaporizing, melting, sawing, assembling, and so on. And in the studio of PIERRE SOULAGES in France, brushes were replaced by unusual tools made by the artist himself: spatulas, rakes and combs. Some, such as the wooden shaft ending in a sliver of rubber of variable thickness and shape (which the artist used to spread or smooth paint over a surface, varying the direction and force of the stroke), did not even have a name.

The pictorial techniques employed by artists became so diverse and complex during the second half of the 20th century that it would be impossible to list all the procedures used. No single method could be said to have dominated; artists developed their own techniques as they saw fit. In the USA, Willem de Kooning distorted his forms by drying wet paintings with a ball of newspaper. Robert Motherwell and Franz Kline in the same country and Wols and Jean Degottex in France explored the visual and rhythmic possibilities of splashing and crushing actions. Another Frenchman (of Hungarian origin), Simon Hantaï folded and tied his canvases before immersing them in tubs of pigment – dyes rather than paints. After drying, the strings were removed, revealing areas of colour divided by the folds that had remained undyed.

This technique, combining a mechanical procedure with chance, influenced the work

Colette Soulages, *Brushes, Palette and Paints: Pierre Soulages' Tools*, photograph taken in the artist's studio in Sète, France, 1982, private collection.

of Jean-Pierre Pincemin and Louis Cane, two members of the Supports-Surfaces movement, at the beginning of the 1970s in France. Others associated with this movement, such as Christian Jaccard and François Rouan, followed different paths. The first used firework fuses and fire to transform colours and create dark, fire-blackened lines in his work. The second wove together strips of paper or canvas, playing with the repetition and discontinuation that arose from the alternation and superimposition of motifs.

THE PROGRESS OF PHOTOGRAPHY

Innovatory as these experiments were, they nevertheless consisted of the application or projection onto paper or canvas of pigment (sometimes mixed with other elements). Studios could resemble either laboratories or barns. Works could display either the strangest formal complexity or simplicity of the purest kind. The words 'painting' and 'drawing' had not lost all of their relevance, even though they no longer denoted a specific, well-defined set of practices and rules.

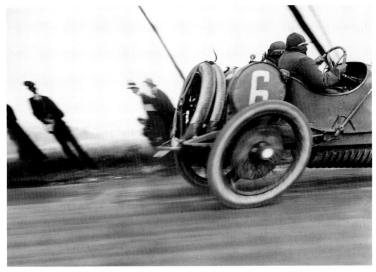

Jacques-Henri Lartigue, *ACF Grand Prix (Dieppe Circuit: Delage Automobile)*, 26 June 1912, photograph, Paris, Association des Amis de Jacques-Henri Lartigue.

The photographer: an artist whose studio is the world

But there were also those artistic practices in which the only part played by the human hand was working the shutter release. In many cases the term 'studio' no longer had any meaning for photographers. Was it the place where they worked? Yes, but this applied only to those photographers who needed closed spaces in which to create a setting, install lighting and deploy heavy equipment.

By no means all photographers used a studio. For JACQUES-HENRI LARTIGUE, Henri Cartier-Bresson (see page 194), Brassaï and André Kertész, photography was an art form that could be practised anywhere; indeed, this was one of its chief merits. Anywhere meant in the street, through a window, from a car, either casually in passing or as the result of watching and waiting. It also meant being able to respond to tricky, spur-of-the-moment situations in which no draughtsman – and still less a painter – would have had time to act. From 1910 onwards, cameras became lighter, smaller, easier to handle and faster. During World War I, hundreds of anonymous soldiers on both sides became

The age of the avant-garde

Henri Cartier-Bresson, *Leningrad, Commemoration of Victory over the Nazis*, photograph, 9 May 1973.

reporters at considerable risk to themselves, and the best shots as well as the most alarming ones (hastily taken pictures of explosions and carefully photographed corpses, for example) were published by the magazines. The sensitivity and sharpness of films increased. Cameras could soon be used in natural light, in the glow of fires and the glare of streetlights. In fact, there were soon hardly any circumstances in which they could not be used.

A new relationship with time

What did the concept of 'work' mean for the photographer? Clearly it was not the same as the work of a painter in his studio. Cartier-Bresson put forward the notion of the 'decisive moment', which implied a very different temporality from that involved in the act of drawing or painting. 'For me', he wrote in 1977, 'the camera is a sketchbook, an instrument of intuition and spontaneity, the master of the instant which – in visual terms

Robert Capa, *Indochina, the Road from Namdinh to Thaibinh*, photograph, 25 May 1954.

– questions and decides at the same time ... To take photographs means to recognize – simultaneously and within a fraction of a second – both the fact itself and the rigorous organization of visually perceived forms that give it its meaning.' This aesthetic of revelation provides no opportunity to try again; there is no question of a second chance – and no need for a studio. All that is needed is a laboratory in which specialists equipped with the necessary machines develop and print the photographer's work. It is possible to reframe, to correct a composition, to obtain a darker or lighter print, but these tricks cannot fundamentally change an image that draws its intensity from the 'rigorous organization' and the 'fact' referred to by Cartier-Bresson. At the very most these specialists can accentuate the dramatic effect or increase the importance of this or that detail.

This was even more true of photo-reportage. Starting in the inter-war period, photo-reportage captured contemporary events and personalities for the popular magazines in images that were expressive, allegorical, provocative, accusatory and sometimes downright unbearable. The year 1947 saw the founding of the Magnum photographic agency in New York by four photographers: Cartier-Bresson, George Rodger, ROBERT CAPA and David Seymour (known as Chim). Capa and Seymour were pioneers of war coverage. Capa had taken the now famous photograph of a Republican soldier hit by a bullet from a pro-Franco fighter during the Spanish Civil War and had witnessed the Allied landings in Sicily and Normandy as well as the invasion of Germany. He was killed by a mine in Indochina in 1954. Chim was also in Spain in 1937, then in Germany in 1944 and in Israel during the War of Independence of 1948. He died in a burst of fire during the Franco-British operation to seize the Suez Canal in 1956. The studio of these photographers was the world itself and their exhibition spaces were the magazines that published their work, such as *Life*, *Paris Match* and *Vu*. Lee Miller followed a US division into Dachau and Buchenwald and urgently sent her photographs of the camps to her employer, *Vogue*, with a telegram: 'I implore you to believe this is true.'

Photojournalism: the critical recorder of an age

In such situations, photography has far more to do with military and political history and the history of ideology and morality than with aesthetic considerations. The same is true for photographers such as August Sander in pre-1933 Germany and Walker Evans in the USA, from 1929 onwards, who saw photography as an analytical rather than a descriptive tool. They wanted the photographic image not simply to be a fragment of narrative, but to explain a situation. Sander set out to make an inventory of German society from the beggar to the capitalist, observing all types with the same

W Eugene Smith, *Tomoko Uemura in Her Bath*, photograph, 1972.

The age of the avant-garde

severe neutrality. During the Great Depression, Walker Evans and Dorothea Lange travelled through the devastated regions of the country, taking pictures of the people they encountered – pictures that became symbols of poverty. After photographing the bitter fighting between US and Japanese forces in the Pacific, W EUGENE SMITH became a master of the photo-essay, combining a chronicle of everyday life, sociology and denunciations of injustice. His most famous work is *TOMOKO UEMURA IN HER BATH*, a tragic allegory of the pollution of Minamata by mercury waste.

This generation of photographers emerged shortly before or during World War II. Their successors risked their lives in Vietnam, Bangladesh and Biafra during the second half of the 20th century. They included photographers such as Don McCullin, Philip Jones Griffith, Jean-Claude Francolon and Gilles Caron, who went missing in Cambodia shortly after covering the events of May 1968 in Paris (where he took the famous photograph of Daniel Cohn-Bendit face to face with a member of the security police). Later came coverage of the fighting in Lebanon (Raymond Depardon), the Islamic revolution in Iran (Marc Riboud and Gilles Peress) and the ethnic conflict in Bosnia (Gérard Rondeau and Gilles Peress). The photographer was an artist continually on the move, an artist whose restlessness was one of the essential factors of his art, a truly 20th-century figure for whom the prototype had been illustrator-reporters such as Constantin Guys, who had 'covered' the Siege of Sebastopol (1854–5) for the *Illustrated London News*, and Orientalist and Africanist artist-explorers, whose very *raison d'être* had been taken away from them by photography.

Metamorphosis of the real: 'photographic amusements' and their development

There was, however, another type of photographer. Their place of work was the studio, their main technique was the manipulation of the image and their exhibition circuit and market were more strictly artistic. From the beginning of the 20th century, exercises presented as 'photographic amusements' allowed calculated, modified and distorted effects to be produced. Models posed in prepared settings, in carefully judged postures and under specially arranged lighting. Negatives were cut, exposed and altered in a variety of ways.

Among the photographic equivalents of the montages of artists like Ernst were the experiments conducted by the greatest practitioner in the field, Man Ray (real name Emmanuel Rudnitsky), an American who settled in Paris and

Man Ray, *Rayograph (Les Champs Délicieux)*, 1922, Paris, Musée National d'Art Moderne.

became a central figure in the capital's artistic life (and nightlife) during the 1920s and 1930s. One of Man Ray's techniques was to arrange objects on photographic paper and expose them to the light, causing their shadows to register on the paper. This produced ghostly still lifes that he named RAYOGRAPHS, a reference both to his name and to the use of light. Another of his techniques was to overexpose images ('solarization'), producing a washed-out effect. He also cut out and re-arranged images in order to isolate a particular element. In Germany, Lucia Moholy and László Moholy-Nagy (natives of Czechoslovakia and Hungary respectively), who worked at the Bauhaus from 1923 onwards, also made camera-less photographic images, calling these 'photograms'. They considered photographs made with or without a camera as simple mechanical processes that should not betray any personal emotion but instead be concerned with form and light alone.

While photography's reproducibility made it, in their eyes, the art of the day best adapted to mechanization, the photograms they made were, paradoxically, unique images which could not be reproduced.

Photographers explored other areas too during the 1920s. One of these was the close-up, whereby the lens was used like a magnifying glass to produce a new vision of objects, textures and structures. Related to the development of scientific photography, this practice produced an 'objective representation of reality', which in the mind of its advocates liberated the viewer from the subjectivity of individual representation. This technique won general support among the adherents of New Objectivity, including Professor Karl Blossfeld, who photographed plant structures from very close up.

Between artifice and reality: the return of the studio?

Whether it focused on 'pure' photography during the 1920s, 'creative photography' during the 1950s or 'fine art' photography during the 1980s, the ambition of those photographers preoccupied with art rather than reportage remained essentially the same throughout the century: to use camera technology, shutter speed, composition and printing process to develop new visual effects.

Artists working in this way – often Dadaist or Surrealist in spirit or even taking an abstract approach – included Imogen Cunningham and Edward Weston between the wars and, later, Harry Callahan, Duane Michals, Joel Peter Witkin and Joan Fontcuberta. Technological developments at the end of the 20th century gave them new opportunities, with digitalization and virtuality making possible all kinds of metamorphoses. The studio became a computerized laboratory featuring the 'paintbox', a tool for disjunction, juxtaposition and synthesis that was used in conjunction with elaborate staging, dressing up, pictorial reference, text and assemblage. In the

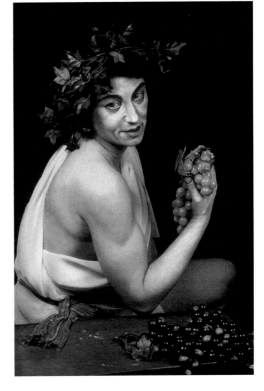

Cindy Sherman, *Untitled #224*, photograph, 1990.

The age of the avant-garde

work of CINDY SHERMAN, Christian Boltanski, Nan Goldin, Paul-Armand Gette, Bernard Faucon, Florence Chevallier, Sophie Calle, Jochen Gerz and others, photography was used as just one of a number of media making up a more complex form of art that could generally be described as installation art. With these artists (and many other names could be mentioned), the notion of the studio came back into its own as a place where images and objects could be combined and transformed in a creative process whose point of departure was the diversity of materials and techniques.

SCULPTURE AND SPACE

The art previously known as sculpture also underwent far-reaching changes during the 20th century. Here again, the first two decades of the century were decisive.

The changing fortunes of bronze

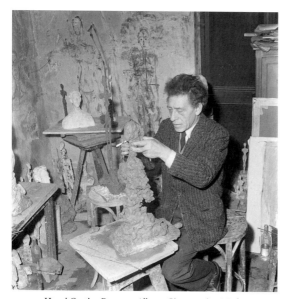

Henri Cartier-Bresson, *Alberto Giacometti at Work*, photograph, 1961.

At the turn of the 20th century, Auguste Rodin was producing work using techniques that had been practised by sculptors since the Renaissance. He modelled clay, sculpted marble and above all made bronze casts, thus continuing a tradition with a prestigious past. After him, sculpture split into a number of different trends. One of these remained faithful to bronze while the others either excluded or ignored it.

The tradition of sculpture in the round continued until World War I. In France, its most illustrious exponent was Antoine Bourdelle, who had worked in Rodin's studio. Sculpture in the round went hand in hand with an aesthetic that proudly regarded itself as classical and claimed kinship with the Graeco-Roman tradition. Aristide Maillol was another sculptor who worked in this style. Starting in 1905, he devoted himself over the following decades to the creation of powerful feminine forms that were supposed to represent (according to circumstances) the Mediterranean, or the French revolutionary Auguste Blanqui, or some moral virtue, while sublimely ignoring each successive artistic revolution that took place. In the work of other artists of less forceful temperament, this sculptural Neoclassicism slipped into academicism – as typified by Charles Despiau and Paul Landowski in France – or degenerated into the colossal, heroic creations beloved of totalitarian regimes, as in the work of Arno Breker and Joseph Thorak in Nazi Germany.

Things were different with bronze. Matisse, a sculptor as well as a painter, started working with clay, switching only later to metal. He modelled the volumes of *Back* or *Head of Jeannette* with a geometric crispness that contrasted starkly with Rodin's fluid dynamism. Picasso, also a keen sculptor, turned to casting after 1904, during his early years in Paris, and again during his 'Boisgeloup' period in the 1930s, when he took over a château in Normandy as his studio and created female figures composed of curves and spheres. ALBERTO GIACOMETTI was still working in bronze after 1945 in his studio on the

Rue Hyppolite-Maindron in Paris's 14th arrondissement, converting his female plaster figures, sometimes partly coloured, into attenuated bronzes with extremely uneven, damaged-looking surfaces. He also made a number of portraits in bronze, including those of his wife Annette, his brother Diego and his friends Jean-Paul Sartre and Jean Genet.

The reappearance of wood

The 20th century nevertheless marked the end of sculpture's domination by bronze, which had reigned supreme since the Renaissance. Wood now became the preferred material of sculptors. Less expensive than metal, it had to be carved and did not lend itself to copying or multiplication.

The first modern artist to sculpt with wood was Gauguin, who used it during his first stay in Oceania to carve statues of the Polynesian pantheon of gods, taking his inspiration from what he knew of the ancient art of Tahiti, the Marquesas Islands and Easter Island. To these influences he added the buddhas of Borobudur and Breton crucifixion scenes. Gauguin's wooden sculptures, which had been ignored for many years, were exhibited at the retrospective of his work held at the Salon d'Automne of 1906, three years after the artist's death. It was also around this time that the ethnographical collections of the Musée de l'Homme, containing numerous masks and other wooden sculptures, went on display at the Trocadero. The exhibition inspired Picasso, Derain and even Matisse to turn to wood as a material for sculpture.

In 1907 and 1908, these three artists carved archaistic, strictly geometric figures in poor-quality woods (off-cuts). Wood also became extraordinarily popular with German Expressionist artists at this time. In 1911, influenced by the collections of the ethnographical museums in Dresden and Berlin, Ernst Ludwig Kirchner and other members of the Die Brücke group hewed lengths of timber into rudimentary nudes that they also painted. The most impressive use of wood, however, was made by Constantin Brancusi, who also departed more obviously from the sculptural tradition than any of the others. Born in Romania in 1876, Brancusi arrived in Paris in 1904. After an academic training he had a brief spell in Rodin's studio. His favourite materials were wood and stone. These he attacked with saw, axe, gouge, mallet and pick in order to extract simple, symbolic volumes: a primordial egg, the structure of the human head encapsulated in three spheres, a schematized anatomy represented by oblique lines, a bird refined into a spindle, and so forth. The most complete collection can be seen at BRANCUSI'S STUDIO, 11 Impasse Ronsin in Paris, which he left in its entirety to the French state (Centre Pompidou).

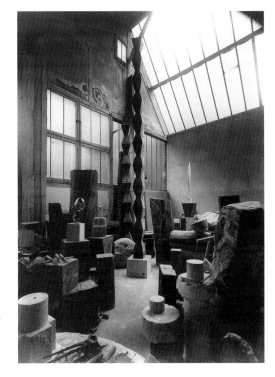

Constantin Brancusi,
Constantin Brancusi's Studio, photograph, 1925, Paris, Musée National d'Art Moderne.

RODIN: THE END OF TRADITION

At the turn of the 20th century, Auguste Rodin (1840–1917) used clay for working out his initial ideas. This was the material in which he 'constructed' his figures and which allowed him to model the volumes and create the surface finish he required – smooth or marked with lines, nicks or incisions.

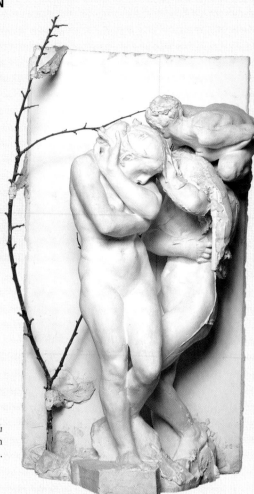

Auguste Rodin, *Two Figures of Eve with Crouching Woman*, assemblage in plaster, 1905, Paris, Musée Rodin.

From clay to plaster: trying out combinations

Frequently, Rodin would reproduce in plaster a form created in clay, and then treat it as a building block that could be put together with others to form groups. This was a new way of working, comparable only to the use of series and variations of which painters were so fond. His studio contained a collection of fragments – heads, limbs and torsos – which he used as elements in composite works. The long work on *The Gates of Hell* (started in 1880 but unfinished) thus proceeded by repetition and addition. The underlying architecture of the work has been almost completely covered by a proliferation of scenes and figures ranging from bas-relief to almost sculpture in the round. The fragments that have been preserved – in other words, the elements that were not assembled – have an aura of their own every bit as powerful as the grandeur of the sculptor's completed works.

Casting: the reproducibility of sculpture

Once the composition had been finalized, Rodin generally proceeded to cast his sculptures in bronze. Bronze guarantees a work's durability and, if it is made up of separate elements, increases its visual coherence. Casting also allows sculptors to make multiple copies of their work. This 'multiplication' is necessary from an economic point of view, as the casting process is a costly one that requires personnel (foundry workers), a substantial amount of equipment, the metal itself and time. Rodin used multiple castings to a far greater extent than his predecessors. Initially, the creator of *The Burghers of Calais*, *Balzac* and *Iris, Messenger of the Gods* shocked his contemporaries with the expressive power of his works, his lack of regard for detail and his 'indecent' celebration of nudity and sexuality – characteristics which can also be found in his works on paper (pen and ink drawings, watercolours and collages). From the end of the 1870s, however, the power of his sculptures won Rodin international fame and opened up for his work a market of unprecedented size that

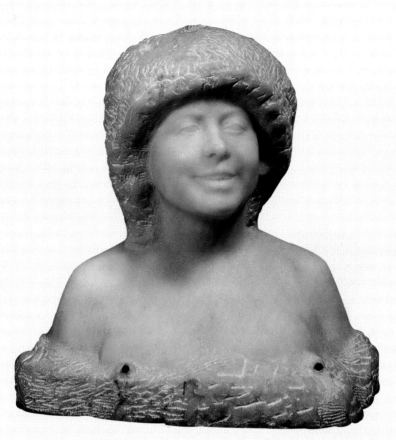

Auguste Rodin, *The Duchesse de Choiseul*, 1911,
marble, Paris, Musée Rodin.

stretched from the USA to central Europe. This inevitably created an impetus of its own. Like the studios of Titian and Rubens before him, Rodin's studio at the Villa des Brillants in Meudon, which he bought in 1895, and at the Hôtel Biron (today the Rodin Museum), into which he moved in 1908, started to operate like a business. A secretary (between 1902 and 1906 this was Rainer Maria Rilke) provided indispensable administrative support, while carefully chosen assistants – many of whom, like Bourdelle, went on to become celebrated artists themselves – not only supervised the casting but sometimes also produced marble figures.

The role of the assistant

Although he alone devised the poses, compositions and assemblages, Rodin often limited himself to a supervisory role during his later years. He did the inventing and his assistants did the producing. In 1890, he created a portrait of his lifelong companion Rose Beuret. One might think this would be an intimate work, but although he was responsible for the plaster cast, the actual marble was carved by Bourdelle. Around 1911, a portrait bust was made of another of Rodin's women, the Duchesse de Choiseul, who between 1904 and 1912 was simultaneously his mistress, his muse and his manager. The marble version, however, is simply a copy of the clay original, and an imperfect one at that. The unknown assistant has failed to reproduce the curls of hair that Rodin created in the clay. The duchess thus sports an unusual Roman-style hairstyle not at all like her actual one. During this period the sculptor slid from bold experimentation to 'mass' production, but this does not detract from his earlier greatness.

In this studio he constantly adjusted the relationship between the sculptures and their monumental plinths, which he designed and constructed himself. The photographs he took of the studio chart the evolution of this total work of art, which defied the conventional limitations of sculpture in space.

Sculptural assemblage: the triumph of debris

Sculpture was thus subjected to just as radical a process of transformation as painting. The relationship with pictorial art was so close that the collage revolution spread to sculpture too, a development that would have major consequences.

In 1912, Picasso gave up modelling clay and carving wood and stone. Instead he put together odd items such as planks, bits of crates and chair legs. Cut to shape, nailed together and sometimes painted, these disparate elements suggested still lifes – musical instruments or café tables every bit as elliptical and disconcerting as collages. While the latter marked the intrusion of real life into the field of drawing in the form of posters, wallpaper and newspapers, Picasso's Cubist assemblages represented an invasion of sculpture by worthless industrial objects.

Pablo Picasso, *Bull's Head*, spring 1942, original, bicycle saddle and handlebars (leather/metal assemblage), Paris, Musée Picasso.

From this time on, studios and techniques changed. The collecting of discarded objects of all kinds became a necessity and the fabrication of the pieces required a wide range of skills. After working with wood, sand and fabric, PICASSO sculpted with sheet metal, employing a cutting and folding technique. He was later taught to solder by his compatriot Julio González. From the 1930s onwards, this skill allowed him to extend the assemblage concept to metals – again recycled. Machine parts, bicycles, tools, toys – the forms of these and many other products of the contemporary world caught Picasso's attention. With a heavy dose of irony, he transformed the ring of a gas stove into a female idol, bicycle handlebars into the horns of a bull and toy cars into a monkey's head. His assemblages represent a constant two-way interchange between industry and art, as he did nothing to disguise the true nature of the fragments he used. With reference to his BULL'S HEAD, he said, somewhat provocatively, that the creature's horns could just as easily be turned back into a pair of handlebars and its muzzle back into a bicycle saddle.

Following Picasso's example, a new kind of art developed. The Catalan artist Julio González twisted and soldered metal rods into human figures. Pablo Gargallo, another Spaniard, assembled thin sheets of copper and iron to make hollowed-out heads and outstretched bodies. Joan Miró (born in Barcelona) and Max Ernst also adopted the new technique, and the American Alexander Calder created mobiles by suspending brightly coloured metal plates from the ceiling in an uncertain balancing act.

After World War II: dynamism and monumentality

After World War II, technical developments transformed the art of sculpting even further. The Swiss artist Jean Tinguely constructed machines animated by circular movements or vibrations, assemblages driven by weak motors that were nevertheless powerful enough to put an end to the idea that sculpture had to be immobile. Tinguely's studio

in Paris looked far more like a garage or scrap metal yard than the sort of place in which, at the beginning of the century, Rodin and Maillol had worked clay in the presence of a naked model. After this, Richard Baquié, in the 1980s, introduced refrigeration systems and ventilators into his work, thus adding even more technological complexity. Gigantism also came on the scene. In 1966, the American artist Mark di Suvero started to make sculptures out of metal beams riveted together and fixed to heavy plinths. Projects like these involved cranes and teams of technical assistants. Technical expertise was also required by another American, Richard Serra, who used boilermakers to press the steel shapes he had designed.

Thus the sculptural 'enterprise' – similar to that directed by Rodin at the beginning of the 20th century, in which collective work of a predominantly technical nature served an essentially individual project – was reborn. A further similarity is that works were often the result of a public commission, whether given by a municipality, an official institution or a patron of the arts. This could sometimes place artists in a tricky situation, particularly when they had to try and win over commissioning bodies or answer public criticism.

Duchamp and the 'ready-made': the end of the artwork?

There were two obvious next steps. The first was to use the object itself instead of just a fragment of the object, and the second was to present an item of debris intact instead of assembling disparate pieces (which raises the question of whether the substitution of an unmodified industrial object for a work of art executed by an artist can be considered creative). In the first of these procedures, the industrial product is put at the service of artistic creation, which is based on appropriation and metamorphosis. In the second procedure – the far more radical of the two – there is no longer either creation or metamorphosis, but literal repetition: the relationship between the artistic activity and the material circumstances is completely different. Fernand Léger summed this up in his description of an incident that occurred when he was in the company of Brancusi and Duchamp: 'Sometime before the 1914 war, I went to the Air Show with MARCEL DUCHAMP and Brancusi. Marcel, who was an austere fellow with an enigmatic air about him, was walking around looking at all the engines and propellers without uttering a word. All of a sudden he said to Brancusi: "Painting is finished. Who could improve on that propeller? Tell me, could you do that?"'

In 1913 at the age of 26, Duchamp invented the READY-MADE, the first example of which was a bicycle wheel mounted on a stool. The name 'ready-made' itself dates from 1915. Here was industry prevailing symbolically over independent, disinterested creation, which Duchamp parodied and treated with derision. In 1917, he submitted a piece entitled *Fountain* and signed 'R. Mutt' to the jury of an exhibition in New York. It was a urinal, bought in a hardware shop, and Richard Mutt was a pseudonym. Hat stand, snow shovel, mouse cage, perfume bottle, typewriter cover – Duchamp took these everyday objects and exhibited them completely unaltered as ludicrous 'pseudo-

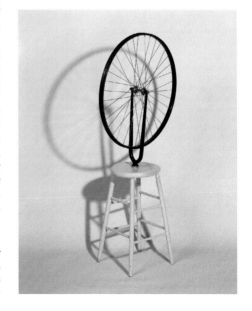

Marcel Duchamp, *Bicycle Wheel, Neuilly (Ready-made)*, 1951 (1st version 1913), bicycle wheel fixed by its fork to a stool, Paris, Musée National d'Art Moderne.

works'. 'Painting is finished,' as Duchamp had remarked to Léger. And sculpture too, as the ready-made, in both idea and practice, reduced aesthetic doctrines and mastery of execution to nothing.

This being the case, what kind of studio could Duchamp have worked in and what kind of artistic life could he have led? At the beginning of the 1920s, he announced that he was giving up art in order to become a professional chess player – which he indeed did for a while, with some degree of success.

Symbolically, he left unrepaired what was considered at the time to be his ultimate state-ment (*The Large Glass*, mechanical forms painted onto a sheet of glass) after it was ac-cidentally cracked. Its original title, *The Bride Stripped Bare by Her Bachelors, Even*, hints that painting, deprived of its prestigious status and supposed mysteries, can no longer charm her 'bachelors', who refused to participate in the game of desire, satisfaction and creation, whether artistic or physical.

The Neo-Duchampians and installations of objects

In spite of the similarity of purpose between Duchamp and the Dadaists and Surreal-ists, Francis Picabia was one of the rare few of these to follow Duchamp down the de-structive path of anti-art irony during the inter-war period. During the 1950s and 1960s, however, the triumph of the consumer society provoked an artistic revolution that Duchamp welcomed and 'sponsored' from afar. The ready-made proliferated, both in its raw state and integrated into a larger work. In the USA, Robert Rauschenberg and Jasper Johns introduced it into their painting-object-reliquaries. In 1959 in France, the 'New Realists' Tinguely, Arman and Martial Raysse began to use shop displays, beach items, ready-to-wear fashion and tins of food in their work. Arman collected together pathetic objects such as dentures, printed circuits and gas masks and displayed them in Plexi-glas cabinets. In 1962, Raysse created his *Raysse Beach* for an exhibition at the Stedelijk Museum in Amsterdam. This comprised sand, an inflatable pool, balls, rubber rings and, on the walls, blown-up photographs of models posing in bathing costumes.

Sculpture? Clearly not, but rather environments, installations in which the ready-made reveals itself as the most immediate and efficient tool for the generally critical pre-sentation of everyday reality. Soon after this, Raysse added coloured neon, taken from the world of advertising signs, and cinema, from the world of everyday leisure. Jean-Pierre Raynaud's *Psycho-Objects* brought together pointed and flexible objects, road signs, industrial signs, and firemen's axes and buckets: a vocabulary of fear and hygiene that the artist found in the city and manipulated – though relatively little – in order to in-tensify the air of tragedy surrounding these clean, anonymous objects. Andy Warhol did something similar with his appropriation of the Brillo box, the Campbell's soup tin, Mar-ilyn Monroe's face and the dollar symbol. The multiplication of these elements, which

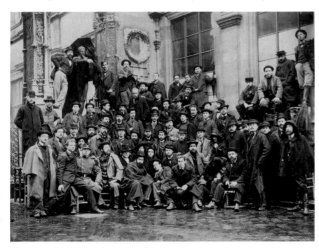

Gustave Moreau's Studio,
photograph, 1897, Paris,
Musée Gustave Moreau.

Video: THE BLURRING OF BOUNDARIES

Bill Viola, *Heaven and Earth*, 1992, video installation.

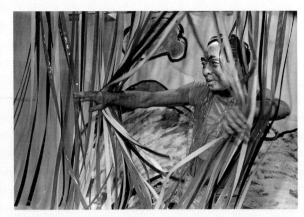

Martial Raysse, still from the film *Jesus Cola*, 1996, photography by Beatrice Heyligers.

At the beginning of the 1960s, with television exerting an ever-greater pull on society, a new means of expression emerged that broke completely with the traditional rules of art.

Enormous possibilities

In 1963, the Korean artist Nam June Paik exhibited a work called *Thirteen Televisions* at the Galerie Parnass in Wuppertal. Connected to 13 frequency generators, the television sets displayed pulses and stripes. Paik was able to claim that he had invented abstract television.

Two years later, the first portable video camera (the Sony Portapack) allowed people to film images and immediately view the results: video became a tool for capturing and manipulating everyday life. Video artists found their place somewhere between cinema and the visual arts. Some remained true to the technique of interfering with pre-existing images, seeing their role as being critical of popular television, while others developed new ambitions. The American Bill Viola (*The Sleepers*, 1992) and the Frenchman Ange Leccia turned video into a tool for experimenting with form and exploring emotional states. Others, such as Raymond Depardon (*Reporters*, 1981; *Captive of the Desert*, 1989; *Caught in the Act*, 1994), saw it as a means of commenting on society and recent history and on the association between personal memory and the memory of places (Pascal Convert, *Villa Itxasgoïty*).

A new means of expression

Whatever their intention, video works presented a new problem: how should they be exhibited? Certainly not in galleries or museums bathed in light. Exhibition spaces now had to be plunged into darkness and television sets or enormous screens installed on which the images could be shown. Occasionally this equipment had to be specially arranged so as to suit the individual logic of complex installations. The relationship between the spectator and the work of art also changed. Viewers could no longer take in – or even think they were taking in – a work in a matter of seconds. They were now subjected to the showing of a film, which took however long the video maker chose it to take.

An increasing number of video artists

Very quickly, video art became more than just a specialist pursuit and started to attract artists who were primarily painters or sculptors. Warhol filmed *Sleep* in 1964, *Empire* the same year, and then *The Chelsea Girls*, which was screened in a hundred or so cinemas in the USA, in 1967. Martial Raysse embedded a video projector in one of his works in 1967. He also made films. The first, *Jesus Cola*, dates from 1966. Pascal Convert created sculptures based on news photographs published in newspapers and also documented the same events or those of the recent past using video.

Photographers also embraced video. These included Raymond Depardon and William Klein, who alternated ironic narratives (*Who Are You, Polly Magoo?*, 1996) and documentaries (*Cassius the Great*, 1964; *The French*, 1982).

The versatile artist

Artists in the 20th century were not defined by their work in a single characteristic medium but by a propensity – and ability – to work in many different media, either together or separately. In other words, the usual categories became obsolete. It became tricky to distinguish artists who were painters from artists who were sculptors and even painters or sculptors from video artists or filmmakers.

saturate the space they occupy and thus the viewer's gaze, is a symbol of a world that obeys only economic laws and whose ambitions are purely commercial. The message of these installations is the supremacy of mass production and mass consumption.

TRAINING: THE FAILURE OF THE TRADITIONAL SYSTEMS

Paintings that are really collages, sculptures that are in fact installations, photographs, videos, films – this permanent revolution in art also affected the learning of techniques and the transmission of endangered traditions. The academies and art schools that were set up in the 19th century, spreading to every major town and city, changed from being places of education to being reasons to break with the past.

Youth versus the academies: the example of France

In France in 1900, as in the previous century, artistic training meant attending one of the country's schools of fine art, the main one being the École des Beaux-Arts in Paris (Quai Malaquais). The aim of this training was to teach students various techniques and to provide them with points of reference. As in the past, it prepared the most talented for the Prix de Rome competition and thus the prospect of a stay at the Académie de France in Rome.

At the turn of the 19th century, the form taken by this competition (a painting or sculpture based on subjects set by a jury) was the same as it had always been, although now the question was raised of how useful a stay in Rome was to an artist's development, seeing that the Eternal City had lost most of its appeal. At the École des Beaux-Arts in Paris, where the young artists worked in studios directed by a *patron* ('boss'), a single teacher stood out for his broad-mindedness. This was Gustave Moreau (see page 204), who helped Matisse and Georges Rouault during their early careers. Other young people such as Fernand Léger studied only briefly under the excessively academic Jean-Léon Gérôme and Gabriel Ferrier. Raoul Dufy arrived in Paris in 1900 on a scholarship and enrolled in Bonnat's studio, but he left soon after in order to embrace Impressionism and Post-Impressionism. These styles had come as a revelation to him when he visited the galleries and the Salon des Indépendants. Another Fauve, André Derain, attended not the École des Beaux-Arts but the Académie Carrière in 1899. The main benefit he gained from this was meeting Maurice de Vlaminck, who was a racing cyclist, a musician and an anarchistic journalist before turning to painting (initially teaching himself). As for Georges Braque, he received his first technical training from his father and grandfather, who were both painters and decorators.

Their reservations did not necessarily mean that these young artists were unaware or even contemptuous of the old masters. Indeed, Matisse and Derain painted copies of pictures in the Louvre and spent hours drawing in the museum's Egyptian rooms. The incompatability stemmed rather from the conflict between the representatives of an academic form of training and young artists who increasingly came to despise it.

Die Brücke and Der Blaue Reiter: off the beaten track

To judge from the training of the founders of the Die Brücke group, which was formed in Dresden in 1905, the situation in Germany was similar. Kirchner arrived in the city to study architecture rather than painting and then enrolled at the Kunstakademie in Munich, but stayed only for the winter of 1903–4. Karl Schmidt-Rottluff was studying architecture at the Technische Hochschule in Dresden when he met Kirchner and Erich Heckel. Heckel was also an architecture student there but left after six months. Emil Nolde, another member (albeit temporary) of Die Brücke, followed an even less conventional route into painting. He learned woodcarving in a furniture factory before moving to Switzerland to teach decorative techniques. He then gave up his job to devote himself to painting. As he was over 30, the Kunstakademie in Munich refused to take him and so he took charge of his own training, assiduously visiting museums and trav-

TRAINING OF A NON-TRADITIONAL KIND

In Germany in 1919, Walter Gropius founded a school of art and architecture that was to become the most important centre of design in the 1920s.

Weimar, Dessau, Berlin

Based in Weimar (1919–25), then Dessau (1925–32) and finally Berlin (1933), the Bauhaus was founded in reaction to traditional art schools and provided an alternative to the conventional training that was still the norm in Germany. Its curriculum was based on recent artistic revolutions such as abstraction and the triumph of geometry and the application of these to architecture, design and the decorative arts. To give an idea of the quality and resolutely modern character of the training given at the Bauhaus one has only to list some of its teachers: Kandinsky, Klee, Oskar Schlemmer and László Moholy-Nagy.

Designed by Gropius, the Dessau building was a rectilinear industrial-style building dominated by glass and metal. It stood as a symbol of the Bauhaus programme, which was to devise a new way of teaching art in accordance with the latest aesthetic ideas, in particular Mondrian's Neo-Plasticism and the Constructivism of Malevich. For the first time ever, the European avant-garde joined forces in order to offer an alternative form of training. The Bauhaus was hounded by the Nazi regime – the sworn enemy of 'degenerate' art. First it was chased out of Dessau and then, in April 1933, its makeshift premises (a disused factory) in Berlin were cordoned off and forced to close.

Bauhaus teachers sitting in front of paintings by Klee in 1928, photograph by Oskar Schlemmer. From left to right: Feininger, Kandinsky, Schlemmer, Mucchi and Klee.

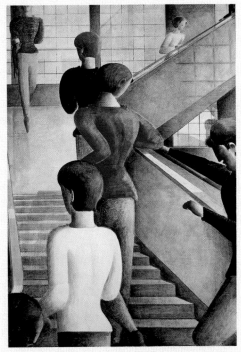

Oskar Schlemmer, *Bauhaus Stairway*, 1932, oil on canvas, 162 x 114cm, New York, Museum of Modern Art.

The USA

The adventure did not end there, however. After the closure of the Bauhaus, a number of its artist-teachers and former students were forced to emigrate. Kandinsky sought refuge in France, where he died in 1944, while the majority (including Mies van der Rohe) ended up in the USA. There they perpetuated the Bauhaus legacy – at Harvard, in Chicago and above all at an experimental school, Black Mountain College, which was founded in 1933 in North Carolina. Until 1949, its arts department was directed by the former Bauhaus student and teacher Josef Albers.

Until it closed in 1956, ideas were taught and exchanged in interdisciplinary sessions and the college was home to many of the modern trends in American art. A number of major American artists rubbed shoulders there. The Abstract Expressionist Robert Motherwell taught at the college in 1945 and Robert Rauschenberg stayed there in 1949 (before becoming one of the co-inventors of American Pop Art), meeting Cy Twombly, Merce Cunningham and John Cage, who organized the first ever 'happening' there in 1952.

elling to Paris, where he spent long hours studying works in the Louvre. Max Pechstein, who joined Die Brücke in 1906, was the only one of the group to complete a traditional art course, winning the Saxon State Prize at the Dresden Academy.

The training of the founders of the Der Blaue Reiter group (1911) in Germany was no less unusual. The Russian Alexis von Jawlensky served as an officer between 1884 and 1896 before leaving the army to settle in Munich. Wassily Kandinsky studied economics and law and taught at the University of Moscow. In 1896, he turned down a professorship in order to devote himself to painting. He spent a year at the Kunstakademie in Munich but rejected its artistic values and formed the Phalanx group in order to champion and exhibit modern art. Klee also spent a year at the Kunstakademie and was then a violinist with the Bern Symphony Orchestra before joining Kandinsky's movement.

The abandonment of traditional training: the inter-war and post-war years

Over the following decades, the gap between traditional teaching and experimental movements grew even wider. There are many examples. In 1920, Jean Hélion started studying chemistry in Lille at the age of 16, but left the following year to become an architectural apprentice in Paris. He spent much of his free time in the Louvre and started to paint townscapes and portraits. His training therefore took place in galleries and not in any art school. In any case, he soon became attracted to geometric abstraction, which no establishment would have anything to do with during the inter-war years. Pierre Soulages had a similar experience. He arrived in Paris in 1937 and passed the entrance exam for the École des Beaux-Arts. Several years later he revealed: 'Seeing what was going on at the school was an enormous surprise and a disappointment. I knew this kind of teaching would do nothing for me. It wasn't what I was looking for and so I went back home to the provinces.'

After World War II, this abandonment of the traditional system of training became more or less universal, as can be seen from the choices made by the generation that produced Pop Art in the USA and New Realism in Europe. Jasper Johns enrolled at Hunter College in 1952 and lasted two days. Andy Warhol trained as a commercial artist in Pittsburgh between 1945 and 1949. Among the French New Realists, Raymond Hains was an apprentice photographer, Arman studied archaeology at the École du Louvre and Daniel Spoerri was a dancer in Bern before becoming a director and choreographer in Darmstadt. Raysse studied briefly at Nice University, Niki de Saint-Phalle was self-taught and Yves Klein attended the National School for Merchant Seamen before becoming a jazz pianist in Claude Luter's band and technical director of the Spanish judo federation. The sole exception among Parisian artists was César, who studied fine art in Marseilles and then in Paris.

A single country stood out where training was concerned. Many of the great names in British art studied at the Royal College of Art. These included David Hockney (who was awarded a gold medal in 1962), Ronald B Kitaj, Allen Jones, Peter Philips and Patrick Caulfield. Peter Blake attended the college between 1953 and 1956 and made his first Pop Art works there. However, a decade earlier, Francis Bacon and Graham Sutherland had followed other – individual and non-institutional – training paths.

On the margins: the French 'free academies'

Another indication of the deficiencies of traditional art training in France was that artists repeatedly banded together throughout the century to found a new type of educational establishment operating on different principles.

'Free academies' had started to appear in France during the last third of the 19th century. These were private studios in which young artists worked in their preferred style, their work being appraised by painters situated on the margins of the official art scene. Two such were the Académie Julian and the Académie Ranson (founded by Paul Ranson, a disciple of Gauguin). It therefore became possible for artists to train outside the

academic system without having to resort to self-tuition. Roger de La Fresnaye is a good example. In 1903, he enrolled at the Académie Julian, where he met Dunoyer de Segonzac and Luc-Albert Moreau. In 1904, he was admitted to Lefebvre's class at the École des Beaux-Arts. After a two-year break due to military service and illness, he returned in 1907, leaving again the following year to attend the Académie Ranson, where two former Nabis, Maurice Denis and Paul Sérusier, were teaching. A little later, in 1910, he joined the Grande-Chaumière studio to learn sculpture under Maillol.

These schools operating outside the official system served as alternatives to the École des Beaux-Arts until the inter-war period. Marcel Duchamp and his brother Raymond Duchamp-Villon worked at the Académie Julian between 1904 and 1905, and Jean Dubuffet attended for six months in 1918. The main advantage of these institutions was their non-prescriptive nature and lack of constraints. Those who enrolled at them were not obliged to submit to any evaluations of their work or enter any competitions (thus escaping the obsession with the Prix de Rome). They were simply provided with models to draw or paint. Later in the century, other French artists were inspired by these institutions. Matisse and then Léger founded their own academies. Matisse soon brought his experiment to an end, while Léger persevered, turning his studio into a centre that attracted artists from overseas, notably from Scandinavia and the USA. Léger strove to develop a form of teaching based on his own approach, which aimed to create a monumental art accessible to all.

EXTERNAL TRAPPINGS: THE UNCONVENTIONAL ARTIST

By avoiding the official art system, 20th-century artists – autodidacts and rebels alike – placed themselves beyond the traditions and conventions that had governed the training of artists in the past. It was entirely logical that artists should also develop a lifestyle that hinted at or indeed provocatively proclaimed their rejection of society's norms. From the beginning of the 20th century onwards, artists and those who moved in artistic circles delighted in offending the conventions and expectations of 'good taste'.

The new artists' district in Paris: Montmartre

Artists' studios – and in practice their living accommodation too, as they were rarely well-off enough to have separate working spaces – were now generally located in outlying districts away from the fine buildings and high rents of the centre.

In Paris, artists' colonies grew up in specific areas. Until the end of the 19th century, painters – of whatever tendency – preferred the recently built districts of Nouvelle Athènes, Saint-Lazare or the Monceau Plain. At the end of the 19th century and the beginning of the 20th, Degas lived on the Rue Blanche, the Rue Victor-Massé and finally on the Boulevard de Clichy. Gustave Moreau had a large house on the Rue de la Rochefoucauld. Only Renoir had already adopted Montmartre by this time, moving into the 'Château des Brouillards' in 1890, although his studio was located on the Rue Hélène near the Avenue de Clichy. Before moving to Normandy and

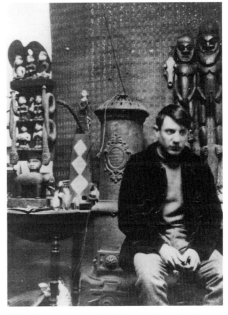

Gelett Burgess, *Picasso in His Bateau-Lavoir Studio*, photograph, 1908.

then to Le Cannet, Bonnard remained faithful to the Impressionist district, as did Vuillard, who lived on the Boulevard Malesherbes and then the Rue Vintimille.

Turning their backs on these areas and their opulent buildings, the young Fauve and Cubist artists moved to the other side of the Boulevard de Clichy, which became the frontier between two zones and two generations. The decision to settle there was motivated by financial considerations. Studio buildings were erected on the slopes of Montmartre, on the sites of former factories or disused warehouses. The rents for buildings such as Les Fusains at 22 Rue Tourlaque, into which Derain moved in 1906, and the BATEAU–LAVOIR, a great wood and glass hulk clinging to the hillside (where Picasso and Kees van Dongen were neighbours), were low. The 18th arrondissement at this time was a working-class district, in which memories of the Commune lived on. It was also a district of reprobates and streetwalkers, cafés with musical entertainment, the famous Médrano Circus and the first cinemas.

Cubism remained more or less rooted in Montmartre from this time on. In autumn 1909, Picasso moved to the Rue Frochot, but took a studio in the Bateau-Lavoir again in autumn 1911, when he moved to the Boulevard Raspail with his new mistress, Eva. Juan Gris also lived in the Bateau-Lavoir, taking over Van Dongen's studio. Braque worked on the Rue d'Orsel from 1904 to 1910 before moving to the Rue Caulaincourt, where Jacques Villon had also had a studio until 1907. Gino Severini, who arrived in Paris in 1906, took a studio on the Impasse de Guelma, near the Place Pigalle, in the same building that Dufy worked in. Braque also rented two studios on the floor above. The art dealer Daniel-Henry Kahnweiler described the period between 1907 and 1914 as follows: 'Picasso and Braque, of course, were still in Montmartre. Braque had rooms opposite what was known as the Montmartre Theatre ... They worked; afterwards they met at five o'clock and came to see me at the Rue Vignon and we talked ... Gris lived in the Bateau-Lavoir as well. He had the studio to the left of the entrance. His two windows looked out onto the square and I could see him at work when I visited Picasso.'

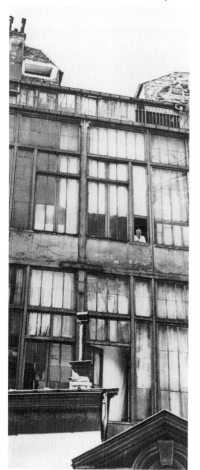

Fernand Léger at the Window of His Studio at 86 Rue Notre-Dame-des-Champs, photograph, after 1913.

The Left Bank: the Montparnasse district

This concentration of studios had its counterpart on the Left Bank, some distance from the Seine, on the edge of the 15th arrondissement. In 1909, Léger moved into the building known as 'La Ruche' on the Passage de Dantzig, near the Vaugirard slaughterhouse. This was a former World Fair pavilion that had been converted into a block of flats for rent. Soutine, Chagall and Modigliani were also there. In 1912, LÉGER moved to the Avenue du Maine and in 1913 to 86 Rue Notre-Dame-des-Champs. The following year, Apollinaire, taking an 'armchair tour' of the city of art, wrote in *Paris-Journal* that 'Fernand Léger cuts an almost working-class figure in Montparnasse, where he has his studio. He belongs to the Norman race – light-haired, slightly heavy-looking, astute and careful. He is one of the most interesting Cubists because instead of imitating Picasso, Braque or Derain, he has followed his own

THE GEOGRAPHY OF PARISIAN SURREALISM

Most of the Surrealists congregated in Paris in the 1920s in three different locations: the Rue Fontaine in the north, close to Montmartre, and the Rue du Château and the Rue Blomet in the south on the other side of Montparnasse (14th and 15th arrondissements).

Accommodation

André Breton moved into a studio at 52 Rue Fontaine, overlooking the Boulevard de Clichy, with his wife in January 1922 and kept it until the end of his life. He announced in the review *Littérature*: 'I have been living on the Place Blanche for two months. The winter is extremely mild and women make charming, brief appearances on the terrace of a café given over to the buying and selling of drugs … I don't remember having lived anywhere else.'

Some distance away, on the Left Bank at 54 Rue du Château, behind the old Montparnasse station, the writer Marcel Duhamel, the poet Jacques Prévert and the painter Yves Tanguy (who became friends in 1920 during their military service) rented a villa together in 1924. This became the setting for numerous encounters and visits.

The third Surrealist meeting-place, also on the Left Bank, was 45 Rue Blomet in the Vaugirard district.

This is where Miró and Masson had their studios. Writers and artists visited them almost daily, among them Georges Limbour, Michel Leiris, Antonin Artaud, Roland Tual and Jean Dubuffet. These places – where the Surrealists read, talked, played word games, drank, smoked (in particular a little opium) – all belonged to an old-fashioned, unmodernized Paris, as photographed by Eugène Atget at the end of the 19th century and the beginning of the 20th, and as conjured up by Aragon in his novel *Le Paysan de Paris* (*The Nightwalker*).

The cafés

Get-togethers in the studio did not rule out night-time excursions and long hours – work sessions of a kind – spent around the quieter tables of local cafés. These included: the Bal Nègre des Antillais near the Rue Blomet; a bistrot opposite the house in the Rue du Château; the Source on the Boulevard Saint-Michel, a one-time Dadaist venue; the Certa, a 'Basque bar' located at 11 Passage de l'Opéra in the Galerie du Baromètre; the Petit Grillon in the same arcade; from 1922, the Cyrano at 82 Boulevard de Clichy – this was the 'café given over to the buying and selling of drugs' (cocaine) described by Breton – and, after 1929, the Radio on the corner of the Boulevard de Rochechouart and the Rue Coustou.

path in parallel to theirs.' Two Cubist tendencies seemed to be facing each other across the river: Right Bank and Left Bank, Montmartre and Montparnasse. A further sign of the times was the arrival, also in 1913, of Moïse Kisling, a painter of Polish-Jewish origin, who moved into an address not far from Montparnasse: 3 Rue Joseph-Bara. André Salmon, Jules Pascin, the dealer Léopold Sborowski and from time to time Modigliani were already living in this street.

The New York loft

In New York, Manhattan was divided into three distinct zones as regards the 'geography' of art. The dealers and collectors of the traditional art business lived uptown, a short distance away from the Metropolitan Museum of Art and Central Park, in a district that was also home to the luxury goods industry.

The avant-garde artists lived and worked quite a way from there, in the SoHo and TriBeCa districts at the south of the peninsula – but at a respectable distance from Wall Street. The Abstract Expressionist generation found space in warehouses that they transformed into studios – long before lofts became fashionable in the 1960s and 1970s. Initially they converted these spaces in a fairly rudimentary way but gradually improved them as their fame and sales grew. Willem de Kooning, Barnett Newman, Mark Rothko and later Johns and Rauschenberg moved into the area. The galleries followed suit, with Leo Castelli, for example, opening on West Broadway. The area thus developed into an artists' quarter and remains one today, to judge from the concentration of studios and exhibition spaces there. As with Montmartre half a century before, SoHo's success in attracting artists was due (at the outset at least) to the fact that it was away from the centre and

The age of the avant-garde

Picasso in His Studio at Vallauris.

offered low-rent accommodation. To live there was to differentiate oneself from the rest of society and to resurrect the mythical bohemian lifestyle. In New York as in Paris, however, this state of events lasted for only a limited time. As soon as they had the chance, artists who had become successful moved to bigger spaces. Matisse settled in Nice. Picasso bought the Château de Boisgeloup in Normandy before moving to the Côte d'Azur (Vallauris, Cannes, Mougins and finally to another château, that of Vauvenargues). Willem de Kooning designed and built a vast villa-studio on Long Island. Jasper Johns preferred a Caribbean island. Distance again, but this time provided by sun-drenched retreats that bore little resemblance to the miserable studios of their early careers.

The avant-garde and their clothes

Just as revealing as an artist's choice of where to live was his or her choice of clothes. Until the turn of the century, painters and sculptors who had achieved a degree of fame would adopt a bourgeois style of dress. However revolutionary the Impressionists were in the studio, they did not present themselves as such in the street. Degas wore a hat and carried a cane. Manet was something of a dandy, as was Bonnard a few years later. Gauguin was a little freer in the way he dressed, but economic or practical considerations contributed to the choice of his clothes, whether he was in Brittany or Oceania. The Fauves and the Cubists, on the other hand, dressed either like Parisian workmen (overalls and cap) or else 'à l'américaine' (coloured shirt and sturdy shoes). This was their way of distinguishing themselves from the middle-class style of dress and 'Symbolist chic', which were both fussily elegant. It was also a way of advertising their anarchism (which was more verbal than ideological). In his account of the Salon d'Automne of 1907, Apollinaire describes Vlaminck as 'dressed in a rubber suit' and 'wearing ties made entirely of wood and painted in garish colours.' 'Blue with yellow polka dots', specifies Kahnweiler, according to whom Derain and Vlaminck bought their clothes 'from shops with English names that they pronounced the French way. One of these was High Life Taylor.' On their feet they wore 'yellow shoes with thick soles, which corresponded exactly to what was thought of then as American'. He added the further detail that 'nobody else was wearing them in those days. The shoes of the day were very pointed.' An alternative style of dress became part of the avant-garde package. The Italian Futurists posed for photographs wearing multicoloured waistcoats and, in 1913, Sonia Delaunay started to convert the principles of simultaneous contrast into elegant, modern clothing and textiles. In 1922, she opened a shop at 19 Boulevard Malesherbes selling dresses, coats, scarves and 'simultaneous' fabrics. In 1923, she created her first Lyon silks and the following year brought out her first collection of menswear and women's wear – town clothes, indoor clothes and stage costumes – for which she made many preparatory studies. They were worn by the sitters for her husband's portraits, including Tristan Tzara and Madame Heim.

Artists began to stand out for the simplicity of their dress and an air of negligence that suggested they despised the normal code of sartorial elegance. In 1945, Henri Cartier-Bresson photographed a gaunt Bonnard in a threadbare jacket several sizes too big for him. PICASSO, whose poses were arranged by photographers with particular care, was

Extravagant Adornments : The Role of Women

The most remarkable examples of extravagance in matters of dress were generally the inventions of women. They were ways of asserting their power as muses and free women who did not care 'what people thought'. Instead of elegance as Poiret, Doucet and Coco Chanel might understand it, deliberate provocation was on display: impropriety, seductive poses and exhibitionism – all designed to provoke a reaction. This in itself became the trademark of 'artistic style'.

The Dadaists and Surrealists were especially keen on displays of this kind. Man Ray photographed Nancy Cunard, Louis Aragon's wealthy mistress, wearing a fierce expression on her face and with her arms weighed down with numerous bracelets. He also made his companion Lee Miller, herself a photographer, pose nude.

The Surrealist artist Meret Oppenheim (1913–85), with whom Max Ernst fell in love, was a creator of bizarre objects full of irony, such as *Fur Breakfast* (a cup, saucer and spoon made of fur). She too posed naked for Man Ray – in front of an etching press, her hands and arms smeared with black ink. Later she produced self-portraits in which she depicted herself as an androgynous creature or as a female shaman with an arrangement of coloured markings on her face evoking tattoos or ritual symbols. Private views and parties were also occasions for displays of originality and calculated shamelessness. Aragon's novel *Aurélien* gives a description

Meret Oppenheim, *Portrait with Tattoos*, colour photograph, 1980.

of the extravagant outfits on display at Zamora's first night (Zamora is the alter ego of Francis Picabia). They include a 'woman, *très Montparnasse*, wearing a turquoise silk turban and a Capuchin-style dress and holding an indescribable little yellow dog between her skinny arms' and Mrs Goodman, Zamora's companion, 'pale blue, extremely low-cut dress, her back … you can just imagine!'

happy to appear before them with bare torso and legs or dressed simply in a shirt and cotton trousers. Right to the end of his life, he donned disguises and fooled around for portrait photographers such as Brassaï, Clouzot and Verdet as if to remind them that bourgeois seriousness was not his strong point. Picabia, Ernst and Van Dongen followed his example, the last of these painting nude self-portraits and taking delight in dressing up. The New Realists and the Americans were not far behind. Yves Klein moulded the naked bodies of Arman and Raysse in 1962, and Pollock and de Kooning appeared in workman's dungarees – half naked in the case of the latter. And Bacon allowed himself to be filmed drunk, surrounded by loutish-looking friends.

More disturbing, perhaps, was the careful attention Duchamp paid to his appearance within the context of his mission to destroy artistic myths. He appeared disguised as a woman (Rrose Sélavy) or sporting a curious tonsure. At times he could be seen smoking a cigar and apparently acting the film-noir *mafioso*, while on other occasions he allowed himself to be photographed by Man Ray stark naked or playing chess with a female opponent whose nudity he affected not to notice.

The Artist's Life: A More Relaxed Moral Code

Using various means, artists of every decade of the 20th century chose to differentiate themselves from the masses. This was made all the more necessary as the spread of

fashions, mass-produced clothes and the standardization brought about by the consumer society tended to promote a uniformity of appearance.

Picasso and his muses

The same was true of morals. Here, too, Picasso was an emblem of freedom. Not that freedom in such matters was unique to the 20th century: the Renaissance of Raphael and Michelangelo could not, as we have already seen, be described as a particularly chaste era, and neither could the age of Gauguin and Rodin. Up until the 20th century, however, convention demanded that affairs and infidelities be conducted discreetly or secretly. Only Gauguin dared to proclaim his opposition to marriage, which in his eyes was a hypocritical institution. This audacity got him into trouble with the religious and civil authorities on Tahiti and the Marquesas Islands.

Picasso had no such concerns. They would have been counterproductive, as his art derived from his life, and the succession of partners from one period to the next was directly related to the succession of different images in the artist's work. Marie-Thérèse Walter lent herself to stylization by curves and spheres while Dora Maar called for broken lines and sharp angles. It would be difficult to confuse the 'Françoise style' with the 'Jacqueline style'. The names of the women who shared Picasso's life (quite openly) are thus recorded for posterity: Fernande Olivier, Eva Gouel, Olga Kokhlova (first wife), Marie-Thérèse Walter, Dora Maar, Françoise Gilot and Jacqueline Roque (second wife). These relationships produced a number of children: Olga's son Paulo, Marie-Thérèse's daughter Maya, and Françoise's children Claude and Paloma.

In the 1930s and increasingly after World War II, the events of Picasso's life were reported in the press. The subject attracted numerous photographers and film-makers (even James Ivory) and risked creating an image of Picasso that blotted out his artistic achievements: the image of a Don Juan who was irresistible according to some and reprehensible according to others. This would be nothing more than mere anecdote but for the fact that two issues are linked here: artistic freedom and moral freedom. Picasso refused to separate them and is consequently the perfect embodiment of the artist who defies convention, choosing to provoke society and live freely.

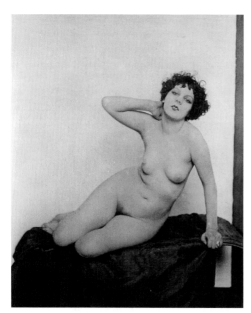

Man Ray, *Kiki de Montparnasse*, photograph, 1921.

The inter-war years: fighting for freedom

In their apology for passionate love, Breton and a number of other Surrealists were simply following Picasso's example. Attitudes in the inter-war years were very different from those before World War I. For the most part the first European avant-garde respected the bourgeois conventions, on the surface at least. Neither Matisse, Braque, Mondrian nor Klee was the subject of scandal. Although the private lives of Kandinsky and Jawlensky were more turbulent, they did not publicize the fact and no complaints of a moral nature were ever made against them. Ideas of social propriety were so oppressive that Kirchner found himself criticized for getting models of both sexes to pose together in his Berlin studio. More serious still was the case of Egon Schiele, who was briefly

imprisoned in Austria in 1912 for 'corrupting minors, rape and immorality' simply because his watercolours were found offensive by some of his countrymen. Despite the total lack of evidence for the first two charges, Schiele was nevertheless found guilty and the judge burned one of his works in public during the trial. A hundred other works were seized by the authorities and never returned to the artist.

The strength of social convention can be measured by the ferocity of repressive measures of this type. The weight of this was particularly heavy in France during the early years of the century – to such an extent that in 1913 Matisse took the precaution of reassuring his admirers, declaring to the American journalist Clara MacChesney: 'Oh, make sure you tell the Americans that I'm a normal man, that I'm a devoted husband and father, that I have three beautiful children, that I go to the theatre, enjoy horse-riding and live in a comfortable house with a garden that I adore, with flowers and everything, just like everyone else.'

A few years later such a declaration

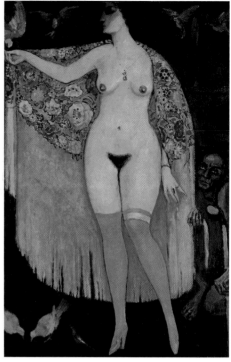

Kees Van Dongen, *The Spanish Shawl*, also known as *Picture, Woman with Pigeons, Begging for Love*, 1913, oil on canvas, 195.5 x 130.5cm, Paris, Musée National d'Art Moderne.

would have been mocked by the Dadaists and Surrealists. Aragon flaunted his relationship with Nancy Cunard, Man Ray made even less of a secret of his relationships with KIKI DE MONTPARNASSE and Lee Miller (who were his models), and Max Ernst and Paul Éluard lived with Gala, Éluard's wife, before she married Dalí. The three of them lived in a villa in Eaubonne owned by the poet and decorated with murals by the painter.

At the end of the 1920s, Picabia lived alternately with Germaine Everling at the Château de Mai in Mougins and Olga Mohler on a boat in the harbour at Cannes. KEES VAN DONGEN and André Derain were always in the news for what they were up to with their models. After this there were very few prohibitions left, as demonstrated by the erotic works of Picasso and Masson and the illustrations produced by the latter for Georges Bataille's *Story of the Eye*. During this time, art photography explored the body more and more insistently. Brassaï produced a series of photographs taken in the brothels of Paris. This was also the time of the Weimar Republic in Germany, which turned away from the rigid moral standards of the Wilhelmine era. Max Beckmann with his

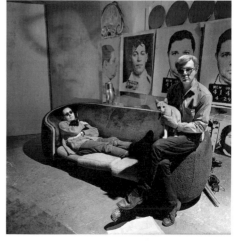

Bruce Davidson, *Andy Warhol and Robert Indiana in Warhol's Studio*, photograph, 1964.

scenes of masked balls and Otto Dix with his cabarets and brothels painted a picture of contemporary morals that included prostitutes, drugs and debauchery of all kinds. Paul Morand described these illicit pleasures in his collection of short stories *Europe Galante*, and Christopher Isherwood depicted the shadier districts of Berlin that Francis Bacon also got to know as an adolescent.

While World War II brought this licentious era to an end, artistic circles continued to demand and enjoy full freedom in moral matters. Francis Bacon made no attempt to hide his homosexuality, painting a pair of men in an embrace in addition to portraits of his lovers. Hockney came out at the beginning of the 1960s in a number of blunt and explicit pictures, and despite America's reputation for puritanism, The Factory, WARHOL's group of four studios in Manhattan (a favourite venue of the jet set and the permissive refuge of drug addicts and the marginalized) could not exactly be mistaken for a stronghold of prudishness.

COSMOPOLITANISM

Unusual addresses, strange clothes, free morals: the virtue of these lies in their ability to affirm the coherence of what (for want of a better expression) can be called 'the artistic world'. The artistic world is different, yet these differences are not an adequate way of defining it. In fact they serve this end so poorly that these external signs, as soon as they become known to a large number of people, are imitated, pastiched and parodied. Thus whole districts have been called 'artists' quarters', and this incorrectly generalized label has been used as a pretext for property deals from Montparnasse to SoHo. Similarly the history of fashion is littered with successive versions of 'artists' style', commercial interpretations of eccentricities whose aim was certainly not to start a trend. And the general development of morals in the West has retrospectively endorsed some of the 'outrageous' behaviour that originally earned its protagonists public condemnation (homosexuality and indifference towards the institution of marriage, for example). Thus artists have increased in influence in societies where the media spread myths and legends, simplifying them or making them up as necessary. This media spectacle of 'artistic life', however, is mere froth, insubstantial and impoverished. It offers up and popularizes specific behaviour without looking into its causes and without examining the reasons that have made it so important for artists to set themselves apart from the masses in specific places and at specific times. It has focused on 'stars' (Picasso, Matisse) and 'celebrities' (Andy Warhol, Jean-Michel Basquiat), removing them from any proper context. It fetishizes eccentricities without understanding how or why they operate as signs of recognition or what the nature of this recognition and this semi-secret society actually is. For it would not be going too far to describe artists in the 20th century, no less than before, as constituting a cohesive society of this kind.

Before 1914: committed internationalism

This society of artists is founded on shifting allegiances and constant agreements and disagreements – and on the permanent conviction that it is necessarily in a minority and threatened. It is also reinforced by bonds of solidarity which, if necessary, transcend generational and aesthetic differences. They can also transcend frontiers and nationalities. This was particularly noticeable during the 20th century – a century of nationalist conflict, world wars and ethnic cleansing. The artistic world is cosmopolitan. It cares little for passports and is hostile to checks and controls.

Before 1914, when propaganda in the German Empire, France and Russia denounced the 'hereditary' enemy on the other side of the Rhine

or beyond the Vistula, artists simply ignored these simplistic views. Apollinaire published items in the Berlin review *Der Sturm*, the organ of the Expressionist avant-garde. Robert Delaunay and Franz Marc corresponded with each other. Kandinsky exhibited in Paris before settling successively in Bavaria, Murnau and Munich together with his compatriot Jawlensky (but also at various times with Marc, Macke and Klee, irrespective of nationality). In Paris, Picasso, Juan Gris, Pablo Gargallo and Paco Durio, all recently arrived from Spain, rubbed shoulders with Van Dongen and Mondrian from the Netherlands, Frantisek Kupka, newly arrived from Bohemia via Vienna, the Italians Gino Severini and Modigliani, the Romanian Brancusi and the Russian Jews Marc Chagall and Jacques Lipchitz. German nationalist propaganda, which classed them all as *Kubisten* and instruments in a campaign being fomented in Germany for the perversion of people's minds, attacked them in vain. Guillaume Apollinaire, a French poet of Polish origin, defended them, along with the Swiss Blaise Cendrars and the Frenchmen André Salmon and Maurice Raynal. The works and doctrines of these supporters might have little if anything in common, but they shared the certitude that they were one and all on the margins of bourgeois society.

During this period, one of the most cosmopolitan of the 20th century, artists' works travelled as well as the artists themselves. Exhibitions of contemporary French art were held in Berlin, Cologne and Stuttgart right up until the months preceding the declaration of war. Their success could be measured in the Cubist influence on the work of artists such as Kirchner and Marc. In 1914, Klee painted his *Homage to Picasso*.

In Paris, the Italian Futurists held their first group exhibition at the Bernheim-Jeune gallery. In Moscow and St Petersburg, artists formed associations to promote exhibitions of

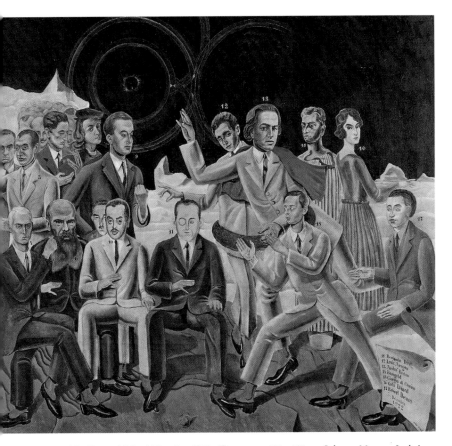

Max Ernst, *A Friends' Reunion*, 1922, oil on canvas, 130 x 195cm, Cologne, Museum Ludwig.

Cubist paintings, and this enabled Malevich, Natalia Goncharova and others to trace the development of Picasso and Léger's work. Matisse's development could be seen in the canvases he painted for the Muscovite collector Sergei Shchukin. This international traffic even extended as far as the USA. In 1913, the Armory Show provided a showcase for the European avant-garde. Duchamp caused astonishment and outrage with his *Nude Descending a Staircase*, achieving notoriety for the first time on the other side of the Atlantic.

Difficulties of the inter-war years

The Great War destroyed this world. It prohibited exchanges of the type described above, caused enormous antagonism and called artists up to fight an enemy who may previously have been their friend. Apollinaire fought on one side, Franz Marc on the other. August Macke was killed in autumn 1914, Marc near Verdun in 1916.

The inter-war period brought a partial resumption of internationalism. Only partial because it was no longer possible in a USSR that kept its distance from the capitalist world and because it was further hindered by the rise of fascist totalitarian states under Mussolini, Franco and especially Hitler. In France, it was maintained through Dada and Surrealism. The leading figures of Dada were Tristan Tzara (a poet of Romanian origin), the Germans Hugo Ball and Richard Huelsenbeck, Picabia (a painter of Latin-American ancestry) and the Frenchmen Breton, Aragon and Philippe Soupault. In 1921, these last three organized an exhibition of the collages of MAX ERNST, a German – and therefore by rights an enemy.

Ernst was living at the time in Cologne, where one of his friends was the Franco-German Arp, who called himself both Jean and Hans. From 1924 onwards, Surrealism was the international avant-garde movement par excellence. In addition to Ernst, French poets and French painters such as Masson and Tanguy, it also attracted the Catalan Joan Miró and the Swiss Alberto Giacometti. The movement claimed for a time to be inspired by the work of Giorgio de Chirico, an Italian whose paintings Apollinaire had championed as early as 1914. The French Surrealists maintained links with Czech and Belgian groups, the latter dominated by the work of René Magritte.

In 1933, Hitler's rise to power changed everything. The solidarity among avant-garde artists became defensive, governed by the urgent necessity to protect the victims of Nazi persecution: the 'degenerate', the 'stateless' and the Jews. The Bauhaus artists left the Third Reich for France or the USA. German avant-garde art was destroyed. All that was left was official art, a mixture of academicism and ideological propaganda. For the Expressionists the only choices were exile abroad, internal exile, or suicide. Kirchner opted for the last of these, ending his life in 1938. Max Pechstein saw 326 of his works, including paintings, drawings and woodcuts, banished from German galleries. Erich Heckel suffered a similar fate. Karl Schmidt-Rottluff was denounced and exposed to public condemnation (and official insults) in the exhibition of 'degenerate art' organized by the Nazis in Munich in 1937. All were banned from working and exhibiting. Despite his initial sympathy for National Socialism, Emil Nolde was soon condemned as well. Thereafter he was only able to execute small works on paper, in secret, which he named his *ungemalte Bilder* (unpainted pictures). Otto Dix was banned from teaching and exhibiting. Many of his paintings, including *The Trench* (1923), were destroyed and he withdrew to Lake Constance. After 1933, Max Beckmann lived in Paris and on the French Mediterranean coast before moving to Amsterdam, where he lived underground until 1945.

While a number of artists collaborated with the occupying forces in various European countries during World War II, many others chose to flee. In this they were often helped by those who, regardless of aesthetic or personal considerations (in other words, not motivated by any particular solidarity between artistic 'schools') had chosen to remain untainted by collaboration and tried to assist those who were being persecuted.

ARTISTS CONFRONTING NAZISM

The Exhibition of 'Degenerate Art' in Berlin,
photograph, February 1938.

In Europe: resistance, neutrality, collaboration

In Europe during World War II, there were three main types of behaviour. A number of artists of communist conviction refused any form of compromise. In France, Ernest Pignon and André Fougeron joined the Resistance. The German Hans Hartung, who had settled in Paris in 1935 after fleeing Nazism, joined the Foreign Legion in 1939. On his release from imprisonment in the Miranda del Ebro camp in Spain he turned down a visa for the USA and returned to North Africa, where he rejoined the Legion. He was wounded in action near Belfort in eastern France in November 1945 and had to have a leg amputated. Other artists – such as Bonnard, Matisse and Braque, who were too old to join up – colluded neither with the occupiers nor with the Vichy regime; indeed, they assisted those who were on the run. Picasso gave Hartung the money that enabled him to cross the Pyrenees. He also helped the Romanian Victor Brauner, who was in hiding in the Alps, and was visited in his Rue des Grands-Augustins studio by members of the Resistance, including the writer Claude Simon. Finally, there were those artists who became tainted with collaboration, in particular those who went on a trip to Germany organized in 1941 by the Nazi propaganda machine. Among them were the painters André Derain, Maurice de Vlaminck, André Dunoyer de Segonzac and Kees Van Dongen and the sculptors Paul Belmondo, Charles Despiau and Paul Landowsky. The artistic world was not subjected to any rigorous purging after liberation, but memories lived on.

The choice of exile: New York, the new artistic centre

Many artists, despairing of Europe, sought salvation on the other side of the Atlantic, in New York. The first to arrive, in the 1920s, were political refugees. The Armenian Arshile Gorky fled a massacre of his people in Turkey in 1920 and Mark Rothko, a Jew, left behind the anti-Semitism and

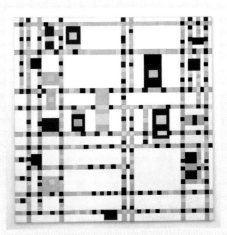

Piet Mondrian, *Broadway Boogie Woogie*, 1942–3, oil on canvas, 127 x 127cm, New York, Museum of Modern Art.

pogroms of Russia in 1913 at the age of ten. Others, such as the Dutchman Willem de Kooning, emigrated in order to escape poverty.

After the initial wave of immigration into the USA following the Nazis' seizure of power in 1933, the East Coast became a place of convergence for artists during the first few years of World War II. Some emigrated as early as 1940. Piet Mondrian, for example, left for London in 1938 only to be chased out of the British capital by the onset of German bombing. Others arrived from France a little later. Jean Hélion had escaped from a prisoner-of-war camp in Pomerania and reached Paris in February 1942. Thanks to the help of a close friend of Marcel Duchamp, the American Mary Reynolds, he was put in touch with members of the British intelligence service, taken over the frontier into the free zone, crossed the Pyrenees and made it through Spain to Portugal, where he embarked for New York. Others embarked from Marseilles, where the partly reconstituted Surrealist group was staying at the Villa Air-Bel. Max Ernst, though clearly anti-Nazi, had been interned by the French authorities as an enemy alien. Thanks to the American Emergency Rescue Committee, designed to help European intellectuals, he was able to emigrate to the USA at over 50 years of age. Others who emigrated included André Breton, Marcel Duchamp, Man Ray, Fernand Léger and André Masson.

The combined influence of all these artists of different styles and from different generations who found themselves in the same place at the same time gave rise to the movement later to be known as 'Abstract Expressionism'. This was the product of an improbable synthesis that grew up around Gorky, de Kooning, Pollock, Motherwell, Rothko and Newman in the years after 1944, and the result of countless meetings of countless exiles.

The age of the avant-garde

After the war: a new internationalism

After 1945, the nationalist divisions began to heal. The artistic world became as cosmopolitan as it had been in the years before 1914. Although founded in Paris in 1948, the Cobra group took its name from three other capital cities (COpenhagen, BRussels and Amsterdam), as it was formed by three Dutch painters (Karel Appel, Constant and Corneille), a Danish artist (Asger Jorn) and a Belgian poet (Christian Dotremont). The group was later joined by other Scandinavian, Dutch and Belgian artists as well as the Frenchman Jean-Michel Atlan.

At the same time, the French movement known as Gestural Abstraction or Lyrical Abstraction or (more controversially) the School of Paris acknowledged the German Hans Hartung, the painter of Swiss origin Gérard Schneider (who both lived in Paris) and the Frenchman Pierre Soulages as its leaders. The members of this group forged links with their New York counterparts and in the 1950s the contemporary art scene became decidedly international on both sides of the Atlantic. This remained the case right up until the end of the century, all the more so as new communications technology, the ease and speed of travel and the free flow of works and ideas created a common Western space (limited in the east, until the collapse of the Berlin Wall in 1989, by the border between the capitalist and communist spheres of influence). This common space was also open to artists from other regions, particularly Japan – as the 'Gutai' ('Incarnation') group of young Japanese artists showed in the 1950s – and Korea (the installations of Nam June Paik).

A 'common space' does not imply that it was a space free from antagonism, tensions, rivalries and disputes, but that debate was, by definition, international. The forums for this exchange were the biennials in Venice (from the end of the 19th century) and São Paulo (after World War II), the Documenta in Kassel (held for the first time in 1955) and the contemporary art fairs in Basel, Madrid, Paris, Chicago and, since 2003, London.

Other opportunities for artistic exchange were the exhibitions showcasing the work being done in New York, Amsterdam, Berlin or London. These touring exhibitions began in the 1950s (largely at the instigation of the Museum of Modern Art in New York) and moved from capital to capital, showing developments and revealing the ideas behind them. At the start of the following decade, in 1961 and 1962, the Stedelijk Museum in Amsterdam organized exhibitions in which the American Neo-Dada and Pop Art movements were brought together with European New Realism. This was an important initiative in the sense that it demonstrated clearly that the time of Expressionism was over, in New York as well as Paris, and that a new era was starting – that of Robert Rauschenberg, Jasper Johns, Andy Warhol, Martial Raysse, Raymond Hains and Jean Tinguely. These artists knew each other, kept abreast of each other's work and even worked together on specific projects. In 1961, in a collaboration that was clearly unconcerned with questions of nationality, Johns, Rauschenberg, Tinguely and Niki de Saint-Phalle organized a concert performance in Paris dedicated to John Cage.

This was a time of much international toing and froing and changes of address among artists. The American Larry Rivers came to live on the Impasse Ronsin in Paris, and the Canadian Jean-Paul Riopelle and the American Joan Mitchell lived in Vétheuil, a suburb of Paris, for a considerable length of time. Arman and Christo chose to live in New York, and Raysse made frequent trips to Los Angeles between 1963 and 1968. In the 1980s, the Italian Sandro Chia also chose New York, while the German Anselm Kiefer settled in France.

During the final quarter of the century, initiatives comparable to the pioneering exhibitions of the Stedelijk Museum were launched in many cities. These took the form of surveys of an artist's work, featuring such major figures as Georg Baselitz, a German Expressionist painter, Jean-Michel Basquiat, an American painter of Haitian origin who emerged from the urban graffiti culture, or members of the Italian Transavantgarde such as Francesco Clemente or Enzo Cucchi. This is by no means an exhaustive list and one might also add (in no particular order) the names of Gerhard Richter, Daniel Buren, Anselm Kiefer, Mario Merz, Christian Boltanski and Per Kirkeby. What unites these artists is that their careers all developed along international lines. In a world in which information

travels fast thanks to television and the press, totalitarian regimes that try to prevent their authority being threatened by outside influences are doomed to failure. This has already happened in the People's Republic of China. Slowly (and not without danger for those involved), contemporary art made an appearance in Beijing in the 1980s. It was soon forced to pursue its development in exile in Europe and the USA, where in the early years of the new century its success continues to grow steadily at international fairs and exhibitions.

THE AVANT-GARDES

Solidarity in the face of successive attempts at repression – all too often it seems that the history of the visual arts can be analysed in terms of opposition and incompatibility. Modern artists, at a remove from society, more often than not proclaiming their hostility to it and receiving only disapproval and rejection, are a small and sometimes threatened minority who have very little in common with the artists of the past – when, through commissions, religion or politics determined most artistic production. This was not at all the case in the 20th century, during which one thing never changed: the appearance of a new movement or technique would provoke negative reactions at best and outrage at worst.

The age of insults

To give examples of such negative reactions is to draw up a list of the century's artistic revolutions. The first occurred in 1905 with the scandal of the 'cage aux fauves' ('wild beasts' den'). The

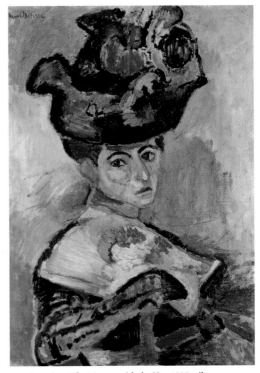

Henri Matisse, *The Woman with the Hat*, 1905, oil on canvas, 80.6 x 59.7cm, San Francisco, Fine Arts Museums.

pictures of the young painters (including MATISSE, Derain and Vlaminck) who used bright, non-realistic colours were hung together in the same room at the Salon d'Automne. It was the critic Louis Vauxcelles who described these painters as 'fauves' ('wild beasts'). This set the tone for things to come. The same kind of abuse that was used in the press in the early years of the 20th century has been served up ever since. What are these artists whose work is too brightly coloured and too disrespectful of the conventions of realism – madmen, jokers or children? Madmen: 'Gathered here are the most preposterous pictures, painted, surely, by delirious brushes ... Did Messrs Derain, Manguin, Matisse and the rest even bother with brushes? Perhaps they painted with spades, sticks or any other household object you care to mention' (Henri Fauche, *Le Petit Caporal*, 21 October 1905). Jokers: 'Is this art? Or is it a practical joke? Did the Salon d'Automne want to add the surprise of an enormous hoax to its gallery of attractions?' (Étienne Charles, *La Liberté*, 17 October 1905). Children: 'Blue, red, yellow, green: patches of colour randomly juxtaposed. The barbaric, naïve games of a child trying out the paintbox it was given for Christmas' (Marcel Nicolle, *Journal de Rouen*, 20 November 1905). After this,

The age of the avant-garde

Cubism, Dadaism, Surrealism and abstraction were on the receiving end of similar insults in France, though neither Futurism in Italy nor Expressionism in Germany was greeted any more favourably.

From generation to generation

For the most part, the history of the critical reception of these movements resembles the model established – quite possibly deliberately – by the Impressionists. A new generation appears, provokes suspicion and disapproval, casts around for a way of making itself known, formulates rules, asserts itself as a movement and starts to achieve recognition through scandal and struggle. This recognition grows and the avant-garde ceases

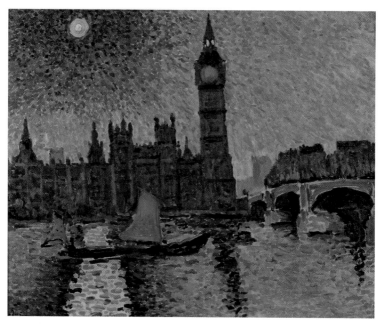

André Derain, *Big Ben*, winter 1905, oil on canvas, 79 x 98cm, Troyes, Musée d'Art Moderne.

to be the avant-garde as it acquires disciples and admirers. This pattern has played a key role in the history of 20th-century art.

What happened to Fauvism happened more or less in the same way to Cubism. The generation of painters and sculptors universally celebrated in 1905 was born in the 1860s (Bonnard in 1867, Vuillard in 1868 and Maillol in 1861). Having come through a difficult patch at the beginning of the 1890s, these former Nabis now triumphed at the Salon d'Automne. They appeared to be the successors to the Impressionists, who were still active although considerably older (Monet was born in 1840, Renoir in 1841 and Degas in 1834). Confronting this powerful older generation were Derain (born in 1880), Picasso (born in 1881), Braque (born in 1882) and, in the same group although older, Matisse (born in 1870). In other words, artists of 25 or 30 years of age were lined up against artists aged 40 or 60. Little by little, the younger artists began to reject the pictorial solutions developed by the older generation: their colours became vivid and non-imitative, their planes stood out distinctly from one another and their volumes were structured around emphatic lines and geometric shapes, the very opposite of the evanescence and trembling brushstrokes on which the fame of Monet and Renoir was built.

This confrontation became surprisingly direct at times. At the end of 1905, the art dealer Ambroise Vollard commissioned a series of London townscapes from DERAIN, financing the painter's journey and stay in London. Why London? Because the series of London

pictures painted by Monet (from 1900 onwards) enjoyed considerable critical and commercial success. There was nothing mysterious about it from Derain's point of view: this was simply his answer to the Impressionist master on his own territory. Raoul Dufy had the same attitude when he took up certain motifs beloved of Manet, Monet and Boudin (the Normandy beaches and jetties) in 1905–1906, treating them with a vigour and simplicity of style far removed from the elegant handling and atmospheric effects of his predecessors. Picasso, at the same time, was taking Degas' and Toulouse-Lautrec's figures of modern life and modern poverty and treating them in a completely different way.

New exhibition venues: gallery versus salon

The reactions that these young painters provoked were fierce. This had a number of consequences. The 'Fauves' were a group founded and named as a result of public disapproval, and so too was 'Cubism'. In each case, however, the ironic nickname became a badge of pride. At least for a while, the insults reinforced the coherence of a group that would never have formed or defended itself in the way it did but for the need to present a united front.

Furthermore, because public rejection prevented them from exhibiting their work in certain spaces, avant-garde artists had to come up with other venues for exhibitions. From 1874, the Impressionists, whose works had been refused by the Salon juries, financed and organized their own group exhibitions.

The Fauves and the Cubists also exhibited in private galleries as the result of rejection or abuse at the Salon des Indépendants and the Salon d'Automne, to say nothing of other, more reactionary venues. Ambroise Vollard, Eugène Druet, Daniel-Henry Kahnweiler and Berthe Weill were some of the dealers and gallery owners who were starting to develop into an alternative force in the art world. Marginal figures to begin with, they gradually became more central as the artists whose work they showed gained in influence. Changes in the art market thus accompanied changes in the work being produced – new venues were found for new art. Pablo Picasso was the first painter of the 20th century to refuse categorically to take part in the salon system, which (as we have seen) had dominated the art world for three centuries. The Spaniard's decision represented the logical conclusion of a phenomenon that had started with Manet and the Salon des Refusés. Manet, knowing that he was exposing himself to the possibility of a humiliating refusal, never stopped trying to get his pictures accepted by the jury, but Picasso refused point blank to suffer this indignity. From 1907 onwards, his friendship and business relationship with the dealer Kahnweiler lifted him, happily, above the mêlée – all the more remarkably as Kahnweiler rejected most of the normal practices of art dealers and conducted hardly any publicity on behalf of his painters. Braque, Léger and Derain also adopted Picasso's approach and in 1908 stopped exhibiting at either the Salon des Indépendants or the Salon d'Automne. A slightly less radical break was effected by Matisse. He continued to send a few paintings to the salons, but anyone who wanted to buy his work had to go along to Vollard's or Druet's or the Galerie Bernheim-Jeune (which also represented Van Dongen).

The support of the critics

The third member of the trinity – apart from artists and dealers – were the critics. For the Fauves and the Cubists these were Guillaume Apollinaire, Blaise Cendrars and André Salmon. They exerted their influence through the prefaces they wrote for catalogues published by the galleries and more often through articles in the daily press and periodicals, which they occasionally founded themselves. Apollinaire championed the Fauves and then the Cubists. In 1912, Salmon published *Une Jeune Peinture Française*, a panegyric to Picasso (to the detriment of Braque), and in 1916 he organized the exhibition 'L'Art Moderne en France', which revealed to the public the painting known from that time on as *Les Demoiselles d'Avignon*.

Everything was now in place. The 20th-century avant-garde – an association of artists,

Artists and the Printed Word

Artists did not sit back and wait for critics to champion them. In the 20th century they took up the pen themselves, not only in intimate journals (as Delacroix had in the previous century), but also in publications aimed at the public.

The dailies

The Italian Futurists were happy to publish their manifestos in newspapers. The first of these was the manifesto published by the poet Filippo Tommaso Marinetti in Le Figaro on 20 February 1909. There followed (sometimes published in Italy and sometimes in France): 'Let's Kill the Moonlight', the 'Manifesto Against Backward-looking Venice' and the 'Manifesto Against Montmartre'. On 11 February 1910, five painters (Boccioni, Balla, Carrà, Severini and Russolo) signed the 'Manifesto of the Futurist Painters'. They did the same thing again on 2 April that year with the 'Technical Manifesto of Futurist Painting', and in 1912 Boccioni published, in his name alone, the 'Manifesto of Futurist Sculpture'.

Reviews

At the same time, the French Cubists and German Expressionists were experimenting with new supports and printing techniques.

They founded periodicals based on the literary and philosophical reviews of the day (such as Le Mercure de France) and the numerous poetry publications available (from Vers et Prose to Le Festin d'Ésope). Text played a more important role than the visual aspect in these publications. They included Apollinaire's review Les Soirées de Paris, and Der Sturm, the name chosen by Herwarth Walden for the review and gallery he founded in Berlin in March 1910. Although this latter did contain some photographic reproductions of paintings, drawings and sculptures, greater prominence was given to wood engravings. Many other reviews were published by Expressionist artists, including Franz Pfemfert's Die Aktion.

Illustrated art magazines

They also published limited print runs of more ambitious, costly magazines that were illustrated with original art in the form of lithographs or engravings. The almanac Der Blaue Reiter, which the Munich-based group of painters including Franz Marc, Wassily Kandinsky, Alexeï von Jawlensky

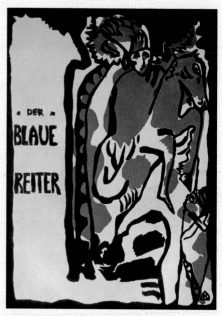

Wassily Kandinsky, *Cover for the 'Der Blaue Reiter' Almanac (St Martin and the Beggar)*, 1914, after an engraving from 1911, Munich, Städtische Galerie im Lenbachhaus.

and Paul Klee published in 1912, was a prime example. Another was *Blast*, the organ of the Vorticist avant-garde (a mixture of Cubism and Futurism), in which the American poet Ezra Pound rubbed shoulders with the French sculptor Henri Gaudier-Brzeska.

Book illustrations

Following on from experiments such as Manet's and Mallarmé's collaboration on a French translation of Poe's *The Raven*, artists and writers began to work together much more around the time of Cubism. At Kahnweiler's invitation, Derain produced a series of illustrations in 1909 for Apollinaire's first collection of poems, *L'Enchanteur Pourrissant*, and in 1910 Picasso made etchings for Max Jacob's *Saint Matorel*. In 1912, Derain created the woodcuts for *Les Œuvres Burlesques et Mystiques de Saint Matorel Mort au Couvent* (also for Max Jacob and Kahnweiler), and later, in 1919, he provided drawings for André Breton's first volume of poetry, *Mont-de-Piété*.

Kahnweiler, Apollinaire and the Avant-Garde

The Dealer Daniel-Henry Kahnweiler in Picasso's Studio, photograph, 1910, Paris, Musée Picasso.

Card from Pablo Picasso to Guillaume Apollinaire, dated 16 July 1916, Paris, Musée Picasso.

Daniel-Henry Kahnweiler (1884–1979)

Of Jewish-German origin (born in Mannheim), Daniel-Henry Kahnweiler was nicknamed 'our prince' by his fellow dealer Louis Carré. Having arrived in Paris in 1902 to train in finance, he acquired a liking for lithographs and started collecting them. By way of a test, his parents gave him 25,000 francs and a year in which to prove himself. He bought works by Derain and Vlaminck and exhibited them in small premises that he opened in 1907 on the Rue Vigneron.

Convinced of the need to discover talented artists and exhibit their work as quickly as possible, he championed Picasso and other great Cubists such as Gris, with whom he formed a close friendship. He also ventured into publishing, bringing out the work of Apollinaire and Max Jacob. In 1920, from Switzerland, where he had taken refuge during the war, he published his own book *Le Cubisme*. The same year, his premises were seized as 'enemy property' and the art it contained was sold at auction. He then opened the Galerie Simon on the Rue Astorg, signing agreements with new artists, including André Masson. Although by now a naturalized Frenchman, as a Jew he had to take refuge in the Lot Valley during World War II and his gallery was sequestered. Louise Leiris ran it after 1945, receiving helpful advice from Kahnweiler.

Guillaume Apollinaire (1880–1918)

Writing for a number of different newspapers, Apollinaire championed 'Le Douanier' Rousseau, Derain, Vlaminck, Picasso, to whom he devoted an article as early as 1905, and Braque, for whom he wrote a preface for the catalogue of the artist's first exhibition at Kahnweiler's gallery. Apollinaire also ran a review, *Les Soirées de Paris*, founded in 1912 with the help of Baroness d'Œtingen and her brother Serge Férat. He collaborated on *Montjoie* and in 1912 put together *L'Art Nègre* in collaboration with Paul Guillaume. This was followed a few months later by a volume called *Méditations Esthétiques*, subtitled *Les Peintres Cubistes* – the first attempt to write a theoretical description of a movement that by that time had increased its audience considerably.

Apollinaire was also interested in the work of Robert Delaunay, for whom he invented the term 'Orphism'. That his literary work was strongly influenced by his artistic friendships is seen in *Calligrammes*, which experiments with a new visual relationship between words and objects, and in his 'poem-conversations', based on chance and the ordinariness of everyday life, which like Breton's work explore a new approach to beauty.

A year before his premature death – he died in the Spanish flu epidemic – Apollinaire staged a 'Surrealist' verse drama, *Les Mamelles de Tirésias*, and gave an important talk on the 'new spirit'.

critics and gallery owners – was born. Often they would belong to the same generation and their coalition would be designed for offensive action. The aim of this avant-garde was to use force and provocation to win recognition for themselves as being different from the existing order, which had been in place for some time and possibly decades. The downside, of course, was that they in turn would have to endure rejection and criticism from a younger movement for whom they would represent the established order. In 1916, the Dadaists began attacking the Cubists, claiming they were practitioners of an artistic formula simply learnt by heart and skilfully regurgitated.

The alliance between the arts

In addition to this alliance with dealers and critics there was another alliance – with other arts such as theatre, dance and especially literature.

This type of collaboration was particularly characteristic of the Dada and Surrealist movements. Founded in the Cabaret Voltaire in Zurich in 1916, the Dadaist movement – or Dada – brought together visual artists (Hans Arp, Marcel Janco) and writers (Tristan Tzara, Hugo Ball, Richard Huelsenbeck). This pattern was later repeated in Berlin and Paris. In Paris, the Dadaists contributed to Francis Picabia's review *391* and to André Breton's review *Littérature*, whose title had been suggested to him by Paul Valéry. Dada exhibited at the bookshop and gallery Au Sans Pareil, where the first exhibition of Max Ernst's collages was organized by Breton, Aragon and Éluard.

After 1924 – the year of publication of the first Surrealist manifesto – the movement, now known as Surrealism, was based even more strongly on an alliance of poets (acting as critics) and painters. Both groups contributed to reviews. *La Révolution Surréaliste* appeared between December 1924 and December 1929, with Breton assuming the helm from issue four onwards. It devoted a significant amount of space to contemporary painting, in the form of both articles and reproductions. In July 1930, it was succeeded by *Le Surréalisme au Service de la Révolution*, which continued to be published until May 1933. Breton was again in charge and Éluard was managing editor. It fostered the same alliance between poetry and painting and the same editorial line was taken. Picasso designed the cover of *Minotaure* (published between 1933 and 1939), whose editorial committee included Breton, Pierre Mabille, Éluard and Duchamp. Mention should also be made here of the review *Documents*, published in 1929 and 1930, which united the visual arts (Miró, Picasso, Masson and Jacques-André Boiffard), literature (Bataille, Leiris – both hostile to Breton) and ethnology (Einstein, Griaule). However, this form of collaboration was not confined to the Surrealist movement between the wars. Another area in which it thrived was geometric abstraction. In the Netherlands during World War I, Mondrian propounded a pictorial metaphysics based on the perfect equilibrium between verticals and horizontals and a restriction of the palette to the three primaries (red, yellow and blue) along with black and white in their capacity as 'non-colours'. The experiments that he conducted in Paris from 1912 onwards, starting out with Cubism and reinterpreting it, led to an aesthetic that was as radically different from Cubism as it was from any other pictorial tradition. It seemed natural for Mondrian then to found a review, which he did in Leiden in 1917. He turned the magazine – called *De Stijl* – into the organ of the group of the same name and used it as a mouthpiece for his system, which he christened 'Neo-Plasticism'. *De Stijl* saw itself as a didactic instrument whose aim was to win over the reader through demonstration and dialogue. Several of these texts were later published in book form – *Néoplasticisme*, published in Paris in 1920 by the Effort Moderne gallery, and *Neue Gestaltung*, published in 1925 by the Bauhaus Press.

A change of continent: the triumph of New York

Up until World War II, all avant-garde movements were nurtured in the same place: the continent of Europe. After the war, however, modernity shifted from the old world to the new. America exploded onto the scene and soon came to be regarded, with its diversity of trends, as the true home of avant-garde art.

This phenomenon had its roots in New York in the early 1940s. At this time the art world was dominated by European aesthetic ideas, and European artists had major works in all the important public and private collections. The Museum of Modern Art had Picasso's *Les Demoiselles d'Avignon* and a number of large Matisses; the collection that would later become the Guggenheim Museum owned many historic Kandinskys. The arrival of artists who had fled the war and the Nazis gave extra force to the European influence. The presence of so many painters, sculptors and architects from the old world had two consequences. Firstly it gave American artists, or those recently arrived in the USA, an opportunity to study Cubism, the different forms of abstraction and Surrealism – far more effectively, indeed, than they could have done in Europe, where this kind of work was not on public display. Secondly, this assimilative phase led to a phase of liberation. It became vital for Pollock, de Kooning and Gorky to free themselves from models and points of reference that would have reduced them to the role of mere imitators and pasticheurs had they remained faithful to them.

In other words, an American generation born between 1904 (Gorky) and 1912 (Pollock) had to define itself. This it did in stages, through a series of breaks with the past. It was assisted by galleries such as those of Peggy Guggenheim, Sidney Janis and Samuel Kootz. It eventually succeeded, even under the scrutiny of well-disposed but demanding critics such as Clement Greenberg, Harold Rosenberg and Meyer Schapiro, members of the American Marxist Left that grew up in the years of the Great Depression. Having freed itself from Picasso's magisterial influence, this generation passed through phases of Neo-Plasticism (Mondrian) and organic abstraction (Miró) as well as Surrealist-inspired archaistic and mythical phases. In 1947–8, it started to produce the first works of what would later be called Abstract Expressionism. These were greeted with suspicion by the conservative critics.

The way Abstract Expressionism grew and then withered has certain similarities with the history of Cubism. Cubism began in Europe in the years before World War I; Dadaism put an end to it less than a decade later. In an accelerated repetition of the same pattern, Abstract Expressionism developed in the USA in the early 1950s and Johns, Rauschenberg and Twombly broke with it in the middle of the same decade. A symbolic moment occurred in 1953, when Rauschenberg visited de Kooning in his studio and asked for a drawing, which he got. He wanted not to keep it but to destroy it: he methodically erased it as a way of rejecting the older painter's legacy. Rauschenberg was born in 1925, Twombly in 1928, Johns in 1930 and de Kooning in 1904. The symbolism of Rauschenberg's action is clear: the new generation was coming into its own by killing off its father. It was not for nothing that these artists were considered at the time to be representatives of a sort of 'Neo-Dadaism' – they proved themselves to be every bit as confrontational and anti-establishment as the original Dada movement.

Epilogue

BEING AN ARTIST TODAY

What is the artist's position at the beginning of the 21st century? This can be summed up by one word: confusion – confusion in a great many areas.

TOO MUCH OR TOO LITTLE?

Confusion firstly in terms of artistic creation and the critical reaction to it. The very notion of an artistic avant-garde was under fire throughout the 1980s and 1990s. This was exacerbated by the fact that it had in any case lost some of its vital substance. A journey that had seemed until then to be following a logical path was coming to the end of the road.

Loss of context

To begin with, abstraction superseded figurative art. In the work of Kandinsky or Mondrian, for example, underlying expressive, symbolic or metaphysical meanings were intended to replace an imitative representation of reality – but the link with reality was not meant to disappear completely. However, these underlying meanings soon found themselves excluded. This occurred in tandem with the development of a theory that reduced art to its primary constituent parts: simple geometry and uniform monochromy. American minimalism and movements such as Supports-Surfaces in France at the end of the 1960s undertook a methodical deconstruction that laid bare the material structure of what had hitherto been called 'painting' or 'sculpture'. Shortly after 1960, Frank Stella's *Black Paintings* retained only the colour black, parallel straight lines and right angles. In the mid 1950s, Robert Ryman's work consisted of white squares distinguishable from the wall only by their fixtures. Might these have been meant as a tribute to Malevich's white and black squares? Quite possibly, but their 'featurelessness' makes Ryman's work totally enigmatic. Other minimalist artists, meanwhile, took a radically

Robert Ryman, *Chapter*, 1981, oil on linen, 223.5 x 213.5cm, Paris, Musée National d'Art Moderne.

228

different approach. While Malevich reduced his paintings to the bare essentials in order to convey an idea of infinity and eternity, the point for these later artists was to strip art down to its constituent materials. They included Carl André, who shared a studio with Stella at the end of the 1950s and made sculptures based on the accumulation of identical objects; Sol LeWitt, who created modular structures using square or cubic units; and the painters of the Support-Surfaces movement – Vincent Bioulès, Louis Cane, Patrick Saytour, Marc Devade and others. As early as the 1950s, the American painter Ad Reinhardt was painting canvases characterized by a barely discernible geometry of rectangles and squares in minutely varied tones. In 1962, he declared categorically that the sole object of 50 years of abstract art had been to present art as art and nothing else, to show it in all its singularity, to continually isolate and define it more and more, to make it purer, emptier, more absolute and more exclusive. Thus any connection between a work of art and a context was broken.

The death of art

What was left after art had been reduced to a pure state by the different strands of minimalism that followed Reinhardt and Stella? Where could painting go after the monochrome square? What could be constructed after the white cube? The only acceptable solution seemed to be to declare the end of art as a process of 'making objects'. At the end of the 1960s and in the 1970s, so-called 'conceptual' artists replaced the 'work of art' with words or phrases. This was a way of declaring that the actual finished work is of little importance; all that counts is the process (notes, sketches, models, discussions). The preparatory work, in other words, is of far greater interest than the finished object. From here to the announcement that art was dead was but a short step. This was the final stage of an evolution whereby the modern in art, as embodied by a succession of avant-garde movements, inevitably ended up destroying art itself.

Two different arguments developed at this point. The first followed modernism to its ultimate conclusion and declared the death of art, or at least that of painting and sculpture, which were now definitively outmoded. The other took a diametrically opposing view, condemning modernism as an abusive, destructive ideology and calling for a return to craft, figuration, tradition – everything the avant-garde had stood against over the course of the century. This movement occasionally referred to itself as 'postmodernism', introducing into the vocabulary of art a neologism initially used in architecture to describe projects that departed from Bauhaus-inspired rigour, from Le Corbusier and from standardized contemporary construction techniques.

These diametrically opposing views have both proved to be inadequate. The first view takes no account of a phenomenon that can be continually observed and verified: that art – and in particular painting – is not dead, nor even in its death throes, and that the generation born in the 1960s is going against the ideas of the last modernists all the more readily because they are ignorant of them or are discovering them too late to feel their effect. The second view overlooks the fact that today's artists cannot simply wipe out the world in which they live or all the artistic and political events that have taken place during the century and resume practices that had currency and meaning in very different times.

The conflict between the two trends is misleading for observers as it opposes doctrines that (knowingly or not) are both based on the past – a near past in the case of the modernists and a more distant past for the post-modernists or conservatives. The past could not function as a model, however, if the present did not resemble it. The injunctions issued in its name serve only to increase the confusion. The extent of this contemporary consternation can be seen from the abundance of aesthetic debate on the issue in the USA and Europe over the final quarter of the 20th century, some of the chief protagonists being Michael Fried, Arthur Danto, David Hopkins and Gérard Genette.

Being an artist today

Raymond Hains, *Hoarding*, 1960, torn poster on sheet metal, 200 x 150cm, Paris, Musée National d'Art Moderne.

THE RETURN OF THE REAL: A RADICALLY NEW VISUAL CULTURE

This confusion of ideas is not unrelated to the profound changes affecting the general conditions under which the visual arts are practised. The references that form the basis of the visual arts today differ from those that held sway in the past.

An art of amnesia: television versus the museum

The issue can be summed up as follows: until the middle of the 20th century, the painting of the present was based on a memory of the painting of the past. Whether this memory was used to analyse, question, criticize or do a pastiche of the past, the present could not disregard it. Giorgio de Chirico imitated Titian, Tintoretto and Canaletto. Picasso painted free variations on Velázquez's *Las Meninas*, Delacroix' *The Women of Algiers* and Manet's *Déjeuner sur l'Herbe*. He quoted Rembrandt, Cranach, Poussin and David. Matisse made no attempt to hide the fact that his work was founded on a history of colour which started with Byzantium and took in Florence and Japan. Right up to Pollock and de Kooning, a pictorial tradition extending from the caves of Lascaux to Van Gogh provided 20th-century artists with a central frame of reference. The same was true for sculpture, models for which stretched from African art to Rodin. The increasing sophistication of art reproductions and museums (whose praises the novelist, art historian and politician André Malraux sang in the introduction to his book *Museum Without Walls*) reinforced this, providing artists with an inexhaustible fund

of examples and counterexamples, a system of references covering the entire planet and spanning the history of mankind.

During the second half of the century, and more intensively from the 1960s onwards, the visual memory of the citizens of every developed nation was invaded by other, mechanical images, photographs and images from cinema and television – this last mode of communication allowing the simultaneous diffusion of the same images, regardless of region, over greater and greater territories. This revolution had obvious consequences for artistic creation. To put it simply, the age of pictorial memory was succeeded by the age of 'mechanical' memory (in a non-pejorative sense). Creating a work of visual art was now unthinkable without in some way taking account of the regular flow of press and television images.

To see the truth of this we need only consider some of the many examples. Pop Art and, in France, New Realism were the first to make it clear where they looked to for inspiration. Robert Rauschenberg and Andy Warhol in the USA, Peter Blake and Richard Hamilton in Great Britain, Sigmar Polke and Gerhard Richter in Germany and Raymond Hains and Martial Raysse in France absorbed and transformed press photos, advertising images and film stills. The treatment to which they subjected these images (shredding, enlarging, adapting, colouring, superimposing, erasing) revealed the substance or emptiness of the images incessantly produced and screened by our industrial and media-dominated society. At the same time, Francis Bacon worked from photographs taken from medical textbooks, zoological textbooks or news magazines, from stills of Eisenstein films and from photographs he commissioned specifically as a basis for his portraits. This substitution of references was later accentuated by the universal triumph of television. The televisual medium was tackled early on by artists such as Warhol and Raysse, who parodied its procedures or extended them beyond their normal applications, thus anticipating the work of video artists.

Photography – criticism and consumption

The central role played by the pictorial, or painted, image was thus assumed by the mechanical image – omnipresent, familiar and henceforth all-powerful. There was no subject, moment or action it could not capture, including those that for a long time were prohibited on moral grounds as being pornographic and those whose inherent horror seemed to preclude them from being represented because they revealed the inhuman in humankind. Photographers, not least Man Ray, broke the rules of propriety and decency. Others, one of the leaders among them being Robert Capa, revealed the cruelty of war. After photographing the charnel houses of Buchenwald and Bergen-Belsen, Lee Miller ended her career and George Rodger stopped for a while, both having reached

David Hockney, *Grand Canyon with Ledge, Arizona, October 1982*, 1986, photographic collage printed on colour laser, 113 x 322.6cm, collection of the artist.

231

and even crossed the limits of the 'viewable'. Their pictures had an enormous influence. From this moment on, the photographic image found itself in a strangely ambiguous position. On the one hand, when used for illustration or advertising purposes the photograph serves the consumer and leisure industries, and indeed photography is one of the most popular leisure activities. On the other hand, when used by photojournalists – reporters of extraordinary events as well as chroniclers of the everyday – photography has the ability to capture the present in pictures that can be seen as condensations or crystallizations of the present. In other words, photography can be the inventive, eager collaborator of entertainment and consumption or the agent of revelations that the authorities would often prefer to delay or prevent. In the USA in the 1960s and 1970s, it could celebrate the beauty of a landscape or a film star but also vigorously condemn the Vietnam War and thereby help to influence public opinion. In the first case the photograph is anonymous; in the second case it is signed Larry Burrows, Don McCullin or Gilles Caron. In both cases (the comfortable or the disturbing image), photography affects people's behaviour and forms part of our visual memory.

Painting and the mechanical image: confrontation and appropriation

There is nothing surprising, therefore, in the fact that photography now seems to be the central point of reference of all artistic creation that claims to be contemporary. It has become part of the artist's world just as it has become part of the modern mindset. The painter Sigmar Polke is one of a number of contemporary artists who paint, draw and film, either alternately or at the same time. Since the beginning of the 1980s, the work of David Hockney has been based on the principle of a confrontation between tools – between the Polaroid and pastel, between the wide-angle shot and canvas (see page 231). Although anxious to show that painting can still form part of a realist tradition, Éric Fischl exhibits colour photographs too. Jean-Marc Bustamante, having been the assistant of William Klein (himself a former pupil of Fernand Léger and later a photographer and film-maker), also refuses to separate work that requires a darkroom from that which derives from drawing. He calls this second type of work 'Panoramas', using ambiguity as an effective resource.

Even those for whom painting remained the sole or main form of expression were influenced by photography. After a short abstract phase, Malcolm Morley, in the mid 1960s, produced several series of paintings that claimed to be 'modified' copies of advertising photographs. In 1971, he then reinterpreted one of the most remarkable photos of the Vietnam War (by Burrows) in oil paint on canvas. The other American Hyperrealists also openly admitted that they were fascinated by the mechanical image, while in Europe, particularly in France, Hervé Télémaque, Alain Jacquet and Erro practised a more dis-

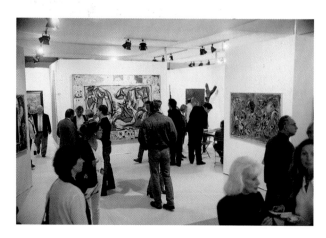

View of the Interior of the French International Contemporary Art Fair (FIAC), photograph, 1998.

tanced form of satirical appropriation. The external world also exerted a very real pressure on German art over the following decade, particularly in the work of Jörg Immendorf. The same was true in French art of the 1990s, a decade which saw the emergence of a new generation of painters. The work of Vincent Corpet, Marc Desgrandchamps and Djamel Tatah referred constantly to the world of changing, fleeting, enigmatic contemporary images. Philippe Cognée's pictures took their themes from television. The artist photographed the screen and transformed the resulting image using an original encaustic technique or at other times worked directly on the photographic prints.

Inseparable from photographic references, televisual references burst into the field of artistic creation at the end of the 20th century. Video permitted the production of images as well as the manipulation of those that are broadcast day in day out on television. However different their techniques, it was symptomatic of the importance of these new developments that such artists as Ange Leccia, Pascal Convert and Fabrice Hybert turned to video. Leccia and Convert worked on the image itself, editing, framing and colouring in order to accentuate what normally flits by on the television screen before viewers have the opportunity to view it critically. At the Venice Biennale in 1997, Hybert converted the French pavilion into a studio in which he presented pseudo talk-shows 'as on TV'. Others, such as the Swiss video artist Pipilotti Rist, use a wide range of technical effects, including coloration, disruptions of rhythm and changes of angle. Rist even uses an endoscopic camera to produce the desired disturbance of vision. All the evidence suggests that these are simply the initial results of a critical use of video. Far from succumbing to the fascination of images, video forces them to reveal the lies or vacuousness at their heart.

A CULTURE INDUSTRY

These critical attitudes have one thing in common: their target. They all, from different angles, attack a society based on the production and consumption of images. In the 1960s, Guy Debord and the Situationalist International (1957–72) labelled this society the 'society of the spectacle'. Its most efficient agents are the film and television industries, whose power is in direct proportion to the financial and technical resources at their disposal. The second half of the 20th century was characterized by the apparently unstoppable expansion of these two industries and their market, the vehicle for a modern world stifling poetic expression and turning art into a decorative commodity.

Contemporary art up against 'cultural consumption': the difficulty of resistance

It has become necessary to distinguish between this leisure market and the infinitely smaller contemporary art market. The art of the past seems for the most part to have toppled into so-called 'cultural consumption', with paintings reduced to mere reproductions, works summed up in slogans, names seen in terms of profit potential and blockbuster exhibitions repetitively exploiting a small number of schools – chiefly Impressionism and Post-Impressionism – in order to pull in the crowds.

As for the contemporary art industry, this has been characterized by investment activity that is far more sporadic, as was seen during the last ten years of the 20th century. At the end of the 1980s, a fashion for art developed – for art in general and contemporary art in particular – that triggered a sudden rise in prices and a massive increase in purchases and sales that was trumpeted and blown up out of all proportion by the press. This infatuation with art was short-lived. The first Gulf War and accompanying stock-market uncertainty was all it took for international investment to dry up, producing an inevitable collapse in prices and widespread disillusionment. Japanese speculators in particular withdrew from the market as quickly as they had entered it. The American market slid into depression and the European – and in particular French – market into lethargy. After a brilliant start, the International Contemporary Art Fair (FIAC) held in Paris suffered a number of disastrous years. Several

galleries were forced to close and others managed to survive thanks only to the calculated benevolence of the banks and acquisitions made by the state, the market's ultimate saviour.

Since this crisis, contemporary art has returned to what should probably be regarded as the normal state of affairs. The situation at the beginning of the 21st century differs little from the situation in 1929, when the consequences of the Great Depression forced the dealer Kahnweiler, as a cost-saving measure, to switch on the lights in his gallery only when someone came to look round. The market remains fragile and just about manages to bump along at low volumes. It revolves around the gallery, in other words around the relationship between dealers and artists, who expect the dealers to come up with collectors for their work. Its survival presupposes that it can achieve a notoriety that is more than limited and which can only be achieved with the help of the critics, whether in the general daily and weekly press or in the specialist art press. In the USA and certain European countries (Germany, Belgium, Great Britain, Switzerland), the tradition of the private collection remains strong and the work of artists can be found in individual homes and company headquarters. In France, on the other hand, a habit has developed, inherited from the monarchy and reinforced by centralization and Jacobinism, for patronage to be left to the public authorities (the galleries' main customers). In other words, most purchasers of artists' work are museums and national and regional contemporary art funds.

A single comparison will make the difference clear. In New York, the Museum of Modern Art (MOMA) came into being as the result of a merging of private initiatives and collections, notably those of the Rockefeller and Goodyear families. It is administered by trustees who enrich it with contributions and donations. In Paris, it took a political initiative, that of a President of the Republic, to found the Pompidou Centre in a bold individual gesture. The construction of this public building was regarded for a long time as a hostile intrusion into the urban space of the French capital – one whose aim, however, was to provide 20th-century art with an unambiguous presence in the city in which Picasso painted his *Demoiselles d'Avignon* and Matisse his *Red Studio*. To judge from the resistance shown by French society to any art that postdates Monet's *Water Lilies*, we might legitimately doubt the project's efficiency but not the need for it.

Index

Index

Index

Index

SOURCES

Alberti, L B, *On Painting*, translated by Cecil Grayson, Penguin, London,1991

Apollinaire, G, *The Cubist Painters; Apollinaire and Cubism*, translated by Peter Read, Artists. Bookworks, East Sussex, 2002

Apollinaire, G, *Apollinaire on Art : Essays and Reviews 1902–1918*, translated by Susan Suleiman, Thames and Hudson, London, 1972

Cellini, B, *Autobiography*, rev ed, translation and introduction by George Bull, Penguin, London, 1998

Durer, A, *The Writings of Albrecht Durer*, translated and edited by William Martin Conway, with an introduction by Alfred Werner, Peter Owen, London, 1958

Holt, E, *A Documentary History of Art Vols 1-3*, selected and edited by Elizabeth Gilmore Holt, Princeton University Press, New Jersey, 1981–1986

Kahnweiler, D H with Crémieux, F, *My Galleries and Painters*, translated by Helen Weaver, Thames and Hudson, London, 1971

van Mander, K, *The Lives of the Illustrious Netherlandish and German Painters, from the first edition of the Schilder-Boeck (1603-1604)*, edited by Hessel Miedema, Davaco, Doornspijk, 1994

Matisse, H, *Matisse on Art*, rev ed, edited and translated by Jack C. Flam, University of California Press, Berkeley, 1995

Montagu, J, *The Expression of the Passions: the Origin and Influence of Charles Le Brun's "Conference sur l'expression générale et particuliere"*, Yale University Press, New Haven, 1994

de Piles, R, *The Art of Painting, with the Lives and Characters of above 300 of the Most Eminent Painters: Containing a Complete Treatise of Painting, Designing, and the Use Of Prints. With reflections on the works of the most celebrated masters. To which is added, an essay towards an English School [by Bainbridge-Buckeridge]*, 3rd ed, translated by John Savage, London, 1754.

Poussin, N, *Lettres et ropos sur l'art*, collected by Anthony Blunt, foreword by Jacques Thuillier, Hermann, Paris, 1989 (Some translated in E.Holt: see above)

Reinach, A., *Textes grecs et latins relatifs a l'histoire de la peinture ancienne: recueil Milliet*, preface by A. Rouveret, Macula, Paris, 1985

Vasari, G, *The Lives of the Artists*, translated with an introduction and notes by Julia Conaway Bondanella and Peter Bondanella, Oxford University Press, Oxford, 1991

CRITICAL STUDIES

Acton, M, *Learning to Look at Paintings*, Routledge, London, 1997

Antal, F, *Florentine Painting and its Social Background: The Bourgeois Republic before Cosimo de Medici's Advent to Power, XIV and Early XV Centuries*, Harvard University Press, Cambridge, MA, 1986

Antal, F, *Classicism and Romanticism, with Other Studies in Art History*, Routledge and Kegan Paul, London, 1966

Baxandall, M, *Painting and Experience in Fifteenth-Century Italy: a Primer in the Social History of Pictorial Style*, Oxford University Press, Oxford, 1988

Bignamini, I and Postle, M, *The Artist's Model: Its Role in British Art from Lely to Etty*, exhibition catalogue, University of Nottingham Art Gallery in association with English Heritage, 1991

Borzello, F, *A World of our Own: Women as Artists Since the Renaissance*, Thames and Hudson, London, 2000

Branner, R, *Manuscript Painting in Paris during the Reign of Saint Louis: A Study of Styles*, University of California Press, Berkeley, 1977

Brewer, J, *The Pleasures of the Imagination: English Culture in the Eighteenth Century*, Harper Collins Publishers, London, 2004

Burckhardt, J, *The Civilization of the Renaissance in Italy*, translated by S.G.C. Middlemore, with an introduction by Peter Burke and notes by Peter Murray, Penguin, London, 1990

Burke, P, *The Italian Renaissance: Culture and Society in Italy*, Polity Press, Cambridge, 1999

Burke, P, *Tradition and Innovation in Renaissance Italy*, Collins, London, 1974

Chastel, A, *Art of the Italian Renaissance*, translated by Linda and Peter Murray, Arch Cape Press, New York,1988

Chastel, A, et al, *The Renaissance: essays in interpretation*, Methuen, London, 1982

Clark, T J, *The Absolute Bourgeois: Artists and Politics in France 1848–1851*, Thames and Hudson, London, 1982

Clark, T J, *The Image of the People: Gustave Courbet and the 1848 Revolution*, Thames and Hudson, London, 1982

Dempsey, C, 'Some Observations on the Education of Artists at Florence and Bologna During the Later Sixteenth Century', *Art Bulletin*, 62, 552–569, 1980

Eisenman, S F, et al, *Nineteenth-Century Art: A Critical History*, Thames and Hudson, London, 2002

Gombrich, E H, *Gombrich on the Renaissance, Volume 1: Norm and Form*, Phaidon Press, London, 1994

Gombrich, E H, *Art and Illusion: a Study in the Psychology of Pictorial Representation*, 6th ed, Phaidon Press, London, 2002

Harris, A S and Nochlin, L, *Women artists, 1550-1950*, Los Angeles County Museum of Art, Los Angeles, 1976

Haskell, F and Penny, N, *Taste and the Antique: the lure of classical sculpture 1500-1900*, Yale University Press, New Haven, 1982

Haskell, F, *Patrons and Painters: a Study in the Relations Between Italian Art and Society in the Age of the Baroque*, Yale University Press, New Haven, 1980

Heller, N G, *Women artists: an illustrated history*, 3rd ed, Abbeville Press, New York, 2003

Hemingway, A and Vaughan, W (eds), *Art in bourgeois society, 1790-1850*, Cambridge University Press, Cambridge, 1998

Hopkins, D, *After Modern Art 1945–2000*, Oxford University Press, London, 2000

Huizinga J, *The Waning of the Middle Ages*, rev ed, Penguin, London, 1955 (printed 2001)

Lethève, J, *Daily life of French artists in the nineteenth century*, translated by Hilary E. Paddon, Allen and Unwin, London, 1972

Marrow, J, *Passion Iconography in Northern European Art of the Late Middle Ages and Early Renaissance*, Ghemmert, Kortrijk, 1979

Meiss, M, *Painting in Florence and Siena after the Black Death*, Princeton University Press, Princeton, 1978

Nochlin, L, *Women, Art and Power, and Other Essays*, Thames and Hudson, London, 1989

Nochlin, L (ed), *Realism and Tradition in Art, 1848–1900: Sources and Documents*, Prentice-Hall, Englewood Cliffs, NJ, 1966

Panofsky, E, *Renaissance and Renascences in Western Art*, Almqvist and Wiksell, Stockholm, 1960

Panofsky, E, *Meaning in the Visual Arts*, Penguin, London, 1993

Pevsner, N, *Academies of Art, Past and Present*, Da Capo Press, New York, 1973

Ring, G, *A Century of French Painting, 1400–1500*, Phaidon Press, London, 1949

Rosenblum, R and Janson, H W, *Art of the nineteenth century : painting and sculpture*, London, Thames and Hudson, 1984

Taubes, F, *Anatomy for artists*, Pitman, London, 1969

Westermann M, *The Art of the Dutch Republic, 1585-1718*, Laurence King Publishing, London, 2005

Warnke, M, *The Court Artist: on the Ancestry of the Modern Artist*, Cambridge University Press, Cambridge, 1993

White, H and White, C, *Canvases and Careers: Institutional Change in the French Painting World*, Chicago University Press, Chicago, 1992

Wittkower, R, *The Sculptor's Workshop: Tradition And Theory from the Renaissance to the Present*, University of Glasgow Press, Glasgow, 1974

Wittkower, R, *Sculpture: processes and principles*, Penguin, Harmondsworth, 1979

Wittkower, R and Wittkower, M, *Born under Saturn: the Character and Conduct of Artists: a Documented History from Antiquity to the French Revolution*, Weidenfeld and Nicolson, London, 1963

Wright, C, *The French Painters of the Seventeenth Century*, Orbis, London, 1985

Photo credits